Editing: Teresa Go
Book design: Xie Min, Yu Shuai
Cover design: Zhang Jing

Scalo head office:
Scalo Verlag AG
Schifflände 32, CH–8001, Zurich
PO Box 73 / CH–8024 Zurich, Switzerland
tel +41 44 261 0910, fax +41 44 261 9262
publishers@scalo.com, www.scalo.com

Distributed in North America by Prestel, New York; in Europe, Africa,
and Asia by Thames and Hudson, London; in Germany, Austria and
Switzerland by Scalo.

YUEMUTANG **ART** DESIGN **PHOTOGRAPHY**

Beijing Yuemutang Art, Design & Photography Ltd.

Sponsored by **The Intelligent Alternative,** Beijing

Printed in China
Bofung Printing Group Limited
First Scalo Edition
ISBN 3-03939-036-8

For my mother who gave me life, and for my father who lends it purpose

NINE LIVES
The Birth of Avant-Garde Art in New China

Karen Smith

SCALO

CONTENTS

GLOSSARY

General Socio-Political Terms

Mao Zedong, aka Chairman Mao, aka the Great Helmsman
Mao Zedong was born on December 26, 1893, and died on September 9, 1976 at the age of 83. He was the head of the Chinese Communist Party for forty-one years from the historic Zhunyi meeting (1935) during the Long March. He built the Red Army, usually referred to as the People's Liberation Army (PLA; *Jie Fang Jun* in Mandarin), which took part in the anti-Japanese War and the civil war in China, finally chasing the Nationalists to Taiwan. He established the People's Republic of China on October 1, 1949. Mao is the most important personage in China's modern history.

Great Leap Forward
A campaign of rapid industrialization launched in 1958 that sought to bring Communism to the countryside. The Great Leap Forward resulted in three years of famine and millions of deaths throughout China—estimated at more than 14 million people.

Bad Categories
These were defined as "nine black elements"—landlords, rich peasants, counter-revolutionaries, bad elements, rightists, renegades, enemy agents, "capitalist roaders", and bourgeois intellectuals.

Re-education in the countryside: being sent down to the countryside
The nationwide "sent-down" campaign was officially launched on 22 December 1968, when the People's Daily published Mao's "supreme directives" stating that "it is necessary for the educated young people to go to the countryside to be reeducated by the poor and lower-middle peasants". By the end of 1976, when the large-scale campaign stopped, over sixteen million urban youths had been sent to the countryside—possibly the largest migration movement in human history.

Danwei
The work unit. *Danwei* were established in the early years of the Party, in revolutionary base areas, as a way for organising labour and production around basic socialist principles. Over time, they turned into a site for the organisation of social life, existing to provide welfare benefits to their members: the institution through which the expectations of the revolution were to be realised.

Communes
Communes were introduced in 1958. They enabled the Party to direct agricultural production according to state economic planning. Communes succeeded in improving overall rural healthcare and basic literacy, but where they represented the "proletarianization" of the peasantry, they took away the peasants' basic decision-making rights and ownership of the most important means of agricultural production—land.

Dazibao
Literally "big character poster". The use was specific to the Mao era and particular to the intense years of political struggle during the Cultural Revolution (1966–1976). Content initially centred on propagating the directives of campaigns, but also extended to criticism of factions and denunciation of individuals.

Chinese (language), Mandarin, putonghua, guoyu, pinyin
The official language of China is *putonghua*, translated as Mandarin or the generic "Chinese [language]". Whilst this remains the official lingua franca of China, the peoples across the various provinces speak a divergent range of vernacular dialects. *Guoyu* literally means "national language" and is now more commonly used to mean the Taiwanese dialect.

Pinyin is the term for the phonetic romanisation of Chinese characters used on the Mainland—as opposed to the Wade-Gilles system of phonetics used in Taiwan.

Opening and Reform
In March 1979, Deng Xiaoping stated that to maintain the correct orientation of China's modernisation programme it was essential to adhere to Four Cardinal Principles: keeping to the socialist road, upholding the dictatorship of the proletariat (the people's democratic dictatorship), leadership by the Communist Party, and Marxism-Leninism and Mao Zedong Thought. Deng's efforts to rationalise the ideological, political and organisational lines set China on the path of development, which was prerequisite for carrying out socialist modernisation and the policies of reform and opening to the outside world.

Reform meant adopting an open policy that would invigorate the economy. Where 80 per cent of China's population lived in the countryside, it was there that the reform began. Four special economic zones were established and 14 coastal cities were opened to the outside world, the idea being that some regions and some people would be allowed to become prosperous first, so that others would follow their example, allowing the economy to make rapid progress, eventually enabling all the Chinese people to prosper. In Deng's words: "To be rich is good".

Guanxi
Literally "relationships", and stands for any relationship between one person and their acquaintances. A significant level of the meaning relates to an anticipated reciprocity between the two parties.

Yuan / mao / renminbi (RMB)
Units of Chinese currency. From the mid-1990s, one US dollar was equal to 8.2 yuan. A mao is one tenth of a yuan. "Renminbi" is the name of the currency: namely "the people's money".

Cultural Terminology and Word Usage

Avant-garde, New Art Movement, New Art, Contemporary Art
Avant-garde is the sexy term. Invoked from abroad, and latterly applied by the Chinese when it was politically expedient to do so. The New Art Movement is the Chinese term applied to the birth or emergence of avant-garde art in China. The art was referred to as new art until the mid-1990s when it became common to say "avant-garde". Generations of artists that followed the founding fathers of the New Art Movement are more usually called contemporary artists.

Children's Cultural Palace
An institution created during the Mao era, in which children received a grounding—largely ideological—in various creative disciplines.

Painting Institutes
Also created under Mao's directives on culture as work units to which professional painters would be assigned. The mission was to provide the technical excellence of visual imagery to meet the requirements of the Party's propaganda department.

Chinese painting, ink and brush painting, shan-shui, guohua
Chinese painting is a generic term used to mean the application of black ink to rice paper with a Chinese brush: hence ink and brush painting. It is also referred to at times as *shan-shui*, meaning literally mountain-water, which is more correctly a genre of ink painting. "As part of a powerful twentieth century trend toward the westernisation of China's economy, society, and culture [beginning in 1911], the art education in China's modern schools was dominated by European artistic techniques. Painting in the traditional medium of ink and color on paper was now referred to as *guohua* (national painting), to distinguish it from western-style oil painting, watercolor painting, or drawing, and became only one of several options for a Chinese artist." (The Yates Collection)

Soviet Socialist Realism, Maoist Revolutionary Realism, Socialist Realism
The same entity is referred to by all the above terms, the difference being a sequence through time. Soviet Socialist Realism came first, taken from the USSR by Chinese artists sent there to study in the 1950s. Once back in China, these artists turned the skills of the technique into what was termed Maoist Revolutionary Realism through the 1960s and early 1970s. The generic term for all stages of development is Socialist Realism.

Stars Group
A collective of didactic artists from the ranks of workers, who came together in 1979 to "make way for freedom of spirit and expression in a society that did not allow original thought or creativity." The twelve principle members were Huang Rui, Ma Desheng, Yan Li, Wang Keping, Yang Yiping, Qu

Leilei, Mao Lizi, Bo Yun, Zhong Ahcheng, Shao Fei, Li Shuang and Ai Weiwei. The name derived from their philosophical stance: "Every artist is a star. Even great artists are stars from the cosmic point of view. We called our group 'The Stars' in order to emphasize our individuality." (Ma Desheng) Quotes taken from Hilary Binks, "The Stars Group of Artists", courtesy Zee Stone Gallery, Hong Kong.

Scar Art, Sichuan School, Country Life Realism (xiangtu xianshi zhuyi)
Schools of art that emerged in the post-Cultural Revolution era. The first was a re-examination of the emotional experiences of the generation of high school graduates who were sent down to the countryside in the early 1970s and who lost ten years of their youth to the programme. A portion of those who became artists in the late 1970s, put their skills to tracing the emotions they harboured: often pained, equally revisited through the prism of a youthful romanticism. The Sichuan School then followed closely behind, taking a slight departure from the official line in painting actual scenes of the lives of ordinary minorities that they had witnessed or that could be found in the remote regions—untouched by the ideology that constrained their own lives. Country Life Realism was the final outcome: *xiangtu xianshi zhuyi* invoked an idealised vision of life in the rural regions that might be gritty and hard but was, at least, relatively unaffected by the reality in the ideologically constrained urban conurbations.

TIME LINE

YEAR	ARTIST	ART WORLD	HISTORY
1944	Born—Li Shan		
1949			October 1: Founding of the People's Republic of China (New China)
1955	Born—Xu Bing	From the mid-1950s, Chinese artists sent to the Repin Academy, Moscow, to study Soviet Socialist Realism	
1956			Mao Zedong's campaign Let One Hundred Flowers Bloom, Let a Hundred Thoughts Contend is launched. Anti-Rightists campaign launched
1957	Born—Wang Guangyi		
1958	Born—Wang Jianwei, Zhang Peili, Zhang Xiaogang		Great Leap Forward
1959			Wide spread famine following the Great Leap Forward
1962	Born—Geng Jianyi, Gu Dexin		
1964	Born—Fang Lijun		
1966			Cultural Revolution begins
1968	Li Shan graduates from the department of stage design at Shanghai Drama Academy		
1972			Mao decides to send highschool graduates to the countryside for "re-education"
1976			Death of Mao Zedong; end of the Cultural Revolution; Tangshan earthquake
1977			Deng Xiaoping succeeds Mao; universities begin to reopen

YEAR	ARTIST	ART WORLD	HISTORY
1978			Deng Xiaoping announces "opening and reform"
1979		First Stars Group exhibition in Beijing	January 1: Diplomatic relations with the US are normalised
1980		Second Stars Group exhibition in Beijing	The one-child policy becomes officially enforced
1981	Xu Bing graduates from the printmaking department of the Central Academy of Fine Arts, Beijing		Trial of the Gang of Four, Beijing; the implementation of "opening and reform" now begins in earnest
1982	Zhang Xiaogang graduates from the oil painting department of Sichuan Academy of Fine Arts		
1983			Anti-Spiritual Pollution campaign launched
1984	Wang Guangyi, Zhang Peili graduate from the oil painting department of Zheijiang Academy of Fine Arts, Hangzhou	National Arts Exhibition disappoints progressive elements of the art world with its apparent return to Maoist ideological guideines	
1985	Geng Jianyi graduates from the oil painting department of Zhejiang Academy	The birth of avant-garde art in China marked by the emergence of the New Art Movement; Wang Guangyi founds the Northern Art Group; new art magazines launched—*Art Trends* in Wuhan, *Fine Arts* in Beijing; Robert Rauschenberg has solo show at China Art Gallery, Beijing	

YEAR	ARTIST	ART WORLD	HISTORY
1986	Wang Guangyi organises a conference on the new art in Zhuhai Painting Institute, southern China		
1987	Xu Bing completes post-graduate studies at the Central Academy of Fine Arts, Beijing		
1988	Wang Jianwei completes post-graduate studies at Zhejiang Academy Xu Bing has controversial solo exhibition at China Art Gallery in which *Book from the Sky* is shown for the first time	Conference on new art in Huang shan, Anhui province—Geng Jianyi and Zhang Peili produce challenging art works	
1989	Fang Lijun graduates from the Central Academy in Beijing Gu Dexin participates in "Magiciens de la Terre" at the Centre Georges Pompidou, Paris	"China/Avant-Garde" exhibition opens at China Art Gallery (Feb. 5), and is closed the same day	Student protests culminate in the June 4 incident
1990	Xu Bing moves to the US	Yuanmingyuan artists' village is established in Beijing; Gu Dexin forms XinKeDu with Wang Luyan and Chen Shaoping	

YEAR	ARTIST	ART WORLD	HISTORY
1991		The exhibition "New Generation," organised by Wang Youshen and *Beijing Youth News Daily* is held at the Museum of Chinese History in Beijing; First Guangzhou Biennial: *Oil Painting* in the 1990s is held in Guangzhou; Zhang Xiaogang travels to Germany for one year	
1993		Ten Chinese artists debut at the 45th Venice Biennale, including Wang Guangyi, Geng Jianyi, Fang Lijun, Li Shan, Xu Bing and Zhang Peili; "China's New Art, Post 1989" takes place in Hong Kong before embarking on an extended world tour (curators Johnson Chang and Li Xianting); "China Avant-Garde" opens its tour at the Haus der Kulturen der Welt in Germany (curators Jochen Noth, Andreas Schmidt, Hans van Dijk)	
1994	Fang Lijun has first solo exhibition, at Asian Art Museum, Fukuoka	Zhang Xiaogang, Li Shan and Beijing painter Liu Wei are the first Chinese avant-garde artists to show at the São Paulo Biennial	
1995		XinKeDu is dissolved	China formulates policy on eugenics

YEAR	ARTIST	ART WORLD	HISTORY
1996		First Shanghai Biennial is held in Shanghai; the first exhibition of video art is shown in the gallery of the China National Academy (formerly Zhejiang Academy) curated by Qiu Zhijie and Wu Meichun	Deng Xiaoping dies; Jiang Zemin becomes president
1997	Wang Jianwei invited by Catherine David to participate in her controversial interpretation of Documenta, the influential survey of cutting edge art that takes place in Kassel, Germany, every five years		
1998	Fang Lijun has solo exhibition at the Stedelijk Museum, Amsterdam		
1999	Xu Bing wins the MacArthur Award, and receives a purse of USD 319,000		NATO bombing of the Chinese Embassy in Belgrade
2000			China gains accession to the World Trade Organisation; proclaiming GDP growth since 1980 at 9% per annum
2001	Zhang Peili is made head of the New Media department at the China National Academy; Wang Jianwei wins the Video Cube Award at FIAC, Paris	Under the auspices of a China Culture Festival in Berlin, the Ministry of Culture sanctions an exhibition of contemporary art by cutting edge young Chinese artists	

YEAR	ARTIST	ART WORLD	HISTORY
2001		Third time round the Shanghai, Biennial becomes a biennale and goes international, curated by P.S.1's Alana Heiss and independent curator Toshio Shimizu	
2002	Xu Bing has solo show at the Sackler Museum, Washington	The work of Wang Guangyi, Fang Lijun and Zhang Xiaogang is the subject of a major retrospective "Image is Power" held at He Xiangning Art Museum, Shenzhen	
2003		First Guangzhou Triennial of Contemporary Art; First Beijing Biennial; the first offical Chinese pavilion at Venice is cancelled due to SARS	Jiang Zemin steps down; Hu Jintao becomes president
2004	Xu Bing wins the inaugural Artes Mundi Art Prize, Wales	Works of Zhang Peili and Wang Jianwei are each made the focus of week-long screenings at MoMA, New York	
2005		Xu Bing, Zhang Peili, Wang Guangyi, Wang Jianwei are appointed to the advisory board of OCT Contemporary Art Terminal (OCAT) in Shenzhen (art center established by He Xiangning Art Museum, Shenzhen); Wang Guangyi, Zhang Xiaogang and Fang Lijun are each commissioned to produce a mural to be displayed in three subway stations in Shenzhen	

INTRODUCTION

The birth of avant-garde art in China makes for a story that is unique. That is because culturally, China is unique. In the early 1980s, as a nation, a people and a culture the People's Republic of China (PRC)—"New" China in the title of this book—was profoundly different to any other. Whilst this sounds ridiculously obvious, what is at odds here was more than a complex language and a range of tongue-twisting dialects spoken across a diverse ethnic mix of peoples with differing taste buds, sense of dress and aesthetics, traditions and spiritual values. The differential lies in a sense of difference accrued to the people courtesy an extremely insular upbringing. From the Han dynasty (206 BC–AD 220), in the minds of its ruling classes, China was the centre of the world—as the direct translation of the characters *zhong* (middle 中) *guo* (kingdom 国) demonstrates. It would take close on two thousand years before they were persuaded otherwise.

When Mao Zedong established the PRC in 1949, and installed a Marxist-inspired system of governance, his belief that, via socialism, New China could be entirely self-sufficient and self-cultivating was not entirely deluded ambition. Now, against Cold War policies it was the turn of the West to keep communist China at arms' length, effectively isolating the nation again, but with an innate confidence in the enduring prowess of Chinese civilisation, it was not an isolation Mao feared.[1] His lacuna would prove catastrophic in the wake of his death as the proud façade of national confidence promulgated by the Party clashed with the insular mentality of the people that arose out of their isolation. Deng Xiaoping's clarion call for modernisation—motivated by the need to redress the nation's economic weakness and to make up for lost time and status in world affairs—set in motion a massive

1. In 1956, when Zhou Enlai put forward a protocol for "The Five Principles of Peaceful Co-Existence (of different social systems)" , in remonstration the United States imposed sanctions that isolated China—as Cuba was effectively isolated from the 1960s. Hence there was little communication between China and the West and no commercial relationship until US-Sino diplomatic relations were re-established on January 1, 1979.

reflexive pendulum swing towards the first world. Where the outside world had once seemed primitive, now it was cutting edge, and the Chinese people the ones who had much to learn, and everything to gain, from post-industrial nations, a situation which horrified, shamed and stimulated the people by turn. Providently, where Deng Xiaoping's "opening" revealed how far behind the world Mao had allowed China to slip, "reform" promised retribution. A better tomorrow was on the agenda once again: and this time it seemed it might just be on its way.

Awareness of "difference", of insularity, and the people's sense of shame at how backward China had been allowed to become, underpin any map of aesthetic evolution in New China that we might care to draw. They are elements inalienable to the avant-garde, and the reason that the circumstances of its birth are unique. The reason the avant-garde took life in China when it did can be explained where the first post-Cultural Revolution graduates from the academies, which had reopened from 1978, and considered their next moves as the first true independent artists they believed themselves to be. Xu Bing was first in 1981, Zhang Xiaogang followed in 1982, then Wang Guangyi and Zhang Peili in 1984, etc. Each endured a period of perplexing struggle as they endeavoured to transcend a staunchly academic training, which corralled all personal impulses to rigid principles that placed absolute emphasis upon figurative realism. All students were taught that the sole purpose of great art was to present the common people with an uplifting spiritual experience, via an unambiguous expression of recognisable forms and emotions that would leave no doubt as to the greatness of the socio-historical age and civilisation to which they belonged. To this end, the four years' training necessary to attain a degree consisted in the main of drawing from plaster busts, interspersed with field trips to villages and factories to apply the skills acquired in the studio to sketching the nation's peasants and workers in action; to mastering the only form of art acceptable—Socialist Realism. As students and then as graduates, when these pioneers-in-the-making surveyed the aesthetic landscape at the start of the 1980s, the first task deemed necessary for the modernisation of the nation's art was to break the monopoly held by Socialist Realism, and the ideological stranglehold it imposed upon all creative expression. More than a decade would pass before the stern busts of Lenin and Marx were legitimately usurped—albeit by reinstating classical Greek and Renaissance models, which merely complied with a system of instruction in which technical skills were in excessive measure of academic values. In the final year, students confined their energies to graduation projects, the content of which was dictated by department heads, who supervised individual interpretations with unswerving diligence. The process left nothing to chance, or to a wayward imagination. Once outside of the academy, to break the noose its tendrils wove around its progeny was no easy task.

A primary source of inspiration was the access artists enjoyed to publications imported from the free world. All of the individuals who played an important role in the New Art Movement—as the avant-garde is known in China—spent the most instructive hours of their academy training in its library. In the early 1980s,

educational institutes were permitted to subscribe to international magazines and to order books from overseas (during the Mao era, there was no commercial relationship between China and most western nations that would have facilitated this). For the art academies this represented a phenomenal range of previously blacklisted catalogues, monographs and art histories. What students gleaned from their pages was literally mind-blowing. All was hungrily imbibed and, once digested, regurgitated in a fusion of innovative attitudes, ambitions and creative activities around the country.

Modernisation was the anthem of the age: with this as the primary goal of all artistic endeavour, the nascent avant-garde determined that the creation of a credible contemporary Chinese art scene such as could hold its own abroad required fluency in the language of modernity. In short, it was imperative to master one hundred and fifty years of western cultural development from Modernism to Post-Modernism at the earliest moment possible, and apply the lessons learned to the local cultural conditions. It was in this way that the brightest new artists of the first generation developed individual sensibilities and diverse pursuits with extraordinary speed. As the people adapted to the unfamiliar vocabulary of "opening and reform", the academy graduates made it their task to develop a visual language that could encapsulate the nation's momentous reawakening and proclaimed desire to join the international community. The challenge was as great as it was problematic. None knew with any certainty exactly what constituted modern art. The last time China's artists had enjoyed any firsthand experience of vanguard art circles abroad had been in the 1920s and 1930s when a handful of painters and sculptors had travelled to Europe and Japan, where they learned of the tremendous impact that the dramatic breakthroughs of Picasso and Matisse were having on perceptions of form and colour: no less than the tearing apart of all established values of artistic beauty and representation. However, the interjection of the Cultural Revolution and the narrow, absolute limitations it imposed upon all creative output efficiently handcuffed these artists, thus denying the new generation of the 1980s any alternative models within their own cultural framework. Unperturbed, young artists turned to the West for a road map that would guide them out of the cultural quagmire engendered by three decades of subjugating art to the political ideology of Party propaganda. Without hesitation or inhibition, they experimented with a succession of role models, dancing recklessly across decades of evolved practise that separated artists such as Andrew Wyeth from Andy Warhol, Picasso from Duchamp, Matisse from Gerhard Richter, all the while embracing a western lexicon of aesthetics that was almost entirely unrelated to any social, cultural or intellectual experience to which they could lay claim. Where the formative experiences of China's new artists were at enormous odds with those that informed western frames of reference, this adopted lexicon sat awkwardly aboard the wilful determination of the avant-garde to embrace its tenets. Again, the artists were unperturbed, electing to overlook the differences in exchange for an invaluable touchstone against which to measure the success of their own experimentation and their advance towards the international art world.

Although this story is unique, a degree of allusion to a comparable scene closer to home is useful in trying to imagine the dynamics at work across China. To invoke the ambience of the era in which the avant-garde emerged, it is not far-fetched to look to Europe in the early 1900s. In particular, Paris in the wake of Baron Haussmann's de-re-constructive renovations of the French capital's heartland and the creation of nouveaux suburban districts in the 1860s—such as those which appeared on the fringes of Beijing in the 1990s and to which the art community gravitated. Whilst acknowledging the variant political arenas and tactical play of Paris and Beijing, Europe and China, the Chinese avant-garde exhibited as much energy, engendered as many groups, cliques, theories and manifestos as had appeared in Europe in the early decades of the 1900s. The artists had as much difficulty showing their work and a similar lack of supporting system, market, or collectors beyond a faithful, daring, and visionary handful of thoroughly modern-minded patrons. With hindsight, a significant portion of initial experiments with established western styles came dangerously close to imitating them—blatantly in many instances. This was in part unconscious, and in general it was also not viewed as being problematic. The traditional method of mastering ink and brush painting extolled copying as central to the learning process, and even today amongst the ranks of contemporary artists, an individual's imitation of the work of a peer represents a flattering nod to the critical, or latterly commercial, success achieved by his or her style. Compounding this is the Chinese system of education, with its emphasis on rote learning that under Mao lent itself to the enforcing of the necessary, unified socialist outlook. This was an effective impediment to the development of personal thought processes, and inevitably impaired individualism. But not entirely, or there would be no avant-garde art to speak of. Significantly, for the generation that graduated in the 1980s, the boxes in which the system sought to contain them threw such structural boundaries as the State employed to maintain order within the system into sharp relief. Stepping beyond these confines lent a power and poignancy to the messages infused in the new art: even the subtlest departure from orthodox prescriptions implied some kind of statement about the substance of the social environment, the nature of its ideology, cultural attributes, and changing aspirations. As a number of masters emerged from the clusters of European artists, so did a handful of Chinese. Without these artists—broadly speaking those covered here—the history of contemporary art in China would be entirely different.

In 1985, when an avant-garde crystallised out of thin air, it did so without the benefit of modern means of communication. The New Art Movement spread nationwide as if by osmosis; initially at least, and prior to tangible signs of change that saw the launch of new art magazines such as *Art Trends* in Wuhan, and *Fine Arts* in Beijing. These provided a welcome platform for promoting new theories, as well as for displaying the growing crop of domestic artworks. Reports on international events and news updates on leading trends and the artists driving them defined the broader international landscape, and afforded Chinese artists a sense of where they themselves stood vis-à-vis the progress they were making in catching up with

the West. This platform and the exchange of ideas it encouraged bolstered the confidence of the local community immeasurably, to the degree that by the mid-1980s, the activities of new artists were of such voluminous proportions as to merit the term "movement". But if it sounds like this movement led an organised revolt against the old order, that was not the case: it was not a rebellion of seditious intent, for whilst artists sought to change outmoded official attitudes towards artistic form and content, they believed their advance to be in line with that of the nation's modernisation. In short, that their art would do for culture, what Deng's reforms were achieving for economic growth. Before the advent of the government crackdown in 1989, China's new artists were as fervent in nationalism as they were competitive in enthusiasm.

In the honeymoon period from 1985, when the movement gained a name, and early 1989, curious to taste fruits that were so unaccountably forbidden under the official charter on culture, the growing number of graduates began to weave western concepts into their creations. Their logic, taken from their certainty that the untenable aspects of Maoist ideology, which had atrophied China's industrial and economic advance, and which Deng Xiaoping was in the process of reversing, were matched by equally unsustainable notions concerning aesthetic values and the relationship of creativity to society, was compelling. The State, however, was not to be swayed and remained categorical about the need for "healthy art". In the mid-1980s, to a society nervously, hesitantly exploring the concept of human beings as individual drops of water, after long years of moving as one surging ocean, modern ideas about art seemed curious but rather pointless. What purpose did modern art serve? Who was it for? Who could understand it? Who would buy it? The unfamiliar currents of modern art, as evolved in the West, engendered much official apprehension in China, which was even more perplexing for the authorities when artists abandoned the picture plane and began exploring conceptual approaches, including performance art, installation and site-specific intervention.

In spite of the endemic principles and boxes the State threw at the art community, the period between late 1987 and early 1989 proved a time of unprecedented social laxity across China, for as Deng Xiaoping led the nation along the path of economic reform, the preoccupied cat afforded the mice an unexpected breathing space in which to play. In 1987, a group of leading new art critics decided that the time was ripe to organise a major survey of new art, and to create an opportunity for society in general to appraise the dynamic strides towards the modernisation of art that had been achieved. The result was "China/Avant Garde", a groundbreaking exhibition that stands as a landmark in China's contemporary art history. The opening took place on February 5, 1989. However, within the first hour, the avant-garde found itself on thin ice following the firing of a gun into an installation work. That the bullet fired was live was as worrying for the authorities as it was deemed necessary by the artist, Xiao Lu, in making her point—even though she afterwards claimed not to have known that the bullet was other than a blank. The incident instantaneously brought the avant-garde into conflict with the authorities; the shot,

subsequently named the "first shot of June 4", a catalytic wake-up call to the regime about the dangers of leaving culture unsupervised. Whilst it seems naive not to assume that the ensuing clamp down was inevitable, it came as a genuine shock to the art community at the time. The triumph that buoyed up the avant-garde at being granted permission to enter a State museum did not eclipse the organisers' common sense in regard of handling the momentous opportunity it presented to them. The fundamental ethos of the movement was to challenge outmoded attitudes towards art that were the legacy of the past, not to confront the regime of the present—at least not directly for the convention of using historical evidence to illustrate a current point remained a highly effective means of communicating a contrary opinion, as would be demonstrated by Political Pop in the early 1990s. However, where "China/Avant Garde" promised an unprecedented platform for new art, the stakes were running high for new artists; with every artist of avant-garde pretensions desperate to be selected, individual credibility was on the line. In response to being passed over, a number of individuals opted to stage spontaneous interventions during the exhibition opening, further inciting officials, already fuelled by fury at the gunshot, to impose a heavy fine upon the organisers, and a two-year ban on exhibiting in the China Art Gallery upon all the artists connected with the event. While the clearly polluting notions of western thought bore the brunt of the State's wrath, the avant-garde found itself effectively ostracised.

"China/Avant Garde" was China's Frieze, except that rather than marking a new era of public awareness and a shift towards the mainstream, as the original Frieze in London (1988) achieved, "China/Avant Garde" signalled a retreat to the fringes, temporarily forcing the scene underground. Ice turned to permafrost as spring became summer and, defying the intractable modus operandi of the PRC, the mass of students in Tiananmen Square took public demonstration to a level the State could not tolerate. The protests, which resulted in the June 4 incident, inserted a dramatic and deflating pause into China's cultural advance. But although the first act of the New Art Movement had been brought to a peremptory close, all was not lost. In the silence after the "China/Avant Garde" exhibition, artists drew comfort from the fact that in little more than five rumbustious and animated years from 1985 to 1989, they had created a brand new, previously inconceivable art scene in China. And in just a few short years more, frustrations at the confines of the immediate cultural environment would be distracted by the foreign horizons that unexpectedly loomed into view. The response was complicated. New horizons also provoked new seams of contradictory emotion, as the self-loathing that accompanies humiliation rose to the surface again, fuelled by the artists' sense of the ostracism imposed by their own nation. In short, as shall become clear, it pitched a challenging curveball across the evolutionary path of the avant-garde.

The outside world first began to catch glimpses of China's new art in towards the mid-1990s, presented in a rush of curated surveys, largely initiated by foreign institutions. Works by China's first post-Mao generation of artists dominated these exhibitions, evidencing for all who saw it an unexpected break with both traditional

Chinese cultural characteristics and the principles of Socialist Realism. To a foreign audience, and pursuant to the daring student protests that had made headlines worldwide in 1989, far from affirming the proclaimed triumph of the State over the people's demands for change, China's new art suggested an exciting challenge to the ideological order and a daring reclamation of the desire for free expression. Thus, the surprisingly radical impression this engendered, of a force of artists from a nation still perceived as being in the grip of a repressive totalitarian regime, prompted the pronouncement of a Chinese avant-garde. Given its external origins, the use of the term continues to be the subject of academic debate. However, then as now, it serves to evoke the dynamism of the new age these art pioneers ushered in.

In terms of engaging with the outside world, the new breed of Chinese artists found much to leverage from the immediate circumstances of their environs and the exigencies of its political ideology. Official definitions of what constituted healthy art remained immutable, not only for the revolutionary ranks of 1980s graduates, but for their successors through the 1990s too, yet the situation was not all bad: the official, authorised version of culture established a clear counterpoint against which artists could push, neatly underlining the radical position of any art form that chose to be anything it was not. Within this context, the appropriation of political iconography to art proved an efficient method of getting attention, foreign applause against Chinese distain, which proved mutually advantageous. Thus Political Pop was born, followed by Cynical Realism. Exhibition closures in China commanded news coverage from the foreign press, although less for the art itself than to illustrate the ongoing repression of personal freedoms in the PRC. Genuine critiques of the art were slower to appear, and not always positive in conclusion: commentators were quick to point out numerous obvious parallels with known works by western artists—the similarities rather than the differences, which often required greater knowledge of Chinese culture, its socio-political history, or art, to discern. In general, where China remained culturally insular, this did little to deter the new art scene, in particular those artists of the first generation who had carved out their own distinct niche. In spite of the exigencies domestic Chinese politics imposed upon the development of the visual arts through the 1990s, across China exhibitions continued to be held at regular intervals, and although the exposure artists could expect was sporadic, options continued to increase significantly. State tolerance towards contemporary creativity was first demonstrated in its public support of the 2000 Shanghai Biennale, which followed a daring contemporary exhibition produced by the Ministry of Culture for its Chinese Cultural Festival in Berlin in 1999. Culturally, China had progressed: the western styles of art that had inspired the first period of avant-garde experimentation—roughly from 1982 to the mid-1990s were being met by a counter-current that celebrated "Chinese-ness". In the new creative phase, in addition to taking from the best the western art world had to offer, visual artists now looked to the stylistic approaches evolved by avant-garde pioneers of the 1980s, whose art by now defined a contemporary Chinese aesthetic for the outside world. For the avant-garde, the growing number

of aforementioned biennials and triennials in cities around China, and the promise of the first China pavilion at the Venice Biennale 2003, marked the end of an era of being "outlawed" and "underground". The increasing number of private galleries opening up in major cities also proved beneficial. By 2005, the twentieth anniversary of the birth of avant-garde art in China, it was easy to forget that for the majority of time it took for the situation level its ballast, the intensity of the cultural climate forced anyone choosing to be an artist to be different, to commit to a brave new and untrammelled path, full of adventure, potential fame and fortune. That intensity was echoed in the art. Its diminishing in the works of younger generations reflects the dilution of politics, of ideology, with nothing to replace it but an increasingly vapid commercialism.

Whilst the masters of the Chinese avant-garde profiled here are artist—pioneers, they also represent the last generation of Chinese people to experience, in unmitigated fashion, a radical metamorphosis of their nation: they were born in a communist state, raised under a totalitarian regime, and came of age as artists in the embrace of socialist-styled capitalism. While describing them as a generation, they should properly be termed two or even three. Li Shan, the most senior, was born in 1942. Xu Bing, Wang Guangyi, Zhang Peili, Wang Jianwei, and Zhang Xiaogang all have birth dates in the second half of the 1950s. Geng Jianyi, Gu Dexin and Fang Lijun were born during the early to mid-1960s.

The life stories of these nine artists span extremes of intellectual poverty to the mass information age, poor quality canvas and pigments in brittle oil binders to high technology and, in most cases, rags to riches. They are creative pioneers, impetuous performers and fly-by-night philosophers who changed the face of art in China. All continue to be a vital force in what is happening now. By the early 2000s, these leading avant-garde artists exerted as much, if not more influence on domestic art circles than western role models like Gerhard Richter or Damien Hirst whose art defined new realms for conceptual pictorial language and understanding physical materials for Chinese artists in the 1990s. Their lives illustrate their differing experiences, and the diverse impulses they bring to creating artworks. Subsequent generations have raised the aesthetic bar but the uniqueness of much of the early avant-garde art—specifically works produced by these nine artists—that was dictated by the aura of the times, remains unsurpassed. This is a history that has yet to be set in stone. Opinions and voices will change their timbre but the stature of these nine lives will not diminish.

SECTION 1

EMBRACE!:
PREVAILING IDEOLOGY, NEW PHILOSOPHY

The ideology referenced here is Maoist as much as Marxist. In particular that interpretation of culture to which Mao gave vision at Yan'an in 1942; that art should serve the people, whereby serving the people required the taming of all visual expression to propaganda, such that met the needs of socialist education. This entirely overshadowed the youth of all avant-garde artists.

Philosophy refers to ideas that were new to post-Mao China, and which hailed primarily from western cultures and covered everything from post-modern aesthetics, art criticism, science, economics, political science, cultural philosophy, religious faith, and sociology to psychology.

The three artists in this section, Wang Guangyi, Geng Jianyi and Fang Lijun, produce art that directly reflects their individual responses to the principles of official propaganda; reactive, admonishing, cynical, proud. Wang Guangyi always believed himself to be making contemporary art to match the times—the analytical process of western philosophy applied to local ideology such that would render it modern—of which Chinese society would be as proud as of any other national advancement towards the twenty-first century. Geng Jianyi, on the other hand, doubted the capacity of ideology or philosophy to represent incontrovertible fact. Through art, he gave form to a mocking and seditious subversion of the intractable ideological principles of his environment, as well as the practices and formats by which they were most recognisable to the people. His experimental artworks further tested the efficacy of relocating foreign theories within the cultural framework of the PRC in such a way as to highlight effectively their incompatibility. Fang Lijun embraced a rather different path. Refusing to concern himself with the past and the claustrophobic confines of its socio-political traumas, he prefers to live in the moment, giving little thought to yesteryear or tomorrow. Of all the artists here, he has followed the entrepreneurial road mapped out by Deng Xiaoping with the greatest success.

There is no period in Chinese history where the art that was created did not contain some substance of each era's prevailing ideology, even within that of traditional ink and brush painting.

The eruption of new art in China was abrupt. The new artists were amazingly swift in confronting the guiding principles of their age and seeking apt, newly imported ideas to counter them, to challenge, refute, and ostensibly replace them. Western ideas did not always dovetail neatly but their being established and recognised theories was all the affirmation the avant-garde needed. The socio-political, historic and economic backdrop of this moment in Chinese history is especially crucial to making sense of what occurred collectively and individually within the burgeoning new art scene in the 1980s. It is the big picture into which all the smaller pictures—the stories and the art—of all the artists profiled here fit, as they arrived at their styles, won respect, became an influence, and achieved celebrity.

The stories of Wang Guangyi, Geng Jianyi and Fang Lijun are particularly useful in illustrating the big picture paradigm that spans the evolution of the art from 1985 to the present. If for no other reason than because via the models they established their work was the springboard for major trends. Their art was therefore instrumental in laying the foundations of content, form and market patterns for the emergent Chinese avant-garde, that were adopted, adapted and are followed, to a great extent, today. Pertinently, in their highly individual ways, they addressed the transformation of ideology that dominated the cultural atmosphere in China through the 1980s, away from Mao Thought towards Deng Xiaoping's progressive economic reforms. All three artists further demonstrate a penetrating grasp of the new philosophies that were slipping unimpeded across Chinese borders.

The story of Wang Guangyi provides a succinct summary of almost all the factors at work in the minds and hearts of his generation. It contains poverty, politics, self-doubt, insecurity, and a profound national pride. His career was launched by a manifesto produced in 1985 that described the far northern city of Harbin—his hometown—as poised to herald a new Renaissance. This was to be a Chinese Renaissance, by which he meant an historically significant cultural awakening that would impose upon "the West" a Chinese perspective on the world and redress the insouciance of western cultural imperialism. His theories pivoted on the main thrust of the prevailing ideology—Mao Thought, set out in the ubiquitous Little Red Book (Mao Yi Lu)—with which he had grown up and that underpinned daily life to the end of the 1970s. To this blueprint, he added philosophies that were very new to China at that moment (1982–84). First were the imported texts of thinkers such as Hegel, Heidegger, Wittgenstein and Sartre. Next were Deng's reforms, which featured the first serious concession to modernisation: that it was acceptable for (some) individuals to become rich. Third, and subliminally most significant, were the slender

wisps of western capitalism that had begun to filter in as Deng opened the door. All informed Wang Guangyi's ambition. He took the prevailing ideology that had perforce guided his youth and directed his adolescence and turned it into a new philosophy for the new Socialist-with-Chinese-Characteristics China. It was almost an act of filial piety. The strands he identified were the basic tenets of the modern world as he perceived it—internal and external, domestic and foreign—made immediate, recognisable and simple. The new philosophy he aligned with the extant Chinese one took its lead from western capitalist-driven consumerism, but there was a subtext: American-style meritocracy, which allowed for individual triumph over circumstantial adversity. It preached the breaking free of one's birthright and origins through perseverance and faith. An ideal not so far removed from the overly-invoked Chinese adage of the lotus rising out of the mud, its purity uncontaminated by the detritus of reality. Wang Guangyi's role model was no modern art master, not even Andy Warhol, whose doctrine his own so obviously invoked. Instead it hailed from a pre-industrialised age and matched the mood of industrialisation in the China surrounding him. The figure he seemed to adopt as his role model was Martin Eden, the hero of the Jack London novel of the same name. It was an image that transcended politics. Wang Guangyi identified with the frustrations born of rejection and the lowly social standing of the uneducated seaman, Martin Eden. He viewed himself as the lowest of the low in a society fully conscious of the status and power enjoyed by those with a position in society; the kind of position Wang Guangyi knew he could never attain. He turned to art to gain himself respect and respectability, to restore national pride in China's home-grown culture, and make his fortune. This, he achieved. In an astounding rags-to-riches leap from obscurity into the limelight, he realised his goal in just over ten years. Wang Guangyi's story illustrates the against—all—odds struggle of China after Mao, as a nation, as a collective of people and as individuals. In 2002, after years of being marginalised at home in spite of the international reputation he had accrued, his work, together with that of Fang Lijun and Zhang Xiaogang, was the subject of a large retrospective titled "Image is Power" at He Xiangning Art Museum, a State-owned venue in Shenzhen. It was the first time that more than one work had been granted permission for public display in one exhibition. Wang Guangyi sensed that the tide has finally turned, even though the avant-garde has far to go before it can hope to challenge the monopoly held by mainstream culture in the public sphere or in private homes.

Geng Jianyi comes at both life and art from a diametrically opposite perspective to Wang Guangyi. It is one that equally relates to personal experiences of Socialism and idealism, but that constantly returns these to an emphasis on benevolence, truth and a moral code associated with the long

dynastic history of the pre-Mao era; China as the Confucian-structured, Daoist-guided, empirical Middle Kingdom. Almost from the first, Geng Jianyi elected to side-step the prevailing socio-political ideology that Wang Guangyi embraced with ready enthusiasm, in favour of the new philosophies of western Modernism and—new for his generation—recherche'd elements of classical Chinese thinking. From the mid-1980s to the mid-1990s, he frequently employed the physical forms these new philosophies made possible, namely installation, conceptual and performance art, to reflect the impact of the prevailing ideology upon the most mundane aspects of daily life. Yet his sense of the prevailing ideology took more profound Chinese cultural sensibilities into account that went beyond Communism, Marx, and Mao. The resulting artworks exude a social bent geared towards highlighting an issue and questioning the validity of accepted conventions. It was all done in an unassuming way that made the works seem far less political than the glaring surface of Wang Guangyi's dynamic paintings, when in fact the opposite was true. In his own valiant way, Geng Jianyi adopted the role of the truth-telling fool of Shakespearean tradition; just like the emperor who, according to Chinese folklore, tested the loyalty of his followers by pointing to a horse and calling it a deer. Would the faithful correct his gauche mistake? All too often, fear kept them silent.

Graduating in 1984 and 1985 respectively, these two artists were at the forefront of the avant-garde. In fact, the emergence of the New Art Movement was directly linked to the graduation exhibition of Geng Jianyi's class at Zhejiang Academy of Fine Arts in Hangzhou, just one year after Wang Guangyi had departed.

Fang Lijun is marginally younger than Geng Jianyi, but old enough to be considered the leader of the next generation. He was active beyond the Central Academy even whilst studying and participated in the 1989 "China/Avant Garde" exhibition in Beijing as a student. From the late 1980s when be began formulating his bald-headed lumbering figures, Fang Lijun had no truck with the prevailing ideology except to ridicule it. Or did he? Given that he was directly exposed to new philosophies during his time at the Central Academy in the capital, Beijing, one might expect his understanding of avant-garde to be more in line with its western meaning—reactionary, challenging to established systems and structures. Indeed, his initial comment was more in the vein of rebellious youth giving a finger to the establishment. And perhaps it would have remained the ardent feistiness of youth had he not collided with the prevailing ideology in the run up to his graduation in June, 1989. During the student demonstrations in Tiananmen Square, like the curious and ardently committed students, patriotic locals and spectacle-hungry masses, Fang Lijun

was drawn to the Square, to drink in the *re nao* (a favourite Chinese expression for describing a lively scene of activity, here the atmosphere generated by the impassioned students). All wished to taste that naive and fleeting sense of community and solidarity that suffuses mass-gatherings where, from weddings to funerals, protest marches to music festivals, emotion is at its most contagious. Perhaps, at its most human. But in Tiananmen Square, the contagion was abruptly brought under control when the government took remedial action and the demonstrations came to an end on June 4. The ensuing crackdown was responsible for cancelling Fang Lijun's graduation, as the academy closed in upon itself to brace the wrath the State unleashed against it. This wrath was primarily in response to the students who had helped to build The Goddess of Democracy, a monumental replica of the Statue of Liberty and a sculpture that became the symbol of the movement for audiences worldwide.

June 4 proved a horrifying incident in which Fang Lijun did not play any direct part yet, ultimately the State's crackdown still struck him well below the belt: in the blink of an eye, four years of academic study culminated in a monumental anti-climax. All he had striven to achieve went unnoticed as his youthful hopes for the future were forced back into their bottles and tightly corked. In Fang Lijun, the frustration that remains just beneath the casual, public surface. It oozes out at times through the pores, as an allergic reaction to the lingering tendrils of the omnipotent ideology that persistently interfered with the new philosophies, no matter how hard Fang Lijun's generation tried to shake free. Geng Jianyi once offered a metaphor which expresses much of his own world view and assists in understanding Fang Lijun's frustration: In 1995, he told a group of visiting German artists from Berlin: "We are like adults in a children's swimming pool. Every time we stretch out a limb to make a full stroke, we hit ourselves against the sides of the pool. In such a confined space, we have learned not to keep doing things that will only hurt ourselves." One surmises that in his painting, Fang Lijun tries metaphorically to pull the sides of the pool apart to achieve a wider expanse of water for his iconographic swimmers. For a number of years it did not seem to have effected much of an impact on reducing their, or his own sense of futility. Futility penetrates the paintings and Fang Lijun's rendering of it has established him as the voice of compassion and empathy for the lost, the disenfranchised, of China's youth; pawns broken in socio-political games they rarely understood.

My first meeting with each of these artists also reveals something of their character: Wang Guangyi was entertaining diplomats at home in Beijing in early 1994. He confidently confided that one work had just sold at Marlborough Fine Art in London for GBP 38,000, whilst seamlessly

reassuring the visitors that he could not accept a penny less than USD 20,000 for any of the canvases on display; Geng Jianyi was in Beijing in November 1994, at the home of the art critic Huang Du, where we engaged in serious discussion about the collaborative project he had just completed—an attempt to produce a collective work and inaugurate a more expedient way to reach an audience; Fang Lijun was relaxing at his new home in the eastern suburbs of Songzhuang, where we spent a steaming weekend in the summer of 1994, most of it silent, crushed by the unremitting heat. Our host passed most of the waking hours under the spray of a hose in the small dousing pool in his yard. The first was defensively confident and proud; the second earnest, committed and philosophic; the third edgy, frustrated and bored. All affectations can be traced back to the artists' varying backgrounds. Wang Guangyi's family existed beyond even the catholic poverty of the era. Geng Jianyi possessed the marginal privileges permitted the child of an army cadre. And Fang Lijun, the son of former landlords, bullied but tough and, being only one of two children, had an easier, more plentiful upbringing than his slightly elder peers. All were equally shaped by the moment and manner in which they first engaged with society and began to recognise its parameters: each contrived to assist them in devising a workable strategy for their lives.

And now? Wang Guangyi works out of an enormous studio. His paintings have grown in scale and his prices outpaced China's domestic annual growth ten-fold. He masterfully commandeers the covers of the new crop of Chinese magazines and newspaper supplements. Geng Jianyi has become almost a total recluse, in many ways happier for it for it allows him the concentration necessary to produce his sublime works in photography and video. Fang Lijun drives his deluxe space cruiser around the country in lulls between intense periods of painting. The route goes mainly between Beijing and Dali, in the south, where he owns homes and studios. When not painting, carving monumental woodblock prints or resting, he can be found entertaining leading figures from the worlds of art, business and even politics at his string of chic, successful restaurants in Beijing.

In terms of contemporary art, as the Mao era fades into the past, the potency of the old ideology dissipates with each passing day. The lessons of personal experience have imbued individual perspectives with their own mutating logic, which through time has mitigated the impact of western philosophies, dilluting the force exerted in the 1980s and 1990s. As generations rise and fall, Wang Guangyi, Geng Jianyi and Fang Lijun remain as focused as ever. These three artists are everything the avant-garde ever dared to dream of becoming.

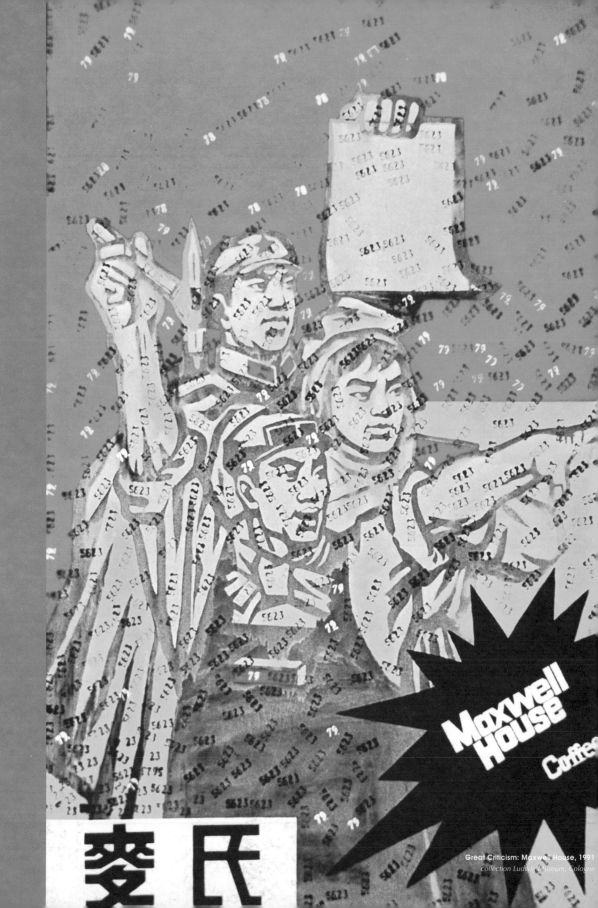

WANG GUANGYI:

FROM MAO TO NOW

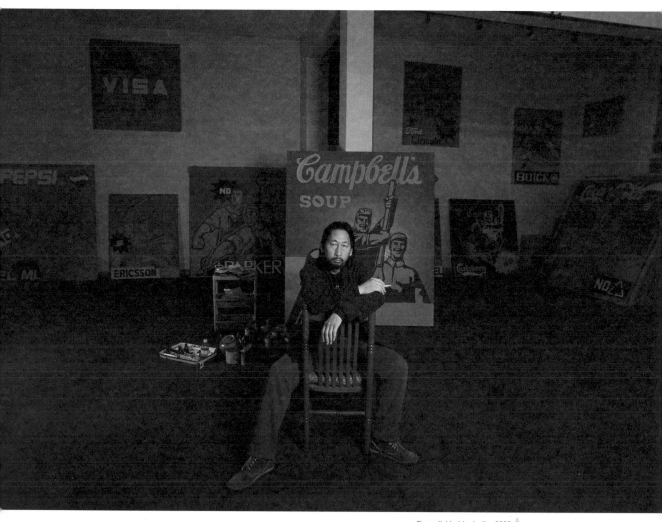

The artist in his studio, 2000 人

photograph Liu Heung Shing

"I guess the real facts is that I dont know nothin' much about such things. It ain't in my class. But I'm goin' to make it in my class"[1]

The story of avant-garde art in China without the painter Wang Guangyi would be a story short of a principle character; a tale of western Modernism devoid of its Andy Warhol. "Mr Wang is one of the most important artisit (sic) in Contemporary art Movements in China" he scrawled on a 1992 canvas. Modesty had him place a question mark at the end of the sentence but the point was already moot. He would afterwards claim the statement as an act of self-doubt, a questioning of his own identity and ability at a moment dwarfed by the intense mood of impotence that spread across China post 1989, in the wake of June 4. But at thirty-six years old, Wang Guangyi already held an influential seat in the steering committee on China's new art: he stood at the helm of the elite of New Art Movement circles. He was soon to gain an international profile, too, as his paintings assumed a leading role in early exhibitions abroad of what was swiftly accorded the moniker of Chinese avant-garde art. By 1995, just three years after his moment of self-doubt, Wang Guangyi could be described as one of China's handful of internationally aclaimed art stars, which was particularly satisfying to an artist who had pulled himself out of abject poverty to become a model for success that a generation of younger artists now sought to emulate.

Wang Guangyi's approach to making art cannot be described as a quantum leap for aesthetics but in China it broke every prescribed mould. In the early 1980s, China emerged from a long period of being cut off from the outside world, under a suffocating social—psychological and creative—control instigated in the 1960s as the directives of Maoist principles took effect. Within the lingering confines of these boundaries, here within the nascent art world was an individual daring to go

1. Jack London, *Martin Eden*, first published 1909, this edition Penguin Twentieth Century Classics, Penguin Books, 1993, p. 42, spoken by Martin Eden.

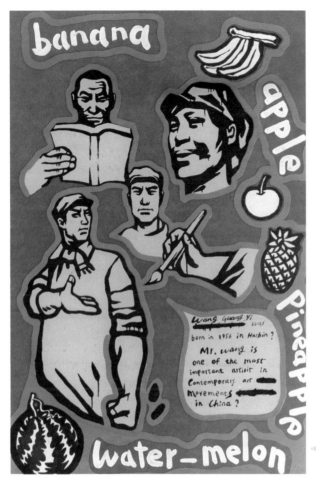

Great Criticism: Fruit, 1992
The Farber Collection, New York, courtesy China Avant-Garde Inc.

where no other Chinese artist had gone—although others were swift in following his lead. Wang Guangyi was driven by an inexhaustible desire to put China on the international cultural map, with himself as its champion. This was the dream to which he inspired the avant-garde to harness its efforts.

Wang Guangyi was born in 1956—or 1957 depending on which version of the facts you choose to believe, for accounts vary. Where in the past he might have deemed it necessary to alter his date of birth for some obscure bureaucratic purpose, he subsequently stands by 1957. A discrepancy here of twelve months makes little odds: Wang Guangyi arrived on a stage dressed with poverty and small hope. The People's Republic was preparing for the Great Leap Forward, which took place in 1958 and was a concerted attempt to accelerate its industrial and agricultural production to the levels of a modern nation. The PRC, however, did not attain a visible degree of modernity until the mid-1990s, until such crippling policies as Mao imposed were well passed. Through this same period, the scrawny kid from the provinces—as Wang Guangyi describes himself—grew up, got educated, grew his hair long and became a leading avant-garde artist. By the early 1990s Wang Guangyi's life had altered

dramatically. As an independent artist he had begun to lift himself out of poverty, paying homage to the efficacious hope that Deng Xiaoping's reform was making a reality. Miraculously, a few years on, as the late 1990s became the early 2000s, Wang Guangyi firmly belonged to the moneyed class of China's burgeoning nouveau riche. He owned a smart apartment in the southern quarter of the capital and a large villa-studio complex in the suburbs. A further addition to his property holdings was under construction. He drove an Audi A6, black inside and out, identical to those assigned to the higher echelons of the PRC government ministers. Most reassuringly, as China gained accession to the World Trade Organisation, unemployment spread like a bush fire and the gap between rich and poor grew apace, Wang Guangyi realised he would probably never have to experience financial worry again. He is justifiably proud of his achievement. Reserved by nature and never more than sparing in his use of words, his speech approaches lyrical prose when an opportunity presents itself to talk of the lowliness of his family's status in his youth and the enormity of the hardships he overcame to occupy his new niche in life. Here, the coercion that is usually prerequisite to drawing out a statement on his art is superfluous.

In 1990 it would have been impossible to rank artists by their fortune. It would have seemed unfair to count the margins between pennies, and uncomradely to drive a capitalist wedge into the brotherly solidarity of the socialist ethic. But by the mid-1990s, as a people straining to put poverty behind them, personal wealth was becoming an obsessive focus for Chinese nationals. The image of deprivation that Wang Guangyi so emphatically describes is curious because he grew up during a time when the vast majority of Chinese people struggled to feed and clothe themselves, and when constitutional equality dictated that no one ought to have more than anyone else. The people were poor; the majority profoundly so. Thus, as we shall see: "Such a life [as that of Wang Guangyi] is an inspiration to all. It shows us that a man with will may rise superior to his environment."[2]

That was then. Now, financial security allows Wang Guangyi to indulge in a favourite Chinese pastime: gambling. He plays with all the passion that has earned his fellow countrymen infamy at gaming tables from Atlanta to Las Vegas: he certainly plays more seriously than the fellow art stars and a select number of rich, culturally-inclined entrepreneurs who are part of his intimate clique of card players. Each regularly takes the equivalent of several thousand American dollars to the card table, which passes from hand to hand with rhythmic velocity.[3] On one such summer night in 2001, around a table in the studio of painter Zeng Fanzhi, Wang Guangyi occupied the place reserved for Christ in a tableaux of card players that unwittingly echoed Leonardo da Vinci's *Last Supper*. It was as if the host deliberately provoked the analogy. Zeng Fanzhi had recently completed a masked tribute to the Renaissance composition—the trademark motif of a figure with a white face mask was the distinctive feature of Zeng Fanzhi's paintings from 1995 to 2001—which hung on the wall directly behind the gamblers. Seated in the centre, his back to the painting,

2. Ibid., p. 111. Ruth Morse, Martin Eden's sweetheart, idol, and finally wife, speaking of an unfortunate man in her father's office who had, through hard work, managed to lift himself out from his inferior circumstances and make good.
3. The preference is for a game of pure chance played entirely blind. Each player receives three cards, placed face down on the table. Without seeing their hand each player then bets on what they might have. No skill is require beyond brash bravado; the game's ethic is simply who dares wins.

Wang Guangyi fondled his beard, perplexed by the cards that "betrayed" him even as he dealt to the other card players—Yang Shaobin, Fang Lijun, two curators and their supporters. Meanwhile, the conspiratorial whispers around the table mirrored every gesture of the figures depicted at that fatal supper. But even occasional nights when the chips were down meant little against the intractable big picture gains Wang Guangyi had accrued.

It is not difficult to imagine how China, 2000, consumed by commercialism and economic growth, could be a world apart from the scene of devastation that was the People's Republic at the end of the Mao era in 1976. Yet even the early 1980s bore little resemblance to Wang Guangyi's formative years, which unfolded through the 1960s. The profound poverty visited upon the people during this time was the result of decades of civil unrest, and the dramatic social restructuring that followed the founding of the PRC in 1949. The situation further deteriorated courtesy of a series of bad harvests and natural disasters. Mao's decision in 1956 to launch agricultural cooperatives, and to oust all petit bourgeois inclinations via the Anti-Rightist Campaign in 1957 set the focus of society for the next twenty years: too much revolution at the expense of constructive agriculture.

Throughout Wang Guangyi's childhood, society was characterised by a stringent uniformity; foremost, in thought and deed, but effected through the people's living standards and their function in the grand task of revolution. Difference rendered individuals vulnerable. Every schoolchild knew the fable of the sorry fate of the first sparrow to fly from the tree.[4] Wang Guangyi's recollection of simple incidents of childhood is illustrative of the events and sensibilities that shaped his life: "As kids, we painted on glass. Besides scraps of paper, cardboard or newspaper it was all we had." As an added attraction: "We could project the images by shining a light behind the glass. It was intensely competitive. If you made a good painting, you got to hang out with the other kids. If not, you were ignored." The experience honed Wang Guangyi's urge to compete and win: "When these kids asked me to paint things for them, it brought me enormous pleasure. They respected me. I was important to them. And I always wanted to be in the limelight."

As a child, the limelight was the antithesis of everything Wang Guangyi knew. Chinese society contained no cult of celebrity—apart from Mao—and, in addition, as he thought of himself as an ugly kid from the poorest of backgrounds with little in the way of prospects, it seemed unlikely that such a future would ever be within his reach. That did not stop notions of fame and riches holding a delicious, if distant, allure: to be in the limelight became Wang Guangyi's guiding principal. He took courage from a significant role model, drawn from the figure of Martin Eden, the hero of Jack London's novel of the same name—one piece of literature that was deemed applicable to revolutionary class struggle and available to the masses. Wang Guangyi read it in the first bloom of adolescence and, after a tortuous childhood of striving to keep up with the other kids—to stave off certain ostracism—the chord it struck imbued him with hope.

In Wuhan, 1992
courtesy the artist ≫

To read *Martin Eden* is to discover one uncanny parallel with Wang Guangyi's life after another. Like Eden, initially Wang Guangyi also "struggled in the dark, without advice, without encouragement, and in the teeth of discouragement."[5] Equally, Wang Guangyi perceived himself to be: "extraordinarily receptive ... his imagination ever at work establishing relations of likeness and difference."[6] The Martin Eden analogy became almost a textbook for Wang Guangyi to follow, a mythology to weave around his personal history. "Even today I can recite passages that particularly moved me," he muses. Asked for a recitation, he proffers the line: 'Such a life is an inspiration to all. It shows us that a man with will may rise superior to his environment.'" This, Wang Guangyi ultimately achieved.

Martin Eden offered particular resonance because, given the circumstances of Wang Guangyi's working-class existence in the under-developed and remote far north of China, he had little trouble persuading himself that "Everything reached out to hold him down ... Existence did not taste good in his mouth."[7] He knew, too, that while, "you belong with ... all that is low, vulgar, and unbeautiful. Yet you dare to open books, to listen to beautiful music, to learn to love beautiful paintings, ... to think thoughts that none of your own kind thinks ..."[8]

That Wang Guangyi became an idealist was unavoidable. From birth, his generation was suckled on government propaganda aimed at propelling China into the modern age. Powerfully manipulated messages—the nature of which he would appropriate as an artist—unceasingly promised a better tomorrow on a rocket ride to economic advancement that would outstrip America and Britain (*chao Ying, gan Mei*). It was an idealism that denied the facts of hunger and poverty, which were staring the people in the face, and ignored all individual suffering incurred in the race towards a promised Utopian future. The era's youth experienced this in a very different way to their parents. They were young, and as Young Pioneers and as Red Guards, were viewed as the hope of the nation. They were unfettered, undisciplined and encouraged to invert all established order in the name of serving Mao's revolutionary goal of making everybody equal; equally loyal, equally obedient, equally submissive. The same type of idealism would be carried over into the drive for a new modern art.

4. *Qiang da chu tou niao*: the first sparrow to fly from the tree and break free of the group is thought to be the one first shot down. Conversely, When all take flight at the same time, the enemy is confused and there is more chance the entire group survives.
5. Jack London, *Martin Eden*, p. 162.
6. Ibid., p. 34.
7. Ibid., p. 111.
8. Ibid., p. 77.

By the end of the 1980s within the circles of radical artists, wherever he was, whatever he was doing, Wang Guangyi's actions were closely watched by the art world. By 1990, he was arguably the first role model for a contemporary artist in China. He achieved this not by being the most talented artist per se but by having one of the art world's sharpest minds. Wang Guangyi's quick wits made him a radical figure: not in terms of his creative technique but in the form and content of his work. Where other leaders of the New Art Movement drifted abroad almost as it began (despairing of ever owning the freedom to make the progress they sought to achieve)—Cai Guoqiang in 1986, Chen Zhen and Gu Wenda in 1987, and Huang Yongping in 1989—Wang Guangyi remained in China to become the most vocal and active individual within domestic art circles. This status was achieved with a series of signature works that defined the early impulses of the nascent art scene as it emerged in the mid-1980s. Driven by a fierce prowess, characteristic of his home territory in the far north of China, Wang Guangyi championed a new art that was rational, cool and honed to provoke. In the mid-1980s, he led his contemporaries as an outspoken theoretician and an active organiser of exhibitions, discussions and events. In the late 1980s, he deconstructed sacred images from western art history. He parodied Michelangelo's *Pietà*. He took Jacques-Louis David's most famous death scene, Marat stabbed in his bath, and coolly "murdered" him once again. These paintings were executed using unrelieved planes of grey, their original richness of colour distilled out, the depths of passionate emotion sapped from masterpieces that represented the spiritual heights of western art history. As the decade turned, he almost single-handedly put the "pop" into the myriad art forms that were emerging. But not before he had delved deep into western philosophy and formulated a new cultural doctrine for a contemporary China—one that resonated with initiatives outlined by Mao in 1942, and was as equally nationalistic in tone.

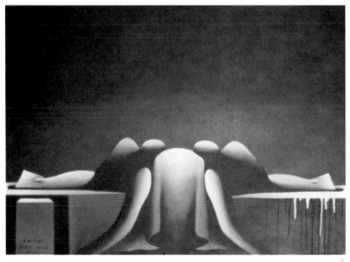

Post-Classical Series: Death of Marat, 1986 ⋀
Sigg Collection, Switzerland

⋀ Black Reason Series: Blurring the Model, 1986
private collection, Beijing

To arrive at his position of fame and fortune, Wang Guangyi had to overcome the social, economic and personal disadvantages to which he was born. He is unapologetic about his pride in achieving what most people in 1970s China believed impossible; fame, wealth, status and comfort, all in liberal portions. Millions of Chinese were born into families like his, families of uneducated workers feeding from one of the State's numerous "iron rice bowls". Wang Guangyi differed in the extreme sense of insecurity and lack of self-worth that he claims plagued his early years. A normal adolescence? Well, his sensitivity towards his personal circumstances was significant enough that he felt it necessary to weave a mythology of destitution and despair as a cloak around his youth. His most pressing need was to reverse the lack of education and sense of individual freedom that he fervently believed was responsible for holding his father down.

"He read the newspapers every day and believed all they contained," is the criticism Wang Guangyi levies at his father. In daily life, every parental wish that Wang senior uttered reiterated the prevailing social mores; "do's" and "don'ts" beyond reason for a child. Understandably perhaps, he was a man scared of standing out—he had seen too many sparrows felled—and Wang Guangyi was a precocious child. What might have been the rebellious nature of adolescence, his father saw as a disturbing and potentially harmful streak of non-conformity: "To me, he was an obsessive observer of social rules. To him, I was a potential danger to society who would not abide by the rules." Relations remained distant and strained, politely formal, from then until his father's death in 1996. Whilst he remained alive, nothing of Wang Guangyi's career, or growing success, was ever spoken between them, beyond a cursory acknowledgement that the son was not starving and managing his own life well enough to be of no cause for concern.

Beyond the glass paintings of his pre-teen childhood, Wang Guangyi's first serious attempts at painting were landscape studies produced directly from nature at the age of fourteen. These were daubed on small pieces of card rescued from the garbage, first sealed with size before going at the subject with the most rudimentary of oil pigments. Early inspiration was found in the inclination of pre-Soviet Russian artists for French Impressionism, which he saw in the few available books. The physical similarities between the landscapes of Russia and Harbin were marked. It was these Wang Guangyi sought to emulate.

Wang Guangyi began to study art formally at middle school. In 1972, aged fifteen, he was accepted into the art classes run by Harbin's Children's Cultural Palace, which he attended twice a week. Then, in 1974, he was sent to the countryside along with thousands of high school students to learn from the peasants where he would remain for the next three years. "This experience," he recalls, "changed the sentimental nature of the character I was in my early teens. For that I will always be grateful."

The experience provided a rigorous training ground for Wang Guangyi's future role as art world leader. Having to adapt to physical labour, and to maintain good relations

with his adopted community of workers honed people skills that proved essential in later life. As an artist, his talent for leadership and fine grasp of the human dynamics within Chinese society proved far more useful than technical skills, which all art school graduates possessed. Wang Guangyi's swift abandoning of landscape painting in favour of conceptual theory, for example, was more than a rejection of the historical notion of a genre. His upbringing imbued him with a thirst for success, the desire to avenge the circumstances that kept families like his in impotent poverty, and the wits to seize upon every opportunity to do so. His strong competitive edge was his most valuable asset.

≪ Embracing western art (a catalogue featuring the Moderns kept to hand, here open at Matisse, right), Zhejiang Academy of Fine Arts, Hangzhou, 1984
courtesy the artist

In 1977, Wang Guangyi found himself with the opportunity to escape his environment and fulfil his artistic ambition. When the national newspaper announced that the universities were once again open for business, he threw himself into preparations for the art school entrance examination immediately. However, for all the energy expended, he did not have a smooth time applying and was rejected three years running. Finally, in 1980, it was the oil painting department of Zhejiang Academy of Fine Arts that awarded him a place. Zhejiang Academy, China's second most important art academy after the Central Academy of Fine Arts in Beijing, is located in the southern city of Hangzhou. Founded in 1928, it owes its prestige to a rich rol call of past graduates and a teaching faculty comprised of the nation's most respected—if more conventional—artists. Wang Guangyi was one of only three students admitted to the oil painting department that year, a privilege he shared with Zhang Peili, who would become China's most widely regarded video artist.

Entering the academy was the start of a new and positive chapter. Wang Guangyi was twenty-four, a fully-grown adult but a novice in a novel world: a worker transplanted into the domain of a talented elite. The damp, muggy climate and local character of the Zhejiang people were distinctly different from those in Harbin. Up north, winter reigns for eight months of the year with sub-zero temperatures that habitually dropped to minus 40°C. Hangzhou dwells in a cloud of mist, through which the suns rays barely penetrate and where winter in the draughty studios and unheated dormitories is a dark, drawn-out affair. Back then, students relied on the heated passion of intense experiment and debate to stave off the cold.

Wang Guangyi's admittance to the academy coincided with the first trickle of information to filter in from the West as China began to open up. Almost overnight, students learnt of modern art, rock 'n' roll, philosophy, fashion and a fantastic range of other, wholly individual ways of being. The trickle soon became a flood, and the different perspectives on life, art and philosophy that were revealed, changed the way this generation thought and created. Across the country, the cultural influx engendered new concerns that set the stage for the New Art Movement, which would explode into being in 1985, just one year after Wang Guangyi graduated. The studios resounded with intense discussion and debate as students grappled with new ideas. As Wang Guangyi recalls "Discovering artists like Picasso made an enormous impact." At this time, this meant Picasso's mournful and romantic early Blue and Rose periods; those more easily justified by academy officials than the shocking Cubist style.

Wang Guangyi's crowd pivoted on himself and Zhang Peili, who was his most intimate friend, and included Geng Jianyi and Wei Guangqing, who were admitted to the academy one year later. Both Zhang Peili and Geng Jianyi were far more pragmatic art linguists than Wang Guangyi but nonetheless they shared many ideas. The cool-toned, flat and emotionless style of painting that he would develop through the late 1980s has its origins here in common approaches explored by all three artists in their search for new approaches to painting. By the time Wang Guangyi and Zhang Peili graduated in 1984, the questions that preoccupied them had gone beyond "likes or dislikes" in regard of painted subject matter or painterly technique.

"We didn't understand much of the philosophies we read, but we had become aware of the relation of art to society. We believed that through art we could change the people's lives."

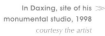
In Daxing, site of his ≫
monumental studio, 1998
courtesy the artist

Immediately after graduation in 1984, now officially an oil painter, Wang Guangyi went home to Harbin to take his obligatory place in the system. He had been assigned a teaching position in Harbin Institute of Building and Architecture. He returned flushed with the fervour of student life, and within a few short months, had shot to nation-wide, art world fame as the leader of the Northern Art Group. From the end of 1984, snowballing through 1985, art groups were formed all over China as recent graduates and would-be artists united in an explosion of art activities that prompted recognition of a movement. The Northern Art Group was one of the most influential to appear, and had a core membership of ten visual artists, philosophers and writers,

who came together in a casual way, bonded by Wang Guangyi's infectious energy and ambition. Within months of being formed, a first exhibition was organised; the grandly named Northern Art Group Biennial. The aim was to create an event of great significance. Such daring was prompted by their awareness of a privileged piece of inside intelligence. It came to Wang Guangyi's attention that China Central Television (CCTV) wanted to make a programme on the emergent new culture. For the producers and directors of China's most closely guarded propaganda medium, such a programme, if conceived as a biopic of a random group of avant-garde artists had no hope of getting past the broadcast censors. What was needed was an event, ideally a public event, that in order to take place at all would have to receive an official seal of approval, thereby upping the chances of getting the project passed by the station's regulators. Wang Guangyi summoned every skill of persuasion he could command, and after much friendly coercion, Jilin Academy, in the city of Changchun near the border with North Korea, agreed to host the exhibition. The resulting fifteen-minute CCTV programme—a first for the new art—was broadcast during prime-time viewing. Although the content would not remain for posterity—the programme pre-dating the era of home video recorders and extensive library facilities at the television station—Wang Guangyi enjoyed his first fifteen minutes of fame.

Following this, the Northern Art Group began loudly touting the Heilongjiang-Jilin region as the anticipated site of a sequel to the fifteenth-century Renaissance. The idea was readily embraced by the enthusiastic first crop of art history graduates, who had recently been assigned to State-run art magazines as writers and editors. Through their earnest efforts, the handful of sanctioned art publications became increasingly amenable to publishing new ideas.[9] At the fore and instrumental in promoting and documenting China's new art through the 1980s were Li Xianting and Gao Minglu, attached to *Chinese Art* (*Mei Shu*) magazine and *China Fine Arts Newspaper* (*Zhongguo Meishu Bao*) respectively. The Northern Art Group manifesto was published by *Zhongguo Meishu Bao* in early 1986. In formulating this manifesto, Wang Guangyi continued to follow Martin Eden's lead in "drawing up lists of the most incongruous things and was unhappy until he succeeded in establishing kinship between them all ... Thus, he unified the universe and held it up, and looked at it ... observing and charting and becoming familiar with all there was to know. And the more he knew, the more passionately he admired the universe ... and his own life in the midst of it all."[10]

In 1992, Hans van Dijk (1946–2002), a Dutch-born contemporary Chinese art historian and long-time resident in China, wryly described their manifesto thus:

> In contrast [with groups in other parts of the country] the Northern Art Group was far more optimistic about the possibility of combining eastern and western art. The group was united by the desire to establish a new world culture, whose coming they prophesied in difficult theoretical tracts full of quotations from a host of 19th-century German philosophers.

9. 1985 marked the beginning of a period of increasing relaxation across society, including publications, lasting until 1989.
10. Jack London, *Martin Eden*, p. 151.
11. Hans van Dijk, "Views on East and West in China's North and South: Painting in China After the Cultural Revolution: Style Developments and Theoretical Debates Part II: 1985–1991", *China Information*, Volume VI, No. 4 (Spring 1992), Leiden University, Leiden, The Netherlands.
12. Ibid.
13. A term largely applied to artworks that employed the image of Mao and other political and cultural icons,

Having purportedly made a comparison of Oriental and Occidental civilisations of the past 5,000 years, the group concluded that both were past their zenith and currently in decline. However, they predicted that, since in both the East and the West, the cultural centre of gravity had, over the centuries, been moving from south to north, the two traditions would eventually merge in the far north of China, and usher in an era of a new world culture.[11]

However crazy the "Renaissance" idea seemed, a little faith and intense activity produced the desired effect, although curiously, to all intents and purposes, this so-called avant-garde approach unintentionally imitated the results achieved by State propaganda images and rote learning. The point though, was that the Northern Art Group was in place, awaiting the first hint of this epochal movement, its significance and avant-garde character beyond dispute. The Chinese art press printed enthusiastic reports suggesting that the group had reached a milestone in the history of art. However, van Dijk concluded: "Their works did not quite match their theoretical prowess: they produced somewhat awkward paintings inspired by the Pre-Raphaelites and the surrealism of [Paul] Delvaux and [René] Magritte."[12]

Shu Qun was the wordsmith of the group, who penned the groups statement of intent: "Our art is not about painting per se: our paintings are a vehicle for communicating our rational philosophies about life." The adopted banner of "rational philosophies"—in which rational means reasoned along cerebral rather than emotional lines—finds expression in the works of all Northern Art Group artists as an intense mood of sobriety. Shu Qun's compositions were flat, planar and geometric in form, created with mathematical precision, with titles that reference "original states", exemplified by an immense ink scroll painting by another leading group member, Ren Jian. There was a rational reason for this too, found in the natural environment of the north, which exuded a healthy, if frigidly cold and crude atmosphere, seemed to suggest to Wang Guangyi possibilities for a new kind of artistic strength. Harbin was a city of strong Russian and, later, Japanese influences, particularly in its architecture. Having studied in southern China in Hangzhou, Wang Guangyi had

Frozen Northern Wastelands: No. 32, 1986 ⋀ ⋀ Frozen Northern Wastelands: No. 30, 1985

first-hand experience of the enormous socio-cultural difference between the northern and southern provinces. He explained it using the simple example of divergent sensibilities towards colour: "Northerners paint colours dense and strong, the tones pure and saturated. Southerners like their shades soft and elegant, watered down." So, different approaches to colour and form in painting were indicative of variant social environments; the harshness of the north-east demanded a style altogether more brut, whilst the misty, dream-like quality of Hangzhou lent itself to a gentle meditative aesthetic. This northerner took some aspects of southern paleness back with him to Harbin, but the *Frozen Northern Wastelands* series, produced from 1985 to 1986, and the *Post-Classical* series, which followed from 1986 to 1988, were exclusive attempts to express northern sentiments.

That Wang Guangyi was born into a harsh environment in a harsh time is evident in the cold landscapes of the *Frozen Northern Wastelands* paintings. The vague, nebulous lands that fall away behind the figures are as enigmatic as those of Leonardo da Vinci—deliberately so. Within these chilly realms, figures cluster together as if for warmth or comfort that is perpetually unrequited. Wang Guangyi, who had known these environs all his life, was fond of their austerity. But in spite of his inclination towards painting them, the sense that all artists had gleaned from their readings of modern western art and theory was that simple, lyrical beauty was not enough to achieve greatness; art required a profound message. This was where the significance of the Northern Art Group's theories lay, for having been assigned work back in his native region, it seemed likely that, as was the expectation of life-long job commitment in China, Wang Guangyi would spend the remainder of his years there. It was not a thrilling prospect. He needed a vehicle to bring the action to him. Harbin as the location for this eastern Renaissance was

Post-Classical Series:
Madonna and Child, 1986/7
*The Farber Collection, New York
courtesy China Avant-Garde Inc.*

therefore incidental, not inspirational: it was merely the place where Wang Guangyi happened to be. With no idea that within a few years it would be so easy to move around China, the Northern Art Group simply tailored the theory to the habitat. It took some wild imagination to convince themselves, and others, that Harbin would reorient the aesthetic world order with itself—and Wang Guangyi—at the centre, and no one was overtly surprised when Harbin failed to live up to the expectations claimed for it, demonstrated when Wang Guangyi took leave of the city, leaving the Northern Art Group and its theories to return to the ether whence they'd been plucked. For a brief two-year window, it was Wang Guangyi himself who was the centre. All the same, it was via the Northern Art Group that he found his limelight, and entered the Who's Who of the Chinese art world.

In the process of evolving the *Frozen Northern Wastelands* series, Wang Guangyi gave a first hint of how prolific he could be, as he shifted into philosophical gear. The shades of the paintings are minimal, flat and hard-edged chunks of dark greys and browns, pale greys and dull mink, opal, ferret, the colour of dust on old bound book covers, and the smoky haze of an industrial horizon. The sense of northern sobriety here echoes the dour timbre of seventeenth-century Flemish landscapes and still-lifes, or the bleakness reflected in Edvard Munch's *The Scream*. The reference to western art history is relevant: it indicates the visual experience that this generation acquired at art school. In an effort to circumvent Socialist Realism and academic classicism, it took its cue from the rational philosophies that Wang Guangyi had imbibed in Hangzhou: Heidegger, Nietzsche, Hegel, Sartre, Kant and Wittgenstein. For all the philosophical complexity of the sources called into play, the designs and concepts of the *Frozen Wasteland* series, similar to the *Post-Classical* and *Great Criticism* series that were to come, are presented via painting techniques that are simplicity itself. Wang Guangyi was still young and new at the game of art, and where for so long content in art had been emphasised over technique, he fell into the general pattern of employing the old ways—those techniques of realism—as a means of presenting

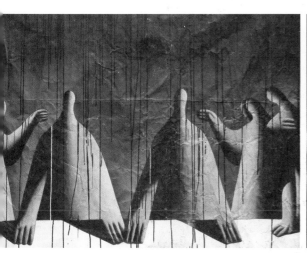 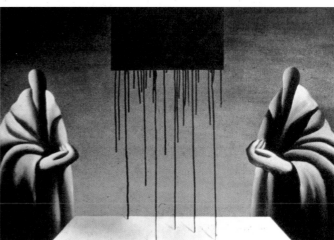

Post-Classical Series: Angel at Supper, 1986 ⋀ ⋀ Post-Classical Series: St Matthew, 1986
private collection Beijing, China *private collection Sichuan, China*

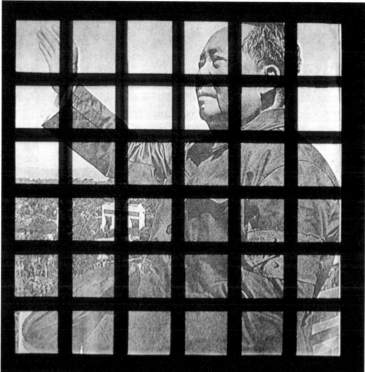

 Black Grid: Mao, 1988

 Waving Mao Zedong, 1989
private collection China

new content—largely western concepts. Had he remained in the confines of Harbin, he may well have faltered. Happily, fate intervened. There was to be no further *Frozen Northern Wastelands* paintings or activities for the Northern Art Group. In 1986 Wang Guangyi was invited to Zhuhai—one of China's first special economic zones (SEZs), freer and more forward-looking than the vast and still profoundly backward interior. He was to take up a position as a professional artist in the newly established Zhuhai Painting Institute. It seemed his talents had been recognised: his dream of being a professional artist was finally materialising into reality.

From Harbin to Zhuhai, Wang Guangyi moved from the far north to the far south of China. He also found himself removed from the comfort of the group ethic and the security of the group voice. Life in Zhuhai was entirely different and for a long time Wang Guangyi felt lonely and isolated: "It was good for me, though. The loneliness and isolation forced me to confront new problems. If I hadn't gone south, I may never have produced the *Post-Classical* series." Evolving out of the *Frozen Northern Wastelands* series, the *Post-Classical* series was similar in tone and style. In many respects, the paintings were concerned with idealism—the idealised benchmarks along the path of western aesthetic development. Here, Wang Guangyi subverted master works of classical western art history. His compositions mirrored original paintings such as El Greco's *St Matthew*, Rembrandt's *Prodigal Son*, and figures plucked from Velasquez' tableaux, but reduced their religious reverence or historical heroism to a bitter, cold terrain devoid of human emotion. The resultant works almost appear as disfigured or out-of-focus infrared images of the original paintings. The forms are rounded, generic and soft in the manner of Salvador Dali's surrealistic distortion. In this manner, they seem to question the unifying warmth of religion in western society. Those who declaim China's attitude towards organised religion might interpret them as a comment upon the lack of a true belief system or an all-embracing religious sensibility in China. Whichever reading one favours, these paintings demonstrated that here was an artist not completely in

the thrall of western culture per se, and who, in reducing fine examples to flat emotionless façades, seemed even to question its relevance to the Chinese situation.

In Zhuhai, ideas flowed fast. Exhausting his interest in parodying extant western masters works, Wang Guangyi started working on a new set of pictorial devices that ultimately brought him back to China. Ironically, these were not related to the feverish advances in social infrastructure taking place in Zhuhai—that came later when he left the SEZ behind—but to the primal images of his formative years: to Mao. With clearly stated intent, the *Red/Black Reason* paintings proffered a cool, analytical vision of his own cultural inferences, in simplified motifs that he repeated, turned into patterns and overlaid with minimalist-styled blocks and lines reminiscent of Russian Futurism and Soviet poster art. Numbers and letters emerged from pools of poured paint, carefully controlled drips ran across semi-obscured figures that gradually assumed the form of the silhouette of Mao in some of his most familiar postures.

Not long after his arrival in this southern sub-tropical haven, Wang Guangyi was asked to suggest an event to raise national awareness of the fledgling Zhuhai Painting Institute. Keen to demonstrate how open they were, the institute's directors leapt at

Great Criticism: Time, 2002
collection Guangdong Art Museum, China

his idea of a symposium on the new art. Not entirely clear what such a conference might mean, but altogether familiar with the convening of meetings that underpinned socialist governance, the directors instinctively felt that a symposium fitted the bill: it suggested an event academic, high-brow and harmless, so the seal of approval was given. Funds were also put at Wang Guangyi's disposal to invite representative critics and artists from all over the country. For Wang Guangyi, it was an unbelievable opportunity to network, to further relationships in a new leading role, and to add a second fifteen minutes to his fame.

The event was a first in bringing art world activists together from all major provinces, and would set the pace for a multitude of similar meetings. Against the tide of conferences on oil painting organised by State-mandated coteries like the National Oil Painting Committee, it added a new voice and challenge to the orthodoxy.

Within the space of a few years, artists of the first generation of post-Cultural Revolution academy graduates usurped Socialist Realism and crowned Conceptualism in its place: "We altered the course of art in China, for we overturned the ordained mandate and pushed modern, conceptual and individual creativity to the fore."

In the mid-1980s, a leading topic of discussion was *renwen reqing*, meaning warm or zealous humanism, the impulses of which, ironically curtailed by the tenets of Socialist Realism, a number of (older) artists now sought to exhume. Amongst those who harboured notions of freely expressed personal sensibilities, ink and oil painter Wu Guanzhong was the most vocal advocate of spontaneity in form and colour that embraced emotion and gave it free rein. This trend did not sit well with younger artists of more avant-garde inclinations who felt that the era of Impressionist-like sensuality was, for the international art world, passée.

In Zhuhai, after what was to be a brief flirtation with the re-examination of western idols which occupied him between 1986 and 1987, Wang Guangyi immersed himself wholly in his *Black/Red Reason* style. Then, in 1988, at a second major meeting of new artists in Huangshan, a few participants from Shanghai showed works pivoted on pure abstraction, thus devoid of any socio-political overtones. Wang Guangyi's immediate reaction was to denounce what he saw as personal emotionalism in an art, without clear resolve or direction. Again, he reiterated comments that had first been published in *China Fine Arts Newspaper* (*Zhongguo Meishu Bao*) in September 1987, challenging so-called avant-garde artists to *qingli renwen reqing—qingli* meaning "to expunge"—to make art a matter of intellect and contemporary relevance. The willing plunge into a cool intellectual form of self-expression was primarily about becoming international. There would be no attempt to initiate a Chinese-style of, for example, Impressionism; a style now sanctioned by the State and championed by members of the Chinese Oil Painters' Association. To officialdom in China, potentially "bourgeois" landscapes and portraits wrought in sensual palettes of colour were a safer option than the distortion unleashed by Picasso in the name of a Modernism the State did not trust. (A notion of distortion that was never formally paralleled with the marvellously expressive distortion of form characteristic of figures or objects

Mao Zedong: AO, 1988
The Farber Collection, New York
courtesy China Avant-Garde Inc.

in traditional ink pàinting.) As Communism gave way to Socialism with Chinese Characteristics, and all manner of weird forms began to take life in the name of art, officialdom would wash its hands of the avant-garde. For the time being, the artists paid no heed: "We believed that through art we could change the people's lives." They were soon made to see that their modern approach to art was not as powerful as they had persuaded themselves.

As the 1980s drew to a close and preparations for the "China/Avant Garde" exhibition gathered speed, Wang Guangyi was furiously putting the finishing touches to a series of paintings that would establish him as a fearless rebel and irascibly secure his place in art history. The title of the compositions said it all: to the innocuous words Red or Black Reason was added the single character "Mao".

Mao Zedong died in 1976. Shortly after, the Gang of Four, led by Mao's wife Jiang Qing, was ousted. As the trial of the Gang of Four began in 1980, portraits of Chairman Mao were quietly removed from the public arena where they had hung for several decades, which was as long as some people could remember. The State was careful not to apportion direct blame but deemed it wise to relieve the general populace of visual reminders of the previous era. Eight years later, in 1988, Wang Guangyi daringly resurrected the Chairman in eight large paintings of fire-engine red and sombre grey tones that mocked the billboard style of portraits ubiquitous during Mao's reign. These imposing paintings portrayed the Chairman beneath a grid of thick lines. On a small scale they might have resembled the squaring up of a preparatory sketch or photograph for a portrait on a monumental scale. Yet, these works were anything but small and in the hands of an avant-garde artist satirical comment was implicit. With the grid motif, Wang Guangyi placed a non-traversable

barrier between Mao and his audience, using lines that suggested a strategic map, a blueprint for analysis. Within the monochrome palette, in which all colour was drained from Mao's face, there is an eerie sense of dissection about to be performed. The paintings were to a large degree the culmination of ideas that underpinned both the *Post-Classical* series and the emotionlessness behind the *Reason* group. How to take an icon or idol and negate all the human emotion it inspired? The original portraits had accorded the masses the same access to Mao as altarpieces provide the faithful to Jesus. Wang Guangyi's barrier required people to pause momentarily before approaching the deity, the implication being to do so with care. The grid forced an objective reconsideration; a sense reinforced by a palette of cold reds and steely blue-greys.

Three of the eight *Mao* paintings were shown in the "China/Avant Garde" exhibition in Beijing just months before the student unrest erupted in Tiananmen Square. They caused as much of a stir as Picasso's 1908 Cubist painting *Les Demoiselles d'Avignon* had in its time. Although disappointingly, not exactly in the way Wang Guangyi had envisaged. "Through the image of Mao, I imagined finding a means to demonstrate how it was possible to *qingli renwen reqing*." Yet, on the contrary, during the brief

Great Criticism: Planters, 1993 ≫
collection Hanart TZ Gallery,
Hong Kong

照毛主席的指示办事

span of the exhibition, the works served to rekindle all the warmth of feeling the people still held in their affections for Mao.

From within the special economic zone of Zhuhai, at a safe distance from the capital, Wang Guangyi could afford to be daring. But then came a semi-unexpected blow that was to curtail his public exposure in China for almost a decade. A live shot was fired from a gun into an installation work by participating artist Xiao Lu, who aimed to leave no room for doubt that art was well and truly dead, symbolically re-enacted by the bullet. The exhibition was immediately closed down. As the dust settled in the aftermath of "China/Avant Garde", a number of participants found themselves in trouble. Wang Guangyi had managed to escape any direct reprisal until one of the Mao paintings was reproduced in the American publication *Time Magazine*. This brought it and Wang Guangyi to the attention of both the directors of the Institute and of Zhuhai officials. When they summoned Wang Guangyi for a chat, they were polite but decided. They gave him six months to find another position in another unit, preferably in another part of the country, thus removing any potential future problem from their precinct. This made Wang Guangyi a martyr to the cause of new art; an avant-garde rebel on the edge.

Society did not reject him entirely though and, in 1990, he secured a teaching position at the School of Industrial Design in Wuhan, the provincial capital of Hubei province. Here, he embarked upon a new phase of creation that was to produce his all-important *Great Criticism* paintings, which won international and commercial success. For the Chinese art world, the Mao works remained pivotal, for they reaffirmed Wang Guangyi's place in the limelight. Ironically, too, in 2003 when the China Art Gallery in Beijing reopened after a major refurbishment, Wang Guangyi was invited to contribute three paintings for the inaugural show. The largest one of the three *Great Criticism* paintings hung in the ground floor hall on the east wing was *Great Criticism: Time*. For Wang Guangyi, time had come full circle.

For Wang Guangyi's experiment in applying modern philosophy to art, Mao was an easy, if daring, target. The paintings were the embodiment of the emotionlessness he had propounded since 1987. From its inception in 1985, the New Art Movement frantically sought a new, discernibly Chinese modernity that would win both recognition and acclaim at home. Post 1989, pushed further from the fold of their native community, artists would draw ever more directly upon key influences in the international art world. Yet, in spite of the narrow space in which artists were forced to operate in China, for artists like Wang Guangyi, accruing honour for the nation remained a motivating factor in the determination to take on the West and its aesthetics. Although it might appear otherwise, Wang Guangyi's generation was not interested in an undeviating regurgitation of modern western art in a similarly linear fashion. Artists were as keen to build new China as any Red Guard. Mao's ultimate target was for the PRC to "overtake Britain and catch up with America" (even where that hope was short-lived, dashed by the failure of the agricultural cooperatives and the famine of 1959). Every act Mao undertook was geared towards fast-tracking China's industrial development and technological advancement to realise this dream. It was hardly surprising that when the avant-garde emerged, at what was a physically and spiritually impoverished time, it, too, embraced this agenda. This agenda spawned an urge to identify the cream of western, modern art history cool and invoke it in its own practice and goals. Wang Guangyi was not alone in believing that he was creating a new art for the people that dove-tailed with China's rapid march forward, adopting what he perceived as the most advanced creative thinking from the West to

Great Criticism Series: Coca-Cola, 1990–93 ≫
The Farber Collection, New York,
courtesy China Avant-Garde Inc.

57

do so. Beyond being points of reference and departure, western artists like Marcel Duchamp, Josef Beuys and Andy Warhol became inimical benchmarks.

In the oppressive post-June 4 period, as the State retained its grip on the people's reins, Wang Guangyi sensibly lay low. Not one to be idle, he was plotting his next move for which, taking a leaf out of Warhol's book, he delved into the socio-political environment surrounding him in search of the most immediately communicable motif available. By the time of the First Guangzhou Biennial in 1992, undeterred by his run-in over the Mao images in 1989, he drew again upon the iconography of his formative years and placed what had long been off limits at the disposal of the contemporary art world. This was the harnessing of Socialist propaganda to social change, and would prompt critics to appropriate the term Pop Art for the trend Wang Guangyi now inspired.

There would have been no "pop" without an identifiably popular iconography from which to acquire motifs. Wang Guangyi's masterstroke in alighting upon the choice of words. "Great Criticism" was a tongue-in-cheek reference to all that Mao tried to make the Chinese people reject through relentless criticism of the so-called negative traits of bourgeois inclinations. In the paintings, the clashing ideologies of socialism and capitalist consumerism meet as Wang Guangyi unabashedly appropriated propaganda images depicting China striding towards an ideal tomorrow. The cartoon-styled exaggeration of muscle definition and radiant goodness implied all the aspirations and social and communal values for which Mao and Chinese socialism stood. Across these, Wang Guangyi slapped the various logos of famous western brand names that were entering China's market to represent the most prized trophies of new consumerism. The clean lines, pure primary colours and dynamic thrust of socialist motion against a prominently placed brand name that squealed of bourgeois pleasure made the paintings impossible to ignore. The compositions concisely invoked the ideological conflicts taunting a socialist society, which in its drive to modernise was experiencing the first major wave of consumerism and brand-name mania. The visual harmony of the ideological mix juxtaposed in the paintings is heightened by the polarity of their apposition. Here are two incongruous ideologies that ultimately promote the same ends via different means and social values. In the era of opening and reform, these two opposing ideals had begun to co-exist and were swiftly reconciled by Deng's endorsement that it was acceptable and good for individuals to acquire wealth. Overnight, with the flood of consumer products that entered the market, socialism's "better tomorrow" came almost tangibly within grasp. Western nations, hungry for a share of the untapped Chinese market, patiently began to grapple with the complex import tariffs and marketing regulations, often to see their products reproduced in low-grade, pirated imitation. Where the State saw profit margins, the new breed of entrepreneurial individuals saw opportunity. So did Wang Guangyi.

In combining brand names and socialist propaganda, Wang Guangyi had no need to connect the nature of the product with the specific message expounded by the image of the earnest young pioneers he appropriated. Brand names of modern luxury cars never race against State-manufactured tractors. The titles of grand houses

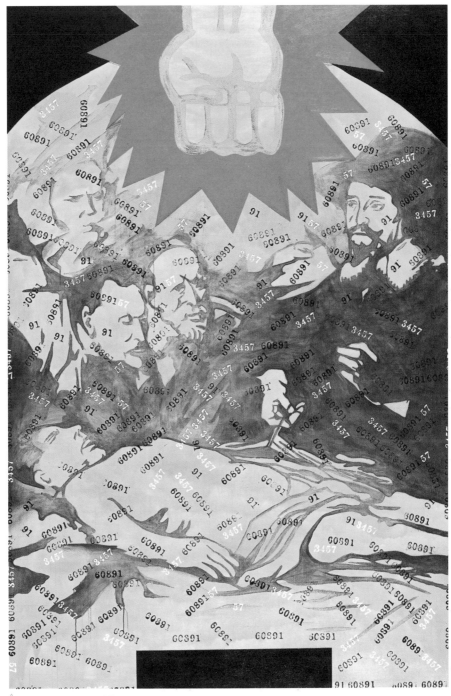

ꓘ Rembrandt Criticised!, 1990
private collection, China

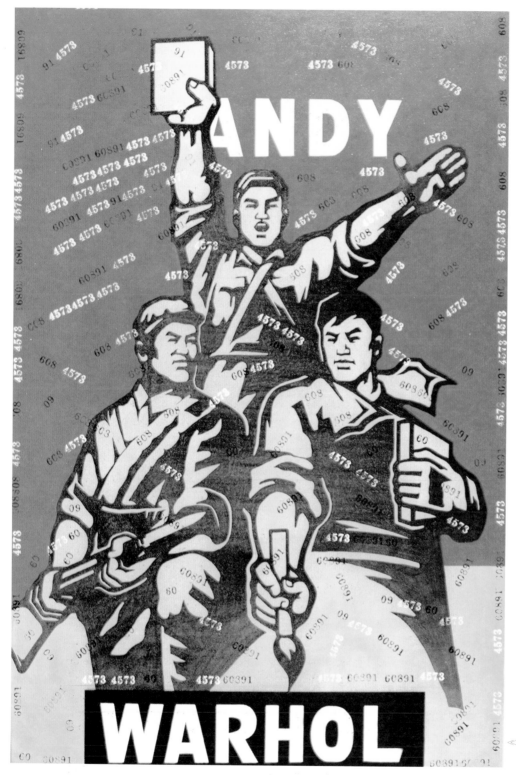

famed for their luxury goods do not contrast the trappings of the petit bourgeoisie abroad with the humble existence of the poor in China. The logos of fast-food chains are never painted over scenes of malnutrition or hunger. Where there appears to be a correlation it is almost incidental. Combination is the essence here; the simplest and most direct statement of fact, and subtlest mode of playing out a game of (self-)criticism in a way that was correct, patriotic and inscrutably subversive.

And it all began with Wang Guangyi drinking a can of Coca-Cola whilst perusing a copy book of socialist propaganda: "I put the can down to turn a page and suddenly, I found that the posturing of the soldier-peasant-workers against the Coca-Cola logo made strong visual sense. The more I looked the more intrigued I became. In content and style, both graphics are the product of two very different cultural backgrounds, and each totally embodied its own fantastic kind of ideology."

This discovery launched the litany of brand names that today reads like a list of *Vogue* advertisers, but the most well known and widely reproduced is *Great Criticism: Coca-Cola*. It was used as the cover for an issue of the international art magazine *Flash Art* in 1992. The poor reproduction from a poor photograph never-the-less conveyed the immediacy of Wang Guangyi's approach. For its owner, New York collector Howard Farber, "It was this painting that first attracted me to contemporary Chinese art. The size, the brilliant red colour, and the images of revolutionary soldiers juxtaposed with the Coca-Cola logo had an immediate effect upon me. It is like the Mona Lisa of Chinese contemporary art, an image that history will regard as the most enduring icon from the Political Pop period."

Wang Guangyi's work now emerged as central to what was promoted as a daring new genre in Chinese art: not just Pop, but Political Pop. A decade later, Chinese art critic Liu Chun wrote: "After expressing his controversial view of this overheated[13] icon [Mao], Wang Guangyi ... turned to the *Great Criticism* series. He brought together propaganda images from the Cultural Revolution and contemporary brand names from western advertising in a highly ingenious way ... Thus, Political Pop was born."[14]

13. A term largely applied to artworks that employed the image of Mao and other political and cultural icons. Use of the word "overheated" is a pun on the term in Chinese for Mao Craze which is Mao *re* (hot).
14. Liu Chun, "Wang Guangyi", *China Avant-Garde*, p. 47, published by Tianjin Publishing House, 2000.

It was the age that was new, however, and not the genre. Wang Guangyi's paintings appear to contain a directness that contravenes the veiled criticism Chinese people traditionally prefer. Wang Guangyi is a smart player who realised the potential of such manipulation in the light of steadily increasing flow of interested western parties. His quick recognition of the potency of the Mao image demonstrated an innate understanding of the efficacy of political and commercial nuance in art. With Warhol as his aesthetic guide, Wang Guangyi's notion of an artist was entirely contemporary in concept. If he clung to any romantic vision of artist as metier it lay in the ability of the artworks—if successful—to pluck an individual from obscurity and thrust him into the limelight. Furthermore, in his vision, reverence and cool were inseparable from the wealth that he perceived as going hand-in-hand with fame. Wang Guangyi had no time for the romance of the penniless artist trapped in his garret and starving for his art. He knew all about hunger and there was nothing glamorous about that. He had wallowed in poverty all his life and it wasn't something that commanded respect. The Moderns' notion of passionate pauperism serving as fodder for art was, to the thinking of the new Chinese artists, passée, vulgar, and even uncouth. The point was not just to be an artist; aside from garnering critical acclaim, the goal was to be a rich, celebrated artist. It required a brilliant concept, which Wang Guangyi found in the *Great Criticism* series.

In the early 1990s, as China began to recover from the damage done by June 4 at home and abroad, foreign journalists returned to the capital. After a decade of groundwork for opening and reform in the 1980s, China was now changing visibly. The focus of life was shifting from politics to economics, and to freedoms which, in the eyes of the State—uninitiated in the wiles of consumer culture—presented little apparent threat to social stability. Superficially, at least, the environment was taking a turn for the better. It was now that the winning formula of the *Great Criticism* works would begin to catch the imagination of the western art world.

Wang Guangyi was one of the earliest ambassadors of new Chinese art abroad, but it was not his pop-style reincarnations of Mao that had appealed to western audiences. A number of paintings exhibited in the "China/Avant Garde" exhibition were removed from the public realm following the closure of the show and only a handful of the most influential works found their way into the hands of foreign collectors.[15] The result was that Wang Guangyi's early paintings remain little known outside of Chinese art circles. It was a fortunate piece of timing for Wang Guangyi: had these been presented to a foreign audience, it is likely that viewers would have had mixed reactions to them. The face of Mao, immediately recognisable as China's Chairman, in the *Black and Red Reason* paintings, might have suggested some form of protest, but the other series required a context to clarify the underlying approach. Without context, paintings of the *Frozen Northern Wastelands* and *Post-Classical* series are open to misreading. Perhaps as melancholic laments on a deeply impoverished world, which they are in a sense, but their lack of emotion only gains visual weight

15. A number of works were collected by the exhibition's sole sponsor Song Wei. When his business activities collapsed in the early 1990s, the works he had collected were consigned to a storage space where they were abandoned for almost ten years.

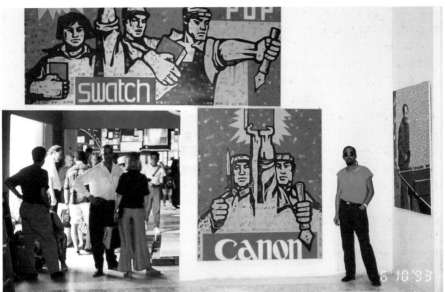

if viewers are able to link them to a period of Chinese history in which emotion had been exhausted and a general numbness prevailed.

From the first major international showing of *Great Criticism* paintings at the 45th Venice Biennale in 1993, the works offered a foreign audience a succinct metaphor for a modern, post-Cultural Revolution China. By quoting recent Chinese history and familiar western products the canvases instantly conveyed "China" to people who were largely without any other frame of reference. It took Wang Guangyi an instant to arrive at the concept, and only a few brief instants more to become a self-made man. Corporations with strong China trade relations were quick to acquire their *Great Criticism* logo to decorate the walls of their headquarters or chairman's office. Museums flaunted potential contretemps with corporate sponsors and also added works to their collections. Collectors, too, dived in and plucked out their favourite brand. From then on, no collection of contemporary Chinese art would be complete without a *Great Criticism* work.

To be rich and successful, to achieve fame and fortune was perceived by artists like Wang Guangyi as their contribution to elevating China's status at international level. Concepts of Chineseness and a history of humiliation were a driving force in shaping attitudes towards new and cool art: "From the start, I was determined to produce art that was contemporary, Chinese, and that would be accorded international respect. It was not about being a non-conformist, at least, not in a deliberate way."

Wang Guangyi's "Chineseness" and the ignominy of his background fed the impetus required to propel him beyond the constraining circumstances of his childhood. From the mid-1980s through to the end of the century, artists were stigmatised by the

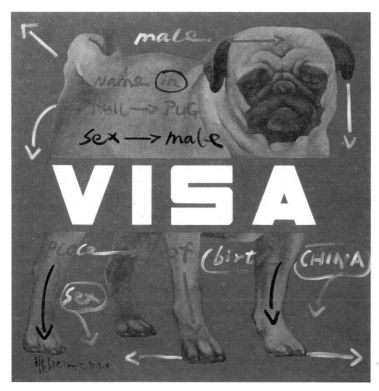

≪ Red Visa No. 1, 1995
private collection Germany

State's persistent association between "all things western" and the spiritual pollution of its people. With an interest in foreign culture, philosophy and life, artists were by default potential pollutants. Inevitably drawn to the forbidden fruits of western spiritual culture, the avant-garde oriented itself towards Modernism, and then even more swiftly towards Post-Modernism. The conclusion drawn was that successful contemporary art evidenced a compelling emphasis on the comment an artist could conjure. Whether this was smart, concise, profound, or at times deliberately provocative, for new artists in China, the approach to the type of comment made was habitually informed by the latest international trend. Initially, without a role model to build on at home, the influence of western art was not unreasonably magnified out of proportion. Yet, even when new art began to find its feet within its immediate cultural framework, European and American innovations remained the benchmarks against which Chinese art cool was measured. In the same manner, artists subscribed to a notion of success built upon perceptions of the foreign standards by which such things are judged. Wang Guangyi's attainment of such success was marred only by the lack of cultural infrastructure in China, which perpetuated a hostile reaction towards new, modern, or contemporary art. The State remained suspicious of free expression in general, and of Wang Guangyi's art in particular, right through to the early 2000s. From the mid-1990s to the early 2000s, with their attention-grabbing format, his *Great Criticism* paintings were regularly weeded out of exhibitions in State-run museums. In China, at least, the series was apparently penalised for their

author's prior audacity in reworking images of Mao. Not so abroad, where examples were used to illustrate nine out of ten reviews or feature articles on contemporary art from China, even, on the odd occasion, for exhibitions in which Wang Guangyi did not actually participate. For curators abroad presenting new art from China, nothing said "People's Republic" quite like Wang Guangyi's *Great Criticism* paintings. The critical acclaim and commercial success he enjoyed overseas was the consolation prize for being screened from public view at home. The healthy rate of sales played a large hand in further mitigating these perplexities.

"It might seem strange that we looked so enthusiastically "West", but we were determined not to be dictated to any longer by our own social situation and ideology. We wanted to exercise our right as to what and how to paint: to make our art our own. We wanted to engage the West on equal terms. To do this we had to understand western art theories." Which was not what Mao had in mind when he invoked the need to take from the West what could be used. Art fell into "the rest", which was to be discarded: the portion Deng likened to flies (in his well-known saying "open the window and the flies come in" [along with the fresh air]). Creative practitioners across the arts found themselves on the horns of a dilemma. The image of China being uncivilised, or backward, had become a thorn in their side. Mao's over-confident reiteration of the paradise that socialist China was compared to the rest of the world had a whiplash effect when, after his death, the people had to deal with the effects of how far off the mark his forecast had been. These were the auspices under which the New Art Movement began.

As the artists began to travel abroad in the early 1990s, Wang Guangyi was spurred on to produce a small series of paintings titled *Visa*, featuring flat planes of red and yellow upon which sat one of several breeds of dog, with the customary facts that appear on all passports—sex, age, nationality—loosely scrawled over the surface. In Hong Kong, in 1996, asked about the political implications of the "visa" being a metaphor for the Mainland authority's control over the people's freedom of movement, Wang Guangyi was visibly angered. "The paintings are not about passports," he growled. "They are about visas; externally imposed restrictions of other nations on the freedom of the Chinese."

The sense of discrimination against Chinese travellers was palpable to any artist who had tried to apply for a foreign visa. Wang Guangyi had first-hand experience of the headaches of international travel. In the early 1990s, he frequently jet-setted between the world capitals of culture and art: Paris, Venice, São Paulo and Berlin, to name but a few. Despite being privileged with the freedom to travel—the envy of so many Chinese—the visa issue irked him enormously. So much so that in the late 1990s it was not uncommon to hear him dismiss the five star hotels and fine cuisine of western nations with casual, searing disdain. He repudiated the hotels for their mediocrity, foreign food for its inedibleness, chipping away at the pedestal upon which China had placed foreign affluence. His criticism demonstrated to the people at home that he had a grasp of the West and the ability to judge it. He revealed himself to be zealously—if bitterly—nationalistic. It was nothing less than

that which Mao instilled in the people as a means of redressing western "imperialist cultural superiority". The situation was complicated by the demon of unmanageable expectations; again courtesy of the PRC's isolation during the Mao era and the ensuing years of restricted information and travel. Expectations founded on a little knowledge gleaned from random sources that was entirely without context and frequently proved out of all proportion to the reality with which artists like Wang Guangyi were confronted. One close friend, multimedia artist Wang Jianwei, once suggested; "It was as if [the first generation of artists to go abroad] expected Champagne and were given wine. No matter how good the wine, they were in no position to judge: nor even what Champagne was if anyone had thought to offer it to them. With such grandiose expectations, it was inevitable they would feel slighted when Champagne was not forthcoming."

Wang Guangyi, reliving echoes of Martin Eden pretended not to care for such frivolous trappings: "That was the paradox of it. ... he was proud. He desired to be valued for himself, or for his work [alone] ..."[16] Which in essence he was, although the work would have meant much less without its made in China label.

If Wang Guangyi found initial fame in China, the commercial success that arises from critical recognition definitely lay abroad. It was a dichotomy that caused endless vexation until a tiny number of domestic collectors began to buy in the late 1990s. It took an absence of ten years exhibiting in China following the "China/Avant Garde" exhibition in 1989 before Wang Guangyi's works appeared in not one but two shows in China. And when *Great Criticism: Coca-Cola*, 2000, also took the cover of *China Guardian*'s autumn 2000 auction catalogue, the future at home began to seem faintly brighter. Yet the battle to reconcile fame abroad with marginalisation at home dominated the period in which Wang Guangyi emerged. This was exemplified in the first participation of contemporary artists from China at Venice in 1993: a landmark in the crusade to conquer all western aesthetic heights. In 1993, the documentary filmmaker Wen Pulin brought together the Chinese participants in the Venice Biennale as an informal gathering at the Central Academy of Fine Arts in Beijing. He had been filming art activities and events in China since 1988 and wanted to document the reactions of these art

In his Daxing studio, 2000
photograph courtesy Soobin Gallery

16. *Martin Eden*, p. 443.

pioneers at what was an historic juncture for China's new art. The taped footage of the meeting, which runs to nearly six hours, shows the group of artists sitting close together around a low table, drinking tea and discussing their exploits and the significance of this event with great enthusiasm. Wang Guangyi, at the head of the table, reclines against the wall looking by turns bored and frustrated, and saying little. He answers questions with monosyllables and no apparent willingness to elucidate. It had been an unexpectedly traumatic event. Problems with the scale of space allotted the large number of Chinese paintings had caused a split in the group of artists. Wang Guangyi had initiated hanging his *Great Criticism* works on the exterior of the Italian pavilion only to be told by Biennale sponsors that the publicity this gave to the western brands that appeared in them was inappropriate. Further frustrated at the language barrier, which naturally placed restrictions on media interviews, Wang Guangyi decided that he had been snubbed by the western press. Significantly, following conflicts over wall space, he and his close friend Zhang Peili had become bitterly estranged. A common occurrence within the competitive world of art perhaps, but for a Chinese, such a brutal break with a trusted friend was of lastingly injurious import. Wang Guangyi had sustained a painful dent in his ego.

Still in uniform serge outfits in the late 1970s, by the mid-1980s, Chinas youth had become extremely fashion conscious. Denim, flares, and collar length hair were officially banned, but that did not stop would-be trend-setters bucking the rules. Like many new artists, Wang Guangyi grew his hair long. He also added an ear to

Great Criticism: M&Ms, 1995 ≫
collection Hanart TZ Gallery, Hong Kong

ear, nose to throat beard. In the mid-1980s, artists already felt separate from the rest of society, so why not don distinguishing marks to complete the picture of cultural rebel? As the collective began to dissolve in the 1990s individualism became increasingly important. Head-banging tresses now began to disappear in favour of the razed pate adopted by emergent art stars like Fang Lijun. Wang Guangyi's locks gradually shrank in length, too, but he never went as far as the close-cropped skulls of the younger generation. The beard was retained as an anthem to his individuality, though latterly maintained.

Self-image was always important to Wang Guangyi, even before most others had taken stock of themselves in a mirror. His demeanour was consciously formulated to reinforce the artistry he conjured on canvas. Never quite attaining a level of self-assurance that would make him natural in front of a camera, he hid his eyes behind the sheen of distance-enhancing sunglasses. One hand unfailingly nursed a cigarette. The strong sense of self-effacing reserve was a prominent aspect of Wang Guangyi's character as a student and only slightly diminished with age. "He did not trust people easily," remarked Zhang Peili. "As a friend he was reliable and trustworthy, one of the few people I would talk to about my personal feelings, and vice versa, even though our relationship was always very serious. He was not as confident as the image he projected ..."

Before arriving at middle age and a commensurate sense of self-assurance, Wang Guangyi was impeded by an air of suspicion towards the world, particularly towards those who asked questions and were not satisfied by the first answer they received. Then, he reacted as if jabbed by an electric cattle prod, harbouring an anger of chilling ferocity. But the flip side to the cool, hard exterior is a soft underbelly, revealed most incisively when he entertains potential clients—collectors, museum directors, critics or curators. He can be hysterically funny, which makes him a welcome friend at any artists' gathering. He brazenly says what he thinks—especially if it gets a laugh or makes people gasp at his audacity. In 1994, a group of diplomats visited Wang Guangyi's studio in Beijing. It was then on the fourteenth floor of a high-rise within acre upon acre of impersonal, tall, repetitive blocks, rising up out of a surrounding maze of construction: Fangzhuang was Beijing's first major residential redevelopment project, and Wang Guangyi was the art world's first home-owner. He was not one for fancy interiors. The decor he had selected for his apartment consisted of plain tiles, bare concrete and functional yet formal furniture. In the comfort of his own home, surrounded by a fortress of canvases, the art star was at his most relaxed and natural. He smoked copious amounts of cigarettes but he was far from silent—comfortable with the object of such a visit if not with the people. In spite of his difficulty with English, he held the floor and revealed how well he understood how to schmooze and to cut a deal. His prices then were beyond what any of the diplomats felt inclined to pay—they were beyond what most non-serious collectors are prepared to pay for an artwork, approaching USD 20,000 even without the intermediate cut of a dealer. As the visitors probed him on this, he stood firm. However, the more he refused to bend, the more his audience was convinced that his work absolutely had to be worth an amount more at home in Soho, New York. Wang Guangyi had learnt well from his Northern Art Group Manifesto experience: say something often and loud enough and everyone will believe you. The steady flow of visitors to the studio kept his success rate high, the mythology very much alive. Visitors knew they were in the presence of a contemporary Chinese master, a sentiment they carried away with them and recounted over elegant embassy dining tables: stories that ran like wildfire through ex-patriot social cliques.

Yet, through this time, the issue of China versus the West, of "Third World" against "First World" was profoundly embedded in Wang Guangyi's psyche. Around 1995, the word "no" appeared as an element of the *Great Criticism* works. The "no" was implicit in the paintings, but the physical presence of the word comfirmed the obvious. "It emphasised exactly what these paintings are against." Which is? ... in the final analysis, hard to define. The legacy of Maoist Socialism? Surely not consumerism? The no's coincided with a period of growing nationalism in China: 1995 saw the release of a book entitled *China Can Say No*. A variation on positive thinking for a less than confident people, it was an immediate bestseller. The contemporary colonisation of China was, in effect, being undertaken by the influx of western brands, rather than invading armies. The sense amongst some sectors of society was that it amounted to the same thing, reflecting the mood of a people held at siege by change. Intellectuals denounced the blind following of western ways. Amongst artists, there was Wang Guangyi. Once again, his forthrightness won a following. After all, his product was gaining ground in its invasion of the West. He understood that the winning formula of the *Great Criticism* series had the kind of shelf life that meant he would never have to exist in fear of anything again. Certainly, neither poverty nor obscurity. Yet even as he achieved an international reputation, he would say, "I don't understand the notion of "international" art, and I don't believe people who say that there is an international standard for art. Art relates directly to your environment and background. We have to find a standard for new art within contemporary Chinese culture. Then we'll have something to take to the international aesthetic table."

By 2000, with a veritable smorgasbord of Chinese art spreading over the international aesthetic table, attitudes amongst the nation's young academy graduates were becoming fearless too. Their art now raised universal questions about human existence but visually, it was far from being specifically Chinese. Is the element of nationality in art always identifiable or requisite? From foreign quarters, responses to this question have been mixed. A good portion of it entailed criticism of derivation or imitation in the art. Yet overall, nearly two decades after the avant-garde first stepped onto China's cultural stage, Wang Guangyi's standard for contemporary art within Chinese culture appeared to be a real possibility.

From the steady sales of his work, by 1995 Wang Guangyi found himself with more than enough disposable cash to purchase a second property. Within the ranks of urban metropolitans, home-owning aspirations were multiplying quicker than spores in a Petri dish. Luxury property developments were springing up around the capital. Work units were selling off apartments in housing blocks, and already affluent couples were looking to move up the property ladder. With land becoming available for leasehold, a number of artists were already building their own homes. Wang Guangyi chose to combine options by taking a plot within a villa complex and annexing a two-hundred-square-metre studio to the main house, which occupied every inch of the designated garden. The completion of the studio was celebrated with a grand vernissage.

In January 1996, a motley crowd of artists, foreign friends, diplomats and journalists, gathered outside Beijing's Friendship Store on Jianguomenwai. The chilly concourse was the starting point for a convoy out to preview Wang Guangyi's studio. It was whispered he had paid USD 100,000—cash—a monumental sum by standards of the day. Cars and buses loaded, the journey began heading due south. The route crossed roundabout after roundabout, each one more lawless than the last. Forty minutes out from the centre of Beijing the terrain became provincial, rough like a frontier land. The locals by the wayside were bundled up in padded wraps that apparently had altered little since the late 1970s. Fashion seemed to have passed the southern quarter by. At odd intervals, the horizon was broken by giant billboards that protruded from the roadside fringe of trees, proclaiming wondrous housing developments just a few hundred metres back from the highway: luxury apartments in the middle of nowhere. Fifty kilometres south and the column turned due east. The road narrowed as it approached the boundary wall to the compound. As the daylight faded, guests were treated to the bizarre sight of block after block of candy-coloured villas, the architecture coined from every location west of the Adriatic. Purple, pink, lavender, sky blue, and all shades in between coated walls that carved Italianate, Spanish, neo-Roman, Californian and pseudo-Mediterranean domiciles out of the space. The buses were waved through to the second phase of the development: an estate of luxury homes arranged like grounded campers on a trailer park, bumper to bumper, with no privacy and no individuality. Well, except one. Wang Guangyi's villa was the first to be completed. Others were but bare shells awaiting attention. The interior was impressive. Beneath the four-metre high ceiling, the space felt cavernous. Wang Guangyi had hung a few paintings on the walls but otherwise the studio was naked and freezing cold. No matter, with anyone who was anyone of the moment in attendance and alcohol flowing to the strains of a local jazz band, Wang Guangyi had once again set a benchmark for the local art world.

Three years later, it still took more than an hour to travel to the studio, which Wang Guangyi did on a daily basis, and the scenes of suburban life witnessed from the car window were little altered. Yet three years on again, in 2001, with the opening of an express highway, the journey time was cut to twenty minutes and the route presented an altogether different impression of the area. The quality of the new road proffered compelling evidence of the speed of China's advance. By contrast, the state of the compound surrounding Wang Guangyi's studio complex was shocking. It felt like a ghost village. Villa after grey-walled villa stood on its tiny seepage of land, the boundaries of the plots still unmarked. Doors hung off hinges, whilst some villas had no doors at all. Windows gaped, smashed glass glinted in the headlights. It seemed that Wang Guangyi was the sole resident; the king of a burst-bubble dream of suburban dwelling for the nouveau riche that had not materialised.

To keep abreast of the times, occasionally Wang Guangyi explored other approaches to art, experimenting with physical three-dimensional materials and ready-mades, like fruit and vegetables. His first serious attempt was in October 1994, when he produced a set of three-dimensional fluffy *Visa* works for the Beijing leg of the *Asian Art Show*. These preceded the *Visa* paintings he produced from 1995 to 1997, and began with the contorted faces of crying babies which he later substituted with dogs. One suspects that the dogs were also a reference to imperial colonialists in the nineteenth century: foreigners who placed the vast Chinese masses, at or below the class they accorded dogs. In the installation version, the baby appeared washed with a red hue, as if under dark room lights, against a black base upon which white characters were emblazoned. These works demonstrated a certain socio-cultural awareness, and a clear point of view. However, the appearance of latching on to politically correct issues in installation pieces, which presented images of drug taking paraphernalia and the phrase "Are You An Addict?" strain credibility. To that point neither drug abuse nor AIDS were under public scrutiny in China—very much the opposite—and thus areas in which Wang Guangyi lacked direct experience or understanding. Apparently, the glamour of the age, and the broadening influx of western media, including films, was latterly proving as infectious amongst contemporary artists as western art theory. Wang Guangyi's works in this vein were evidence that it was not enough to play with intellectual concepts: inspiration had to be heartfelt and trenchant. In his defence: "We were not brought up to think so deeply or to analyse in any way that might seem logical now", suggests Wang Jianwei. "Nobody was." This mattered little to the greater trajectory upon which Wang Guangyi had set his course. He continued painting, only occasionally dabbling in more physical forms

of art; an example being the three-dimensional renderings of socialist revolutionary figures—the heroes from his *Great Criticism* paintings. Of substantial import was that from the mid-1980s, Wang Guangyi was an influential trendsetter. In particular, the impact of his presence in Wuhan, close to the Hubei Academy of Fine Arts, as he launched Pop Art, was profound.

By the early 2000s, the younger generations of emerging artists were less convinced about Wang Guangyi's art. They pronounced it the product of a smart mind with a perfect sense of timing, but locked into the era of opening and reform post-Mao. What next? they asked. What more? There are also those like multimedia artist He An—who hails from Wuhan and experienced Wang Guangyi's legacy directly—who are almost fanatical admirers: "People place too much emphasis on process when it is the final result that matters. It is the final result that strikes an audience first. Here, Wang Guangyi reigns supreme. When I was at art school, I didn't understand the *Great Criticism* series. I didn't even think they weren't well painted. But gradually I came to believe he was the best of the Chinese avant-garde, the one raising fundamental issues whilst others focused on details of execution. His work is neither forced nor contrived. Wang Guangyi always managed to surprise."

"Our generation was born into bitter, hard times", Wang Jianwei reiterates. "We are all idealists. We do what we do because we can't do anything else. Some do what they have to do to survive, making art because it sells and because the hardship of their early years instilled in them a desire to succeed in whatever way they feel is appropriate. One can analyse this generation ad nauseum, but its individuals are not that sophisticated; their backgrounds did not permit them to be so." If Wang Jianwei doubted a sophisticated interpretation of Wang Guangyi's art he did not show it in 2001 when Wang Guangyi cajoled him into writing an appraisal for an art magazine

Faces of Faith, 2002 ≫

of the sculptures Wang Guangyi had extrapolated from his *Great Criticism* works for a magazine article. "After spending some time talking with Wang Guangyi," he said, "I have to admit he really is smart, and almost more than anyone else, he has held true to his original idea."

This was not in question: the line Wang Guangyi delivered in 2001 had altered little from that a decade before: "Our experience is absolutely different from that of western artists, which should lead to a different view on contemporary art. Strictly

Great Criticism: WTO, 2001
private collection, Beijing

speaking, even the term "contemporary art" is a western concept. It is meaningless in terms of present-day Chinese culture. The foundation of our creative impulse is what I call "socialist experience". Socialist experience has had an enormous impact on us. Having covered some distance, we ought to consider how to establish our own contemporary culture based on such personal experience."

Even as Wang Guangyi celebrated a major retrospective together with Zhang Xiaogang and Fang Lijun at the State-run He Xiangning Museum in Shenzhen in 2002, detractors were to be found on the sidelines, their eyebrows raised mildly, cynically, at the sheer volume of the *Great Criticism* series. They suggest that comfort has made Wang Guangyi soft, happy only to keep on selling what is a highly marketable product. In the midst of modernisation and consumerism in China, money speaks louder than anything else, and is a cushion that keeps more penetrative criticism at bay. True, there is a question of repetition in the *Great Criticism* series that lends credence to the critical paint-on-demand jibes levied by those who take issue with Wang Guangyi's approach. Has he sold out? Or is this actual contemporary mass production, Warhol inspired, Chinese styled? A decade after he produced the first in the series, Wang Guangyi continues to produce *Great Criticism* paintings, yes, but the irony is that they have become his brand image and demand continues to eat up the supply. Ultimately, the continuation of the *Great Criticism* series can be interpreted as the paramount point. "With buyers being more than ninety per cent western, the thriving interest in contemporary Chinese art reflects western attitudes towards China in the late 1980s and early 1990s—in particular, to the art itself. The language, the motifs, the signs and the references to westerners own art history and culture provides a significant comfort factor. In all his art, but especially the *Great Criticism* works, Wang Guangyi provides plenty of both, surreptitiously pointing to the new imperialism of West over East; the creeping infiltration of materialism. Regardless of the views expressed by Chinese critics, as interest from abroad continues to grow, Wang Guangyi's only restriction is not having enough artworks to go around.

The *Great Criticism* series is adjunctive to the vastly successful brand building process in the western world, and essentially delivers proof of this success. Wang Guangyi built his with images that were definable as a Chinese brand type even without knowledge of the Chinese context, with all the emotions contingent to the western view of China. For this reason, the *Great Criticism* works draw in people who might not normally take note of contemporary art, but who recognise a brand that for one reason or another they have an affinity with. And it does so lend itself to instant interpretation. In December 2001, Wang Guangyi installed a sculptural rendering of a socialist figure that looked as if it had just stepped down from one of his paintings, in a park in Shenzhen. The work was a commission for the "Fourth Annual Sculpture Exhibition" organised by He Xiangning Art Museum nearby. Shenzhen is a damp, humid place, where it rains one day in five. Wang Guangyi's sculpture was cast in fibreglass and covered with a skin of yellow millet, glued on with PVC glue. In the climate, preservation was going to be problematic, so the work was enclosed in a glass box. Given the weather conditions, the glass merely

magnified the heat and made a torpor of the turgid sub-tropical air inside. A year later, Wang Guangyi's statue was still strident in its glass prison. The millet had been cooked by the elements and the glue had parted company with the fibreglass. But there it was, a metaphor in the making: the old form of socialism, sloughing off its skin, to emerge anew ...

From the first, Wang Guangyi willed himself to shut out what he did not wish to see and focus on the future horizon he yearned attain. His only concern was with fame and wealth: how to acquire both in ample portions using art as his tool. What made his philosophy successful is that it was exactly that simple: "Becoming wealthy, buying a villa and enjoying a luxury lifestyle was not something I ever really imagined would be within my grasp. It was an ideal. All people want to succeed. There are many different kinds of success. It might be to do something well, and be recognised by others ... or to live very comfortably, to become rich. Everyone wants this, and I am no exception ..."

With success and recognition, Wang Guangyi has mellowed, becoming more at ease with himself as the rise in his social and economic status ushers in new comforts. He remains a modern-day hero, not only within the art world, but also by virtue of being an underdog made good: the victim who triumphed over adversity. Within Chinese art circles, he continues to serve as a model even for those who see him as a victim of his own success. In the 1990s his art was the sign of the times, but these times were defined as running from the birth of the avant-garde in the New Art Movement, to the Northern Art Group, through to the Pop Art of the early 1990s. Where change

is a sign of evolution in western art practice, in China it is perceived as suicidal for artists whose style has not yet registered on the international art world. Every shift in style included the retention of one element associated with the artist or the brand-building would have to start again from scratch. Difficulties compounded where non-Chinese speakers struggle to remember Chinese names. Reinvention requires the kind of drive that Wang Guangyi exemplified in the 1980s, when he was busy inventing himself and new art in China the first time around. Today that energy is put to developing a recognised profile in China.

In China, however, in spite of small beginnings in a handful of museum shows, a real, or informed, audience has yet to come forth. As education lags and exposure to visual culture is limited, imaginations have yet to apply themselves to art: "My two older brothers have seen my work and they just find it amusing. My parents would not have understood but at least they felt they didn't need to understand as long as this thing I was doing gave me such a good lifestyle. My brothers can't grasp that the paintings command such high prices. They both have good jobs but one painting earns far above what they can make in years. What do they think the paintings mean? When they saw them, the comment was This about the Cultural Revolution, then? Such a simple reading. They think I'm trying to tell people that Coke or cigarettes are bad!"

Wang Guangyi's finest moment was realising that, in the global corporate world, which drives art as much as it does economies, such things are by-the-by. The only thing that matters is successful, instant, brand recognition. Wang Guangyi owns the double pleasure of having cornered the very market for avant-garde art from china that his works were instrumental in defining.

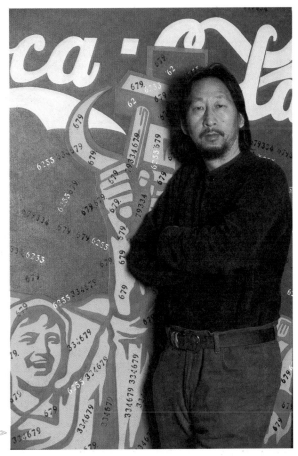

The artist in his studio, 2000 ≫
photograph Liu Heung Shing

GENG JIANYI:

TRUST ONLY HE WHO DOUBTS

Geng Jianyi in Beijing, 1995

"A joke goes like this: A man walks down the street when he feels himself about to sneeze. He stops, throws his head back in anticipation, and stands there, looking up, waiting for the sneeze to come. Time passes. Still no sneeze. A large crowd gathers round him, all looking up expectantly, trying to spot what had caught his eye.

When he realises the urge to sneeze has passed, the man continues on his way, easing himself through the crowd, which continues to search the sky in vain for whatever it was he might have seen—no one doubts that there had to have been something. The funny thing is how often the same thing happens in the art world ... "[1]

Geng Jianyi first became famous for laughter. In fact, in his aesthetic wake, the guffaw, which he immortalised on the picture plane in 1987, snickered its way through the minefield of new art trends in the 1990s to endure through to the early 2000s as a much-favoured motif. Today, a laughing face—mostly in the guise of a cynical leer—is a motif synonymous with China's contemporary art. It is not that Geng Jianyi is a joker in conventional terms. His sense of humour is not as wry or sharp as that of Zhang Peili—his mentor and ally since their years at Zhejiang Academy—but it inclines towards a level of satire that borders on cynicism. What holds it back at the brink of pure cynicism is a certain philosophical seam in the artist's nature, the charm of which lies in its innocence.

The "laughter" which Geng Jianyi depicted in 1987 that became one of the defining images of the New Art Movement, runs across the four-panel painting titled *The Second State*. The creased features of the huge face on each of the panels pounces upon viewers with a perturbingly ambiguous mockery. Do they laugh at an off-canvas joke or at us, the audience? Bearing the title in mind, perhaps they laugh because there could be no more suitable reaction to the state of art in China in the late 1980s: awkward, contradictory and without clear resolve. Geng Jianyi's generation was primed on awkward contradictions, political, social and personal. Broadly beaming smiles dominated the paintings of Maoist Revolutionary Realism—obviously not those depicting the torment of poverty with which people struggled, but the emotional response of the masses to the presence of Mao Zedong: joyous, uncontainable, for he was the "red sun in their hearts". But this form of beaming

1. Geng Jianyi, "Art and Audience", published in *Zhongguo Meishu Bao*, Issue 22, 1988.

expression denoted more than personal emotion: visible delight in the new socialist society was the individual's civic duty, and a very public face to be worn at all times, only exchanged for earnest intensity when reading and studying Maoist thought. For in the world into which Geng Jianyi was born, human emotion was firmly directed towards serving the nation and bolstering its ideology. The warmth of feeling for Chairman Mao wrapped up in the smiles of people portrayed in endless celebratory compositions was the only kind of outward pleasure that absolved the public expression of emotion. And then it was de rigueur. Anything else was deemed unpatriotic and punished accordingly. So the people could smile at their Chairman and at the benefits he brought them, but the broadness of a beam could never cross the boundary into face-distorting laughter of the kind Geng Jianyi depicted in *The Second State*. Thus, in a basic human reaction, he established a mould for confronting established prescripts for art, for challenging orthodox social habits, and for questioning the truth of State propaganda's illusory reality.

Geng Jianyi was born in August 1962. It was a quirk of fate that the artist whose nature would most closely adhere to the ancient Chinese philosophy of *zhong yong*—defined as following the middle way between all extremes—would be born in Zhengzhou, Henan province. Its location in the very centre of the Middle Kingdom is considered the source of Chinese civilisation. It was just a coincidence however, for his family had no ties to the city. Attached to the People's Liberation Army (PLA), his parents were sent around the country where they were needed.

Geng Jianyi was the middle of three children; an older brother who dutifully followed in their father's strict footsteps and entered the army, and a younger sister of a delicate, sensitive nature with a passionate love of literature and poetry. Geng Jianyi's character fell neatly between the two. He is both highly self-disciplined and deeply sensitive: polemic traits that hold the other in check, and the reason he never gives himself up to a display of emotion in art or to pure romanticism in life. Yet, as he embarked on his own independent path, he did not allow discipline to confine him entirely to a predictable daily routine. In his habitually rational way, intoned as being the duty of an artist, Geng Jianyi eschews the habits of the masses, particularly those with whom he came into contact in the course of a normal day during his years as a teacher at a technology institute in Hangzhou. He was never so aloof as to strike others as disturbingly different, but distant enough to permit him to keep the world at arm's length, so as to observe life around him. A softly spoken, self-contained child, Geng Jianyi could amuse himself for hours with a pencil and a sheaf of paper. Ill-disposed towards athletics, he was not given to running wild with the neighbourhood children in that era of adolescent freedom. In the late 1960s and early 1970s, when the age-old Confucian social order was inverted by the Red Guards Mao unleashed; the fictitious vision William Golding posited in *Lord of the Flies* was a menace that lurked constantly in the shadow of reality. Geng Jianyi's reflective nature was, for his parents, an assurance that this child would not get into trouble on the streets. Later, this aspect of his character assisted him in circumventing all that was extraneous to the minimum necessary engagement with Chinese society, with all that confusing illusory emotion that veneered social interactions.

The Second State,1987 (detail) ≫
Sigg Collection, Switzerland

Through his youth, Geng Jianyi's family was more fortunate than most. With his parents ceded to the PLA a degree of comfort was assured, or at least the harshest of discomforts were avoided. His father was a political instructor and a strict, disciplined man. He had to be. His role of instilling Marxist-Leninist thought to platoons of PLA officers and soldiers required him to be stoic, cautious and sparing in word, thought and deed. He consciously elected to shut away many emotions that could be damaging to his position, yet, the forthright values of strength and pride he demanded his children imitate and exemplify were inherent in his character. When inimical traits in the children's character contravened his standards, Instructor Geng was reduced to internal turmoil. The rigorous demands he placed upon their conduct—in the sincere belief it was for their own good—were especially challenging for Geng Jianyi's younger sister, whose poetic soul frequently incited the expression of emotions to which her father could not reconcile himself. Geng Jianyi was her support and mentor, the only person she could turn to in moments of uncertainty. By contrast to the strict guidance of his father, Geng Jianyi's mother was a tower of resilient, loyal strength. Gentle, wise and much loved, she provided a balance that kept the family grounded.

The circumstances of his immediate home life and the general mood of society moved Geng Jianyi to adopt a degree of self-restraint verging on saintliness. It allowed him to develop a level of self-discipline that in turn enabled him to endure many trials, even to stick with art at times when doubt and disparaging incidents almost forced him to surrender to civilian life. Simultaneously, it denied in him the sins of greed, covetousness and envy, which plagued the emergent art scene. But if Geng Jianyi was predisposed towards keeping his head down, controlling his emotions and losing himself in his art, as a child he was not entirely the diligent student one might imagine. A great many of the first generations of new artists recall difficulties concentrating in the classroom, distracted perhaps by the excitement of the turmoil bubbling around them. But where learning was demoted by Mao, students felt vindicated in focusing their attention elsewhere. Geng Jianyi was neither rebellious nor aggressive, but his mind was usually far from the lesson in hand. His fine drawing skills were his saving grace and, as many

NINE LIVES THE BIRTH OF AVANT-GARDE ART IN NEW CHINA GENG JIANYI **83**

of his peers in the New Art Movement, he was plucked from art classes at his middle school and directed to the local Children's Cultural Palace by a teacher keen to see his talent given room to grow.

Classes at Zhengzhou's Children's Cultural Palace were taught by a pre-Cultural Revolution graduate of Guangzhou Academy of Fine Art who diligently applied the tenets of academic practice to his instruction. He was good, inspiring even. His classes were so popular that places were fiercely contended. Geng Jianyi found he had much in common with the dedicated, talented few who were admitted. As the years passed, the teacher's links with his alma mater enabled a number of the older students to gain places at the Guangzhou Academy when it re-opened in 1978. The honing of Geng Jianyi's skills nurtured a confident sense of self-worth, and when he came of age he chose to apply to the Central Academy of Fine Arts in Beijing. Technical skills, however, were secondary to the knowledge required to pass the all-important ideology exam.[2] Geng Jianyi, like many of his contemporaries who latterly joined the New Art Movement, failed. The following year, having grasped what was required to make the grade, he was accepted for the oil painting department of Zhejiang Academy in Hangzhou, but the fallacy of such tests left a lingering impression.

Away from home for the first time in his life, Geng Jianyi muddled through the overwhelming barrage of new experiences and awakenings at a measured pace: one might say that if Wang Guangyi was the hare, Geng Jianyi had more in common with the tortoise. He kept to himself, not exactly reserved but quietly absorbing ideas, applying them and learning from the experiments and the mistakes they engendered. Unlike Wang Guangyi, whose focus was fixed on the end result, Geng Jianyi was fascinated by process, because it was in the process of producing art that he saw the secret of how to employ art to "enlighten the lives of the people" resided. The classes followed the statutory curricula of drawing from plaster casts, sketching from life, and eventually learning how to mix and apply oil pigments to achieve the required sense of realism. Zhejiang Academy, however, had already evidenced a progressive strain in the aspirations and approaches of students in the year above Geng Jianyi, which included Wang Guangyi and Zhang Peili. Geng Jianyi shared a studio with them in his second and third years—their final two—where he witnessed at first hand their struggle to reconcile their dynamic new impulses to the immovable principles of Socialist Realist painting upheld by the academy: it was a battle they lost.

Intake more than doubled in 1981 and Geng Jianyi's class of ten-or-so students comprised a number of strong personalities: Liu Dahong from Shanghai, Wei Guangqing from Hubei, and Qiu Ping from Wuhan—one of the few women artists to have a hand in the New Art Movement before moving to Germany in 1988. Firmly believing in their potential, these students quietly initiated a rebellious departure from academic principles, each unobtrusively egging the next one on with innovative approaches that vied to out do the rest. In late 1984, it came time to begin preparing graduation work. Consolidating all the knowledge, influences, experience and practise that he had garnered at the academy, Geng Jianyi sketched out an innocuous series of paintings, one that, unbeknown to him at the time, would be instrumental in shaping avant-garde visions and the direction of oil painting through the 1990s.

2. Titled"wen hua ke", this name of this examination translates as cultural studies, but in fact its content was based on Maoist thought and ideology. All students were required to be well versed in this nationally important topic.

In the studio at Zhejiang Academy, 1988

photograph Luo Yongjing

The oil painting department's class of '85 would have made less of the impact it did were it not for the support and mediation of Zheng Shengtian, head of the department and the person directly responsible for the work the students could produce for their graduation project. He was also their staunchest supporter, occupying a novel position of having one foot in each of the two camps—conservative officialdom and avant-garde student body. Zheng Shengtian had reason to be excited by what he saw in the students' endeavours to achieve a personal style. He had lived abroad, had travelled, and had a unique perspective on European and American art, classical and contemporary. He had previously taught at the academy from 1959 to 1981, the year in which he was invited to take up a fellowship at the art department of the University of Minnesota. Before returning to Hangzhou in October 1983, he travelled North America, Europe and Russia, visiting museums and galleries, and drinking a large draught of modern culture.

Back at Zhejiang Academy, his open-mindedness proved invaluable in opening the students' eyes to the broader domain of art that existed beyond the dictates of Revolutionary Realism. He had little interest in seeing these young students produce superficial reproductions of proscribed imagery or formulaic illustrations of set topics. As he explains: "Prior to the class of 1985, all graduation projects were asked to conform to the principles of Soviet Socialist Realism. Every student in Geng Jianyi's class wanted to show their individual approach to content and form, which I encouraged."

Students dutifully—gleefully—reciprocated his encouragement with a dynamic range of proposals, all of which Zheng Shengtian approved. Thrilled at the prospect of contributing to what they sensed would be a groundbreaking graduation show, each student set to work. However, when the exhibition went up and academy officials made their tour of inspection, the obvious departure from the tenets of Socialist Realism, which was howlingly visible in the work, proved as untenable as ever. Reviled by the academy's directors, the paintings were deemed alarming enough to merit an intense discussion at an emergency meeting of the entire teaching staff. For three days the directors reiterated the principles to which all students were expected to adhere and strongly advised the more lax elements within the teaching staff to reflect upon their position, and the responsibility they had as teachers at the academy, to the students and the nation's cultural development.

One of Geng Jianyi's compositions depicted a young man and a woman sitting side by side at a table under a naked light bulb, facing towards the viewer yet neither looking at them nor any other clearly discernible point of focus. It was, as Zheng Shengtian recalls, "criticised as being meaningless. I thought it was a fresh painting because the emotion was very real. There was no drama but something that touched our daily life, in a style of painting exactly appropriate to the theme."

Conservative critics condemned it as departing from the classics and rebelling against the orthodoxy. Zheng Shengtian was summoned before the Academic Committee to explain the bad tendency he had allowed to arise: "I made my stand but I was in a minority."

Bravely, he put his views in writing in a tenacious essay that was published in the academy's journal, arguing against accusations of "too much emphasis on individualism" and "truth is not the ultimate goal of artistic creation" (popular critical—ideologically correct—sayings of the era). In time, as China advanced, his views would be vindicated

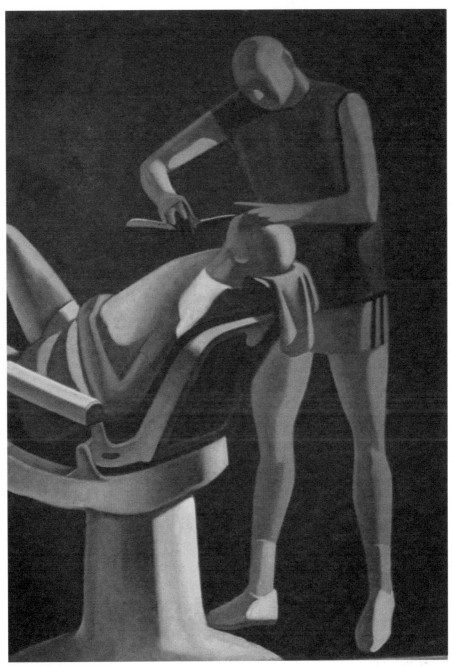

△ '85 Another Shaved Head of Summer, 1986
private collection, Beijing

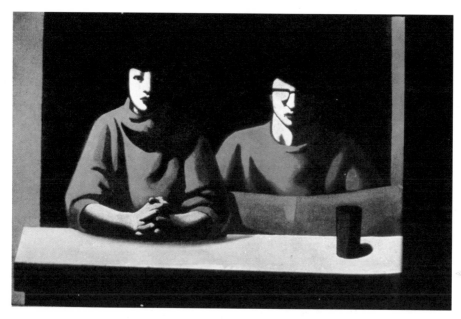

but Zheng Shengtian would then no longer be at the academy: he left in 1986. In 1985, his essay fell short of placating academy leaders but it did succeed in gaining wider attention for the exhibition, the artists and their works within the art community across Mainland China. In the summer of 1985, *Fine Arts Magazine* (*Meishu*) sent reporters to Hangzhou to investigate the case. Subsequently, the magazine published a feature in which favourable comment was passed on the students' work, and a large number of the paintings were reproduced as illustrations. The summer of 1985 was a moment of frenzied activity all over China, mostly executed by art students who had already graduated, less by actual students. Following on the heels of the unctuous 1984 Anti-Spiritual Pollution Campaign, and together with the publication of these works in a State-owned magazine, here was concrete evidence that change was possible. It further added fuel to the belief held by artists like Wang Guangyi that "through art we could change the people's lives". Thus, what made the case of the oil painting department's graduating students resolution pivotal was the precedent it set for students to challenge the system—the monopoly of the State's unalterable vision of art—and win.

There were several elements in Geng Jianyi's compositions that signified a radical development of oil painting within the Chinese context. Of major impact was the smooth, textureless surface of the paint as he applied to the canvas—this would be characteristic of all the paintings he produced between 1985 and 1989, after which he did a hundred-and-eighty-degree flip into consistency and grain. The early planar flatness was not dissimilar to that of his partner-in-kind Zhang Peili, or that which Wang Guangyi brought to his *Frozen Northern Wasteland* paintings. Each appeared to aim to invoke a totally unemotive image of quotidian life, and this was particularly true of Geng Jianyi's approach in which it was a challenge to find anything interesting—that is exciting, moving or seductive—beyond a cool, designer-like chic. It was surely a challenge, too, for the artist to identify the

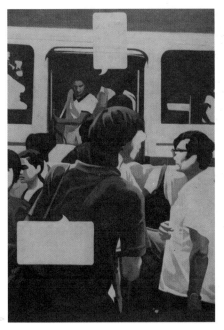

most mundane of subjects to portray. In the graduation works to which Zheng Shengtian particularly referred, Geng Jianyi's image of a couple caught in the overhead glare of an uncovered white light invoked the private life of two people devoid of any commonality. It was as if they existed in an emotional void; two entities resigned to the numbness of a life together without any shared passion.

In 1986, Geng Jianyi followed this with compositions of men and women at the hairdressers—the most well-known one being '85 Another Shaved Head of Summer—of crowds waiting motionless at a bus stop, and several other paintings now lost. Each one of them appeared to experiment with an idea, an act of intellectual curiosity that would become of crucial importance to the themes Geng Jianyi would later explore. One of the few artists of this generation to embrace a pluralist approach to materials and media, Geng Jianyi never moved far from the core concerns evidenced in these early paintings. By 1987, he had refined his concept of applying paint to canvas and the goals he wished it to achieve. All this culminated in The Second State, those disembodied visages, their features creased by soundless laughter.

In the mid-1980s, as Geng Jianyi evolved his style, all around him, throughout China, paintings were being produced in myriad forms from photo-realism to Country Life Realism,[3] to expressive extrapolations of academic techniques. The majority were clearly textured in a more painterly fashion than anything Geng Jianyi painted. Yet, as early as 1985, he had ceased to view painting as painting, instead he saw the process as conceptual; a means of engaging the audience and possibly changing lives. He needed to reach out to them, to be society's mirror, even if society did not wish to confront the limitations or mediocrity of its existence. The driving motivation to reduce the timbre of a finished composition to the leanest possible reduction of emotion arose as an analytical response to the lives being lived around him, and in which he himself was immersed. Yet here, Geng Jianyi was not falling foul of the "zealous humanism" that Wang Guangyi so disdained. As mentioned earlier, Geng Jianyi consciously strove to maintain a distance between himself and the world—all the better to view it clearly. The point of view reflected in his paintings was a perspective accorded by his one-step-removed stance. This disengagement leads him at times to mock society, in the vein of The Second State and, at times, beyond, though by means more subtle. He sets tests and traps, which is easier from a distance, with the clarity born of detachment. Accordingly, Geng Jianyi has consistently held himself back from infusing his works with any personal emotion. Yet

3. In the period following the Cultural Revolution, the first strain of new art to be significantly classified was *xiangtu xianshi zhuyi*. The closest translation is Country Life Realism, rooted in Mao's proscription for learning from the peasants and a back-to-basics way of life.

in the post-Mao era of getting rich quick, Geng Jianyi's approach was clearly more than a tongue-in-cheek parody of selflessness in art. In terms of official aesthetic guidelines, the problem with Geng Jianyi's art lay primarily in the "anti-style" he appeared to adopt. More damningly, the deliberate lack of passion and any distinct mood beyond an emphatic impassiveness towards life's humdrum of activities was tantamount to a negation of everything Mao's doctrine on creative expression represented. In this sense, Geng Jianyi's works are more political than those of many of his contemporaries. In the manner of a literary "fool", he speaks truths and points to folly that can only be voiced as a humorous jest. In Geng Jianyi's philosophy, painting was clearly not about actual reality, contravening the way propaganda painters presented the squeaky clean ideals of Socialism as real situations.

For Geng Jianyi, the use of certain symbols—mundane actions—is a way of challenging or testing the viewer's awareness. He clearly enjoys making people feel awkward about themselves. This was the point of the spiked laughter in *The Second State*. It was also rooted in fact. One experience that is often bewildering for non-natives is that the overwhelming reaction of Chinese people to emotions of aggression, pain, tragedy, or even awareness of their own folly or mistake, is to laugh. Giggles and titters continue to be far more commonplace than uninhibited western articulations of discomfort. The people—the masses—laugh because there is little else they can do, for anger would only serve them rudely, under a feudal lord as a commune leader. Equally, against the Confucian legacy that gave precedence to relationships of kinship over individual emotion, individuals were not expected to put their feelings first. Such emotional restraint is a total contrast to the unharried one-child youth that emerged in the 1990s, unburdened by experience of the Cultural Revolution or the conventions of traditional social mores. Contemporary youth smooches in broad daylight and openly speaks its mind: Geng Jianyi's generation balked

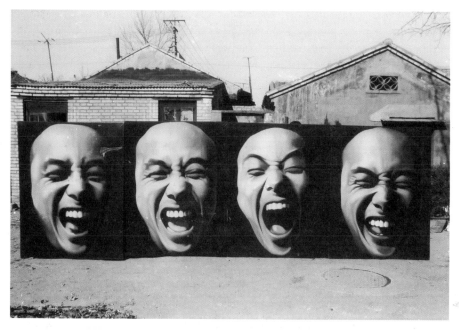

The Second State, 1987
photographed in Beijing

at holding hands—unless with intimate acquaintances of the same sex.

Laugh and the world laughs with you, it is said. In *The Second State* this is not the case. Follow the passage of the laugh across the four faces as it moves towards hysteria in the distorted features of the final visage. You sense that this is not a joke you want to share, even if you could. The line between hollow and hearty laughter is fine. The more you look at these faces, the harder it becomes to decide: true or false happiness, real or fake emotion? There is a sense of coldly calculated aggression. Change the environment and the interpretation alters, which was what happened when the works travelled with the exhibition "Inside Out, New Art from China".[4] From New York to Hong Kong the sensation was startlingly different. In New York, the faces looked out at an earnest audience belonging to a democratic superpower. In Hong Kong, they seemed to sneer at a nervously indignant local audience all too aware of the shadow of a less than democratic superpower creeping smugly over them from across the Territory's northern border.

For Geng Jianyi the goal of *The Second State* was to shock, by forcing the viewer to believe that the looming expressions were inescapable, in short, to concentrate all the faculties of the audience on the impact of the subject alone. It was an idea concerning the indomitable barrier between audience and art that had been incubating in Geng Jianyi's paintings since 1985. Could it be removed and how? Certainly the removal of an invented pictorial space as in *The Second State* and *'85 Another Shaved Head of Summer* was one approach. Without this illusory framework surely it would be possible to generate the impression that the subject of the painting occupied the same space as the viewer? Geng Jianyi intended viewers to experience the painted action directly, for them to be absorbed into the drama, as if enticed onto a stage in the middle of a play. The paintings worked, brilliantly so on some levels, but the concept was ultimately flawed. The majority of viewers had been conditioned to read a painted image as an invented reality, a man-made construct defined by the four sides of the picture plane—even Chinese viewers who were used to gazing at idealised Utopian vistas. That cultural conditioning proved itself to be more resilient than Geng Jianyi had imagined. Frustrated, he decided to put painting aside.

"The story goes that a grandfather had a handsome long beard. One day, his grandson asked him: "Grandpa, when you sleep, where do you put your beard? Outside or inside the quilt?" That night Grandpa did not sleep as he tried unsuccessfully to find the answer to the question. The next day, unable to bear the burden of his failure, he cut off his heavy beard. [The question of] how he had previously slept so tranquilly with his beard perplexed the old man to the end of his days. Yet, if the old man had replied "It is where it should be", the beard would have remained and grown to even finer proportions."[5]

The title of this chapter, *Trust Only He Who Doubts*, is a quote from China's great humanist writer-novelist Lu Xun (1881–1936), whose influence and popularity in Chinese literature is what Charles Dickens is to its English cousin. In respect of Geng Jianyi, the phrase "Trust only he who doubts"[6] encapsulates the idiosyncrasy underlying his art

4. "Inside Out, New Art from China", curated by Gao Minglu, commissioned by the Asia Society and the San Francisco Museum of Modern Art, USA, in 1998.
5. Geng Jianyi, "Healthy Attitude", from his speech for "Garage Exhibition", Shanghai, 1991.
6. Simon Leys, "Some Sayings of Lu Xun", *The Burning Forest*, published by Paladin/Grafton Books, 1988, p. 204.

as much as his personality. To doubt is a crucial aspect of creativity. It is only through doubt that we experience certainty and can advance. Without doubt, scientists would not rerun experiments to reconfirm their findings and to pinpoint erroneous variations. Journalists would take people at their word and not seek the other side of a story. Within western cultural frameworks this is as basic as it is simple, yet in 1986 when Geng Jianyi conceived *The Second State*, the doubt that propelled his impulse was radical because Chinese people were not supposed to doubt anything, even the evidence before their eyes. The masses submitted their perception of their environment to the reality depicted in Party propaganda. The problem lay with the power of power. If Mao said black was white, then it was, and if tomorrow it was black again, it was not for the people to argue. However, 1980s China was not China under Mao but that ruled by Deng Xiaoping who was implementing new policies of openness and reform. New-found wealth, opportunities and the promise of what had previously seemed an intangible glorious future plugged the blanks in the general inner confusion being experienced by the masses. In spite of the campaigns that rolled around at regular intervals, Deng Xiaoping stood by his slogan "to get rich is good", and certainly, no one wanted to doubt that. It was true, too, that people had become adept at avoiding distasteful or perplexing questions. It was not that the situation was not transparently clear, the people were not blind. But the people, and the State, had long ago concluded that life was less taxing addressed in a circumlocutory language that evaded issues rather than defined them. Why spell out the inexorably limited horizon ahead of the population?

Through the 1980s, within the art community, there was not the slightest doubt as to the correctness of the direction or form that art was taking: at least not prior to the "China/Avant Garde" exhibition in 1989. The people were slowly recovering a little faith in the constancy of policy found under Deng, but were still not up to doubting; not openly. Meanwhile, against all this, Geng Jianyi found himself plagued by doubt and, through a succession of documentary-style artworks, unconsciously made this highly subversive activity the crux of his approach. From the late 1980s, his works were frequently formulated to test the audience and to challenge accepted truths, both the visual evidence before people's eyes and that which they are fed via various conduits, primarily the media. The subtext was the efficacy of the propaganda machine that had been indoctrinating Chinese minds through recent decades. Did anyone still have full command of their senses and faculties? In his own quiet way, this was the question that Geng Jianyi set out to answer.

Initially, like the majority of his generation who put themselves through art school, Geng Jianyi was also fired by the notion of being an "artist", as opposed to all those artisans in the pay of the Propaganda Bureau. His graduating class won wide praise for setting a new benchmark for being a pure artist because they broke rules and expressed themselves independently, flying in the face of official condemnation. In the 1980s, there was no onus upon the would-be painter/sculptor/print-maker to earn a living from their craft, because there was no domestic or international market for their art. Thus, an idealised purism lingered in the genetic make-up of the new artists, even as the market, which emerged in the mid-1990s, was swift in revealing how easily "pure" credo were compromised by monetary rewards. In painting, the approach Geng Jianyi established would be picked up

Tap Water Factory. 1987 >>

and extended in various ways by younger artists like Song Yonghong and Wang Jinsong, who studied at Zhejiang Academy under the influence of the class of '85 in their first year, and Fang Lijun in Beijing, whose late 1980s drawings echoed an intense aura of isolation and ill ease. In the early 1990s, these artists tentatively depicted their doubts in the form of mocking parodies of a multitude of familiar scenes in the early 1990s. It took a few more years before the general population was impelled by its own doubts to air them in public. In the late 1980s, to doubt or question the socio-political situation was an isolating position because it meant standing outside the general melée, of being out of step with the masses. Yet, although this stance said everything about the atmosphere in which these children of Mao found themselves as adults under Deng's reform, it was one particularly suited to Geng Jianyi's nature. Yes, life was changing but not as fast as the artists were accruing knowledge. Outlets for creative energies were few, so what purpose did so much new philosophy serve if its exponents were up against a system that refuted these polluting western ideas? It was not a question anyone wished to dwell upon—at least, not until the number of outlets improved towards the late 1990s.

History affirms Geng Jianyi as the originator of the malaise and cynicism that in China's new art became termed Cynical Realism. Significantly, his comment on human nature opened a debate on doubting what one saw and was told, validating it as a worthy activity. In spite of the acclaim *The Second State* won, Geng Jianyi gave no thought to capitalising on the critical success it garnered. He was already in the thrall of other material approaches, fixated upon resolving the viewer-artwork puzzle. Was it possible to remove or divorce an entity or motif from the natural elements that clung to it like ivy

to a wall? His experiments on canvas through the late 1980s had ultimately negated the test. Neither an object nor a subject could be cleanly detached from a physical location or context in a convincing manner. Frustration at this realisation forced a decision; if he could not take his subject/object to the viewers, then he would drag the audience in, physically, if that was what was required. To use three dimensions was a start, for by creating a physical space the viewer was able to enter the work bodily. Geng Jianyi's earliest piece to attempt to create an all-embracing environment was the installation *Tap Water Factory*, created in 1987, immediately after *The Second State*. In form it exploited the viewer as unwitting voyeur, as manipulated pawn, sucked into a maze-like structure where, at deliberate intervals, their control over their curiosity was challenged. *Tap Water Factory* comprised a symmetrical arrangement of passageways leading to a central space that contained seats upon which the audience could rest. The challenge arose from the unconventional peepholes that punctured the walls of the structure: openings that allowed those on their way in to view those already within. Equally, it afforded those within a view of the people entering the work or those departing: "In [Chinese] art today, one point is still neglected," Geng Jianyi wrote in 1988, "namely the relation between audience and work, viewing and being viewed. This is not simply about the meaning of a work or the audience's response to it but the relationship between the two, like that between a magnet and iron"[7]. *Tap Water Factory* was intended to emphasise this, creating a relationship and then confusing it. Where the audience should be viewers, suddenly they are made part of the work. Neither the work nor the audience is permitted to retain their original role, each only functioning by illustrating the standard relation between the two.

Between the Victorian peep show and contemporary reality television lay a Chinese environment tyrannised by street committee watchdogs and personal dossiers that laid the facts of each life bare. In *Tap Water Factory*, Geng Jianyi demonstrated that as curiosity pushed all eyes towards the windows to spy upon others, everyone within the space was implicated. The allusion to the transparency of Chinese society, specifically of the era in which Geng Jianyi was born and raised, was inherent. To test his audience's level of perception concerning truth and doubt, he then turned his focus to the art community with a piece he titled *Forms and Certificates*, a humorous interactive project aimed to unveil one of those "funny things that happens in the art world". In 1988, artists and critics of the New Art Movement prepared to gather in Huangshan for the most ambitious conference on contemporary art to be held in China. Geng Jianyi decided this was an opportunity to test the avant-garde, and to see how aware the new artists really were. He did it via the nationwide mailing of official invitations that were sent out in the name of the organising committee. Attached to the invitation was an additional form of his own invention. Upon receipt of the conference pack, the majority of invitees duly did as they were bid—as they had been schooled to respond to the stifling bureaucracy that was the Chinese system—earnestly filling in the enclosed forms and returning them as requested, little suspecting that the completed documents would be displayed at the conference for all to see. There was little reason to believe that the form was anything other than regulation for it was the model of authenticity. Not a few of the attendees felt foolish when confronted by the answers they had given to random questions like "What is your favourite animal/food/music?" were revealed to their peers—although many would

7. Geng Jianyi, "Art and Audience", published in *Zhongguo Meishu Bao*, Issue 22, 1988.

subsequently claim to have seen through the ruse. Beijing artist Wang Luyan claims that it was the question "Do you like women?" that gave the game away, but most of the artists dutifully expressed their preference. Even if they found such questions odd, it did not prevent a large number of them from complying. *Forms and Certificates* highlighted the conformist impulses and level of indoctrination that hampered even the avant-garde.

When all the participants were assembled for the opening of the conference, Geng Jianyi initiated the second part of the work, handing out standard certificates of merit to those who had submitted correctly completed forms. The certificates were suitably and irreverently titled *Vegetables Are Not As Tasty As Meat*. The prophetic non-sense of the title undisguisedly pointed to the nature of the discussion that was poised to take place: that issues unrelated to each other, which were irrelevant and unproductive were already drawing the attention of artists away from the business of producing art. Innovation was being lost in the process of embracing so much new philosophy. Artists needed to hold an independent point of view. What concerned Geng Jianyi was that even these highly educated and relatively on-the-ball avant-garde artists remained in the thrall of the omni-potent bureaucracy, hemmed in by forms and regulations, which they solicitously took at face value. One could hardly blame them; they had experienced a social conditioning of Pavlovian proportions. Only if the trigger for such impulses was removed could people be free of it. This was later illustrated in the changed outlooks of those artists who spent significant periods of time abroad from the mid-1980s. But as long as the trigger remained within sensory range, the social pressure to conform was overwhelming.

The forced closure of the "China/Avant Garde" exhibition hit Geng Jianyi hard. Not so much because of political views he held, but for the general malaise it threw over the prospects for the future of art in China. He returned to Hangzhou comforted by a sum of money in his pocket from the sale of *The Second State*, but caught up in the mood of the moment in Beijing as student discussions resounded through the public arena, and followed the excitement as it spread to other cities, other campuses. All came to an abrupt halt with the June 4 eruption in Tiananmen Square. On June 5, Geng Jianyi and a friend vented their spleen. On a canvas of enormous proportions, they scaled up a scene of the square taken from a photograph published in a foreign newspaper, and executed it in various shades of red. In a fly-by-night excursion, the collaborators hung the work from a footbridge over Hangzhou's busiest street where it startled the early risers passing by. Its swift removal was followed by an inevitable investigation. Geng Jianyi was implicated—"the eyes of the Chinese police are as sharp as diamonds," he later mused—yet directors of the technical institute, where he had taught since graduating from the academy, determined to protect him. His act was recognised for what it was; an out-pouring of invective energy rather than a considered attack on the political regime. Geng Jianyi was quietly instructed to maintain a low profile. True to his nature, he was not idle. Nor was he distressed by having to keep himself to himself. It was a fine opportunity to concentrate on producing some new work without the usual distractions.

The 1990 work entitled *Building No. 5* hinted at the on-going mood of the times, specifically Geng Jianyi's having to remain out of sight; invisible. *Building No. 5* was a site-specific piece that comprised a trail of discarded shoes spaced a pace apart

throughout a small administration building in the institute that had been earmarked for demolition and vacated for the purpose. The shoes were intended to reconfigure the footfalls of the building's former inhabitants through the imagined course of their day. This it achieved, poignantly emphasising the melancholy of emptiness and imminent loss against the imagined bustle of its former functional life. But the empty shoes also conjured a physical trace of people who were no longer there. "There" was left hanging metaphorically for the audience to conjecture.

It was not until 1991 that life in China—in Beijing primarily, or amongst educated urban elites—regained something of its pre-1989 vigour. For artists, this naturally meant an event that gave the making of art a purpose. This much-needed distraction was provided by Zhang Peili in the form of an exhibition in Shanghai for the benefit of visiting Japanese curator Toshio Shimizu. The impulse was important—and positive—as a catalyst for creativity at a time when many artists were ready to throw in the towel.

Whilst participating in the "Garage Exhibition" as it was subsequently titled, the artists were introduced to Italian art historian Francesca dal Lago by Beijing-based critic Li Xianting. Dal Lago was organising a two-man exhibition in the capital for Fang Lijun and Liu Wei and invited Geng Jianyi and Zhang Peili to produce a second in May 1992. During her trip, like two innocent naifs, Geng Jianyi and Zhang Peili naturally asked this Italian native about the Venice Biennale: "At the time, the Biennale was a dream. We had no comprehension of what it might look like, the kind of works it might contain, but it had a mythical significance that told us this was the apex of artistic success." Dal Lago was about to make a trip to Italy and promised to bring back information.

No one anticipated that she would return with Biennale director Benito Oliva in person. Within a short space of time Li Xianting had been appointed curator of a special Biennale exhibition "The Eastern Road", with critic Kong Chang'an—who had emigrated to Italy following the "China/Avant Garde" debacle in 1989—invited to select Chinese works for the "Aperto" show. The curators selected works by ten artists: Wang Guangyi, Geng Jianyi, Fang Lijun, Liu Wei, Li Shan, Zhang Peili, Xu Bing, Wang Youshen, Yu Youhan and Feng Mengbo. The 45th Venice Biennale would be a milestone in the story of Chinese contemporary art: "It happened so fast, from being an ideal to an event in which we were going to participate. It seemed so easy, too easy."[8]

8. China had previously participated in 1980 and 1982. Unpublished paper, "From Crafts to Art: Chinese Artists at the Venice Biennale, 1980–2001", Francesca dal Lago.

Geng Jianyi and Zhang Peili first travelled to Beijing for their two-man exhibition. This was held in the basement of the Diplomatic Restaurant next to Qi Jia Yuan Diplomatic Compound, which also accommodated a bar where China's rock star equivalent of Mick Jagger-meets-Bob Dylan-meets-Bruce Springsteen, Cui Jian, performed. The show was modest in scale but attracted a huge audience. Geng Jianyi showed a group of paintings entitled *Decorative Edge*, the composition of which appeared similar to that of a commemorative stamp. The portraits depicted within the deckled edge were of indeterminate but, one assumed, important national figures. The features were glossed over by his analytically simplified style. He further included examples from the *How to ... * series—step-by-step diagnostics of how to walk, how to laugh, or how to cry. These comprised blown up photocopies of black and white photographs that Geng Jianyi had taken of a model demonstrating the correct way to proceed through the specified action. These were pasted onto untreated plywood boards, which mimicked the childlike instructions that were regularly pasted onto community notice boards for the "children" of Mao and Socialism to learn and follow. It was a level of condescension that the people were in no position to challenge.

Amongst the crowd at the opening was another foreign art historian, the late Hans van Dijk. As dal Lago helped Oliva make his choice for the Biennale, Hans van Dijk was also assisting with the curation of an exhibition to be shown at the Haus der Kulturen der Welt in Berlin. There had not been such a notable year for new art in China since 1985: "There was no sense of suddenness about all the events in 1992. But then I wasn't really paying attention to these kinds of aspirations. If I was selected to participate that was fine, if not that was also fine. At the time, no one grasped the potential significance of these shows."

Between these two exhibitions and "China's New Art, Post 89", which also took place in 1993, audiences were able to see a wide range of Geng Jianyi's works. In the lull following 1989, he had picked up his paintbrushes again and produced several compositions under the group title *Forever Effulgent*. Against the red rays of the inextinguishable sun that had become the symbol of Red China, he substituted the radiant features of Mao with

How to . . . Put on Jacket, 1992 ≫

those of a smiley panda and other cultural iconography. Testing audience recognition of another Chinese emblem, *Work of Art No. 3* comprised bamboo baskets used to steam dumplings, here filled with imitation dumplings made from folded pockets of red plastic. The instructive panel about *How to Put On/Take Off a Woollen Pullover* served to reinforce the cynicism in case anyone was in doubt as to his message.

Significantly, Hans van Dijk was keen to show the 1990 installation work *Building No. 5*. The only means of exhibiting it was to enlarge photographs that Geng Jianyi had originally taken as a record of the work. Captured using a domestic brand of black and white film the images were grainy and thin on textural depth, yet as a photowork, *Building No. 5* was a successful, powerful piece. The monochrome black and white induced a haunting, dramatic aura that convincingly conveyed the sense of the building's subjugation to socialist simplicity and function, the subsequent dereliction and the shadowy absence/presence of ghosts. The process of producing the photographic representation of the work kindled Geng Jianyi's interest in the role photography could play in conceptual art. He was swift in putting this to the test. The initial result was the conceptual works *Who Is He?, Proof of Existence* and *A Reasonable Relationship*. Through these, Geng Jianyi established a method of juxtaposing photograph with text that was deliberately manipulated to test audience perceptions of photographs as incontrovertible truth. This inspired an ongoing fascination with the medium.

In tandem with his trip to Venice for the Biennale in 1993, Geng Jianyi had also been invited to spend ten days in Spoleto, where he would prepare an in situ work for the exhibition "Artistic Meeting". Gu Dexin and Zhang Peili were also participating. For Geng Jianyi it was a first trip abroad. His most enduring impression would be the length of the flight and the obstacles of delays and missed connections that most frequent fliers are forced to take in their stride. Spoleto proved a beautiful place. The exhibition site, a three-hundred-year old stone palazzo, which had been church, library and most recently a hospital, was equally pleasing. For his project, Geng Jianyi had chosen to use the building's magnificent stone stairway. It was to be draped, from the ground floor up to the roof, with an unbroken flow of white silk, forty metres in length. The effect was

Decorative Edge, 1992
private collection, Beijing

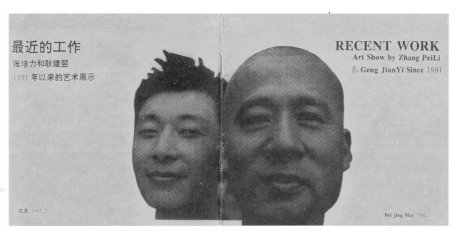

stunning. The contrast between the hardness of the stone and the delicate naturalness of the silk inspired a degree of awe in the audience. So much so that the visitor's first reaction was to back up in surprise as they approached the stairs, and next, fearful of having tainted the purity of the white shroud with their unclean soles, cast a nervous glance to the floor. The work was a perfect meeting of yin and yang, the feminine beauty of the silk complementing the masculine strength of the stone. It also offered a perfect counterpoise of East-West: silk, an intricate part of the myth of China's socio-cultural history, played against the architectural munificence of the building that fulfilled all notions of romantic, artistic, chivalrous, sword-brandishing Italy from the Sforzas to Machiavelli. The silk imbued the stairway with a mystical, magical quality, especially when ascending for the staircase emerged on the roof with the enigmatic symbolism of a Leonardo drawing. This simple work could be read on many levels. Silk certainly represented the productive and aesthetic heights of Chinese culture that, like the palazzo, had endured through centuries. But could it—pure, delicate, of supple strength as a metaphor for culture—survive in a modern, changing society? The installation was meant to be functional, people were supposed to walk on it. The test was who would knowingly, willingly defile the whiteness of the stairs' new carpeting and leave their imprint upon the treads? Geng Jianyi surmised that for westerners this would be deemed a destructive mark on an expensive, highly prized commodity that of all people the Italians would appreciate. The contrary answer to this test was that many—altogether too familiar with red carpets perhaps—proved him wrong.

From Spoleto, Geng Jianyi travelled to Venice with Zhang Peili. Fierce in-fighting between the Chinese artists, largely caused by nervous tension ruffling their fragile egos, caused lasting rifts in previously unassailable friendships. The dream had become a reality, but the reality had been tarnished. Geng Jianyi was relieved to return home.

Geng Jianyi's next work was a curious one. It was another test, perhaps carrying the momentum gathered in Spoleto, yet unrelated to the specifics of either this experience or that of the Chinese interaction in Venice—beyond ridiculing human faith in the enduring bond of emotion that joins two people together. His subject was the Chinese

marriage law, and the work took the form of an interactive project that placed thirty people in a classroom to test their knowledge of the official matrimonial regulations as set down in the Chinese constitution. It was a searing mockery of official stipulations imposed upon the invisible boundaries delineating personal replationships—as rules for conducting proper relationships, the clauses of the Chinese marriage law read as little more than an extension of Party policy. First written in 1952, it clearly reflected the political concerns of the time, above and beyond those exclusively related to marriage. Evidence of socio-political change is found in the codicils added from 1953 to 1989. Now, each participant was required to fill in the blank spaces Geng Jianyi had created by removing significant phrases from the letter of the law. The young people participating in the event were more than a little bemused by the language and largely at a loss as to how to fill in the blanks.

That he should choose to appropriate the marriage law as a topic for art was perhaps not so unusual in itself. It was the one law of which most Chinese people over twenty-six, and certainly all those that were married, should have been aware. But once again, just as with questions soon to be mooted in *Who Is He?*, *Proof of Existence*, and later, *This Person*, there was an underlying sense that Geng Jianyi

Marriage Law, 1993

was seeking fundamental answers to his own life. He had been married since 1986, and to the outside world he was a dutiful husband. Yet he chose to live alone, almost like a monk in retreat. Marriage was one convention to which he succumbed before the doubt set in. By which time it was too late and loyalty and an inherent conservatism had him duty-bound.

A typical Saturday afternoon in Hangzhou, in that restless hour where the afternoon has not yet ended and the evening not yet begun. No one really knows the hour, even those who set so much store by the accessories they strap to their wrist. The light gives

little hint, save after noon. It is in this vapid hour of the day that a man enters one of a successive line of uniformly drab apartment tenements. Tenements that were built to house the employees of State-run work units nationwide at the height of China's socialist prowess; built, here in Hangzhou, in the 1960s, yet appearing a century older. This aspect of serving the people proved that what is implemented in frenetic—even if enthusiastic—haste will never be heir to longevity.

Inside the main double-swing doors that flap at the entrance to the building, a corridor stretches into dimness. The contrast between the interior and the bright light outside on this clear mid-October afternoon clouds the visitor's vision. But even when his eyes adjust, the clouding lingers with the shadows of the lightless space. In the greyness of the perennial dusk, it is impossible to make out the features of those who pass through on their way in, out, up, down the dust-carpeted stairs: anonymity assured. The man makes his way up the stairs, heading for apartment 602. Unaware that the occupants are out, he climbs the stairs, blending into the anonymous air and yet ... he is spotted. His height and broad shoulders make him hard to miss on the narrow flights of stairs or in the illuminating shafts of window light as he pauses to allow another body to pass. He is first shadow, then silhouette, yet, his features are apparently impressed upon the mole-sighted residents who, by habit of circumstance, are used to the half light and, ever vigilant of their warren, well used to scrutinising strangers in their midst. Committing all to memory, they move on, veiling their natural curiosity. But, the neighbourhood watches, Argus-eyed beyond any need to know. At the end of a long corridor on the sixth and highest floor, the visitor arrives at apartment 602, and knocks, in vain. When no response is forthcoming, he turns, retraces his steps, back, down, finally attaining the light and evaporating into the dense city whence he came.

Who is he? This was naturally the first question that Geng Jianyi posed when he returned home to be told by his neighbours that someone had come calling. From their descriptions, Geng Jianyi knew immediately who it was but the variant details of the person in question offered by these eyewitnesses, sparked the idea for an artwork about uncovering which individual traits signify identity, and to test the levels of awareness possessed by individual beings within the heaving mass of society. Eleven people had seen the same person, and although their descriptions matched in parts, they differed in others, the details as contradictory as they were similar. *Who is He?* was a concept made into art by a simple piece of information gathering, proceeding from the subtle urge to question the reasons for incongruous interpretations of the same facts that, given in good faith, can, and do, occur.

Soft Stairway, 1993 >>

Discrepancies between what we see and what we believe we see reveal the fallibility of perfect vision. By virtue of their profession, police everywhere encounter the inconsistent reports of eyewitnesses to the same event on a daily basis. Why? Perhaps because the factual nature of what the human mind perceives is eternally subject to interference from our individual routines, distorted by the varying emotional states we experience in the passage of a day and the numbness that results from over-familiarity with a particular environment.

"I am interested in our awareness of what happens," Geng Jianyi said at the time, "what is taking place, and what will unfold, and our part in the process." Geng Jianyi's preference is always for the mundane and he has a knack of redefining it, but never in a way that is silly or too-clever-for-its-own-good, or that doesn't show a great deal of thought and prior consideration. Neither does he overburden his works with moral fables or complex analogous theory; they are undeniably there, but not thrust in your face. Geng Jianyi never mocks in a mean way, and never holds his audience in contempt. He holds fast to the middle ground,[9] all just so in the centre between two extremes. From this unthreatening point of equilibrium, he gently hints at human follies, as a master instructing a pupil.

Who is He? was a set up, arranged by Geng Jianyi to illustrate his neighbours' half-awareness of a simple event that was taking place around them, and their own part in the process. Living in close proximity to these ordinary people—mostly staff members of the same school faculty where he himself taught—Geng Jianyi was in a position to observe the effect of daily life upon their senses. Many were creative in their own right, having studied some aspect of fashion or textile design, art or craft to gain employment at the Institute. Clearly, they had allowed their sensibilities to dull, and seemed comfortable that way. Geng Jianyi did not have an answer to the problem but he had a way to highlight it. After the incident, he asked each of the neighbour-witnesses to write down where and when their encounter with the visitor had taken place, and to describe him as best they could. He then returned to the empty spaces indicated in their statements to photograph the spot, placing the prints together with the texts. This completed the artwork.

At the end of their written descriptions, the witnesses were encouraged to provide small sketches of the person they believed they had seen. Although the glasses and cropped hair match overall, these are no photo-fit positives. Childlike in essence, the drawings give no hint of national character, certainly little hint of the western preconception of slant-eyed Asians. For the most part the eyes are round and carefully lashed, the head described by a single oval, with a hooked line that defines the nose. Zigzag spikes represent the hair, and two circles link to betoken the eyeglasses with their wire stems wrapping back over variously shaped and at times invisible ears. The drawings are remarkably good. They demonstrate a uniform constancy in the degree of confidence in drawing human features. If nothing else the careful practise of repeating individual strokes when learning to write Chinese characters in a calligraphic flourish results in a co-ordination between hand and eye: a fine control of the writing implement and a precision with line. Here again Geng Jianyi employs photography for its particular qualities and associations. These black and white frames of empty architectural space are haunting, ominous, appearing as fixed facts; incriminating evidence of place. They bear no clear relation to the person in

9. *Zhong yong* was one of Confucius' teachings (551–497 BC), and is commonly known as The Doctrine of the Mean. It basically teaches neutrality, following the middle path and never inclining towards the either of two extremes lying on each side of the central course.

Who is He?, 1994

question, yet, by virtue of their presence, implicate him in a time and space, as the tacit perpetrator of an unspecified crime. By use of these means, the simple act of seeking out a friend is imbued with sinister intent.

In this simple undertaking, Geng Jianyi appears to be exposing the sort of breaches of human rights that plagued the decades from 1949 to 1979, and were most countenanced during the Cultural Revolution. But one cannot claim it to be more than subconscious allusion, no matter how succinct it appears.

If the result of doubt is confirmation, it is exemplified in Geng Jianyi's 1994 work *Proof of Existence*. The work's title places it between overt political statement and scientific report. In essence it is both, referencing a human need of confirming individual, personal existence, and for truth within a repressive, totalitarian regime.

As if conducting a private investigation, Geng Jianyi sought out all locatable traces of one ordinary individual, from family and friends, childhood to maturity; from primary to high school, commune to work unit. In their official capacity as parent, teacher, employer or colleague, each person provided written evidence of the individual's existence in a specific time and place. Of course, it did not convey too much to anyone who could not read the original Chinese statements, which prompted Geng Jianyi to have it translated. However, in English words and phrases are denied the impact they have in Chinese because English equivalents simply do not tally with the context or with the myriad implications—chilling at times—elicited, courtesy of the political ideology to which the language had been commandeered—never to be the same again.

Whilst a satire on personal dossiers underlies the work, the actual inspiration for *Proof of Existence* had more to do with the specific mood gathering force through the early 1990s, post-1989. Against the splurging wave of modernisation, during which time individual movement became freer, and divisive rural-urban boundaries began to blur, there began to be signs of rampant consumerism that presaged an economic boom. "I was walking through Hangzhou, through crowds of tourists, shoppers," Geng Jianyi recalls, "and it occurred to me how easy it was to become lost in the multitude of the new society. Surrounded by so many people, what is an individual? We know famous people exist

because their image is fixed in the media. They get written about, documented for posterity. But what happens to the rest? A few photographs in a family album?"

The subject he elected for the work was a young twenty-something who Geng Jianyi decided was the most typical ordinary person he could find. The work itself spins around all the socio-political history that one can throw at it but also alludes to dreams of immortality, of how to "live on" after death; to own a shred of immortality. How does one leave a mark on a world deluged by marks? How should the Chinese reconcile themselves to a new anonymity, not for being part of the political masses but as one of 1.3 billion individuals embracing the freedom of mass consumption? Geng Jianyi's concern for individual worth and preserving a mark was demonstrated when his mother died in 2000. He spent months compiling an album of photographs documenting her life. It was a proof of existence as meaningful as the other.

Prior to his first trip abroad in 1993, Geng Jianyi was one of the handful of Chinese artists a western audience might recognise, having appeared in the *New York Times Magazine*, as part of a feature on the Chinese avant-garde by writer Andrew Solomon.[10] In the photograph, which was wrongly captioned "Zhang Peili", he cut a strikingly handsome figure, standing pensively in three-quarter chiaroscuro against an ox-blood red backdrop with flashes of vermilion that was actually a mural painting he created for a bar in the Hangzhou Culture Centre in 1992. What made the image arresting was the artist's unwavering, not defiant but unflinching and slightly challenging, gaze. Geng Jianyi's eyes are large even by western standards. Size and concentration combine to a penetrating stare that is almost a permanent fixture. Yet, for all their apparent openness, these eyes do not operate as a window on the artist's soul. That is carefully held at a respectful distance.

This sense of deliberate distance was echoed in a work he produced in 1995, which comprised six sheets of glass the size of an average door, all standing vertically. Sandwiched between the layers of glass were curtains of satin and cotton, grey and black, which intentionally lent the glass the quality of a mirror. Yet only to a certain degree, for no matter how hard you sought your reflection or that of the surrounding room in the glass it was always held some way off in a sequence of distorted reflections. The edges and details were lost

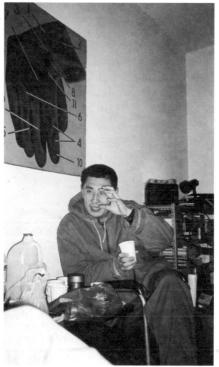

Geng Jianyi in Zhang Peili's studio, 2001

10. Andrew Solomon, "Their Irony, Humour (and Art) Can Save China", *New York Times Magazine*, December 19, 1993, Section 6, pp. 42-51, 66. Illustration of Geng Jianyi behind title p. 42, and writing at desk on p. 50.

to the blurring of layer upon layer of glass. The work was titled *No Matter from Which Side, It Is Still Possible to See*. The fact that it wasn't, was the point. That is the sensation one has being subject to Geng Jianyi's gaze, while he seems to see all.

In 1997, Geng Jianyi produced a startling video work also pivoted on a gaze. *The Direction of Vision* was a soundless film featuring an eye-to-eye encounter with a duck in the final moments of its life. Not that this was clear from either the title or the first few moments of the video. Geng Jianyi hooked his viewers by confronting them with a tight close-up frame of the duck's eye—reminiscent of that well-known scene from the Luis Buñuel film *Un Chien andalou*, where the razor slides across a human eyeball. But fascination swiftly gives way to prickly horror when the viewer realises that the dimming of the bright black pupil that takes place through the filmed sequence signals the end for the duck. The fade from bright sheen to dull misting is a dark parody of the cinematic fade out at the end of a story; here the end of a life. In China, particularly in Beijing, where thousands of ducks are consumed every day as a delicacy, the bird is viewed as no more than a culinary treat. But in this artwork, with the full form of the duck concealed by the close proximity of the camera, the eye became a window on a living thing, and for the brief duration of the image, the dividing line between human and animal was imperceptible. There is something

bitterly cruel about this work, disturbingly so when aligned with the outwardly gentle, peaceful soul of the artist who created it. *The Direction of Vision* offers a prime example of the distance Geng Jianyi can achieve from life for the sake of absolute perfection in art. There is nothing remotely callous in his person, but the cold calm he brings to executing his art hints at a side of his personality that Geng Jianyi keeps hidden.

The size of Geng Jianyi's eyes is enhanced by a halo of sallow rings that betray the jaundice of hepatitis. Chinese society had long been riddled with the disease. For Geng Jianyi's generation, children inherited from parents who

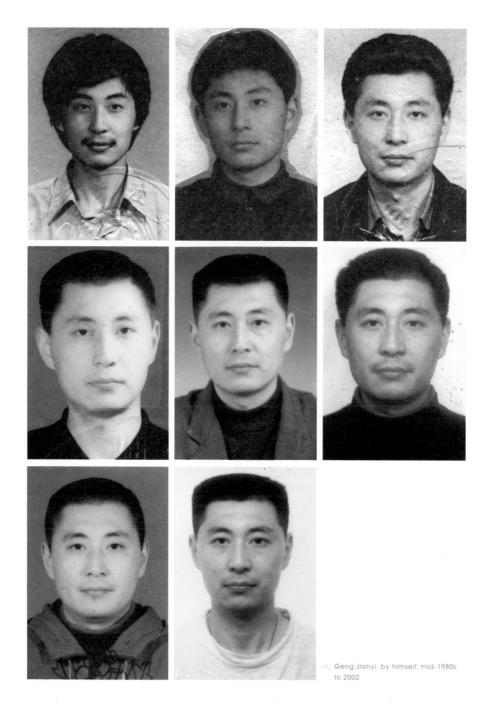

Geng Jianyi, by himself, mid-1980s to 2002

had struggled through food shortages in intense communal environments lacking adequate sanitary facilities. Geng Jianyi deals with it daily, and it frequently wears him down. His well-intentioned attempts to eat well, to rest and exercise, to avoid stressful situations, cigarettes and alcohol, are invariably unsuccessful. Particularly where nicotine is concerned. Whenever thoughts start to flow, and whenever he is required to discuss his ideas, he reaches for a cigarette; it is the only thing in life upon which he is unswervingly dependent. He has a genuine disinterest in material possessions. He doesn't even own an expensive audio visual system, which, by the late 1990s had become the focal point of living rooms across China. Instead he acquired basic serviceable models, which function, which suit. He enjoys jazz and classical music and, judging from the volume of DVDs he possesses, has more than a passing interest in film. Fine clothes, expensive shoes, or superfluous gadgets leave him cold. Despite possessing amazing culinary flair, his kitchen is frequently bare and, day-to-day, he makes do with simple food. That is when he remembers to eat at all. Background illness and a largely sedentary life—he does not even own a bicycle and disdains exercise to the point of avoiding even walking wherever possible—keep his skin as pale as that of a girl. His hands have an almost feminine delicacy, though a thoroughly male crew cut keeps the masculinity in balance. The only items that really excite him are computer software, camera equipment and materials brought to his art. The income he receives now and then from the sale of works pays the bills. By 2000, this was enough to purchase a large stylish apartment which, after removing most of the walls, he kept as Spartan as a hermit's cave—until personal circumstances led him to give it up and move again in 2005. He enjoys books and owns an impressive library, but being immersed in experimental realms of creative practice, by far his most prized possessions are his darkroom and camera equipment.

Whilst Geng Jianyi observes his filial duties well, friendships occupy a privileged position in his life. Loyal and supportive, he gives selflessly, at times to his own distraction, for in putting others first he is apt to deny his own needs. And people take from him, not to exploit him or because he is easily beguiled but because there are few people they would rather receive from. Geng Jianyi has a rare gift of never imparting the slightest hint of ulterior motive. Friends are, thus, equally willing to reciprocate. New York-based photographer Lois Conner practically hauled an entire darkroom from New York to Hangzhou to get him started. The knowledge of photography and professionalism she shared with him was pivotal to the experiments he embarked upon in the late 1990s.

Faces, people, characters, are motifs that Geng Jianyi has most frequently drawn upon as the focus of artworks. He seemed to sense instinctively that audiences are most comfortable viewing that to which they feel akin to or with which they can readily identify. Images of the human form certainly make viewers more receptive to the message an artist wishes to convey. In Geng Jianyi's work, the human element is at times, simple, at others abstract; almost always open to interpretation, but ultimately rooted in universal conditions.

The issue of identity runs through the conceptual text-photo works he produced in the 1990s, a play with portraiture pivoted on questions pertaining to the image of a person; that projected by the individual against that imposed by society. This was clearly described in *Identity Cards* for which Geng Jianyi collected all available ID cards from a similarly

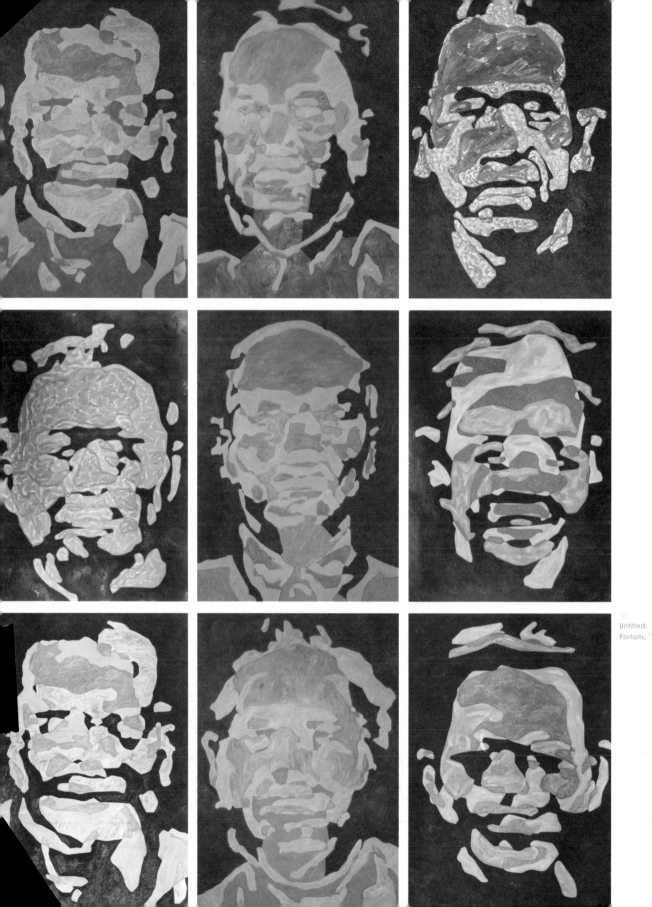

Untitled:
Portaits, "

ordinary person to the young man in *Proof of Existence* and blew up the thumbnail images attached to them. The portrait shots reflect a span of years, via specific moments; a coming of age at which point identity cards become mandatory; obligatory student, work unit and medical cards; peripheral ones like library cards and park passes; and eventually the retirement card.

Geng Jianyi had been testing the public's reading of features in the distorted portraits he produced since the mid-1990s. In 1995, he used such an approach to explore identity in a series of nine canvases, each featuring a large head segmented into patches of colour as if a graphic analysis of light hitting the planes of the face; yet without relating it to realism. Brush stroke, pigment, tone and texture lend weight to the personalities. This led to an equally ambiguous series depicting full figures. Perhaps each composition depicts the same person as an adaptation of Cubist notions. Whatever the motivation, the paintings invoke the blurred, shifting, indeterminable nature of identities within a Chinese socio-political context that imposes clear definitions of everything. The layering of faces creates a "portrait", not of a physiognomy but a personality, or perhaps of a public identity become an instantly recognisable motif, like the image of Mao. They are symbols that stand for actual people in the way that the reduction in a Warhol portrait signifies a persona. They bear little physical correlation with the real world yet are utterly convincing anatomical structures. The simplification of the human body via patterning of forms stresses the fact that the image is a painted approximation of reality. Inherent is a subtle reminder to his audience that nothing is quite as it appears on the surface and certainly never as simple.

In early December 1994, Geng Jianyi travelled to Beijing to promote a conceptual project that local critic-curator Huang Du pronounced to be in a "significantly new fashion". In fact, the fashion was not new, for it pivoted upon group collaboration, of which Geng Jianyi had experienced as part of the Pond Association in Hangzhou in the late 1980s. These activities marked the first attempts by his friends and peers to connect with society via works of art. Public interventions included suspending life-sized paper cut-outs of human figures in postures recognisable as tai chi moves. It was impossible to gauge how the public responded to this occurrence in their local habitat as impressions were not recorded; they weren't even forthcoming. A few suspicious glances, the odd amused chuckle was all the disappointed artists received in the way of feedback.

November 26th as a
Reason, 1994

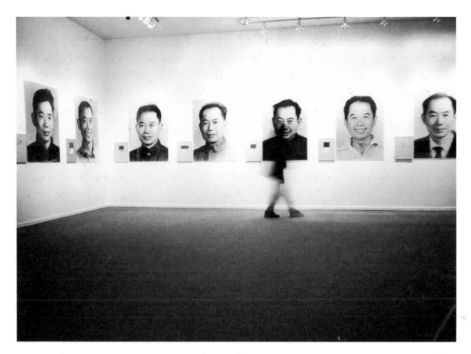

Identity Cards, 2000,
at Presentation House Gallery,
Vancouver

Between 1992 and 1993, with intervention still occupying his thoughts, Geng Jianyi was inspired to try again. Zhang Peili was in New York, so he determined to recreate the scenario with Wang Qiang, another leading Pond Association member, and a number of established and younger artists located in Hangzhou, Beijing and Shanghai. He masterminded two separate activities, connected by form and approach but taking different reasons as their point of departure. The first was titled *November 26th, 1994 as a Reason*, and was published in January 1995. The second was *45 Degrees as a Reason*, which was completed in April.

Whilst November 26th, 1994, obviously referred to a time, forty-five degrees carried no such specific value. It simply sought to induce a new angle of perception about making art and its content. The specific reasons provided a frame of reference within which to work, to stimulate ideas outside the artist's individual concerns. In approaching potential participants, Geng Jianyi and Wang Qiang emphasised the reason as being an armature upon which to shape a work of art: "Society, personal circumstances, space, materials, and time impose limitations on all of us. In China, in art, in life there are limitations. I wanted to explore them, to define them, and to work with them to change the way limitations were perceived." The choice of forty-five degrees as a theme was specific to this notion: "Imagine the base line (0 degrees) is reality and the vertical (90 degrees) is the ideal," he explained. "The mid-point, 45 degrees, is the compromise that most people have to walk in life, some closer to the ideal, some closer to reality. Limitations are an inherent part of this but they can be seen in two ways: whilst those limitations that are imposed incur frustration, those that are embraced can open doors onto new territory."

For the first project, on November 26th each of the eleven artists who elected to take part made a work relevant to the date and the city in which they lived. These included Zhan Wang's work highlighting the bulldozing of the history-suffused hutongs in Beijing, to Chen Yanyin's recording of an emotional scene in Shanghai; and Yang Zhenzhong celebrating the birthday of an unknown person whose grave revealed November 26th as his date of birth. Geng Jianyi chose to test the nature of trust in a performance piece titled *A Reasonable Relationship*. For this, he hired an acquaintance to travel to Shanghai and complete a series of tasks that were laid down in a contractual agreement ratified by the signatures of hirer and hiree before a witness. Geng Jianyi claimed an agoraphobic fear of crowded places as a reason for seeking help to obtain an objective update on the urban environment of Shanghai in his stead. Thus, the hiree was dispatched to make her report. Any hint of a personal transaction during the course of the day was to be punishable with a fine.

When the documentation for all the works was complete, it was sent to Geng Jianyi who compiled all the data and printed it up in the form of a package of postcards. It was these he travelled to Beijing to distribute. This neatly packaged form of documentation was intended to enable the artists to reach an audience that would not otherwise see the original works. For reasons of lack of space, the cost of materials involved, the scale or complexity of the work, several pieces were presented in plan form further making the project a forum for ideas. However, poor printing quality and the attitude of participating artists left Geng Jianyi disappointed at the result. The potential of the format as a means of disseminating ideas was not taken as seriously as he had anticipated. And yet, the idea would soon be appropriated, in slightly amended packages, by other artists, and deployed as an effective means of self-promotion.

Discouraged, and sensing the general shift towards Beijing as the centre of the arts scene, in the spring of 1995 Geng Jianyi took a decision to move to the capital. Beijing, he believed, might offer greater opportunities to develop his art and to enter into a more dynamic aesthetic dialogue with other artists: "Artists are like blades of grass. When the wind blows they all move in the same direction, like sunflowers that always grow towards the light that nourishes them. It's not as so much about a place being good or bad but offering better opportunities. There were more activities and exhibitions, more dialogue and discussion there." He hoped that in Beijing he could put more time and energy into his own development. This was not to be. For the entire year of his stay in the capital, Geng Jianyi was frustrated by one problem after another. The first was securing a place in which to live and work, which not easy given the bullish real-estate market of the time and a limited amount of apartments that were both affordable and large enough for his purpose. The second factor was ill health. The long-term effects of hepatitis, which the more relaxed lifestyle and healthier mode of living in Hangzhou had kept in check, were exacerbated by the northern climate, the cold, the pollution and the penchant of the art community for eating late, drinking long and talking well beyond the hour at which Geng Jianyi preferred to take his repose. He became physically run down, the worry of which affected his mental state. In the meantime, in mid-1995, relief was found in the form of a trip to the US for an artists' residency programme. For Geng Jianyi, it provided an opportunity to extend his testing to an international setting.

It was an unusual request from one artist to another but, during the summer residency programme in Omi, upstate New York, Geng Jianyi asked each of the nineteen participating artists if they would save the rubbish that was produced in the course of making their work. Each was requested to sign a release form, which included a space for the artists to state their reason for agreeing to participate in the project. Both amused by the idea and with an environment-friendly conscience about making art, all signed the deed. To assist them in their work, Geng Jianyi helpfully provided each artist with a black plastic waste disposal bag to put their bits in. He titled the work *The Needs of Negative Reality*. In locating the negative portions of matter that were cast off in the process of producing a positive object, Geng Jianyi aimed to examine the choices that artists make as they work through ideas. By virtue of the materials it contained, Geng Jianyi's work was formed of debris. Despite the carefully prepared visitors' book placed next to the consent forms on a pristine white lectern, and the sanitary white podium he constructed to display the bags, to the innocent eye it was just a mass of garbage bags filled with ... garbage.

As the days of the residency passed into weeks, Geng Jianyi sensed his work might greet a tough audience at the final exhibition. Omi had accumulated a solid reputation through the years: a broad range of artworks from artists of diverse cultural backgrounds and the promise of cool, clean country air was guaranteed to draw New York City art crowds upstate to escape the heat of the summer months. Whilst Geng Jianyi had no doubt visitors would be broad-minded, he was not sure what they would make of rubbish. As the other artists busied themselves with the act of creating, all that was left to Geng Jianyi was to wait and watch. Once all had agreed to participate, there was little to do but take in the surrounding landscape and wait to pick up the trash. If they thought his request odd, the other participants did not show it. Language was a barrier to a deeper verbal understanding of the artist and his art, but doubts about the seriousness of this quietly reserved Chinese national were quashed as Geng Jianyi wiped the floor with the entire community at table tennis as they relaxed in the evenings. The diligence and concentration he brought to the game revealed him to be a man with tactics and a clearly thought out strategy.

30%, 1992

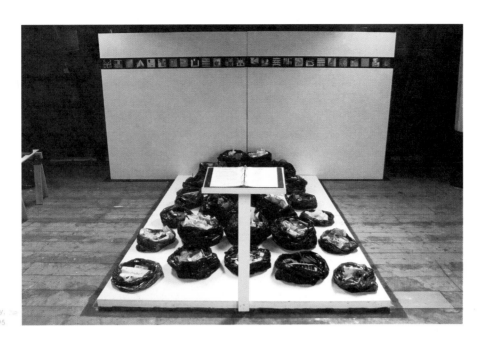

he Needs of Negative Reality,
1995

The show was a success. If the New York crowd was sceptical about *The Needs of Negative Reality* they did not show it. Perhaps they side-stepped aesthetic appraisal by deciding that, in hailing from the PRC, Geng Jianyi would undoubtedly produce work with profound political motifs that were as unreadable as Chinese characters. No one appeared to be offended by his collection of garbage bags, which was Geng Jianyi's only cause for pause. For, in the words of critic Li Xianting, here is an artist focusing on: "The embarrassing, humiliating moments faced by people in contemporary Chinese society, [depicted] in an excruciatingly frank and painfully eloquent fashion, often adding an unexpected twist that causes the viewer, almost numb to the fact that he is living in an unhealthy environment, to be confronted with an intolerable new level of embarrassment."[11] A comment that evidences the insularity of the Chinese cultural experience as much as the jaded palette of western audiences for the quirks of contemporary art.

Geng Jianyi's subsequent sojourn in New York was a catalyst for change. The aesthetic issues that confounded him were now viewed across the distance between his own aesthetic framework and New York. The prism of another culture provided a bolt of enlightenment. Not so much about art for it was now late August and, with most of the galleries closed, there was little to see. It was not exactly a sense of cultural or social shock either. New York was certainly different to the European cities he had explored. Here, he was fascinated by the soaring heights of the buildings and the hectic lifestyle of the people, stunned at their modes of interacting and the value/ belief systems that governed their daily life. Specifically, the experience reconfirmed the awkwardness and anxiety that descended upon him in dense urban environments and close proximity to a scene—patent in New York which appeared so similar to Beijing against the dramatically different aura of major European cities.

11. Li Xianting, "Major Trends in the Development of Contemporary Chinese Art", catalogue to the exhibition "China's New Art, Post 1989", p. XVII, published by Hanart TZ Gallery, Hong Kong, 1993.

His move from the quiet backwater of Hangzhou to Beijing had not been an easy transition. Beijing was huge, yet its artistic community was small, incestuous and, for Geng Jianyi, suffocating. It was not that anyone intended it to be so but that the urgency of the environment and the peer pressures exerted in the battle for stardom, coupled with the rising cost of living and the unavoidable need of maintaining social contacts that followed, were wholly unsuited to his nature. Geng Jianyi clearly had ambitions for his art but he was not ambitious of himself. He enjoyed the company of people but given the choice preferred his own. Social demands were a daunting mental and physical burden. In New York, his reservations were confirmed. In the early hours of one morning, as he lay with Beijing artists Lin Tianmiao and Wang Gongxin on the benches at the foot of the World Trade Towers to view the illusion of curved perspective as they rose into the pre-dawn sky, he realised that heady heights were not for him. Geng Jianyi was not sure what he wanted—the quest that drove his approach to art—but he knew it did not involve conforming to the value system that had evolved within the art scene in Beijing. China had advanced far beyond the socio-political climate in which he created the seminal works of the late 1980s that made him one of the avant-garde's most closely watched and respected artists. New art had advanced on the back of the questions that he,

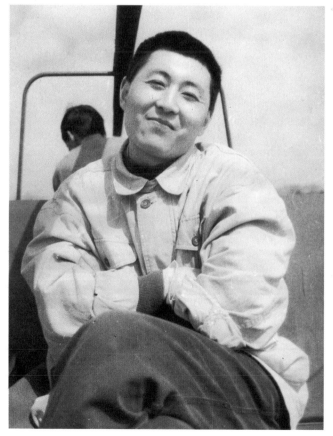

On a boat on the West Lake, Hangzhou, 1995

Untitled, 1996

like other leading artists, had posited. But, as the 1990s unfolded it seemed that general conclusions drawn had little to do with art per se. Artists were veering off at superficial tangents pivoted on wealth and fame with alacrity. It was understandable, unavoidable, necessary even, but rid of the innocence that had been a unifying bond for his generation.

In 1995, Geng Jianyi knew that to stay in Beijing and engage with the scene there effectively meant condoning its motives and values at the expense of compromising his own. There was no holier than thou in his assessment, for he enjoyed the benefits his own fame produced, but he viewed these as the incidental by-products of his creative process, like the debris he collected in Omi. Vexed by doubts about his own world, he realised he would not find the answers he sought adrift in the hectic waters of Beijing's coercive society. To test this conclusion after returning from New York he stuck it out for another six months. Then, satisfied that he had proved himself right, he withdrew to the familiar haven of Hangzhou.

Back in Hangzhou, in April 1996, Geng Jianyi's recovery from his Beijing experience took a while. First he took steps to placate his liver and restore his health. His progress was marred by a succession of external interference. The question that occupied him was whether or not his engagement with art was ultimately a relationship worth fighting for. On occasion, he found himself asking if he was cut out to be an artist at all. Geng Jianyi is a genuinely philosophical member of the avant-garde, yet not of the type like Wang Guangyi, who turned to philosophical texts to vindicate his position. Geng Jianyi prefers classical fables and Buddhist teachings. He

耿建翌
GENG JIANYI

WATERMARKS 水印

is primarily interested in how art functions in society. Can it reveal fundamental truths about human existence as the parables in Buddhist teachings of which he is so fond? At times his approach in this vein works beautifully. At others, the results perplex him. By the late 1990s, he was becoming silently frustrated with works that he felt failed to communicate at all. Within the growing cacophony of the new art's broader advance, Geng Jianyi began to question the role of the artist, its meaning and function, and equally that of the art produced.

The intimate observation of life and careful analysis of the social environment evidenced in Geng Jianyi's work definitely arose from his interaction with people in general, with society as a whole. Yet, towards the end of the 1990s, he consciously elected to become something of a recluse on the damp shores of Hangzhou's West Lake. It left him one step removed from the exhausting machinations of the Chinese art world, but several steps closer to his art. He closed the door on a period of frustration and embarked on a creative exploration that had little to do with catering to popular art world trends but a lot to do with testing his ideas in peace. It was a deliberate absence that had everything to do with getting things right. Distance from the capital allowed him to be selective about where and when he showed his work. More importantly, it permitted the time to drift in uncharted directions, to run aground and set sail again on a new tack.

The first tack brought him to a resurgent interest in marks. This he blended with a number of prior interests in a new direction that took the form of a book. One mode concentrated upon readable content—mimeographed images of figures, faces, and a trail of lines and textures that suggested an abstract unfolding of a story. The second mode subverted a book's conventional function of containing information. Both processes and goals were contravened as he adulterated text, removing all words of a particular kind (possessives, pronouns) or, in a more extreme fashion, removing all words bar one kind.

In 1995, using the mimeograph technique of reproducing texts that was widely used in the 1960s and 1970s, he produced small series of carefully yet simply bound books. The pages were covered with random markings made with a pen on transfer paper, rubbings of textured surfaces. This expanded into pencil rubbings of anonymous pages where the only variance is the deterioration of the dog-eared edge and the weight of the hand applied to the pencil. Out of this developed a series of extraordinary watercolour paintings of the blank pages of a book, like valued parchment whose decrees, ordinances and writings have faded leaving only a blank surface behind them. Nothingness. Which rendered them meaningless and therefore worthless to the local viewer beyond appearing as an exercise in technique—quite the furthest thing from that which they actually represented. It was the streak of perfectionism in him that ensured they were so well painted.

In Hangzhou Geng Jianyi found peace to work in a new studio, but fate was not always on his side. In the middle of an incredible period of inclement weather in Hangzhou where water levels threaten floods, he watched helplessly as a set of recently completed books were consumed by mould. This was not the first time that experimentation had resulted in his works self-destructing. By 2000, the condition of a number of his early paintings, like '85 Another Shaved Head of Summer, evidenced the general poverty of the mid-1980s. The low-grade pigments, which were all students could afford, were ruined by brittle binders

Five Semi-Spheres, 2003

and additives, rendering them quite unstable. The bright red hue that once coloured the barber's shorts receded to a shade of dead salmon. The yellow shorts of the sitter turned van Gogh Sunflower green, whilst the lead white showed every sign of inverting itself into blackness. Poverty was one aspect, but Geng Jianyi habitually painted over old paintings with which he was not satisfied. Within a short space of time they were heavily cracked and peeling. What were amongst the most important works of the New Art Movement were also some of the most fragile.

Whilst there was little Geng Jianyi could do to rectify the problems with materials used in his past, he became extremely conscientious about the works he was producing in the late 1990s. Towards the end of the 1990s photography became an important focus of his work. His experiments with light-sensitive paper and the unpredictable results of chemical reactions between light and exposure began in 1995 when he produced a series of random, abstract compositions using developer and fix on unexposed paper. One of these was shown in Vancouver, another in Australia, both undergoing their transformation on the journey and during the period of exhibition; delayed exposure to light producing all manner of marks. In 1999–2000 he used such darkroom techniques to manipulate a series of portraits, scratching and drawing into the image, removing any sense of location or clarity of the features, although underneath the original image was professional to perfection. Given the approach—exposing paper to a negative and drawing into the image with developer—it is hard to say how stable these images are, but this is of little concern to the artist. He is more interested in the subtle change that will take place in the work over time. The photographic works combine so many elements from his oeuvre—photography, drawing, marks, ambiguous identity and nebulous form, as well as an extraordinary degree of control—and yet they open up a new area of abstract painting that echoed much of the sensibilities in traditional painting. Quite how these works will evolve—or if they will evolve at all—is unclear. Having completed a darkroom after months of procrastination, he got side-tracked taking other lines for a walk in the realm of computer animation.

If Geng Jianyi can be said to own a burning ambition, it is a desire for artistic credibility, for breaking new ground in a truly innovative way. As one of the most intelligent—wise—artists of the avant-garde—not smart like Wang Guangyi or savvy like Fang Lijun—he has no fixed theory on life or art but offers a perceptive response to any statement one might throw at him. His talent is for making the viewer an unwitting participant in his

art, for locking onto common situations—those stacks of bureaucracy that any society is obliged to take on board, the relationships we take for granted and others we seek to secure, emotions which play games with perceptions. Almost like acupuncture needles that pricked the viewer's pressure points. It is as if you watch the needle, twitch as it goes in, experiencing a moment of discomfort before the relief kicks in; the painful process of learning from experience. Geng Jianyi implies that we should question what we think we know or, at the very least, hold onto the ability to doubt. Doubt holds Geng Jianyi fast, but perhaps it is pragmatism, too, that weighs him down. Intelligence, talent, artistic avant-gardeness and ideological conservatism, the burden of personal and social history ... all these he carries in the same measure as his peers. Yet, he is in a minority—not convinced he is right, but understanding that it does not matter one way or the other. True success cannot be measured by fleeting market favour.

Geng Jianyi continues to produce a consistent and profound body of work. He embodies what the international art world means when it says "artist". The consistency in his art does not lie in an obvious visual stamp, a trademark on the work, which many others unwittingly or consciously adopted. One Beijing-based painter justified it thus: "When you're caught in a sea of change, without any known signature to your name, a consistently recognisable style provides the viewer the comfort of recognition. Style becomes the anchor to painters floating like rafts adrift in a cultural void." Geng Jianyi has had no apparent need of an anchor. He has drifted, yes, and his sea is constantly subject to the whims of the elements, but he at least is comfortable with his raft and its uncharted motion. External forces have always taken second place to inner cues. Examining all the setbacks, he makes no accusations of blame. Life is life, no more, no less and he has a multitude of new ideas to pursue: "I believe in fate and trust it knows what it's up to."

Untitled, 2001

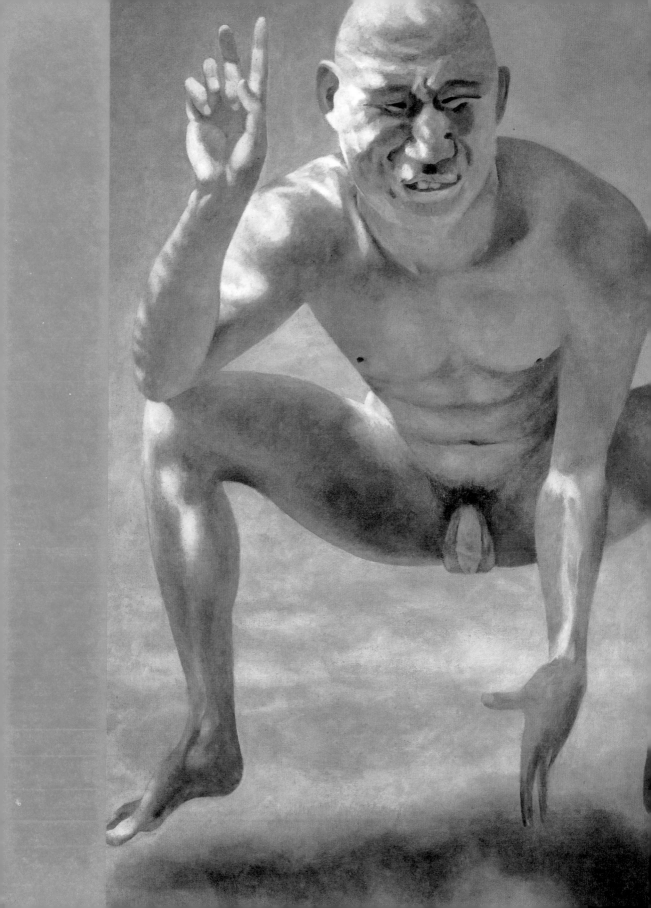

FANG LIJUN:

SWIM OR SINK

Photographed at a Channel [V] press launch in Beijing, 2002

"We all have to do something to solve or release our problems, and the pressure we encounter in daily reality."

In March 1993 an exhibition of paintings by the German Expressionist artist Jörg Immendorf travelled from Hong Kong Arts Centre to Beijing's International Art Palace, in the heart of Beijing. It was a big event, being one of just a handful of solo exhibitions by leading European artists to have been seen in China between the implementation of opening and reform (1979) and this point in the early 1990s, the most significant of which was Robert Rauschenberg's 1985 solo exhibition. As such, the afternoon vernissage was packed to capacity, heaving with almost every significant Chinese artist of the moment and a whole hoard more of hopefuls, too. From the instant Immendorf arrived he found himself drowning in deep layers of artists who bombarded him with forthright questions, all primed by an uninhibited need to know, not specifically about his art but about the grand arena of modern art in the West. The room succumbed to disorienting babble as the maestro was guided round like a prophet besieged by believers vying with each other to hold his attention. Clearly flattered by the attention, the broad beam that stretched across Immendorf's features rescinded but fleetingly as he earnestly responded to the stream of enquiries translated back and forth between German, faltering English and Mandarin.

To put the event into perspective, although of certain renown within the European art world, within the China context Jörg Immendorf was not that famous compared with giants like Anselm Kiefer and Gerhard Richter, names and approaches to painting with which the Chinese artists were extremely familiar. Thus, the enthusiasm

方力钧 I IMMENDORFF
FROM TWO CULTURES I 源于两种文化

SHANGHAI CONTEMPORARY
ALBRECHT, OCHS & WEI

≪ Invitation for Fang Lijun and
Jörg Immendorf's exhibition in
Shanghai, 2002

exhibited was, in part, an astounding example of the warmth of Chinese hospitality at its most searing intensity, but it could not mask a profound sense of insularity; an indomitable part of the art world's existence before China really began to open up in the early 1990s.

In November 2002, a few months shy of a decade later, Fang Lijun was attending the opening of another exhibition, this time in Shanghai. A two-man show that placed his works side by side with those of the same German painter, Jörg Immendorf. Just two weeks prior to the opening, Fang Lijun's gallery, the Berlin-based Pruess and Ochs Fine Arts, had completed refurbishment of a new space in Shanghai (in a partnership with another German national and under an independent name). For an established foreign gallery to open a branch in China, even in cosmopolitan Shanghai, was a curious undertaking that demonstrated much bravado, driven, no doubt, by the enduring and spectacular myth of China's vast market potential. Futile, too, given the actuality of the economic and cultural situation; the unequal equation between interest and spending power amongst even the most educated and affluent of the local people. The proof as ever in the pudding, the endeavour didn't survive to see a first anniversary. But for the inaugural exhibition of this great foray in 2002, and to establish the gallery's East-West profile and standing for the local audience, it was decided to bring together paintings and prints from two of the most successful of the gallery's stable of artists: Fang Lijun and Jörg Immendorf. Within the contemporary Chinese context, the event—a first for a European gallery—made a significant statement, particularly in its affirmation of the regard in which Fang Lijun was held in Europe and, by analogy, "the West". In the decade since Immendorf first visited China, Fang Lijun's status had risen from aspiring hopeful to confident equal. And, judging from the alacrity with which his career had taken off through the 1990s as he became established as an international artist, there was a sense that by the time he arrived at the age Immendorf was at his 1993 China debut, Fang Lijun would probably have surpassed him. In fact, he had already overtaken him in one regard: there was no irony in Fang Lijun's tone as he mused on how the German master must have felt to discover that his works were now priced significantly lower than those of the young

Chinese artist Fang Lijun. And it was not arrogance on Fang Lijun's part. His musing merely belied an apparently genuine sense of amazement—and satisfaction—he himself felt at his achievement. In spite of the cynicism that riddles his paintings and regularly colours his conversation, this tangible wonderment remains, endearingly so, even as it became clear that his success was not just the result of a transient phase of fickle foreign interest. The distinctive qualities of his pantings made him one of the leading influences of the day.

From the outset Fang Lijun was a trendsetter. He was not the youngest artist to participate in the "China/Avant Garde" exhibition in 1989 but he was practically the only one who was still a student. Of greatest import to his generation and the times, Fang Lijun established the first independent model for artistic success in Beijing. He was also the first young Chinese artist in the Mainland to marry a foreign woman, German national Michaela Raab, who was working for the Beijing offices of UNICEF. To the envy of avant-garde circles, which privately dreamt of following suit, and in some cases tried to, she was a first springboard towards the international art world, as well as introducing his work to the foreign and diplomatic communities in the capital.

In 1989 Fang Lijun moved into a house on the fringe of Beijing which almost immediately became the fledgling Yuanmingyuan artists' village. A large part of the credibility that it attained over the next few years would rest upon the growing fame of this roguish Cynical Realist painter, as his style would be dubbed in the early 1990s. His cynical outlook was innate. Fang Lijun grew up despising false ideals and promises of Utopia just around the corner. The reneged pledges that had been made by Mao Zedong's regime would be taken as the butt of his visual jokes, satirised and latterly parodied in the most vindictive fashion possible—as almost perfect imitation, apparently glorifying tributes to mass culture, mass hero worship and mass euphoria,

Fang Lijun and his first puppy, 1994: an artist, a studio, and a lifestyle that set standards for others to follow

bitingly cruel by design. Yet, there are clear indications in his art that Fang Lijun started out from the human condition rather than politics. It was the events of contemporary history that engineered his aesthetic as a political challenge. Political, because he was inspired to take a grim look at what politics does to the people it indoctrinates and because he dared to register local national politics as an all-encompassing net cast over the masses that these policies were supposed to support. Initially focusing on the disaffected—his own generation—he couched it in subtle terms, although the roguish irreverence he injected was discernibly antagonistic to the prevailing ideology. In post-1989 China, and for a foreign audience, the challenge he threw out to the "old"—to the proscribed guidelines on the

form and content of painting—was political because it impugned convention, the State and the ideology that bound the social and national fabric together.

By the mid-1990s Fang Lijun had moved on. Not so much artistically, although his work had clearly matured, but physically. He had left the artists' village behind, and relocated to a new home in the countryside where he would create paintings that made him the most sought after artist of the age. He had swapped the baggy garb of hooligan youth for chic leather and basic, boyish casuals—T-shirts, sweatshirts, anything collarless—in muted blues and greys. Among the long haired artists that appeared through the 1980s, Fang Lijun was one of the few who kept his crew cut: "I neither compared myself to others nor tried to make myself different. I just felt comfortable without hair.. I always loved swimming, so being bareheaded was convenient." With a broad impious grin, rubbing a palm over the dome of his rudely naked, smooth-as-silk skull, he describes himself as handsome in an ugly way: his ears will always stick out after all.

Fang Lijun has been called shy. He might have been once but by late 1990s the hint of superciliousness he emitted was more frustration or boredom engendered by life's tedious interruptions. For Fang Lijun, this means the constant stream of gallerists, curators, critics, arts writers, collectors and the plain curious who seek him out. He is good with people yet this camaraderie is often tinged with an edge of impatience. Fang Lijun hates impostors. He has never been blinded by the egotistical projections of people with power. That had been drained from him as a child, along with several other vexing human characteristics. Although self-effacing and outwardly modest, Fang Lijun despises false modesty and if he seems at times to practise it, it is with absolute contempt for the convention. He is sincere, loyal and increasingly serious about his work. These values are not catholic for the Chinese art community, which is why people find it hard to dislike or to take issue with Fang Lijun. Individuals might find just cause to deride his art but it is impossible to malign the artist. He handles the new role of successful artist deftly in a society where artists have no definitive place and little support. He wines and dines interested parties and gives interviews where necessary. These he can control, but he draws the line at being treated as a media celebrity—a decision alien to art stars that are so very much part of western celebrity culture. By contrast to that of Wang Guangyi's formative experiences, Fang Lijun's taught him that it was better to stay out of the limelight—in China—and never to say too much. Thus, in common with many of his peers, he is habitually hesitant to talk of his art, other than to foreign interlocutors or familiar acquaintances. In dealing with the general populace his speech is eloquent but in a fashion that is enigmatically unrevealing.

What ultimately distinguishes Fang Lijun from the pack is how he combines artistic talent with ambition and a shrewd head for business, which was evident long before he achieved commercial success or decided to open a string of restaurants. It sets him apart. Now, not only is his art critically acclaimed and in demand from collectors worldwide, but his restaurants are both resoundingly popular eateries, and the capital's coolest hangouts for artists, foreign visitors and Beijing's blossoming middle-class, in

each of their locations. Fang Lijun has brought his family fortunes full circle. As an artist he has made a mark within China and abroad that not even a second Cultural Revolution or a June 4, with all the accompanying incompetence and victimisation tactics people could muster, can erase. And now, as a businessman, he has restored all the material security and status to his family that was lost during the original Cultural Revolution. But through all this, neither success in business, nor the jet-set lifestyle, not the mammoth studio, nor the southern China retreat, nor the chic Beijing penthouse, or the sleek black Audi A6—matching that of Wang Guangyi—that he drives, could extinguish the aching emptiness he carries inside. His art suggests a constant questing after the means to redress the sense of rupture and ennui that suffuse his generation. Caught on the cusp of change and left to grope blindly in the abyss of political reform and opening, this generation was mightily peeved that the promise of the 1980s—which followed all the wickedness of the 1970s—went up in smoke as the decade came to a close with June 4. This generation had difficulty imagining that the 1990s were going to be any different, and indeed it would take a new regime—that of Jiang Zemin—to change that.

Fang Lijun was born in 1963 in the city of Handan in Hebei province, which lies 450 kilometres due south of the capital. This was where he grew up and lived until he was sixteen years old. Handan had been an important city in China two thousand years before, as the capital of the State of Zhao during the Warring States period (475–221 BC). It was overthrown by the Qin emperor in 260 BC as part of his unification of all independent states across the Middle Kingdom. Look up Handan in any number of travel guides to China and it does not merit more than scant comment, or, in the case of the Lonely Planets guide, even a mention. The reason its former glory was relevant to native sons like Fang Lijun in the early years of the new millennium was that this chunk of history had been made the subject of two films—Chen Kaige's The Emperor and the Assassin in 1999, and Zhang Yimou's Hero in 2002. Films by directors who represented the closest thing China had come to Hollywood. But being close to the subject of not one but two films—even if indirectly—had returned some sense of pride to the southern Hebei residents; at least, to its arty-cultural elite. During the Warring States period, this area of China was the epicentre of commerce and culture, but in the interim—in particular the twentieth century—Hebei province, which encloses Beijing on all sides, was overshadowed by rise of the capital and the port city of Tianjin, 250 kilometres due east of Beijing. It languished under the cloak of industry and mining, which kept it environmentally bleak and economically strapped.

Under Mao, the ancient Zhao capital of Handan was turned into a city of light industry specialising in textiles and porcelain, and a production base for coal and steel. It was no longer a crucial township but, with a population of one million, remained an important supply base for Beijing, providing the necessary coal and energy to run the capital. Industry grew at the cost of the handful of traces from a distant past that lingered, or had not yet been destroyed: "When I was young, I used to look around the

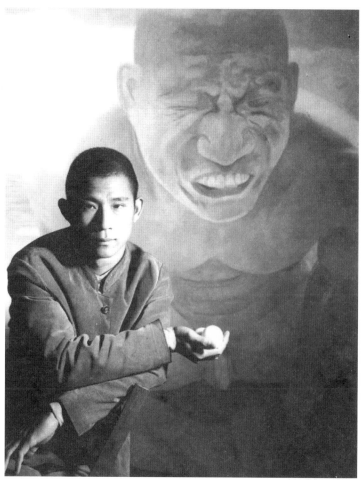
In his studio, 1993

city at the old bridges and streets ... there were even the remains of ancient statues [such as those found flanking the spirit roads that led to important temples] in fields in the surrounding countryside. By the time I got into middle school, these things had gradually disappeared." Poverty did not encourage an interest in preservation and denied either the funds or vision to protect the assets of the past. The events of modern Chinese history, the Cultural Revolution as much as June 4, threw an imagined ideal past into sharp relief. Perhaps tainted by this bitter twist of fate, the more culturally aware or politically minded inhabitants typically idealised the past and the Kingdom of Zhao, yearning for a return of the advanced society that it was in its day, and rule by what was a forward-thinking and liberal governance.

Fang Lijun's parents were not native to Handan, their hometown was the city of Tangshan. The family moved to Handan to accommodate Fang Lijun's father's work assignment within the national railway bureau—a promotion to the position of cadre. However, when the Cultural Revolution began, his family background would see him demoted to the rank of engineer. Unfortunate perhaps, but the original assignment that brought the family to Handan conceivably saved their lives, for on July 28, 1976, at 3:00 a.m., as the entire town slept, a violent earthquake struck Tangshan. Even today, the Tangshan earthquake still rates as the worst earthquake disaster of the twentieth century, destroying 97 per cent of the city's structures, with a death toll between 240,000 and 400,000 people. Had the Fang's remained there, in all likelihood they, too, would have been crushed in their sleep, and the Chinese art world deprived of a pivotal protagonist.

Fang Lijun was the younger of two children. Just two children was unusual because most families had twice that number. In promoting agrarian farmers and industrial workers to a high status in the early years of the People's Republic, Mao encouraged the people to reproduce like rabbits to swell the ranks of the nation's proletariat. China needed all the hands it could muster to work the land and fuel the factories. It also needed bodies to make up an army that would balance the nation's deficit in modern technology with a sheer, overwhelming force of numbers. This was nothing new to the peasant classes, which had long felt the need for more hands most painfully. However, in obliging their leader, the masses helped set one of Mao's biggest misjudgements in motion, causing the population to expand massively. As a result, thousands died of starvation as political campaigns bled the workforce dry, left the fields untended, the factories in disarray, and stringent rationing was imposed to counter the chronic food shortages in 1959. Yet, had the Cultural Revolution not broken out in 1966, perhaps Fang Lijun's mother also might have been more inclined to produce further offspring. In the event, socio-political circumstances were not conducive.

Fang Lijun's parents came from neither the peasant nor the worker class but somewhere in the middle, classified as "rich peasants". Come the Cultural Revolution, rich peasants were defined as bad people, one of the growing categories of undesirables that included landlords, "capitalist roaders", counter-revolutionaries and "rightists", all of whom required remoulding and reeducating through revolutionary struggle. It was to his grandfather that Fang Lijun owed the sin of former prosperity. The programme of rectification brought his grandfather, his parents, himself and his brother down to the lowest common denominator with everyone else. Except that those who had formerly enjoyed a lifestyle beyond that of the general melée—such as rich peasants were judged to have indulged in—were now denied equal social status with the workers and peasants. This included the children who had not even known of their family's former standing or been old enough to grasp the future implications. Such classification had an enormous effect upon normal family life, as the past was made to follow its heirs around. "During that time, evil had a chance to develop fully: People could be animals at times. I was always being bullied. But I gave as good as I got: I was a bad boy, too."

Life taught Fang Lijun to be bad. It taught him not to trust human emotion which, courtesy of the nature of the revolutionary struggle Mao decreed, had been proven to be entirely fickle. Intelligence, goodness, manners, and respect were no longer qualities that determined civilised people from barbarians. With the barbaric undertone of Mao's pogrom to make all equal under the "red" sun, it was civilised, educated people who suffered. Fang Lijun would be forced to denounce his own grandfather and still be excluded from the activities of the Young Pioneers. At school the result was veritable ostracism. Exclusion being the most painful punishment that can be inflicted upon a child, the scars it left run deep. Fang Lijun was fortunate in having a good relationship with his parents, a family closeness that is not at all common. So, despite the criticism that besmirched his family, he never turned on his parents or grandfather, blaming them for his unhappy lot.

Victimisation and bullying instilled in children the means to get away with doing anything, as long as it was done in the name of Revolution and serving Mao. As he became older, Fang Lijun too found freedom in the grey areas of right and wrong that few could clearly define. It could hardly have been otherwise when there was no value system but that invoked by a revolution dedicated to breaking all the social mores of the old society. "I became extremely naughty and sometime stole things. We [the children he hung out with] ate all of the different types of foodstuffs transported by train: oranges, apples, walnuts, pears, honey and even bean cakes meant as feed for horses and cows. To this day, the pencil case I use was taken from a train. We even stole fuel from the tanks to make gunpowder. We produced some very powerful firecrackers with this."

As a loveable rogue—it is an apt description, conspicuous in the impression the artist leaves on just about everyone who meets him and in particular those who have written of his work—Fang Lijun and his gang stole from the trains they lived in close proximity to largely for fun and to complement their own adventures. They did not intend to cause any real damage—although they had little idea of what damage meant and how it could result from their actions. To someone so young, wrong did not seem wrong when everyone else was engaged in it too, and with impunity. Yet: "There were students in the grades below me who were crazy. They stole valuable metal parts from the train to sell them to recycling stores so that they could make money for buying firecrackers during Spring Festival." A high percentage of these students were caught and thrown into detention centres. The minimum sentence was three years. Having honed their knowledge inside, they came out to re-establish contacts with other classmates who now worked for the railroad network in a variety of useful positions. Systematically, they began ripping off the trains. When finally caught, not a few of them suffered the death penalty. It provided a silent deterrent, a warning to be careful, to cover one's tracks, but, above all, not to get caught.

As a child, during the worst of the persecution Fang Lijun was taken away to live in another village with his grandfather. He returned, aged eight, to start school, still an outcast; retrograde, but tenacious. Amusingly, in 1973, he unwittingly found the means to turn his status around. Almost all writings on Fang Lijun cite how he won "acclaim as part of a writing team in the Movement to Criticise Confucius and Lin Biao", contributing to a suitably defamatory essay on why "dickhead" Confucius was a stupid pig. The cartoons he drew of these two maligned figures elicited a delighted public mirth. Gratified by the rehabilitation of his character, Fang Lijun decided it was not so bad to apply his talent for drawing to the propaganda cause. For the moment, it provided an outlet for an inherent seam of cynicism in his character. Experience would soon cure him of his naivety.

Like many of his generation who became artists, Fang Lijun began to draw because his father sought to restrict his playtime with other children: "He was afraid they would beat me up, so he bought lots of paper and pencils in order to make me stay at home where it was safer." Fang Lijun's brother, who was six years older, faired better when the chaos was unleashed, for by then he had learnt to protect himself.

On several occasions he had to protect his younger brother, too, when gangs of Red Guards came to ransack the house in search of incriminating evidence against this rich peasant family that might be harboured there. A strong survival instinct became manifest. Fang Lijun was quick to catch on to what was required of him, indicated by the commendation he received for cartoons he had drawn in conjunction with his much-praised essay. He once confessed to critic Li Xianting: "Because I was born into the wrong class, I had to learn at a very early age to put up, shut up and fake it. In 1976 when ... Mao Zedong died and we went to pay our respects, my father gave me a look. I knew I was supposed to cry but I couldn't. But then I forced myself to cry uncontrollably and people came up to pacify me. My teachers praised me. I realised that if I behaved in a particular way, I'd be commended. And so this was one of the results of my childhood education: the exact opposite of what was intended."[1]

Such experience highlights the fallacy of blind faith and of what happens when individual thought is annihilated. Hence, as Fang Lijun's art evolved, one senses that as much as he mocks the ideology that shaped his own circumstances and that of his generation, the ignorant simpletons who people the paintings are ridiculed for the lemming-like behaviour they—as representative of the general populous—exhibit. Aside from the specific opprobrium arising from his specific familial classification, Fang Lijun grew up with the same restricted experience and educational dogma as millions of Chinese children. Yet even as any interest in art outside of what served the Party's propaganda needs was refuted, the repressive regime could not eradicate the fundamental human instinct to create that lurked within all those who became members of the New Art Movement and its offspring.

"Frankly speaking I wasn't particularly interested in art at first, however my parents used to give me beautiful covered notebooks. I had to finish all the pages in one notebook otherwise they wouldn't give me another. So I was encouraged to draw. And I had an art teacher too, which other kids did not."

Fang Lijun had many teachers. Primarily, these were engaged by the local Children's Cultural Palace, but another important group was culled from amongst the workers in the local Railway Labour Union. It was here that Fang Lijun would meet the critic-curator Li Xianting, also a Handan native, where they shared the same teacher. As skilled amateurs spurred on by revolution, these art teachers were not technically proficient at painting or drawing. It was their enthusiasm that was inspiring. Most of the kids liked to hang out in the Labour Union with the workers. "I decided to check it out too. I was given paint colours and brushes, and I learned something from them. That was when I began to love painting."

Here Fang Lijun experimented with ink, watercolour, pencil drawing and oils, to recreate a wide range of exemplary model paintings deemed suitable for the students to copy. As Wang Guangyi had experienced a decade earlier with painting on glass in Harbin, painting was engaged in as a game in which the children competed with each other fiercely. "My painting was somehow always worse than the others [and]

1. Li Xianting, "Fang Lijun and Cynical Realism", published in the monograph *Fang Lijun*, 2001, p. 22 (English), p. 18 (Chinese), written 1991, amended in 1996 and 2000.

sometimes they laughed at me. I decided to try my best to improve or I would lose all face. When I studied in middle school, I worked harder still, believing that if I could improve, I would get a better job in the future and not have to be a factory worker."

By 1979, when the entrance examinations for colleges and universities across the nation had resumed, family background, which had controlled an individual's fate during the Cultural Revolution, had become less important. As opening and reform got underway, the State attached supreme importance to building a strong economy. This brought about the institution of a new generation of technical schools and colleges, geared towards turning out graduates who, as fabricated cogs in a modern new gear lever, would propagate the nation's industry and commerce. Fang Lijun was in the process of completing his middle-school education—he was too young to go down to the countryside, not having yet finished highschool. Keen to pursue some kind of artistic profession, he applied to Hebei Light Industry Technical College, a vocational school located in earthquake stricken Tangshan, and was accepted. He arrived at the vocational school four years after the earthquake had reduced Tangshan to rubble. Even though the State claimed that in 1978 steel production was back to 1976 pre-earthquake levels, the rebuilding programme appeared to have just got underway, and progress had been slow. In 1980, the four-storey school buildings of the Hebei Light Industry Technical College were the tallest structure in town. The earthquake had destroyed everything. "When you stood on the roadbridge near the railway, you could see that everything else was lower than you. It was a scene of pure misery! It is true to say that I spent three years studying within the ruins of a city."

The vocations taught at the school ranged from ceramics, to textiles, to graphic and industrial design. At the time Fang Lijun applied, only the ceramics department was recruiting students. So for the next three years he studied all stages of porcelain production. "I was happy to be there but it wasn't exactly what I wanted to achieve." In addition to chemistry and kilns, he put as much attention as possible to fine art. He also devoted time to reading art books but also novels, in particular fiction that had been banned during the Cultural Revolution. In the early 1980s, books cost just several mao (then, one mao was equal to just over one American cent) but people were poor. They certainly did not have money for fanciful indulgences. Fortunately for Fang Lijun, both parents had steady incomes and only two children to support, against the large broods of most families in the industrial city. "That's why I had a better life."

His better life even included a monthly allowance of 25 yuan (one yuan being equal to about twelve American cents). It allowed Fang Lijun a sense of independence others did not possess. The result was that in 1983 at the end of the course, he returned to Handan to take up a prestigious job assignment with an advertising company. This was one of a range of brand new careers emerging in tandem with the nation's economic growth. However, advertising companies were little more than the propaganda bureau of a State-owned enterprise, and no-one had a firm grasp of what marketing entailed, of what the potential reach of such a company could be. Everything was done from

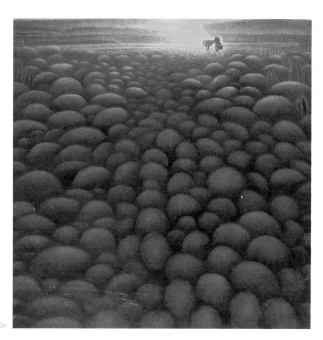
Country Muse II, 1984 ≫

scratch as smart leaders honed what limited entrepreneurial skills could be brought into play as circumstances permitted. They solicited clients, whilst the employees designed the advertisements and painted the product images onto billboards. In this era, the painted billboard was key, the single aim being to make the masses aware of a product in the most visible and immediate way possible. It was advertising in its crudest, least sophisticated form, yet Fang Lijun earnestly channelled his creative energies to tackling the problem of how to present locally produced goods such as cloth or industrial boilers in the most dynamic fashion. Once his quick wit had mastered that, there was nothing more to know and, given the hierarchical nature of the bureaucracy, slim chance of ascending a single rung of the ladder. As an initiative under a State-owned enterprise, the company lacked the autonomy that would have made the work challenging, Further, the people lacked enough disposable income to incite creative entrepreneurs to a competitive edge. "I was in my twenties; those things impressed me deeply. It was a confusing but interesting period."

The company used the meagre profits it accrued to buy painting materials for the workers, and to send them on excursions to art exhibitions or to sketch in the countryside. Fang Lijun delighted in the fieldtrips to the countryside to undergo what was termed "experience of life" in poor rural farming communities to eulogise the life of the people whilst living amongst them. Following one such sojourn in 1984, Fang Lijun produced a series of medium-sized square compositions, using gouache on paper. Painted with a range of mediated yellow-green tones, the works might equally well be described as monochrome in the manner he would frequently employ in future paintings. Here, too, is the first taste of his vision of expansive pictorial space, viewed from a low or high perspective that creates a far horizon squeezed

just inches from the top or bottom edge of the picture plane. Across the expanse, the earth is patterned by incised lines that may be the result of agricultural cultivation or just a means of suggesting the vastness of the landmass. The yellowish glow of light is not indicative of a specific time of day or season. Even where one sketch shows a sky consumed by the murky bloom of a sun, it could be rising or setting. Perhaps it is rising, as in *Country Muse I*, where rounded furrows on the undulating earth snake away to the horizon like the ruffs of fur on a coiled, dormant beast. Or perhaps evening is falling, as in *Country Muse II*, where we gaze over an almost lunar landscape of smooth round boulders to see a solitary figure picking their way towards us, silhouetted against a sinking sun. Conversely, his reference point could have been weather; an on-coming sandstorm or encroaching fog. The somewhat abstract nature of the term "muse" in Mandarin—*xiang lian*—used in the title of these works, possesses an element of melancholic reflection upon the countryside and heartfelt attachment to place. Conceived in the period of Country Life Realism the work dovetailed with the mood of the moment, primarily with that of older high-school children who had been sent down to the countryside, and now mourned lost youth and missed opportunities. This commingled with tender emotions towards the experiences that had been thrust upon them in the countryside. One suspects that even here, Fang Lijun was exploiting an opportunity to probe these emotional depths. After all, most of this youth had been wrenched from the hub of its family group and plunged into hardship and privation in a rural setting that was anything but the glamorous life of healthy labour Mao had promised. A sense of melancholy resonates within the chosen frame of the little paintings, and perhaps explains why Fang Lijun elected to focus on the overwhelming vastness of place; the sense of

≪ Untitled, 1984

isolation and of one individual being so small in the scheme of things, alone, and vulnerable. The vantage point Fang Lijun chose suggests how it takes courage to step forth into a world of Brobdingnagian proportions. This range of emotions, which to a large degree characterises Fang Lijun's art, are found stirring here, but especially one: an awareness that the only way forward was to go out "there", to venture beyond the parameters of this narrow world. In these early works by Fang Lijun, there is further a sense of the earth submerged in water—water being both a conduit to attaining further shores and a barrier between the observer and any far away Utopia of which he might dream. Before the bright, symmetrically ringed sun in *Untitled*, it is hard to tell if the sculpted portion of the paintings below the solar glare is land or lake. Either way, the motifs exhibited here—blinding sunbursts, regular round stones cobbling the ground, and the generally mellow tone of the light and forms—had been logged as motifs in his art. They would be a foundation upon which he would build through the 1990s.

Whilst enjoying the all-expenses paid fieldtrips, in regard of his own job Fang Lijun was not falling in so comfortably with the daily grind: "I couldn't get used to it, and found it hard to grasp the complex relations between individuals within the hierarchy. It was very specific. Like the different ways in which you were required to speak to people in different positions ... this was tough for a young guy to understand." It proved instructive however. By the new millennium, Fang Lijun had achieved an extraordinary degree of finesse in his dealings with foreign members of the business community, and particularly the local community, whom he helped to discover new art in China, to support, to collect, and even take pleasure in. After one year, he decided to resign. It was an unusual and daring move to willingly reject the security of a steady work-unit position at a time when individuals were almost never fired, whatever their offence or misdemeanour. Employees could and did get away with a lot without fear of finding themselves on the job market. However, Fang Lijun felt strongly that: "My work and income were not in the right proportion. My monthly salary was only 41.5 yuan, and I had to paint several advertising boards to achieve it. I usually got a bonus of around 20 yuan but this level of income was not enough to satisfy me. I was also young, and felt that as a man I should do something for my life."

The popular method of "doing something" was to go and earn proper money. It was now that Fang Lijun's inborn ingenuity came into play. More a product of the street than the counterparts in the art circle—who had spent more time in school and had not yet been required to take a job—he was soon to join, Fang Lijun saw myriad potential business ventures unfolding before him. As China inched forward—towards the mythical goal of openness—so a number of choices for the independent person became manifest. One was to do business in the free markets—as opposed to State-controlled outlets, where prices were fixed and related to production quotas. Accommodating excess produce and goods produced by opportunist workers in the employ of floundering State-owned enterprises at highly competitive rates, these free markets were thriving hotbeds of commerce, where people traded various goods freely and benefited directly from the profits. Fang Lijun set himself up selling garments.

"I would borrow goods from a factory go-between and pay him back later when I had sold them. Obviously the goods weren't worth much or he wouldn't have been so trusting." This statement is accompanied by a whimsical look that reveals Fang Lijun has no illusions about the relationship of aesthetic ideals to business. This should have made the garments easy to sell, but competition was making customers wise to the relationship between price and quality—a good nose for a bargain, no less. "I tried for a short period but it didn't work out. I was certainly brave enough—the only one among my friends who had the balls to stand up shout about my wares in the free market. It was not a spectacular failure. Let's just say I was unlucky."

Next, undeterred by the lack of a fruitful result first time round, Fang Lijun approached the directors of the local district railway union with the idea of opening a railway advertising company. "They were interested in my plan. The problem was that I was only thinking in rudimentary terms, like how to set up advertising boards that people would notice." He had not considered how to protect the idea and secure the franchise. His intention was to post billboards along the railway tracks and on trains, which was an innovation for the (Chinese) times. "It was funny that although those district leaders were completely institutionalised in their habits and experience, for some benevolent reason they appreciated initiative. So they offered money and negotiated the sites for the billboards when I needed. I was able to focus on procuring clients and designing the adverts. It went so well that people began to take notice." This innovative idea was deemed too good to be placed in the inexperienced and "powerless" hands—meaning he had no social position or network (guanxi) to support him—of a young upstart, and shut the start-up down. But Fang Lijun had demonstrated the potential for such a company, and the regional railway union heads wasted no time in re-establishing the venture themselves.

One might say Fang Lijun ran on ambition from the moment he was old enough to think for himself. He was never concerned with rising above poverty, for he had not experienced hardship in the way that artists like Wang Guangyi had. The degree of comfort that cushioned his formative years—in spite of the black label his family had carried—allowed him to think clearly, to identify paths that were not open to the ordinary ranks of the proletariat who lived in fear of where their next meal was coming from. Rather, it permitted him to think beyond the crowd, confident in the steps he took. Fang Lijun always had faith in himself, or at least no fear of taking risks. In the two years he spent working in Handan he demonstrated both ingenuity and a desire to achieve. Yet, in spite of all the change that was taking place in China, reform and opening remained entrenched in a process characterised by fastidious pragmatism that reined in the pace of advance, and would largely continue to do so through the early 2000s. Fang Lijun was exactly the kind of bright, hard-working entrepreneurial spirit that the State had created vocational schools to groom. But when these graduates were let loose on society, any gumption they possessed quickly diminished in the face of the oppressive nature of the social hierarchy that confronted them. Inevitably, this gave rise to wild frustration and frequently, where possible, withdrawal from constraining work situations, taking voluntary redundancy or extended compassionate leave. It was certainly the route Fang Lijun felt compelled to

take. He was already dreaming of self-improvement, of studying at university, for the type of improvement he had in mind could only be attained at an academy of fine arts. This set up a new hurdle; if he wanted to sit the entrance examinations to one of the nation's academies he would have to finish the high-school education he had abandoned in going to vocational college in Tangshan. He immediately enrolled in a senior school for six months of remedial studies that would, amongst other things, instruct him in carving printing blocks and hone his drawing skills to a passable standard of accurately rendered realism. Art history was another area to be tested by the entrance exams, together with the individual's general political awareness, which would be appraised by the daunting ideology (culture) exam.

In addition to these studies, Fang Lijun was intelligent enough to realise that inside advice might aid his cause. A series of trips to the Central Academy in Beijing—his first and only choice—were undertaken where he sought out Xu Bing and Tan Ping, both teaching in the printmaking department, to whom he showed his drawings. Flattered by the cleverly calculated attention, both were goaded into parting with valuable tips. Fang Lijun also visited Chen Danqing—the then nationally-famed painter of Tibetan life—in his studio. He was clearly sizing up those considered to be exemplary practitioners in their relative fields.

In 1985, as avant-garde art was born to the PRC amid the blossoming of a New Art Movement of which he was "blissfully ignorant", Fang Lijun was admitted to the printmaking department of the Central Academy of Fine Arts. The Central Academy was the best school of fine art the PRC possessed. In the 1980s, only a handful of students were admitted each year. Since the founding of the People's Republic not a single candidate from Handan had succeeded in passing the entrance examination. In 1985, Fang Lijun was one of two. Once again, the wind was on his back carrying him smoothly forward, as it had seen him was accepted in Tangshan and through his brief flirtation with business. It seemed as if nothing could go wrong, however, eternally unpredictable, history was set to intervene.

Life at the academy was good. Within a short span of time, Fang Lijun had drawn a tight clique of intimate friends around him and was familiar with the best hangouts in the capital. Much time was spent in the area of Shicha Hai and Hou Hai—lakes in the centre of Beijing north of the Forbidden city that were once part of the imperial gardens within—where his friend, Xiao Yu, from the academy's department of mural painting, lived. It was at Hou Hai that Fang Lijun learned to swim. Later, he began to frequent Li Xianting's house, set just fifty metres back from the lakeside, where large groups of artists would gather to drink, to talk, or just hang out by the water. When debates or hunger got the better of them, the assembled coterie would amble along the lakeside to the cheap hole-in-the-wall eateries nearby. Many relationships were cemented at this time. Fang Lijun found no end of interesting people to hang out with. He recalled how at the Central Academy, "Our dormitories were like an inn, especially during the entrance examination season. The beds were constantly occupied by people coming to the academy to sit exams." Indeed, the best of what was new was all the stuff that was not contained in books and lessons, which meant the free environment of the school and its extra curricular activities. There were

lectures, music performances, and a host of other sports and cultural interventions. Artists from around the country regularly presented their works, and academy students were amongst the privileged few to see screenings of experimental films which were being produced by emergent filmmakers who would become famous as the Fifth Generation directors.

When Fang Lijun entered the academy he had had more experience of life than most of his classmates of whom there were nine, including painter Liu Wei, printmaker-turned-photographer Hong Hao and conceptual artist Yang Maoyuan.[2] Having already been through vocational college, worked, and attempted several entrepreneurial careers, Fang Lijun was not the starry-eyed freshman that many of his classmates were. He observed quickly and astutely, and equally swiftly found himself becoming bored. Although he did not notice it immediately, within months of arriving, a sense of disillusionment began to take root: "Before I arrived at the academy, almost all of the teachers there were big names to me. We had all copied their works. But once I stepped into the school and drew closer to these artists, I found that their works began to lose their charm. My attitude towards art became confused." Which attests to the fact that to approach an ideal usually divests it of its mystery.

The rising confusion Fang Lijun now experienced was less because he had begun to accept avant-garde ideas, rather that all the aspirations and ideals he had held about the academy structure were being systematically torn apart by the rigid structure he discovered there. He had mistakenly believed it would be a place of real creative instruction and freedom and all he found was drawing. "I didn't even get into the print studio until the third year. My tutors were talented, but they were not good

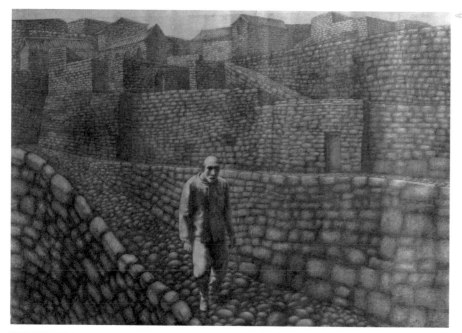

≪ Drawing No. 4, 1988

2. Liu Wei from Beijing Fang Lijun's close friend, fellow Cynical Realist and subsequent neighbour; Hong Hao, also from Beijing, who devoted the 1990s to silk-screen printing, and switched to photography in the early 2000s; Yang Maoyuan from Dalian, who never quite made it as a painter at the time but resurfaced with a new career in installation art in 2000.

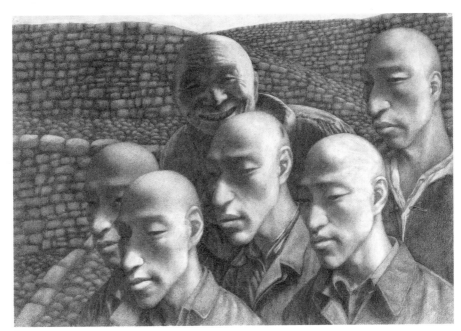

ʌ Drawing No. 1, 1988
private collection Sydney

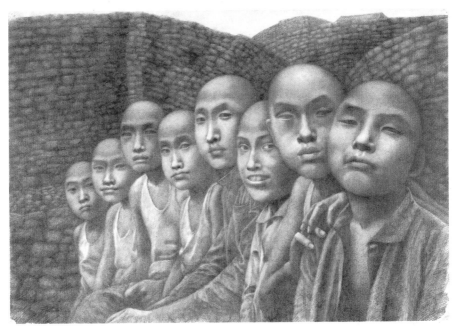

ʌ Drawing No. 3, 1988
collection Art Gallery of New South Wales, Sydney

at teaching. The entire approach was wearing. By the time I graduated, I had lost interest in printmaking. There were serious problems in the methods and quality of the teaching we received."

Intuitively adverse to the constraints of the authoritarian academic teaching regime, Fang Lijun became careful about what classes he attended, and temporarily sought solace in philosophical texts: "I threw myself into Hegel's philosophical writings on logic and made copious notes on the texts. I found the notebook a year or so back. There I was in my thirties, looking back at notes I made when I was in my twenties, which were so confusing I couldn't make head or tail of them or what I was thinking at the time!" He also indulged in extra-curricular adventuring, or a vaguely "hooligan" nature that would be reflected in his art. "As a result, I did not learn very well."

But he did work hard at his art, even where his experiments with form and approach were not considered suitable—most of his work was done alone and unsupervised, and with little relevance to the discipline of printmaking that he was supposed to be studying. Towards the end of 1987 a style began to emerge. It revolved around certain elements that were manifest in the drawings he had made during pre-academy drawing excursions in Hebei. A year later in 1988, the now typical bareheaded figure made its debut appearance in *Drawing No. 4*. At first, these figures were depicted in a simple, naturalistic way. Extraneous exaggeration was kept to a minimum, bearing just a hint of what was to come. The figures took their inspiration from two primary sources. The first was external—the image of farmers from the Taihang mountain region in the east of Hebei. The second was much closer to home and was entirely personal—Fang Lijun's own razed pate.

The first time Fang Lijun shaved his head was in middle school. As a result of his military background, the principal insisted that boys' hair should not cover their ears. "Me and my friends had all been punished for having longer than regulation hair. One day, we all went to the barber's and had our heads shaved clean. We were simply adhering to the school rules." Rather, following orders in a fashion that challenged authority and, significantly, that via one manifest element of individuality, challenged the annihilation of personal distinction within the immediate cultural framework. As China began to open up, Fang Lijun's generation was increasingly aware that this "annihilation" was the root cause of their ennui, and they determined to recover that which had been wrenched from them unawares.

The second time Fang Lijun shaved his head was in 1988 whilst at the academy in Beijing: "I was going through a period of confusion about what I was being taught and couldn't find my own direction artistically. It must have been the heat of summer or something. Coincidentally, soon after I saw some photographs that a classmate had taken of the farmers from Taihang Mountain. I recognised the physique as being perfect for the paintings I wanted to create. Somehow I translated these farmers into bareheaded figures." Stylistically, he never looked back.

As Fang Lijun continued to develop the image through a series of drawings, his initial intention was to rework them as prints. But as the time for embarking

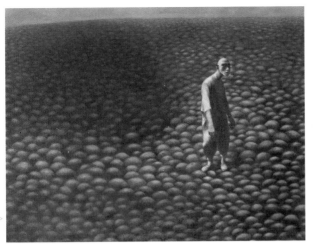

upon graduation work approached at the end of 1988, he had decided to produce a series of oil paintings instead. However, "My tutors were reluctant to let me do that. Oil painting was not part of the printmaking department's curriculum." The personal struggle he mounted against the academy's powers at this time is an important backdrop to his mood, colouring, in particular, the prism through which he viewed the student demonstrations in Tiananmen Square. It compounded an increasing despair of authoritarian governance and rules that might make sense to big-picture stability, but not to those it imposed stability upon. Fang Lijun's depictions of country people already indicated a departure from the conventional pictorial practices of Socialist Realism. There is no glossing over their rough edges or the gauche blandness of their expressions. It is hard to tell what the emotions are here. At times solitary, at others in staggered groups, with their hooded gaze and sharply chiaroscuro'd features, the bald, lubberly figures tramp across fields of cobblestones to no discernible purpose as in *Oil Painting II* and *Oil Painting III*. This provided another perplexing aspect for his tutors. In *Drawing No. 4*, and *Oil Painting II*, the figures turn their heads slightly towards the viewer as if suddenly aware of an observer. Again, it is unclear how these characters feel or how to determine their response to their immediate circumstances. Further, the drawings evidence a revival of the shadowy gloom suffusing the earlier countryside gouache sketches. All the elements that would distinguish his art were suddenly falling into place.

Fang Lijun was still wrestling with the form in his work and gaining faculty approval for it as the demonstrations in Tiananmen Square gathered force. Through the final months of graduation preparations the academy students were drawn like bees to proverbial honey to the astonishing events taking place in the square, just half a kilometre from the campus—which was then in Wangfujing which runs perpendicular to Chang'an Boulevard, one block east of the square. Artist Xiao Yu, one of Fang Lijun's closest friends, commented: "As academy students we knew little of politics. We went to the square for the fun of it, for the excitement of something new happening, the spectacle. There was little intellectual engagement or common ground." Fang Lijun confirms this. "I didn't totally understand some of the things that happened. For example, I signed a petition to release Wei Jingsheng without even knowing who he was." Fortunately for Fang Lijun, there were no apparent repercussions.

As June approached, everything was reduced to turmoil. Except for a small number of drawings and a handful of woodblock prints, against the turbulence of the moment, Fang Lijun was unprepared to graduate, but it soon became clear that there would be no graduation show to aim for. The months of unrest that preceded his anticipated graduation, meant the class of '89 was rewarded with the anti-climatical finale of being swept ignominiously under the carpet. The students were abandoned to drift away, preferably far from the academy, as the authorities clamped down on anyone who might have been involved in the protests. The academy had come under severe scrutiny from the moment the Goddess of Democracy statue was wheeled from its grounds to Tiananmen Square and stationed opposite the portrait of Mao that still hangs there today. This was an immense replica of New York's Statue of Liberty, and which became a poignant symbol of the students' protest. It was equally a symbol which the authorities found entirely intolerable. Its appearance brought the wrath of the State down upon the students, and made the future seem hopelessly uncertain.

Before the Tiananmen Incident occurred, as a student, Fang Lijun had shown a number of his drawings in the "China/Avant Garde" exhibition. He owed his participation primarily to his relationship with critic Li Xianting. Li Xianting's decision to include him in the 1989 exhibition gave Fang Lijun his first exposure in a national gallery—it would be almost ten years until this opportunity presented itself again.

"Initially I was completely unaware of anything concerning this exhibition. Although Kong Chang'an and Hou Hanru [two of the younger members of the curatorial committee] and I lived in the same dorm, we never discussed academic matters." It sounds unlikely given the intense rounds of debate that flourished at this time and

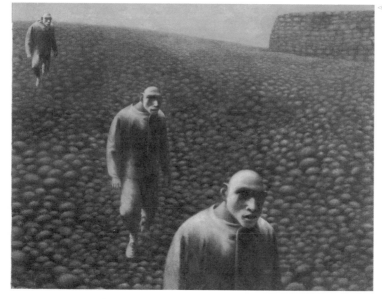

<< Oil Painting III, 1988

in which everyone indulged. In fact, it reflects the complicated relationships rampant within the art circles and Fang Lijun's diplomatic means of dealing with them—giving face to the elder critic who did so much to propel him towards the international art world in the 1990s. In spite of being one of the main curators for the exhibition, Li Xianting was given to acting on his own initiative in selecting artists rather than respecting committee protocol, which required unanimous approval; a system rather less modern than the approach Li Xianting envisaged. With the committee's emphasis on New Art Movement artists, a student like Fang Lijun with no proven track record was unlikely to gain all the necessary votes. Furthermore, drawings were habitually considered as mere preparatory work for formal paintings. Without Li Xianting's recommendation the committee would not have been well disposed towards them. Ironically, with collector acquisition as one of the goals of the exhibition, during the first two hours after the opening, numerous people, both foreign and Chinese, enquired about buying Fang Lijun's drawings, while in general few other offers were forthcoming.

As with most of the students engaged in studies from 1985 onwards, Fang Lijun was not directly involved with the New Art Movement: "At that time, I was young and occupied with my own struggle to make art." Through magazines and lectures given by visiting artists at the Central Academy, he did have a basic knowledge of the movement's protagonists. Fang Lijun is eight years younger than Wang Guangyi, but only three years junior to Geng Jianyi, and the fact that he entered university shortly after they graduated accounts for the distance in experience and outlook he perceives as separating them. Perusing the exhibition, he found no grounds to associate himself with the movement, deciding instead that he stood at the head of the next wave. He dismissed what he saw as the superficial, formal elements of the work of the older generation, pivoted on "too many motifs, gestures, symbols and narrative illustrations of an idea. The "China/Avant Garde" exhibition meant vastly different things to different people. For the 1980s generation of artists, it was the apex of a wave of new creativity." As it turned out, it was also the end of one line; many of the participants gave up art following the closure of the show. "However for us young people it was just the beginning!"

In fact his attitude towards denying emotion and especially the artist's personality in art dovetailed with the theories promoted by Wang Guangyi at the Huangshan conference on new art in 1987, and earlier in the work of Geng Jianyi. And equally, Fang Lijun was not entirely immune to the impact of the New Art Movement artists. After leaving the Central Academy and against the background of resentment and bitterness following June 4, he embarked upon a series of paintings that laid emphasis on the exaggerated heads of his Taihang farmer-inspired figures. Their features were not drawn into reckless laughter as Geng Jianyi had done in *The Second State*, but into cynical sneers and inarticulate foolishness. The most memorable expression, and certainly the one which drew the most comment, was that of the great gaping yawn. Conceivably these figures were inspired to a new scale and unabashed brashness by Geng Jianyi's painting, which was exhibited at the China Art Gallery in February

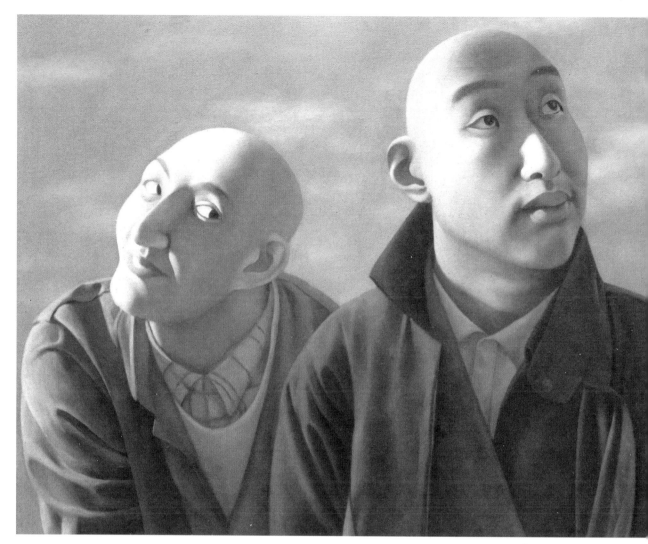

Series 2, No. 5, 1991–92
collection Stedelijk Museum, Amsterdam

1989 together with Fang Lijun's drawings. With a certain nod to the power of the facial expressions Geng Jianyi had created, Fang Lijun took the image of mocking amusement in quite another direction.

When in 1988 Fang Lijun found inspiration in the simple, humble image of rural Taihang farmer-peasants, he had only an inkling of how they would evolve, or how he would employ their physicality to create groups of loafing male figures that were almost indistinguishable one from the other. He would have been amused then by the suggestion that farmers would be transformed into the very badge of his generation. And yet that is what happened as he subjected the loafing physique of a very much benighted sector of the population to a mocking transformation. After all, largely denied a broad education in their youth, his generation had been made stupid and kept ignorant too. Certainly the image of the Taihang farmers was a refractive device.

Whilst they appear to speak of Fang Lijun's own generation, that element of the proletariat about them extends to the great mass of Chinese humanity that had been denied an opinion in the same way that Fang Lijun's generation had been denied its youth and position in society. The expressions remain subtle, glazed by various shades of mockery, disinterest, self-absorption, disdain, or scornful, contemptuous burlesque. Here, self-depreciation is cleverly employed as a conduit for expressing an attitude towards independence and individuality, neither of which Fang Lijun had, although he had been afforded a glimpse of them between 1987 and early 1989. His was the view of an enfant savant who had experienced the past, was witness to the present and ultimately felt disparagingly resigned to what the future would surely hold. This sentiment rippled through Fang Lijun's generation as it sought to navigate the altered reality of the socio-cultural and political environment post-June 4. All were amply able to compare what they had been drilled to expect of the marvellous future towards which China was headed, with the grossly reactive hand played by the State in 1989. It was the gap between propagated Party idealism and disappointingly dictatorial reality. The shock effect of June 4 was all the more forceful coming as it did after almost a decade of opening and reform, and the unprecedented, heady freedoms of the late 1980s.

While the conclusion to his academy studies made for an uncertain end—the entire experience evaporated as if it had been far less than the serious course of study it was—Fang Lijun was at least decided upon his future course. June 4 had settled that for him, unleashing as it did once again "all the evil that people can be capable of", and turning the clocks back upon all the advances that the 1980s had enjoyed. It was particularly disturbing to Fang Lijun who had enjoyed almost a decade of personal progress the likes of which he had not imagined possible as a child. In many ways, just as Wang Guangyi had done, he had transcended his past and triumphed over political stigma and poor social class. For a few years, in spite of needling objections to the academy system, he too had been duped into believing that there would be no revisiting of China's recent political past, i.e. the Cultural Revolution. "After graduation, things suddenly became clear. I knew what my concerns were, and more importantly I knew the approach and techniques required to achieve them. I had decided the work that would occupy me for the next few years: I knew that painting would be my life long pursuit."[3]

Fang Lijun was also determined to stay in Beijing. He might have been a bad boy back in his hometown, but now he was a good student. "My teachers told me I had a good chance of staying in Beijing." And in spite of his disgruntled views he had of academic teaching, which he was smart enough to keep largely to himself, Fang Lijun was recommended to a covetable work unit in Beijing, which came with above average remuneration and benefits. To remain in Beijing required a legal residency permit. Individuals unable to produce papers proving their right to be there were regularly ejected from the capital and, if unlucky, could even be sent for a stint in a labour camp. That did not dissuade Fang Lijun from turning down the proposed job in favour of independence. His degree of self-confidence bordered on arrogance,

3. Pi Li, "A Dialogue with Fang Lijun", in the monologue *Fang Lijun*, published by Hunan Fine Arts Press, 2001, p. 37.

largely due to an unassailable unwillingness to become part of a system for which he had not the least shred of respect.

In July that summer, dodging back and forth between Handan and Beijing as he attempted to secure a safe niche, Fang Lijun persuaded a local farmer to rent him a room in a village in the north-west quadrant of the capital out near the old Summer Palace—the Yuanmingyuan. It was an area to which the academy's students had made regular trips in the course of their studies to sketch from the wild, untamed nature preserved there. The old Summer Palace, once a fabulous landscaped garden of mythical refinity, had been razed by Franco-British Allied Forces in the latter part of the nineteenth century; a particularly painful affront to the collective Chinese memory conjuring, as it did, an era of imperialist colonisation by foreign nations. The ruins were accorded a special place in the heart of Chinese nationals, especially idealistic students. In the 1980s, before urban development began to spill over into the suburbs the area was suffused with rice paddies, lakes and untamed natural scenery. No rubbish was to be found in the streets of the surrounding farming villages, no plastic bags blustered by the wind, nor waste paper caught in the trees and no polystyrene lunch boxes tossed on verges. There were no excluding walls enclosing communities or reliquaries either, leaving visitors free to wander as they pleased. The greater Yuanmingyuan area was home to China's leading universities, Beijing and Qinghua, with the People's University just a few kilometres to the south. On any given day, the grounds of the former palace were pocked with students, reading, studying and making out. From his first visit there in 1987, Fang Lijun felt it was a place a person ought to visit frequently; a place in which he could think.

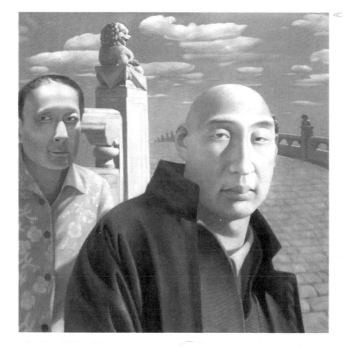

<< Series 1, No. 2, 1990–91
collection Ludwig Museum, Cologne

On one occasion in 1988, his class boarded at Tsinghua University over a period of days to paint at Yuanmingyuan: "Everyday we lay on the grass in the shade of the groves. It was so comfortable. I began to talk with Yang Maoyuan about finding a house to rent somewhere nearby." A search began, and the first place they found towards the end of 1988 was close to Beijing University. "There were now many houses available, cheap, too, but we still couldn't afford them [the rent demanded was 150 yuan per month (USD 18.70)]. Time and again we returned to the academy plotting how to pool our money but it was never enough." Then, in 1989 Fang Lijun secured a room for himself to the west of Yuanmingyuan. He had a compelling motive now—to be near to a girlfriend who was studying at Beijing University. His fortunes had not yet changed and the bulk of the rent money was supplied by his family. "They also couldn't afford to pay all of it but managed to give me 100 yuan a month."

As a young man with no job, living alone, Fang Lijun inevitably fell under suspicion. At such junctures when curiosity went to far, it usually proved judicious to move. Some months later, he and a friend rented a small building in a chicken farm on the fringe of a small village. It was this cluster of humble peasant houses that became known as Yuanmingyuan artists' village. In 1989 the community was in embryonic state, nowhere near the scale it subsequently swelled to as it garnered an outstanding volume of local and foreign press. Its growth was explosive. In late 1989 and early 1990, a handful of artists—initially those living in the vicinity—descended upon the village, encouraging others to follow. The unspoken feeling was that the safety of numbers would offer security and protection against possible intervention from the authorities. But seeking to recreate the energy that stoked the scene through the late 1980s, most wanted to be where the action was. The village's formal existence dates from mid-1990, when of a sudden the trickle of immigrants became a multitude. Within the space of a year, almost a hundred artists had taken up residence there—the number would double by 1992: "It wasn't like now. We considered ourselves best friends. Getting a group together was easy. None of us was professional, we were just free artists. As such we were excluded from the whole of society so it made it easy for us to unite as one group. That's what drove the Yuanmingyuan village."

Fang Lijun's dwelling comprised the simplest of shell structures. That it remained standing was more due to stubborn will than solid workmanship. Two rooms were joined by a passageway. Originally the passageway had functioned as a kitchen, and pipes ran from the stove into the living room and under a brick bed—a *kang*—heating it in the winter in rudimentary fashion if residents could afford coal for the stove. The windows were covered with paper because glass was too expensive. There was no running water and toilet facilities were public, shared by all in the village. "My room was like van Gogh's![4] Not that I had an iron bed like his. Mine was a board balanced on a collection of bricks. Come to think of it, I didn't have any chairs either. I was absolutely poor but because I was young and free it felt great."

If the artists' way of living at Yuanmingyuan conjures images of Soho, Hoxton, Williamsberg or Wapping, while the community aspect might have been similar, the circumstances under which it existed were very different, less the love-hate relationship

4. The reference is to *The Artist's Room in Arles*, October 1888, Van Gogh Museum, Amsterdam.

with the locals than the relentless surveillance by the local Public Security Bureau. Within a tightly controlled socialist society, independence of the kind adopted by the artists was perceived as a mutinous threat to social stability. Despite being ordinary people, the artists were clearly distinguished from the majority of conformist residents by the length of their hair, the alternative style of their dress and the effusive arty stance they assumed when navigating the village. In general, the atmosphere in the community was intense. A counterpart to the poverty that inspired a euphoric sense of brotherhood and solidarity, was the pressure of being scrutinised and alienated which drove divisive alliances, mutual suspicion, and fights. Simple enjoyment of freedom in the studio and the process of making art, was punctuated by periods of hanging out during which earnest aesthetic debates were oiled by copious amounts of beer and bitching sessions about who was doing what that often got out of hand.

Fang Lijun taught part-time at the Central Academy of Fine Arts and twice a week rode his bicycle—a 30-kilometre round-trip—or took a bus to Wanfujing for the two-hour lessons. This earned him 100 yuan a month, just enough to pay the rest of his rent with little left for living expenses. Often, nothing but noodles and salt lined his cupboards, which meant he was freqently forced to "acquire" cabbage and coal from his peasant neighbours: Beijing people habitually store their annually allotted mountain of cabbage outside, and because the supply was so voluminous no one anticipated its theft. But then no one had anticipated the impoverished circumstances of displaced, unemployed youth—a by-product of modern market forces that had begun to take effect. "You often saw artists out to steal stuff at night. It was so cold, and none of us had money to buy anything—not even cabbage." Fang Lijun was fortunate in being able to supplement his income further by producing book illustrations: "Otherwise, I had to borrow from friends."

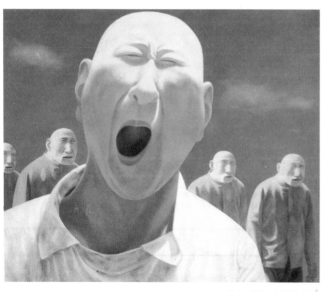 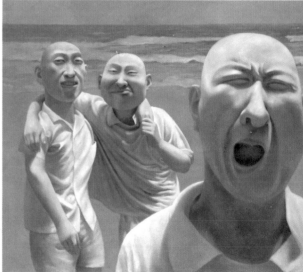

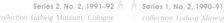

Series 2, No. 2, 1991–92 ⋀ ⋀ Series 1, No. 2, 1990–91
collection Ludwig Museum, Cologne collection Ludwig Museum, Cologne

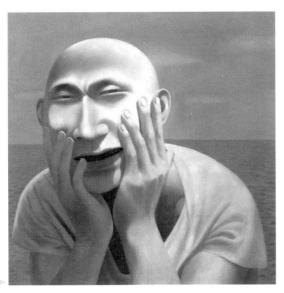

Through the twelve months following his aborted graduation, Fang Lijun continued to work with the medium of drawing; simple pencil marks on paper transformed into anything but simple results. The drawings are intricate, detailed and highly finished without losing any of their ululating vibrancy. He produced oil paintings too, rendered as if traced with a pencil and not a brush. *Series 1, No. 2* shows a relaxed unequivocal youth, with a girl in his shadow, standing before a typical ornate stone bridge. It is almost like a tourist snapshot, except the moment it captures in frame is dour, and non-committal. If the shape of the bridge is an allusion to the ones in front of Chenlou Gate, which sits on the north face of Tiananmen Square—the gate upon which Mao's portrait hangs—then this image is the very opposite in intent of a happy commemoration. It is one of the few instances where Fang Lijun resorts to a literal motif to signify "China" in the broadest possible sense. What is also visible in this work is a pictorial device that he put to work through the next series of paintings and which owed its origin to the drawings executed at the Central Academy. In the same way that he had portrayed village children with bald rogues behind them, so he depicts an innocent-looking girl or a child in what appears to be a landscaped setting, with the cynical louts loafing in the background, quirky smirks playing across their lips. They appear to be drawing nearer and yet are not exactly threatening to the figures in the foreground, more indicative of an intrusive menace. This was Fang Lijun's visual representation of the world as he experienced it: how authority made its presence felt to the individual. The loafers thus take on a double role as his outcast generation and as an embodiment of the darker side of life in China that lurked within everyone's shadow. Still, here the irreverence is more comical than bitter. But then, Fang Lijun was just getting into his stride.

In the latter half of 1990, he produced a draught of the howl or yawn that dominated the painting which made the cover of the *New York Times Magazine* at the end of 1993. It was initially produced on canvas as *Series 1, No. 3*, his first callously cynical expression. Behind the figure that contorts his features, are two *ger men'r*—meaning brothers, buddies, to use colloquial Beijing argot—leering, sneering, a gaggle of lads having a boys' day out by the sea, which rolls freshly on the broad shore behind them. It could almost be Margate, for the yobbishness it conveys is universal. It is natural, too, in as much as it illustrates the attitude of friends at Yuanmingyuan, and

the stance they were unwittingly forced to adopt in dealing with a society that pitted them against it. The casual way they wear cotton jackets and shirts, collars open and skewed, and "radish" trousers—as the then-fashion was termed for pants that gripped ankles in a narrow embrace and ballooned out to baggy folds around the waist—indicate the attempts of would-be independent individuals to personalise the de facto uniform of the age. The one exception is the Chinese-style collarless jacket, which became Fang Lijun's distinctive trademark.

In another, *Series 1, No. 6*, a solitary guy hunkers down before the same sea, closer now, perhaps on a boat for the frosting on the incoming waves is no longer visible on the ocean that spreads behind. The figure stares out at us, eyes slit against the light, resting his chin in his hands. The gaze is ever so slightly quizzical, ever so slightly bemused at whomsoever is observing him so closely, as if musing on exactly why anyone would wish to look that closely, that attentively, with that much care. For Fang Lijun, the joke was that usually it was only the authorities that did.

As 1991 became 1992, people were beginning to watch Fang Lijun closely, too. Gallerists had begun to visit from Hong Kong and the intimacy he maintained with Li Xianting put him in the front line, for all foreign interest in new Chinese art was invariably fielded through Lao Li, as Li Xianting was known to close friends. Up until

that point, Fang Lijun had never seriously believed that his art could make money. It did not tally with the Chinese economic and cultural environment. However, that his main *ger men'r* Liu Wei had sold a few paintings suggested it might be possible: "We decided we had to find other ways, or go more frequently to parties in the diplomatic compounds." In 1991, his wife Michaela organised a show for him and Liu Wei in her apartment. Francesca dal Lago, who had studied in the art history department of the Central Academy at the same time as Fang Lijun, curated a second two-man show for the pair in 1992 at Beijing Art Museum. His advances were being well received, yet overall Fang Lijun showed himself to be conservative—to the point of being shy—when it came to dealing with foreigners either en masse, or in the privileged environments in which they lived in the capital. With no English language to help him, he limited his interaction to those who spoke Chinese. Where many did not, his sense of exclusion was never far away, always present in the nettled flicker of dulled eyes, even where foreign nationals strove to make him and his artist friends the centre of attention.

Following his marriage in 1991, Fang Lijun lived in a number of foreign compounds but maintained a space at the artists' village until 1994. The arrival of the first gallerists in 1991 brought the worst period of poverty, which lasted little more than a year, to an end. But as foreign dealers began to show an interest in the work of the group of artists led by Fang Lijun, the upswing in their fortunes sharpened the sense of desperation in others. In Yuanmingyuan, the side effects of the new avenues that were opening up were rivalry and discord. The village began to fall into disrepute as more and more arty types moved in and the atmosphere became depressed as tempers fired by frustration flared. Arguments and fights became a common occurrence and cohorts of like-minded artists began to form. "Slowly, we became divided into factions, but even members of a particular group could not remain in each other's company for too long."

To those stuck in their parents' homes, or in squashed dormitory accommodation provided with a mind-numbing job, the allure of the artists' village was the possibility of finding like-minded company, inexpensive living, and of becoming part of an elite creative camaraderie. The allure of becoming part of the myth of the "artists' village"—a moniker that the press was quick to attach to Yuanmingyuan and which the arts community actively encouraged—also encouraged artists. The cluster of humble dwellings enclosed by high protective walls, in which the alchemy of art was conducted, swiftly gained notoriety. A notoriety that ensured, within the climate of early 1990s Beijing, it could not enjoy the prize of longevity. In the eyes of the authorities, the wrong kind of people—people the State deemed far from the desired model socialist citizens—were attracting too much attention. Ironically, as the first generation of cultural entrepreneurs, the best of them would make invaluable contributions to the image of a thriving creative spirit in China, and largely devoid of the corrupting practices that plagued most other enterprises. In 1994, the result of all this attention was forced eviction from Yuanmingyuan, which was completed within a year. By 1995, there was little to indicate that any artist had ever set foot in the village, not least because, on the strength of the income received from these

so-called social misfits, the peasant landlords begun building grand new brick and concrete villas, complete with blue-tinted windows and white-tiled exteriors: the very emblems of the new working-class homeowner. The fame of the Yuanmingyuan artists' village rose in measure with that of Fang Lijun and a handful of its other inhabitants. Many more fell frustratedly by the wayside. The village's collapse was inversely proportionate to the upward trajectory Fang Lijun's career was moving along as he left it behind for new pastures. He was about to become the first contemporary artist to join the ranks of working-class homeowners.

The style that Fang Lijun arrived at during his years at the Yuanmingyuan artists' village was one of the main inspirations for the term Cynical Realism. Coined by Li Xianting, it was applied to a number of artists working with figurative forms, distorted by varying degrees to parody recognisable scenes from daily life. In fact, the term *tiaokan*—also meaning cynical or satirical in Chinese—had first appeared in connection with China's new art in an article written by art historian Zhou Yan in 1991,[5] as part of an introduction to an exhibition of paintings by the two artists Wang Jinsong and Song Yonghong. Li Xianting's use of the word "cynical" was born of a slightly different origin—*popi* in Chinese—which he explains in rather circumlocutory fashion in his essay on Fang Lijun.[6] Whatever the source, essentially, the inference boiled

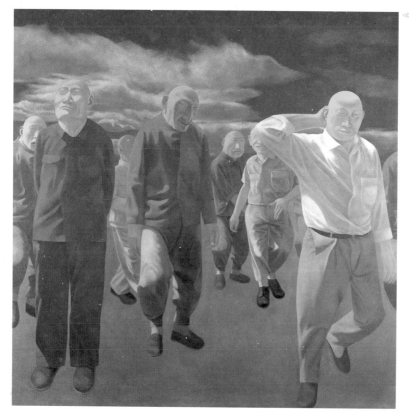

≪ Series 2, No. 4, 1991–92
collection Guy and Miriam Ullens, Belgium

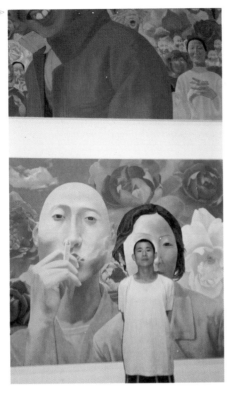

the 45ᵗʰ Venice Biennale, 1993 ≫
photograph courtesy
Wang Youshen

down to a tangible irreverence in the spirit of the art.

On the surface Cynical Realism appeared to challenge the orthodoxy, namely that which Fang Lijun's generation considered the outmoded practices and doctrines of their cultural framework. They were not exactly intent upon negating the constituent power of propaganda. In fact, they adopted the leading, most dynamic pictorial elements at which the Party had excelled, such as a minimal use of colour, laid down in bold, primary planes within decisive lines. The result was clarity of expression that bordered on caricature. And caricature certainly had its uses when commandeered to artistic insurrection. Yet, whilst some artists of the New Art Movement at times played wantonly with fire, the generation that followed immediately after, with Fang Lijun at the helm, never came close to real insurrection in their art. They were far more diffident than their immediate post-Mao era counterparts, for open confrontation had never been encouraged in Chinese culture. "Pulling the tail of a tiger"—a Maoist phrase—inevitably resulted in the most unpleasant of consequences. The younger siblings of the avant-garde artists settled for veiled dissension towards what was for them untenable: the adherence to a single ideology, perspective or worldview, which Cynical Realism suitably refuted.

The substance of Fang Lijun's paintings took a slightly divergent course from the work of other Cynical Realist artists such as Liu Wei, Wang Jinsong or Song Yonghong. The difference related less to particular scenes of daily life than to the personality types that populated them; to the roguish louts and their emotional ennui. Where other artists relied on narrative to commune with their audience, Fang Lijun eschewed it altogether, determined to create the ultimate in ambiguous imagery, a sensation that persists. His work differed from the early paintings of Geng Jianyi, which were concerned with distilling out human emotion as in *Two Figures Under a Light*, or *The Second State*, in which a single emotion is clear. Fang Lijun intended to confuse people, to find a middle moment in which the expression could go either way. Still, from whichever angle you viewed it, Fang Lijun's artistic style is rooted in realism or figuration; not the absolute classical realism favoured by the academicians, yet figures with a bent that pertains directly to his own experience and sense of the world around him.

5. Zhou Yan, Tiaokan Zichao, *Beijing Youth Daily*, 1991.
6. Li Xianting ibid., p. 23 (English), pp. 18-19 (Chinese).

Although there is always a degree of distortion in the anatomy of Fang Lijun's figures, the mood and expression are rendered with painstaking accuracy. It is worth recalling just how beautifully crafted his early drawings are. Right from 1984, the attention to detail is extraordinary—although this is nothing less than what was proscribed as the "correct" way to sketch during that era. In his drawings no part of the picture plane is left uncovered, every inch of pictorial space lovingly accounted for with the kind of steadiness of hand and keenness of eye that suggests a caring precision. The results are neither overly starched nor overdone. The deliberate lack of action or identifiable narrative in the paintings is a perfect invocation of listless aimlessness—even those paintings in which the figures appear to be engaged in some form of motion (usually those mindless activities devised to kill time, equivalent to skimming stones, or flicking coins). Here, the accurate gauge of a mindset mirroring sentiments and images described the novels of Beijing "hooligan" author Wang Shuo are rendered in paint. Wang Shuo's writing defined a roguish literary style. Tales of bad boy street gangs and a modern style of living, both new and outrageous when viewed through the prism of traditional Chinese values. It earned his novels the genre name of hooligan literature, which was also applied to the painters of the Cynical Realist school. Whilst horrifying the authorities, such images, written or painted, were evidence of the modernisation of Chinese society. A youth culture was emerging, bonded together by the primary essence of adolescent emotions. And conforming to generic notions of rebellious youth, Fang Lijun's message was underscored by a large helping of cynical negation without the offer of any clear solution or value judgement that might help society see the error of its ways or justify the moral values that such cynical rogues might hold. In its reaction to June 4, the State provided affirmation that the people, in particular young people, had no voice or role to play. This encouraged them to shrug off all responsibility to a society over which they had no control and no apparent hope of a meaningful individual existence. So they became alternative

people; artists. "We have to do something to solve or release the problems and the pressure we encounter in daily reality," Fang Lijun contests. His generation, in truth, had not been broken by the Cultural Revolution, and was neither haunted nor overly bitter about it either. It was a fine margin of years that created a watershed between them and the beleaguered generation of their parents or the older New Art Movement artists. They had often been left to their own devices, and knew how to hang out and amuse themselves. Some perhaps wished to get educated as Fang Lijun had done, but socialism had bred laziness. For those who could not knuckle down to a dead-end job, there was little incentive to do anything. The picture of what the "better" Chinese world post-Mao—especially post-June 4—could be was extremely blurred.

Of all the schools of art that arose in the wake of the New Art Movement, the Cynical Realists were the youngest and most energetic. Their mockery of the world illustrated their scepticism and mistrust of terms such as modernisation, advance, and reform in the face of the State's duplicity. It was an impression that required time to annul. Change might have been happening apace, but these were neither fast enough nor relevant enough to satisfy the raging energies of the sagacious youth that was Fang Lijun's generation.

As indicated earlier, by the time the Yuanmingyuan artists' village collapsed, Fang Lijun had moved on. With his "great howl" on the cover of the New York Times Magazine and a selection of his works capturing imaginations at the 45th Venice Biennale in 1993, his career had accrued a firm foundation. The paintings that he had created in the several years since he left the Central Academy had arrived at a definitive style and a level of public interest that demanded to be taken seriously. Certainly more seriously than was compatible with life in the artists' village. The tumbledown dwellings at Yuanmingyuan could no longer contain the scale upon which he wished to explore ideas. In casting his eyes around for a new location, his attention alighted

upon Tongxian (since 2002, following rapid expansion, known as Tongzhou—*xian* meaning borough, whilst *zhou* means county), a new suburb on the far eastern side of Beijing and, on the advice of a friend, the tiny rural community of Songzhuang. Songzhuang is now conveniently linked to the capital by a fine new express highway. In 1994, there were only byroads and dirt tracks. The first thing Fang Lijun did was to get his driver's license.

Songzhuang offered ample plots of land. Agricultural modes were changing as Maoist Communism was set aside to rot down like old compost and the inefficient commune system was retracted. Small communities like that of Songzhuang preferred to profit from the land by leasing it rather than working it, especially now that the practice had acquired a degree of legality. It was a perfect place to make art away from all the distractions of dwelling in the midst of an infamous community—although it would be only a matter of years before Songzhuang had become as famous as Yuanmingyuan and enticed far more visitors. By 2001, the concentration of artists in the village was more than double that of the Yuanmingyuan at its height. On the strength of this, the broader community banded together to produce its own artists' directory, a Who's

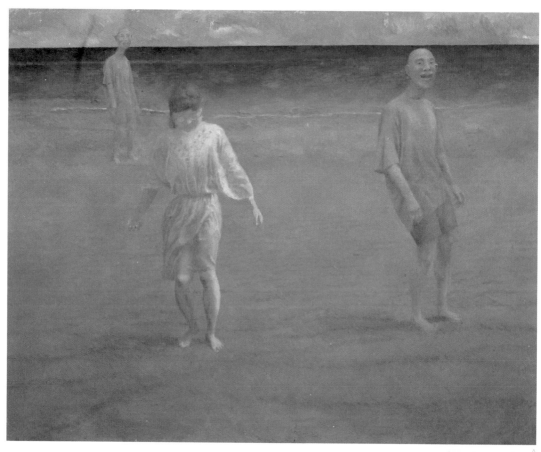

Oil Painting IV, 1989–90 A

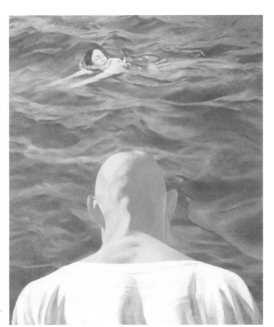

Who of Songzhuang which listed several hundred artists.

With the help of his friend—whose father lived in the village—Fang Lijun secured a 70-year lease on a substantial plot of land which housed a rustic courtyard, some out buildings and enough open ground to erect a studio. The result was a simple home and an expansive area in which to paint, with few concessions to interior luxury. But then in 1994 home-improvements and DIY had not yet become fashionable. A number of close friends were swift in following Fang Lijun east, including Liu Wei, Yue Minjun, and the critic Li Xianting. In the beginning, they did what they could to renovate the dilapidated buildings. The palatial studio-homes, each one more expansive than the last, would come later together with high boundary walls—for the more famous artists—to keep random sightseers at bay. The village was relatively idyllic by comparison with other untamed suburban farming communities of the time. It was well kept, thick with trees and surrounded by cornfields that were luminous green in spring, deep brassy gold in summer, and burnt black as bitumen through the autumn, a dramatic contrast to the brilliance of the harvested corn, which local farmers raked out to dry in neat patches across the village lanes. Through the changing seasons, the air carried the aromas of the fields, of manure, hay and harvest, blended with caustic odours from run-down factories a few miles further out, and the merest hint of the scent of oil paint.

Fang Lijun's courtyard contained a unique feature: a bathtub-sized pool recessed into the earth of the enclosed yard directly in front of his studio. Newly planted—by his diligent and green-fingered father—and struggling to flourish, the flora in this yard had been carefully laid out to hug but not obscure the pool. The pool was formed of concrete, grey as the charcoal tone of the monumental woodblock prints he would soon create, and might have been mistaken for an over-sized birdbath. The only bird that bathed there was the rare breed of one solitary Fang Lijun. Through the glazed wall of his studio Fang Lijun could keep the water permanently in his sights, and as soon as the season permitted, could step outside at regular intervals to immerse himself in its cooling embrace. It was in this bathtub that he collected his thoughts and contemplated the progress of day's painting. It was his model as much as his muse.

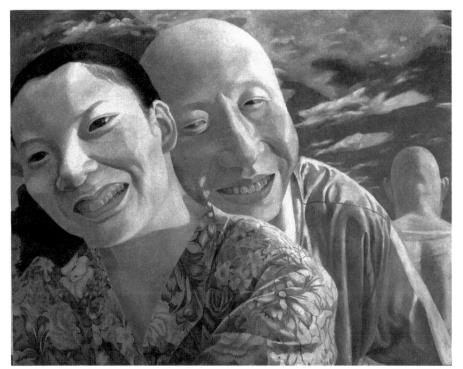

Series 2, No. 8, 1991–92 ⚤

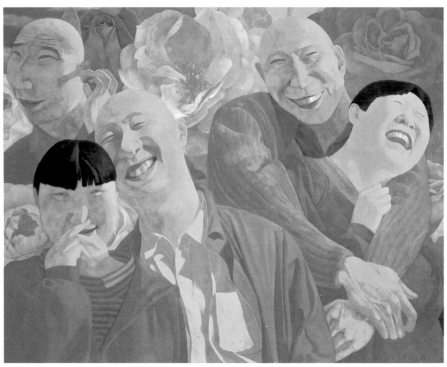

1993 No. 6, 1993 ⚤
collection Bruce Hoeksema, Rome

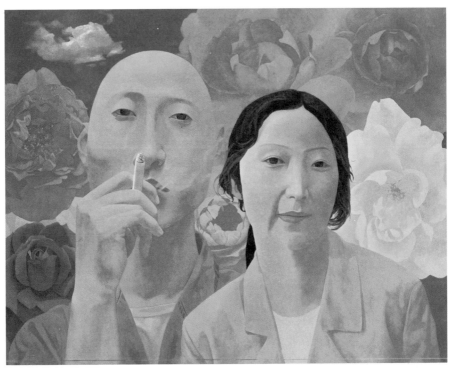

△ 1993 No. 5, 1993
collection Valentino Garavani

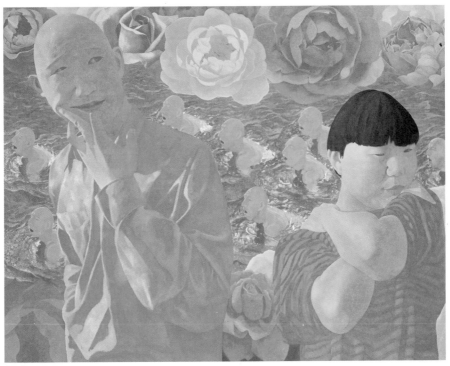

△ 1993 No. 1, 1993

Fang Lijun at his Songzhuang studio, in the "birdbath", 1994

Water appeared in Fang Lijun's painting as far back as 1984, as we have seen, but it was not investigated in earnest until 1989 and then as the backdrop to three figures on a beach. Later, when variations on the poses and facial expressions depicted there were brought to canvas, the seascape was all but excluded in favour of an undefined space capped by a brilliant cobalt blue sky. In a number of compositions painted between 1990 and 1992, the sky was necessary to the perspective, for the viewer was required to look up at the straggling gaggles of louts rather than across at them as one would on parallel turf. This is one example of those subtle political undertones, which here paid homage to the Socialist Realist style, where the only way to view a hero was at his feet looking up. The angle was critical to reiterating the act of hero worship and to Fang Lijun's cynical comment upon the status quo.

The focus on water appeared in a 1993 painting. It evolved in tandem with two other elements that were already present in his oeuvre but not in this form. First was the oblivious swimmer, eyes firmly closed, someway out at sea, away from any reachable land. Second was a bald-headed Fang Lijun with his back to the viewer, staring at the sea. The suggestion was that he was about to dive in. Yet, for some reason he hesitates to plunge into the void, suspended indefinitely in his indecision. Perhaps he was simply enjoying the insult his posture provoked, for at this time, almost ten years after Zhang Xiaogang, Wang Guangyi, Zhang Peili and Geng Jianyi had been confounded by this issue at graduation, it was still considered an affront to depict a body with its back to the audience. Here, Fang Lijun did so blatantly.

What came next was a series of works that seem to depict an interlude of romance and joy that lifted him out from under his mantle of roguish cynicism. Life had settled into a stable routine. There were exhibitions to paint for and career relationships to maintain. He was one of the elite emerging artists whose art had spawned a school. Under these distractions, the tendrils of recent history began to release their hold on him. Paintings such as *1993.1* and *1993.6* visibly illustrate an insouciant current of apparently personal emotion, the colour saturated with joy, the clothing bright, fashionable and casually stylish. The artist-lout now appears as a loveable rogue hugging his girl with a beam of delight that he simply can't suppress. However, the veneer of happiness was just that. What is really at work here is a response to the mood of the moment: to how society had once again allowed itself to be duped into believing that the bright tomorrow they had waited so long for had finally arrived. Fang Lijun seemed to sense that the bubble was poised to burst.

When water began to feature in Fang Lijun's paintings in earnest from mid-1993, it too was outwardly characterised by sensuousness and warmth and suffused by tender emotions. This related directly to a divergent avenue of exploration. In the early 1990s, he was often to be seen at the pool in the Friendship Hotel—where he lived for a while with his wife, and where many arty types hung out—experimenting with an underwater camera. He travelled to the beach and translated his varying experiences of water across canvas, alternating bright colour and monochrome greys. In fact, when Fang Lijun began painting expanses of water he was in a phase of painting in monochrome, usually a range of chromatic grey tones. It was only in 1994 that his water world attained a rich cerulean intensity matching the stretches of sky seen in earlier paintings as the backdrop to the shuffling passage of the lumbering bald-headed youths.

Superficially, the water works depict a body subsumed by an oceanic swell, floating, undulating, glimpsed in passing as it drifts. Yet these works are far more complex than they seem: in many ways they are an important subtext to the main story that unfolds in Fang Lijun's art. The water motif conjures a sense of freedom without bounds,

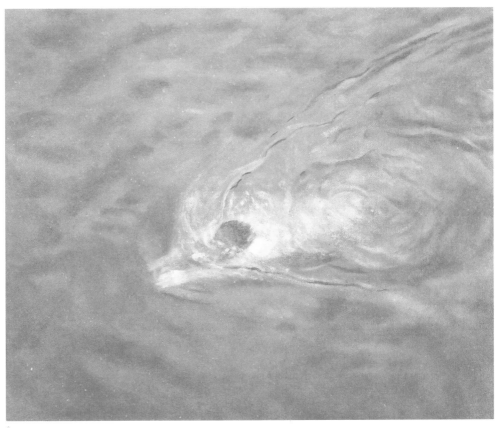

⋀ Untitled, 1995
collection Silvie and Peter Seidlitz

of immersing the self in total harmony with the waves. Yet at intervals, it gives the impression of menacing the swimmer who is forced to tread water endlessly whilst the mind takes stock of the situation in which the body finds itself. The water is habitually boundless with no beginning and no visible shore, whether on a painted scale small or vast. It never seems more navigable or less engulfing. This suspension in a great expanse of sea again revisits the futile power of one individual alone consigned to an overwhelming watery realm. Water compositions would remain a constant aspect of his repertoire in the coming years. They are the most visually simplistic of both his paintings and his prints, but simple does not mean easy. Initially, Fang Lijun struggled to depict water in a convincing manner. It became a challenge, but the motive was not to conquer a technical hurdle. Here was a compelling image he wanted to pursue and on a large scale, proficiency was essential. In retrospect, it appears a subconscious metaphor for Fang Lijun's expanding world and his increasing entrenchment

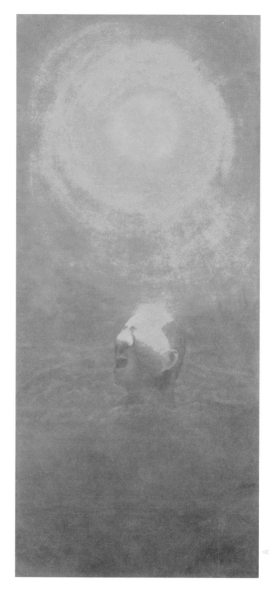

◁ 1997 No. 3, 1997
collection Dr Peter and Susanne
Fischer, Germany

within it as he took on the responsibilities required of him as a professional artist. Ultimately, this resulted in a dynamic return to printmaking in 1996 that set a new benchmark for scale of vision. Through an incredibly concise and adroit approach to line, he continued to cast his solitary figures adrift in great oceans of water, but the timbre of the expression had clearly changed. The sense of ease witnessed in the luxurious blue paintings diminished. Heads now seemed to struggle to rise above the waves, gasping for air. In many, the swimmers fight for breath is almost audible. But whether the features are screwed up in exertion or agony is never quite clear. It does not need to be. Whatever the complexities driving the emotion, the wood-carved water scenes remain amongst the most powerful and memorable of his images.

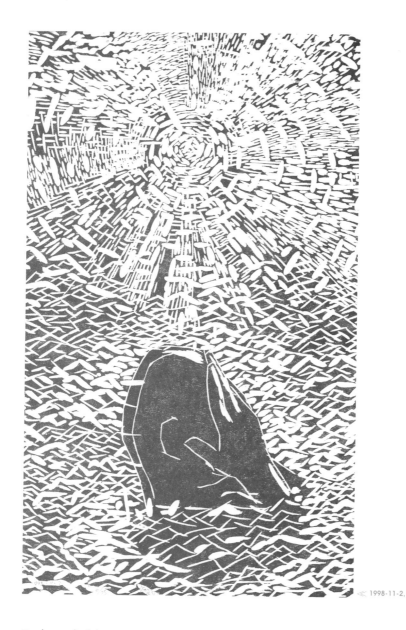

1998-11-2, 1998

By the end of the 1990s, water was once again lulling and assuaging Fang Lijun's body and mind. It was a comfort zone. Through 1997 he produced a series of paintings that revisited the yellow palette and sunlight-flooded scenes that were hinted at in the 1984 gouache works and threw him into xanthos realms thickened with impenetrable mists and viscous seas. Water clearly represented the space he allotted himself in which to contemplate a mood, a sensation, into which he periodically dived before returning to bigger issues of humanity, identity and the socio-political paradigm that overshadowed his generation. It was also at this time, following a period of living in Amsterdam from the summer of 1997 to February 1998, that he quietly got divorced. Apparently, his earlier doubts about romantic bliss and happiness were not without foundation.

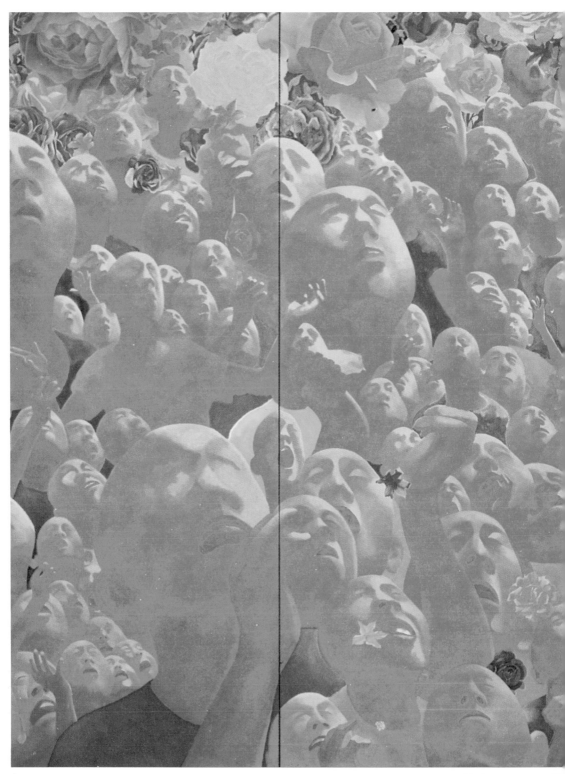

△ 1998 Untitled, 1998 (five-panel work, detail)

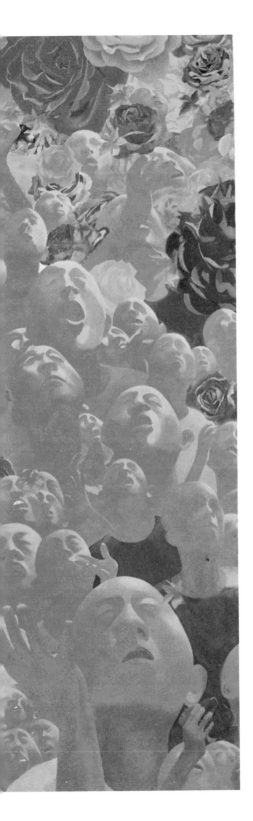

As China advanced through the 1990s, with the economy and consumerism swiftly booming in its wake, the pace of society picked up and the general sense of malaise engendered by June 4 gave way to hope and feverish enthusiasm at the changes taking place. This mood appeared to be mirrored in Fang Lijun's paintings; not in the introspective water works which remained very much his private domain, but in the heaven-ward sky-capped crowd compositions. In general, the colour became brighter and purer, once again flowers bloomed profusely across the picture plane as they had in the mid-1990s, and the inane grins of the generic rogues were incrementally replaced by blissful smiles or blank, open-mouthed introspection. In the paintings, the bald-headed youths perceptibly lost their hooligan angst as Fang Lijun delved into the impact of the cultural framework upon the people. In no uncertain terms, he perceived them as having swapped one ideology for another, Maoism for Dengism, Communism for Socialism with Chinese Characteristics. Duped into stupidity, they were accepting of anything that came their way; willingly ignoring that fact that they continued to exist without any true individual power or voice. Yet, in surfaces of rich colour and floral bouquets, he masked his mocking disdain well, switching back and forth between small groups of figures, often himself alone, and immense crowds.

The multiple-figure compositions Fang Lijun began to produce in the late 1990s (as paintings and woodblock prints) comprise an inordinate and complex volume of people. The generic individuals within these intricate crowd compositions invoke the ethereal naivety and simplistic yearning of children, for they were increasingly younger than the angry, irreverent young turks in the earlier works. Here, Fang Lijun points to both the innocence of childhood that had been denied him, and the sense of loss this engendered as he matured, mingled with the mass blindness of society. He defines a person's understanding of humanity as stemming from childhood experience, whence the emphasis on youth is apt. Certainly, as he began to depict masses of young people, his point about the annihilation of individuality was strongly brought home. In one tangibly cynical aspect of the paintings, Fang Lijun renders the figures with "flesh" colour, straight from the tube. Experience of travelling abroad led to the discovery that there is no equivalent of specifically named

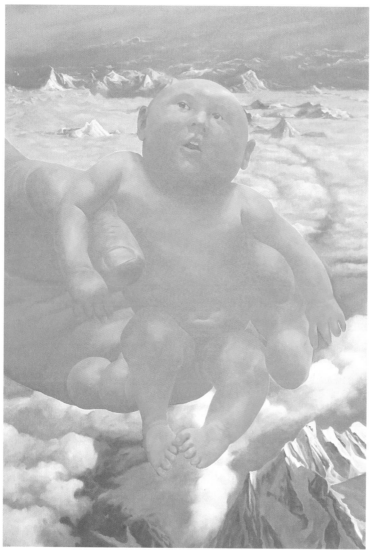

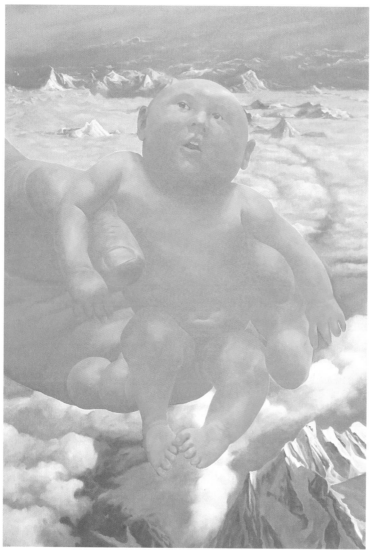 Untitled, 2002

flesh colour in the range of pigments offered by western oil paint manufacturers. This subtle element is his conduit for demonstrating the mad notion of a single, immutable manufactured colour of skin, which even in China is inexhaustible in variation. (It equally reflects the western view that all Chinese or Asian people look alike.) To the casual viewer, the figures in the completed paintings glow with ruddy health, the strong pinkish-orange harmonising with the cobalt blues that perennially wash across the nebulous backdrop. One might further suggest that the sanguine depths of the flesh tone is a cynical allusion to the rosy cheeks and healthy complexions of Chinese Socialist Realism, de rigueur for rendering the whole spectrum of the people, from young pioneers, peasant folk and workers, to revered revolutionaries. The flowers that float within the pictorial space also allude to the blooming of a hundred new

thoughts and ideas—subconsciously scoffing at Mao's own Let One Hundred Flowers Bloom campaign—as China embraced a market economy.

Each of these elements is invoked to give pictorial form to the "abstract essence of humanity".[7] Crowds, masses, of people, stretch as far as the eye could see within the picture plane, covering every portion of the ground. Gazing forward and up suggested an internal vision of Utopia, as was the customary interpretation or reading of such stances under Mao. Where the smiling innocence or idiocy of the expressions is rained upon one focal point, we are reminded of Geng Jianyi's tale of the man who wanted to sneeze. In demonstrating a similar point, Fang Lijun denies the figures any individual traits that would distinguish one from another: he simply repeats the same figure again and again. Not infrequently, they raise their arms like a million fans at a pop concert or blissed-out dancers at a rave, stretching their hands up in anticipation of a shower of glitter, a rain of bubbles or lollipops, a burst of mind-blowingly beautiful light. Here, what is strewn down upon them are the lush blooms of heavy, lurid flowers: all those open ideas that people—intellectuals—had been encouraged to speak forth, only to be crushed by the people-masses. Fang Lijun is clearly cynical about what such manna from heaven implies. His work thus remains cynical but is now so much more human, political in the broadest sense, dealing as it does with the human condition, specifically the metamorphosis of the Chinese people.

In his inimitable role as trendsetter, Fang Lijun was one of the first of the new Chinese artists to be accorded a major solo exhibition at a significant foreign art museum. That took place at the Japan Foundation Forum in Tokyo in late 1996.[8] It was followed by a second at the Stedelijk Museum of Modern Art in Amsterdam in 1998, and a third at the Ludwig Forum of International Art in Aachen, Germany in 2002. He has attained a respectable plateau, and more importantly, is fully in control of his career. Increasingly, it is the local cultural environment and the opportunities it presents that occupy his ambitions.

Grave as the China situation was when Fang Lijun started out as an independent artist in 1989, by the time he had gained an international profile, it had blossomed into a society that offered a multitude of freedoms, opportunities and leisure activities—especially to those able to afford them. Fang Lijun is typical of contemporary artists in China who were never so much "underground" as marginalised to invisibility above it. Without a job in a work unit there was no official record of his existence after leaving the academy, no personal dossier following him around, no colleagues or neighbours to keep tabs on his movement or activities. Chinese artists remain present but largely ignored in public life. A handful of State-run museums are beginning to change this. In 2000, for the third Shanghai Biennale, a series of Fang Lijun's monumental woodblock prints was prominently displayed in the main ground floor exhibition hall of the Shanghai Art Museum. In 2002, he was accorded a retrospective together with Wang Guangyi and Zhang Xiaogang at He Xiangning Art Museum in Shenzhen. Following a six-month overhaul, the National Art Museum of China, which previously shunned his work, included a woodblock print in its inaugural exhibition.

7. Pi Li, "A Dialogue with Fang Lijun", Fang Lijun, p. 40.
8. "Fang Lijun: Human Images in an Uncertain Age", Japan Foundation Forum, Tokyo, November–December 1996.

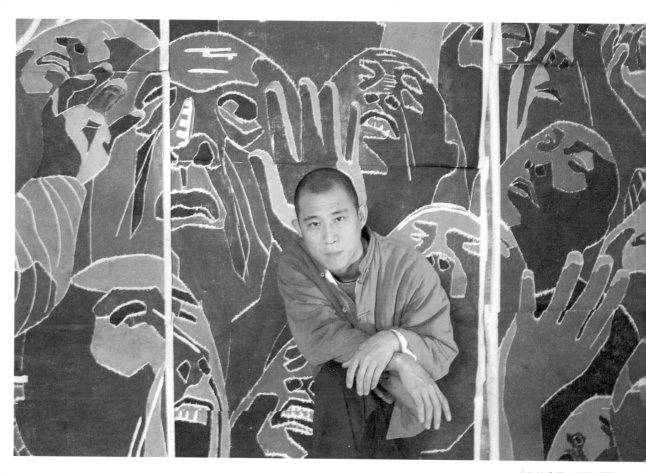

⋀ In his Beijing studio, 2001
photograph Liu Heung Shing

Having suggested that Fang Lijun draws the line at being treated as a media celebrity, and that experience had taught him it is better to stay out of the limelight in China, in 2002 he deliberately stepped right in it: onto a film set where he took a highly visible supporting role beside with leading actors Jiang Wen and Zhao Wei. Titled *Green Tea*, it was conceived as an offbeat art house film about blind dates and contemporary cafe society. Fang Lijun was perfect for the part, and when a hint of romance between himself and the leading lady, Zhao Wei, surfaced he was the talk of the gossip pages, his words quoted, as if he was a household name, which indeed he was amongst the nation's starry-eyed youth. Not even quashed when they parted amically. In 2004, he married a former model, Zhang Xu, at what had to be the wedding of the year.

Meanwhile, desiring a quiet retreat from life in the capital, in 2000, Fang Lijun acquired a studio in Dali, "beyond the clouds" in Yunnan province, where he can work in peace. He had awakened to an interest in his native cultural history, escaping the pressures of work to take tea in Suzhou, to explore remote areas of Yunnan, and

acquire a knowledge of classical antiquities in Shanxi. He even began to collect objects and ink paintings, avidly striving to become a connoisseur. The mountain ridges of Yunnan provides inspiration for new departures and, in 2001, he began to move away from his signature motifs. Images of children took over, arriving at that of naked newborn babies miraculously suspended in lyrical skyscapes, high above mountains and water. This marked the start of a new phase, and as with all nascent motifs with which an artist has to become first familiar, the initial paintings exude an awkward uneasy quality, a sense of fragility embodied in the tension between the enormous hand upon which a baby is habitually sat—a hand that might as easily crush it as protect it—and its tiny body. The sense is entirely ambiguous, as indeed life continues to be within the Mainland, in spite of all outward appearances. The compositions are also undeniably strange, or at least in part unresolved. "These are some of the most difficult works I have painted," he reveals. "It's challenging to paint on such a scale. I am not sure I have them right yet, but I'll get there."

Of all the early avant-garde contenders for international success, Fang Lijun's claim lies in the human angle of his work, not the politics it apparently digests. In every era, every age and within every national border on earth, politics is fleeting. Regimes come and go, and even the most oppressive of governments or leaders whose reach is omnipotent in their lifetimes, is eventually forgotten through time. As eras are consigned to history, the prisms through which they are viewed will always be coloured by the socio-political frameworks that succeed them. Yet mankind goes on and people change surprisingly little from generation to generation. Fang Lijun has an innate sense of this. The strength of his art lies in his ability to capitalise upon the humanity of his own culture, but present it in such a way as to transcend the China situation. His art functions as a poetically visual discussion about indoctrination and what happens when individuality is annihilated, when all individuals in a society decide to conform to an ideal. This issue is highlighted in China by the sheer volume of people. In reality, it is the scourge of all ideologies and philosophies, ideals and dreams that deflect individuals from arriving at their own conclusions.

Specific politics in Fang Lijun's art coincided with the idealistic passion of youth. He soon discovered that where the highly political reign of Mao ended, another succeeded it and another and another ... It engendered an enduring vision of ideological duplicity. Fang Lijun continues to deal with this, but it is equally certain that other concerns will capture his thoughts. Mentally, physically or metaphorically, he is unable to relinquish that great pictorial void, for somewhere in its depths lies the key to understanding the human condition, to the Pandora's box that is the subconscious, and all the "evil" of which man is capable.

SECTION 2

Adopt!:
ALTERNATIVE LIFESTYLES AND TABOOS

To speak of alternative lifestyles in China for members of the arts community means little without a firm picture of the invariably narrow parameters of daily life for the masses, which were erected during Mao Zedong's reign, and continued through to the mid-1990s, against which to compare them. Although superficially, urban communities and the artistic elite appeared to be advancing in great leaps from the early 1990s in the wake of Deng Xiaoping's economic reforms, the parameters that governed quotidian existence through this period only broke free of their absolute constraints under the leadership of Jiang Zemin (1996–2003). And even then, not in all quarters.

Throughout the Mao era, from 1949 to 1976, conformity was key and life was rigidly routine. Politically, it could not be otherwise: the adopted ideologies of Marx and Lenin envisaged individuals as cogs on the wheels of the great socialist machine. Therefore, a deviant attitude or a disparate voice, as well as any individual way of presenting oneself was eradicated—corrected, rather—in the name of social equality and unity, as swiftly as was humanly—and, at times, inhumanly—possible. In the 1980s, as Deng Xiaoping's reign unfolded, it took a while for the people to believe fully that freedom of expression—more in regard of fashion than of faith or opinion—was, incrementally, being tolerated. It was, after all, as if the people had lived their whole life with a minefield in front of their house only to be informed one day that these mines, which had dragooned their every move, had miraculously evaporated. Suspicion was the first retreat.

As the 1980s unfolded, life was pretty much the same whether one lived in town or country. The city streets were grey, congested with bicycles and pedestrians, and capped by the smog of industrial fumes from factories located in the midst of primary urban areas. Even in the centre of Beijing, donkey carts pulled heavy loads of building materials and produce, and roaring commune-blue trucks handled what they could not, spewing smoke from all crevices. The densest of urban conurbations was little more than an over-blown market place. In 1980, when painter Liu Xiaodong arrived to

study at the Central Academy of Fine Arts' preparatory school, Beijing seemed to his eyes no more than "a larger than average market town, populated by peasants driving donkey carts".

Days began with the sunrise and most cities were plunged into darkness at sunset. The supply of electricity was inadequate, although equally, it appeared that the State saw no reason why the people should need light late into the evening, there being few television programmes—and almost no private television owners—and no public entertainment to keep the people up. There were even few streetlights, which left the donkey carts and brave cyclists and pedestrians to battle it out in the dark with deadly consequences. The exception was the main square, such as Tiananmen in Beijing, where students congregated to read up the next day's lessons. Obviously, life in the larger cities and major metropolises was still better than in remote rustic villages. There were more opportunities, better housing, schooling, medical care, and a generally higher standard of living. Therefore, to counter the mass migration of the rural population from the countryside to the cities, the 1980s were characterised by strict government control over the populace's residency papers, which resulted in the introduction of identity cards. All pertinent information was indelibly encoded on the cards. Each individual was required to carry this card at all times, so there was no way to disguise the exact location to which one "belonged", or the extenuating political circumstances of their family status. Where no one could escape their identity, people were rendered powerless.

For city people, a further headache was the personal dossier. An exhaustive record of an individual's life, a dossier included the status of the family into which each person was born, the politics of their parents and siblings, as well as those of the individual. The dossier tracked work history, social progress, "mistakes" and incidents, crimes committed, as well as model deeds and exploits. What elicited greatest concern was a section it contained in which colleagues could register comments about the individual: ostensibly an appraisal of character used in determining the person's suitability for advancement, but often a handy tool for anyone with a personal vendetta to settle. As critic-curator Pi Li noted, up to the mid-1980s "the information laid down in a personal file formed the basis of decisions as to where the individual would be permitted to live, how much salary they would receive per month, and the amount they would receive as a pension. ... all facts of an individual's private life were known via personal files ... and to people who had no relation at all to the individual. This effected a transparent society in which there was nowhere to hide."[1]

It was deemed unnecessary for agricultural workers to possess such a dossier, as it was not envisaged that peasants would ever be granted mobility. Equally, that rural people did not own a personal

1. Pi Li, "Chinese People, Chinese Society: The Chinese Context", *Representing the People*, p. 49, published by the Chinese Arts Centre, Manchester, UK, 1999.

dossier was an effective, if clandestine, means of keeping them out of the urban environment for it was impossible for anyone to gain legal employment in a city or town without a personal file. Where the vast majority of adult members of all family groups with a job worked for a *danwei*—work unit—of some description, unemployment had not yet become manifest. Those without an official job were termed "unplaced" rather than "unemployed". By the end of the 1990s, unplacement would reach 34.4 per cent in rural areas and up to 29 per cent[2] in cities in the north-eastern region, and in former steel towns like Shenyang as automated manufacturing technology ate away at the massive labour force.

Across China, the early 1980s were a time of adjustment and recuperation as society sought to put the past behind it. Continuing low levels of household incomes meant that the masses retained the one-class-fits-all blue cotton canvas jacket and trousers they had worn under Mao. Economic reforms now began to ease the State's grip on individual lives. Still, essential and unremitting daily concerns—to eat three times a day and to provide the family with clothing, medicines and schooling—kept the people's focus rather narrow. Between rich and poor, town and country, the gap yawned itself apart towards feudal proportions, but the impact of that would take time to become clear. In the 1980s, families customarily—perforce—lived together under one roof—parents, elder son, his wife and their child. The one-child policy that had been introduced in the early 1980s for all ethnic Han Chinese people was now law, and fines and penalties, such as reductions in social benefits, were imposed against law-breakers. Minority peoples were not subject to the restrictions in the number of children they could have, and in rural areas, Han families often had a second child where one spouse could prove they were part minority, or where the first was a girl. Most could make a case for a second child if the first was physically or mentally impaired.

Through the 1980s, people everywhere were poor which, for the majority, was a full-time worry, but as almost everyone had about the same, existences were eked out at a relative level of economic equality. The people had long been resourcefully inventive with frugality and all but the few who had pots of money to spare—and spend they did—would remain discerning in their purchases, beginning with the family's daily fare. Amid the grey, and aside from the omnipotent national flag, the most brilliant concentrations of colour were

2. "According to official statistics, China's urban unemployment rate stood at 3.6% at the end of 2001. However, the number of de facto and latent unemployed is much higher. Laid-off workers, surplus labour in enterprises, and latent unemployed people in the rural sector should all really be regarded as unemployed. Laid-off workers differ from unemployed people in the sense that they remain in an employment relationship with a company. In practice, however, most laid-off workers are on leave or have effectively left their jobs; the probability that they will return to their original work is extremely low. An estimate based on 2000 data indicates that broadly defined unemployment reached 270 million, or 29.1%. The number of surplus workers in the rural sector is around 171 million, or 34.4% of the rural working population." Hiroshi Imai, "China's Growing Unemployment Problem", *RIM*, Issue No. 6, September 2002.
"... unemployment figures are downplayed to mask the suffering caused by economic reforms and restructuring. The official jobless rate of 3.6 percent in 2001 does not include *xiagang* workers, estimated to have numbered 10 million [in 2001]. Nor does it include farmers who have left their fields to find work in the cities—a "floating population" of around 150 million migrants who are seasonally unemployed. Tsinghua University professor Hu Angang ... concludes that China's unemployment rate was 7.6 percent in rural areas and more than 8.5 percent in the cities [in 2001]..." Melinda Liu, *Newsweek International*, March 25, 2002.

to be found in the arrays of plastic products that China had begun to manufacture in great volume. This was the era of cheap and cheerful goods that first defined the "made in China" label in foreign markets. These products were practically the only trappings of modernity available to domestic consumers.

No proletarian living quarters possessed a telephone. Work units were hooked up to a centralised intercom that summoned individuals publicly to a communal phone to take their relatives' calls, or to pick up private mail. Personal possessions remained few: one change of clothes, possibly more if the hand-me-downs had not come too far down a chain of siblings, and perhaps a new outfit at the New Year Spring Festival. Almost no children had modern toys. Few teenagers had wider access to music than a portable radio—which only picked up a handful of State-controlled stations—or poor-quality cassette players, with poorer-quality cassette-tapes. Despite the attitudes of most adults towards rock 'n' roll, a passion for modern music such as the Beatles, Pink Floyd and the Rolling Stones took hold. In the mid-to-late 1980s, there was lots of impromptu dancing in the street; disco not strictly ballroom, encouraging an exotic array of outfits crimped together for the occasion. But in general, the average daily existence was simple because beyond work and family there was little in the way of after-office-hours distractions—beyond communal exercise and largely chaste community dancing in parks and public squares. In fact, right up until 1995 when the law was changed, the people's standard working week was six to six-and-a-half days. Leisure time, therefore, was extremely tight, and predominantly limited to school and university students, nursing mothers, the unemployed, retirees and the elderly.

Some individuals might have innocuous hobbies, like kite flying, but there was little in the way of popular, public entertainment. Ironically, far less than during the Mao era when propaganda teams from every bureau and grassroots organisation across the country travelled the length and breadth of their region, no matter how far-flung and remote, to put on plays, show films and perform educational productions aimed at furthering revolution. Prior to the introduction of the five-day working week—which was only granted in the cities—the people had no expectations or demands about the pursuit of personal pleasure. This rapidly turned around and in the late 1990s spawned an enormous demand for music CDs, video and digital discs, which nurtured a small pirate industry into a full-blown economy. It also sustained home interior stores, beauticians, massage parlours, sports facilities, bars and an unprecedented range of eateries.

Existence in the PRC was essentially still insular. In the 1980s, the outside world was still very much outside; an unknown quantity beyond the reach of most people. The majority of those

who did make it abroad went temporarily to study at schools or universities, whilst the rest went permanently to start new lives. Through the 1980s, outside of the picture that this sliver of the people painted to their immediate family back home, within the broader populace, real understanding of what a western culture might be like made little inroads, outside of the carefully selected and contrived images that had been projected in government propaganda since 1949.

On the face of things, in the 1990s, much had changed but little had altered. The cost of living had risen, more in the cities than in the rural areas, where the agricultural boom of the 1980s was fading fast. The gap between town and country had widened, creating an extreme polemic either end between urban-rural, poverty-wealth, and advancement-backwardness. Despite much general technological advance and a palpable modernisation within urban areas, by no means all rural villages had electricity, communicable roadways or even running water. Nineteen per cent of the people still lived below the poverty line and a significant portion of that number existed at a level of subsistence[3]. The free markets were slowly being put out of business by massive supermarket chains that were popping up in every municipal district. Fierce competition was becoming desperate in the rural areas where agricultural reform, better fertilisers and farming know-how continued to force prices down. In some rural regions, all hope of a traditional living from the land evaporated.

Change was unfolding apace. By the late 1990s, China had achieved an irrevocable degree of economic advance and socio-political reform. A significant percentage of the urban populace in the major cities had become homeowners, as State-owned enterprises sold off their staff housing blocks and, simultaneously, the construction industry went into overdrive in the metropolises. Housing was being systematically deregulated and vast swathes of the larger cities marked out for redevelopment. Public transport remained the most popular means of getting around, although taking a taxi was, day by day, less of the luxury it was in the 1980s. In fact, taxis abounded, largely due to a range of locally produced or assembled cars. As private cars became more widely available, bicycles began to lose favour as a convenient and healthy means of transportation—car shows had become the most successful crowd-puller, out doing any other form of cultural entertainment. Around the country, as new roads were laid, it was increasingly possible to drive from one province to another. By 1997 Fang Lijun and friends were regularly driving down to Hangzhou via Shanghai and then, hopping from port-city to city-port on the eastern coast before heading west to the mountains beyond Kunming in Yunnan province. Meanwhile, Zhang Xiaogang and his friends travelled the roads between Chengdu, Chongqing and Kunming, plumbing the

3. According to statistics published by the World Bank, 2002.

depths of the surrounding region that purports to be Shangri-La—which from the early 2000s would become a site of veritable pilgrimage for the arty-cultural elite.

By the end of the 1990s, even if problems were rife, people were living better lives. The negative issues—as problems were discreetly termed—were increasingly those inevitable by-products of modernisation. This included a massive and largely uneducated labour force languishing in the provinces as agriculture and industry modernised. A voluminous tide of migrant workers—comprising a significant portion of the laid-off manual workers—flooded into the cities in search of jobs which often came without any guarantee of pay—or safety. The petty crime rate in urban conurbations—which had been almost non-existent under Mao—took a monumental upward swing for it was now much easier to move around and even to disappear. Ultimately, in spite of the identity cards that all people were required to carry all the time until 2002 when the law was changed, the control that the State exerted over individual lives was no longer far-reaching or all-constraining. Market economics had done much to dilute the former power of the orthodox ideology. It was also creating a new class structure, increasingly western in division—working-class, blue-collar, yuppie, etc.—within which the people now had the power to control their own earning potential. This was significant because, following protracted centuries of general poverty, money now went far and spoke loud. It could purchase just about anything, meaning opportunity as well as the trappings of modern life.

One aspect made the 1990s dramatically different to the 1980s; the advent of new tools of communication such as mobile telephones, cable television and the Internet, not only changed the way in which people communicated with each other but also the prism through which they viewed and perceived the world. Within the relative degree of freedom the system now afforded, a number of individuals were choosing their own alternative ways of being.

Gu Dexin was alternative long before it was fashionable, and certainly before notions of "alternative" were defined in Chinese society (it's still not a term that enjoys a positive cachet). He falls into the category of silent observers or passive on-lookers who thoroughly disapprove of a situation but are reluctant to act for change, other than to voice opinions humorously within the very familiar circles of associates and friends. The world that Gu Dexin began surveying was China during and after Mao, a world watched over by the mawkish eyes of the street-committee members, neighbours and school or work comrades-in-arms. Gu Dexin resigned himself to his own powerlessness, to a life of futility under an irrational ideology. Yet, in discussion and in his art, he provides more than enough hints that he would resist any orthodoxy, in any society, and in any nation one could care to mention. Naturally, Gu Dexin objected to life as lived by the

majority of the people in his immediate world, as proscribed "right" by convention and the State. As a teenager, he was already different, and being by nature a passive rebel, when rejected by the system—his one endeavour to follow established practices was to sit the entrance examination for the Central Academy of Fine Arts, which he failed to pass—he took himself off to the fringe of conformist society. At the same time, his lexicon of thought on human habits suggests he is a natural-born nihilist, which the China framework both complicated and simplified.

Gu Dexin is alternative because he is anti all art produced within an art movement. His own work fell outside any style or form that could be defined until the mid-1990s when the avant-garde acquired a deeper grasp of concepts and terminology such as installation. Where the majority of artists sought to produce tangible, marketable assets—even where they were unaware of a market—Gu Dexin made art that was unretainable, transient, non-tangible, fleeting. In this respect, he crossed the line from just being different, to adopting an extreme alternative stance that railed against every value modern Chinese society had come to uphold in terms of aesthetics and ownership, advance and enrichment. Yet was he really breaking Chinese social taboos as his destruction outwardly appeared? It is not outrageous to describe his approach as a continuation of the ravaging of highbrow culture begun with Mao's 1942 Yan'an Talks on Literature and Art. In fact, Gu Dexin could be classified as a good comrade, for he took Mao's derision of tradition and convention to heart and created his own anarchy. He revels in it, and in that context, his work is not shocking at all. But in the late 1980s, the outside world did not anticipate finding plastic being used as a material for art from China, especially in the manner Gu Dexin employed it: torched plastic sounded overtly reactionary.

What was expected from the first generations of free artists in China in the post-Mao years was that attitude apparently made manifest in Political Pop. This brings us to the painter, Li Shan, and his appropriation of Mao to the picture plane. In the early 1990s, this approach was irreverence of the first order. It was, but as time would slowly uncover, Li Shan was interested in another taboo altogether; one that was not actually stigmatised for a long succession of dynasties in the Middle Kingdom prior to the arrival of the Jesuits in the eighteenth century, and then not again until 1949 onwards, as China attempted to modernise. The topic was single-sex relations, homosexuality on one level, but a uniquely Chinese version in the form of a platonic, mutual admiration and affection between two educated or learned men—or women—that, in Li Shan's words, is more "deeply felt than any normal love". Yet not always consummated in the usual physical way. Li Shan's work appears to fall into mainstream avant-garde inclinations circa 1990,

his strongly personal language and deft emotional sensitivity are brought to another agenda where content is clearly more avant-garde than the style in which it is couched.

Zhang Xiaogang's work falls into the same type of approach. It is painting in which the surface is not exactly what it seems and where the political angles provided a convenient guise, when it seemed prudent to construct one, for intimately personal issues of hereditary family illness. There are similarities between his early paintings—the tiny ink and pencil drawings and small oil sketches on paper—and the early abstract ink paintings Li Shan produced in the mid-1980s—in the way that they each extolled profound local cultural sensibilities. Equally, the early styles of these two artists provided a dramatic contrast to the art that eventually made them famous. In the case of Zhang Xiaogang, it was as romantic as it was Chinese, yet darker and more mysterious. As with storybook illustrations, these diminutive and delicate paper works tell stories. One senses that in the 1980s, Zhang Xiaogang was on some kind of spiritual search, physical and mental; a journeyman, roving, roaming, to escape himself and his family circumstances. His painting is not political in motivation, origin or goal. His taboo is real, tangible mental illness, a stigma in all societies until more recent enlightened times, and a particular cause of discomfort in China. Long-held pagan-esque notions that mental illness derives from afflictions imposed as the manifestation of Heaven's wrath persist—in Christian terms, the sinner experiencing divine retribution. People are neither comfortable dealing with it, nor living with it. During the social turmoil that was generated by a sequence of political activities from the mid-1950s that wrought confusion and destruction wherever a new campaign flared up, the trauma of living with a schizophrenic who happened to be your mother, was magnified for Zhang Xiaogang. It was also inalienably associated with the era of the Cultural Revolution as the worse catalyst for aggravating mental instability, hence the aura in the paintings and the uniforms in which he habitually clothes his figures for example.

In their art, these three artists embraced the other—private—side of their personalities, in a society in which most people were compelled to present a specific public face. They turned to their ids, to that part of their being that is usually protected from the prying eyes and disdainful commentary of conventional minds ingrained with the proscribed ideology. Their approach to and the content of their art arises directly from personal experience and concerns, not intellectual responses to issues of modernism and post-modernism in the manner of so many of their peers. More than any other artists of their generation, Gu Dexin, Li Shan and Zhang Xiaogang are outsiders in their own environments, even where in the case of Zhang Xiaogang and Li Shan, the art has become the most publicly recognised emblems of China's new painting. Gu Dexin, meanwhile, elicits no reaction to being named a leading force of conceptual creativity.

Untitled, 1989

GU DEXIN:

27.02.1962

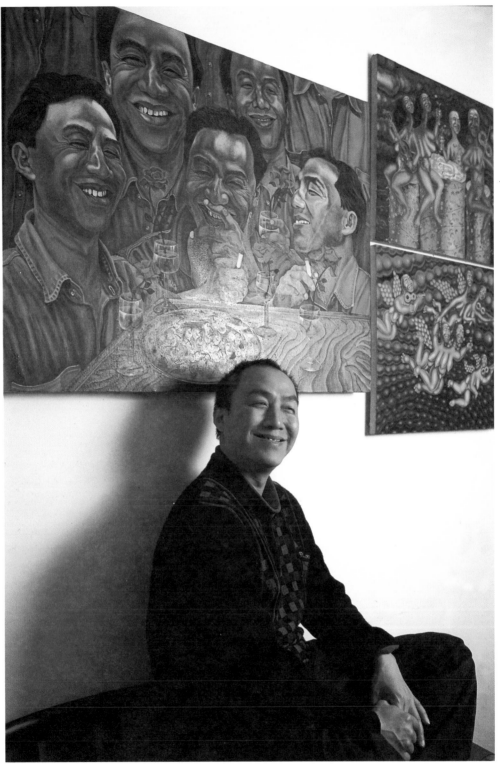

At home, 2001 ⋀

photograph Liu Heung Shing

"You see Xiao[1] Gu? He doesn't say a word about his art. No matter what people ask, he avoids responding directly. No matter how much he's pushed or cajoled he never provides a satisfactory explanation. His silence becomes a mystery ... everyone believes there must be something to [his art] that he's keeping from them. Eventually, they convince themselves that it is great, deep and meaningful work. Xiao Gu still remains silent. He's very smart is Xiao Gu ... "

Zhang Peili

No matter where he is, what the occasion, or what Gu Dexin is supposed to be doing, as soon as a child enters the arena all serious considerations evaporate. Gu Dexin is instantly transformed into every child's favourite uncle, who will play as long as any child has the energy to keep going. On one occasion, extricating himself momentarily from a bout of rough and tumble with Wang Shang, the five-year-old son of fellow Beijing artists Lin Tianmiao and Wang Gongxin, he dismissed his apparent obsession with pre-teens by saying: "I like kids and kids stuff." Minutes later, he quietly slipped away from the adult discussion—on the subject of art, for Lin Tianmiao and Wang Gongxin had recently returned from New York—and returned to the game. From the fevered excitement in their eyes and their broad, collusive grins, it was hard to tell who was having more fun, grown man or five-year-old child.

Later, as Wang Shang succumbed to exhaustion, Gu Dexin, a beer in one hand and cigarette in the other, let slip a portentous addendum to his earlier confession: "I never wanted to grow up," he said, through a veil of smoke that conveniently censored his expression. When asked why, he looked perplexed for the briefest of instants—since when do artists need to qualify their statements?—before grinning,

1. The diminutive *xiao*, meaning small or little, is added before names to indicate a close personal relationship between the two people especially one younger in years.

in the habitually quiet and wise way that he has, and with a shrug, changing the subject. Gu Dexin has an innate aversion to discussions about himself or his art, even on the safe turf of his home, which also serves as his studio. Born on February 27, 1962—the date indicated in the title, which echoes Gu Dexin's practice of titling his works with the date upon which they are created—he was raised through that era when the self, its inclinations, aspirations and emotional states were secondary to the communal furtherment of society, and expected to be suppressed. That is not to say that Gu Dexin's personal passions or perplexities were widely different from those of anyone else: at least, not that anyone has yet proved. Rather, the social climate merely compounded his inherently wary nature and encouraged a quiet, reflective, and introspective external aura. He was barely into his teens when it struck him that his views and sensibilities departed from those ordained conventions individuals were required to exhibit. He knew that if he could not bring his thoughts in line with the establishment, it behoved him to keep his views to himself.

Ultimately, the verbal reticence Gu Dexin exhibits as an adult and an artist was not born of fear. It was more of disappointment at the futility of dissent that had been made irrefutably clear by the retribution regularly meted out to those foolish enough to try, both during the Cultural Revolution and with the student protests in Tiananmen Square in 1989. Yet, it also lay in a more profound belief that all systems create and impose limitations. The modern world, socialist or capitalist, democratic as totalitarian, even where proclaimed as a liberating force, in fact requires its subjects to conform to a proscribed way of living and means of contributing, as defined by the terms of that society. Gu Dexin instinctively objects to control, of any kind. He falls short of anarchy, which would require an active strategy, and suggests an irascible compunction to challenge the generally accepted idea that one is distinct from another, and therefore better or worse, with

Gu Dexin and his wife, Shi Quntian, in Xi'an with the children of a relative, 1988
courtesy the artist

At their home with the son of artist Li Qiang, 1995
courtesy the artist

In Paris with the daughter of artists Huang Yongping and Shen Yuan, 1996
courtesy the artist

In Paris, with the children of artist Yang Jiechang and critic-curator Martina Koppel-Yang, 1996
courtesy the artist

In Beijing with Kim, the daughter of Paris-based curators Hou Hanru and Evelyne Jouanno, 1998
courtesy the artist

all attendant idealisation and discord undertaken in its name. In the post-Mao era, where many people of his generation looked to America as an ideal model of a modern society, Gu Dexin saw yet another institutionalised political regime built on and driven by a nationalistic ideology. Having formulated these opinions, he keeps them largely to himself. They are after all deflatingly pessimistic, although typically, Gu Dexin turns this to his advantage, referring to pessimism as a perfectly valid reason to retreat from mainstream society. Whilst initially this directly resulted from his circumstances and formative experiences in China, it is entirely probable that Gu Dexin would have opted out of any system in which he found himself anywhere in the world. In many respects, opting out in China was easier: there are few first-world nations in which one can choose to be so invisible and so free of actual social responsibility.

The alternative mode of being Gu Dexin adopted ultimately allowed him to indulge in an approach to art that is without precedent in China. As an adult entrenched in the complexities of being a grown-up in Chinese society of an especial era, memories of childhood encouraged the man to idealise the innocent existence he had known as a boy. He perpetually mourns its passing: "There are definite barriers to communicating with adults. I like the way kids communicate naturally ... When you're a kid, you don't feel pressure about doing this, being that. People don't try to tell you how to live."

Did Gu Dexin, therefore, adopt a deconstructive style of creation as a deliberate act of rebellion against those who tried to tell him how to live as he left childhood behind? A poke in the eye for all the individuals, authoritarian forces and bureaucracies seeking to exert personal and social pressure on him to conform to conventional notions of normalcy? Both sides apparently win: the authorities, which given that he abstains from any social duties, view him as a non-citizen and, therefore, a non-person; and Gu Dexin who unhesitatingly accepts his non-status, because it means society can't place any demands upon him and he can exist uninterrupted.

Gu Dexin and his wife, Shi Quntian, who married in 1988, do not have children. It was a conscious decision—though one that in part related to his wife's health—and a hard one to take in a society that places so much emphasis on producing heirs to the family name, and where Gu Dexin is such a natural with children. With the relentless propagation of the one-child policy the pressure upon young couples to produce the permitted single progeny is great. For some couples who hailed from large broods themselves, the disadvantages of life for a single child—no brothers or sisters, and eventually no extended family—acted as a deterrent. This was not quite the case for Gu Dexin. Health issues notwithstanding, he finds little to relish in the responsibility of parenthood because he knows that at one point or another every parent is inevitably compelled to tell their offspring how to live. Even with the powerful force of Mao's policies, which negated the child's duty to view a parent's word as law, the Confucian tenets on filial piety endure.

Gu Dexin's parents belonged to the commendable category of factory workers. This meant that as a child he was never a victim of political circumstance. Although he embraced the notion of doing as he pleased without being bound to the classroom, he developed an acute awareness of the contradictions between the stated goals of the Party and the struggle that was taking place within society. To wit, instructions, orders, or fatherly advice did not sit well. How could they where from Gu Dexin's perspective they sprang from misguided origins, being based on the misrepresented facts of a situation. Thus, he instinctually recoiled from the pressure to conform to soci-political demands built on shifting sands. Gu Dexin rebelled in the only way he knew how, in fashioning his own, independent style of art.

As maturity crept upon him, Gu Dexin did not naively believe that his childhood innocence could be regained. Yet, a will to project a fresh, guileless external aura shaped his manner of engaging with the world, both in terms of what he was willing to do and to concede. He honed this outlook to a degree that confounds people who seek to engage him in general debate or a discussion of his art, developing a deft ability to intersperse jokes with poignant, insightful and often blithely controversial opinions that leave philosophical debaters at a loss for words. His is the logic of Winnie-the-Pooh and Calvin (of the "and Hobbes" fame) rolled into one, but like that of these storybook characters, it is often impossible to argue against. Gu Dexin's Peter Pan quest for his own Never-Never Land was present in the earliest expressions of his experiments in creating art. In fact, his art still exhibits all the exhilaratingly destructive impulses of a young enquiring mind driven to take things apart to see how they work, and what happens when all the components are disassembled and reconstituted in other ways. His de-constructive approach intuitively began as a defiant act of rebellion sparked by, and aimed at, those who tried to tell him how to live as he became an adult. As time passed, it became evident that, although irritating for those who wished to see him engage in a useful profession, his rebellion has definitely been the art world's gain.

Gu Dexin's art is not for the faint-hearted. His creative process involves large amounts of plastic, raw meat, vegetable matter, and a blowtorch: creating a visual splendour engendered by heat reaping havoc and ripeness slipping into decay. Critic Li Xianting describes Gu Dexin as one of the "most important and avant-garde of artists" in China, whose works speak of the "vulgarity behind lofty, glorious and pretentious ideas", and which "combine the beautiful with the obscene, the grand with the capricious."[2] Li Xianting's faith was profound enough to nominate Gu Dexin as sole Chinese candidate for a list of the world's top one hundred artists compiled for the new millennium. This was high praise from high quarters, and came against stiff competition from within the Chinese avant-garde.

2. Li Xianting, "Curator's Notes", *Poly Phrenolene*, exhibition catalogue, p. 8.

Yet as pockets of contemporary Chinese art became a hot commodity through the 1990s, Gu Dexin's work remained the ultimate in elusive, non-collectable, self-destructing art. Each new piece for each succeeding project relentlessly accosted the fundamental tenets of high art, defying a vocabulary that in China, at least, was pivoted on conventional ideas of beauty or "uplifting spirituality". His art does not come close to "serving the people" under any terms of the proscribed guidelines, and even tests the stomachs and mindsets of the most cutting-edge western curators and audiences. Almost without exception, the works are site-specific reactions to the particular environment that each exhibition opportunity offers. None, aside from the protracted photographic work *Meat*, executed over a number of years, exists beyond the timeframe of a show. Many are deliberately designed to have decayed into rottenness even before the exhibition concludes. Each intervention strikes a blow at future anticipations of a Gu Dexin retrospective, but, as he repeatedly asserts, the very notion of a retrospective is merely a habit formed by a market driven art system; a habit that he has no reason to entertain.

The temporal aspect of Gu Dexin's work makes it hard to appreciate at a distance: it has to be seen in the flesh, so to speak, and in contrast to the mainstream trends it seeks to counter, particularly in China. Across the Mainland, Gu Dexin is recognised as being important right from the early stages of the New Art Movement in 1985. By 2000, domestic and international critical and curatorial fascination with his practice and its effects made him one of its most experienced exhibitors at international events. His international exposure dates from 1989. When most artists could only dream about an opportunity to go abroad, Gu Dexin was playing with fire at the Pompidou Centre in Paris at the seminal exhibition "Magiciens de

meltdown of perfume bottles >
from "Magiciens de la Terre",
Centre Georges Pompidou,
Paris, 1989

la Terre". The work in question was fashioned from an array of French perfume bottles—charitably donated by Chanel, which naturally anticipated some positive publicity from the brand recognition. This was of no consequence to Gu Dexin, however, whose first act was to take a blowtorch to the bottles, distorting the familiar outlines of shapes that immediately conjure a fragrance for women everywhere, before tying them to strings of melted plastic hung from ceiling to floor like macabre festive bunting. The mesh of charred and almost unrecognisable objects covered an entire wall in the space, whilst the curious odour of burnt glass and singed vapours of eau de toilette and perfume infused the air over a much wider area. In one sense, nothing could have been more directly and descriptively evocative of a rage against bourgeois values than this destruction of the epitome of luxury. Here, by gifting the perfume bottles, Chanel had been made unwittingly complicit in berating the western capitalist-materialist system so essential to maintaining the cachet owned by luxury brands.

Yet this was not entirely what Gu Dexin aimed to project. He is far from being so consciously or overtly political. He is a thinker, an astute observer of truth, but he has never actively made comments in a direct way. He doesn't see the point. If his works can be termed a response to politics or socio-economics, global or local, it is intuitive in nature. Of all the avant-garde artists, he is the least literal or narrative oriented. Interpretation is placed absolutely in the hands of viewers and intermediaries to make of it what they will. Yet, the question What made Gu Dexin special enough to be picked for "Magiciens de la Terre"— known as a groundbreaking exhibition because it brought the art of so-called peripheral nations and cultures to a western audience—answers itself. In 1989, almost nothing had been seen abroad of the new art being produced in China. The handful of individuals who visited the Mainland in search of art prior to the mid-1990s were largely confronted by oil paintings pivoted on high realism of a romantic, sentimental timbre to which academic technique had been applied in a mechanically bland way. Only the subject matter made them unquestionably Chinese. In the late 1980s, Gu Dexin almost single-handedly met the criteria western interlopers sought.

Interestingly, the curator of "Magiciens de la Terre", Jean-Hubert Martin, did not discover Gu Dexin in China. His knowledge of avant-garde art from the PRC was imparted to him by Shanghai-born critic Fei Dawei, who was in Paris in the first half of 1989—after the "China/Avant Garde" exhibition but prior to June 4. To Gu Dexin's credit, Martin arrived at his selection on the merits of the artist's unique approach alone, for his art had no identifying tags to assist the local audience in contextualising it, either national, or as an "ism". Even then, Gu Dexin had no desire to imitate western art forms in order to gain access to the international arena. Such a strategy would imply ambition, and ambition is, for Gu Dexin, a contrived state, engendered by and necessarily entwined with the forces of a system. In disdaining all systems, his is a non-strategy that places him in a class of his own.

Meat, 1994–2001

Gu Dexin was born in Beijing. His family still lives in the same compound close to the city centre. Although not exactly the typical Beijinger in speech or mannerisms, Gu Dexin's characteristic humour and casual air of faineancy which verges on inertia, accord with the popular profile. As such, he can be an entertaining talker—as long as he is not required to be forthcoming on the subject of his own life. He prefers to proffer personal trivia, which is as open to interpretation as his art.

Gu Dexin is the youngest of seven children, which in part encouraged his lackadaisical approach to life. The baby brother was doted on by his protective

elder sisters who indulged him to the best of their ability. When he began painting at the age of fifteen, the twelve-metre-square room that was immediately made available as his studio was the dormitory accommodation in a neighbouring building within their parents' *danwei* compound where two of his four sisters slept when they were not at work. In their absence, their little brother shut himself away and became lost in the world of his imagination, which he harnessed to canvas and paper. This private world is a further distinguishing trait for few members of Gu Dexin's generation have such an expansive and vivid imagination. The tiny room was like a cell with walls of dark, bare concrete, lit and aired by one ineffectual window. In the early 2000s, before Gu Dexin vacated, its glass was entirely dimmed by the bars that encased its exterior face and years of dust that no one could reach to clean, although certainly it was not so dire under the diligent care of his sisters. When the sisters married and set up in homes of their own, the baby

brother, now seventeen years old, moved himself and his art materials in full-time. The latter were each given special niches. There was no one to clean up for him now but equally no need for him to clean the place up at the end of each day. A decade later, in 1989, the cramped space became both home and studio as Gu Dexin welcomed his new bride, to their home for the next five years.

It was Gu Dexin's habit to nail finished paintings to the wall and, through the years, from corner to corner, the walls accumulated layer upon layer of early abstract daubings in oil paint. In addition, a mass of wild plastic "creatures" climbed over every inch of an industrial metal shelving unit—the only solid piece of furniture in the room. These creatures were the results of his initial experiments with manipulating plastic materials. In 1993, the couple was able to move into another small apartment near by that had also been assigned to Gu Dexin's parents. It was only two-square-metres larger, but it meant that sleeping area and studio could now be separated. A short time later, when State *danwei* began to adjust housing policies and encourage employees to purchase homes, Gu Dexin's parents traded in the two tiny dwellings and made the substitute three-roomed apartment over to their youngest son and his wife—where they will probably live the rest of their lives. So even as Gu Dexin claims no truck with the system, he has certainly enjoyed the benefits it brought, courtesy of his vexed parents who had long given up asking or even wondering when he might get a job, or provide them with a grandchild.

Gu Dexin continues to work at home: his new workspace alone is as big as the couple's first apartment. Again, he surrounds himself with the familiar props from the original space. In time, these were complemented by the addition of variously sized photographs from the *Meat* series that he tacked on the wall, and small airtight containers stacked neatly on built-in wooden shelves by the door in which the individual lumps of meat immortalised in the photographs are entombed. The paintings from his youth, to which he remains deeply attached, were brought to insulate the walls, or so it appears. These dark coarse paintings, their tones dulled by the poor quality of the original pigments and accumulated layers of Beijing dust, certainly deaden ambient sound and enhance Gu Dexin's sense of self-containment. Through the dust it is just possible to discern images of bugs, creepy creatures, and wide-eyed, open-mouthed faces, which intone a teenage Gu Dexin with Dali-like obsessions. Here, too, are the painted prototypes of the earth-mother figures he latterly translated into plasticine. These fecund, festishistic figures are also a feature of oil paintings that hang in the dining area and on one wall of the bedroom. Though closely resembling Gu Dexin's hand—his wife Shi Quntian commandeered the ruddy, multiple-breasted figures that he moulded with plasticine—they were painted by Shi Quntian as a homage to her husband, it would seem, for she is a genuinely adoring wife. Her portraits of Gu Dexin are delightfully accurate in visual semblance and the personal insight into her offbeat partner, particularly his familiar grin.

She has had ample opportunity to observe this grin; twenty years, for the pair were teenage sweethearts. They met through mutual acquaintances when they were just sixteen. Shi Quntian was spoken for at the time but when they met again, an entire year later, she was convinced that Gu Dexin was the man for her and wasted no time in losing the boyfriend, ensuring that Gu Dexin knew the reason why. "He was different from anyone I had ever met," she recalls. "He looked so much like the stereotypical bad boy in films."

He had long hair then, grown as a general protest against the world. It greatly angered his parents. "I had a good relationship with my parents ... but I didn't want them to be involved with my life. So I grew my hair because I could." They read it as a sign that he would end up as a delinquent, which only made them interfere more. Gu Dexin did not relent, not exactly, for he didn't cut his hair, just gradually shortening it to less of an outlandish length as his interest in such a futile battle diminished. Bigger fights awaited as he and Shi Quntian announced that neither wanted any kind of marriage ceremony. Having attended their older siblings' weddings, both were positive it wasn't their style. The couple's disdain of the formality and flounce of conventional ceremonies was immovable. Defying parents, flouting tradition and social pressure, they married without any fuss, registering their papers as if going to the grocery store. "Our parents were disappointed naturally, but we didn't care ... we were not going through any nonsense to get married." In 1989, a year after their papers were signed, Gu Dexin's studio finally became free when his elder sisters moved out. Shi Quntian left home with a simple "goodbye, see you later" to her family, and at last moved in with her husband.

The pair was distinctly alternative at a time when it was definitely not fashionable to be so. Each keenly appreciated the slim chance of finding so compatible a partner, which strengthened the bond between them. Defiantly

In Jilin, 1988
courtesy the artist

romantic in a society that had practically outlawed interpersonal sentiment, they thrilled to exercise free will in chosing each other. Initially this was all they could claim ownership of, for their existence was truly humble. In his bachelor years in the original apartment, Gu Dexin had attempted to follow his creative aspirations via conventional routes, attending laymen's art classes organised by and for the workers, and eventually applying to the Central Academy of Fine Arts in Beijing. Where perennially oversubscribed, he should not have been especially disheartened to be unsuccessful in securing a place first time round. Many artists of his generation, like Wang Guangyi, sat the entrance examinations for years in succession, but Gu Dexin's failure came as a devastating blow, and would prove pivotal in shaping his views on State bureaucracies in China, as well as the standards governing art. In the immediate moment, nursing an injured pride, he took the easy route and ducked out of the system entirely.

There is a broader context here, which makes the extreme nature of Gu Dexin's reaction particularly odd. During the Cultural Revolution, with the majority of educational institutions given over to political activities, a lack of regular education was not cause for discrimination, especially in view of those young pioneers who enthusiastically threw themselves into making revolution. When the universities reopened in the closing years of the 1970s, it was as much a self-serving hope of personal betterment as a selfless desire to contribute to building a socialist Utopia in the People's Republic that propelled people to apply. Fierce competition nurtured conceit amongst the successful candidates, inevitable perhaps where they were one individual chosen from several hundred applicants. Auto-didactic artists, like those affiliated with the Stars Group, who had leveraged their "self-taught" label as a badge of their inherent artistic personalities now realised that the word had begun to acquire the derisory implication of "amateur". And where the impetus for the New Art Movement was resoundingly laid at the feet of those first graduates from the newly opened academies, the activities of the Stars Group were relegated to the status of enthusiastic "laymen". Of the hundreds of artists who participated in the New Art Movement or could claim to be a member of the avant-garde, those respected individuals who were not products of the academy system—or subject to formal training—could be counted on a single hand. Gu Dexin was one. Two of his closest friends, Wang Luyan and Chen Shaoping, with whom he formally collaborated, accounted for a couple more—by the early 2000s, they had all but retired from the scene. Gu Dexin was unique for he was not a prosaic painter, nor were the works he produced in line with accepted aesthetics. Yet, by the early 1990s, Gu Dexin was everything that the Chinese art circle believed an artist ought to be.

Gu Dexin began working with plastic in 1984. It offered the perfect melding of materials and concept, an anything goes field of possibilities for manipulating a substance to produce fascinating results: "Plastic made a deep impression on me

as a child. It was a new material [to China] and it was everywhere. Everything in the house was plastic: shoes, tableclothes, bowls, utensils. I was fascinated by its feel to the touch, that it could be malleable, hard, soft or brittle, and of so many colours and textures."

In order to understand the nature of the material, in 1983, Gu Dexin accepted a part-time job in a small plastic factory. It is the only job he has ever had. His task was to set the process in motion, to empty particles of raw plastic into the moulds which turned out plastic bowls. As the particles descended into the furnace, he would watch, mesmerised as the heat caused the particles to melt. Yet the strongest impression he retains from this experience came not from the plastic but from his interaction with the other workers. This interaction played a large part in formulating views about life in general, and guided the missive he chose to express through art. The factory was a "neighbourhood enterprise"—a community-run workshop—set up to accommodate wayward adolescents who society deemed unfit to be placed with any other unit. "It was the community's way of solving the problem of what to do with bad kids. It was inspiring to spend time with them after work, chatting, drinking ... For the first time, I became interested in people."

Gu Dexin had much in common with these delinquents, aware that he was as awkward a misfit as any one of them. For a brief few months this relationship and the fascination with plastic held him to a routine that otherwise had no allure. The salary was low even by 1983 standards. Gu Dexin took home no more than 80 yuan a month—USD 6 at the 1983 exchange rate—even after overtime. "It was enough to live on. After all, there weren't so many things to buy and what there was was cheap. For us life was fine ... "

As he struck out on his own course of experimentation in the early 1980s, Gu Dexin's name swiftly accrued an element of notoriety: a word viewed warily in China, where individual rebellion has little cachet. What set him apart from the majority of artists was a series of visceral installations that threw up a direct challenge to the niceties of oil painting, which dominated even avant-garde practices. Against strong currents that pushed aesthetic interests in this or that direction, catching large numbers of artists in the swell, Gu Dexin stuck to his preferred materials and elected style of employing them; melting plastic, producing his distinctive cartoon-like drawings, playing with plasticine Constancy and daring earned him respect.

"I am not sure if what I do is art," he declares. "I never considered myself an artist. I don't like the difference it implies. Are artists different? If they have any distinction it is that they create. But anyone can do what I do, which means anyone can make art." It is an argument often used by an appreciably cynical audience to deride contemporary art, yet within the socio-political paradigm of the People's Republic, Gu Dexin arrived at his perception from quite a different set of urges

Installation for ≫
"New Asian Art Show",
Beijing, 1994

and experiences. "Being labelled with the name of a profession [as was routine in Marxist China, exemplified in the "worker, peasant, soldier" terminology] is not proof that a person has specific knowledge or wisdom. It is more important what people think on their own time; that people think for themselves, at all."

Cultural commentator Yin Jinan describes Gu Dexin as: "One of the most intellectual artists to have come out of the avant-garde." "Intellectual" is an odd choice of word given Gu Dexin's background, and the specific socio-political intonations of the word intellectual in Mandarin (*zhishi fenzi*). No one doubts Gu Dexin's intelligence, but in China, intellectualism is a product of a social system, and he remains firmly against systems. Though Gu Dexin took rejection from the Central Academy extremely personally, it provided a stout counterpoint for his work. He was one of the first artists to move away from the picture plane and into object-based art. In 1985, a multitude of performance works and action pieces occurred nationwide but almost no avant-garde artist was negotiating the abstract, physical properties of materials. Gu Dexin was clearly thinking for himself: "Social, political and cultural systems dictate the way in which we speak or act. Even artists are expected to think and act in certain ways. If I say I am not an artist, then how should I speak? Can I speak about making art and be taken seriously? Other profession words merely describe the work a person does, but "artist" implies an almost mystical set of sensibilities. It's like, if I am an artist, then I am expected only to do this and not that, whatever ... It is limiting because you are always managing other people's expectations."

As previously indicated, Gu Dexin came to art without professional training. Whilst it certainly meant that he was not given the opportunity to acquire a polished academic veneer, it equally prevented him from being exposed to preconceived aesthetic values, to constricting creative principals or purported formulae for success.

No matter how those academy graduates endeavoured to break out from under the weighty mantle of their training, few were able to achieve the uninhibited level of experimentation that Gu Dexin found suited to the qualities of plastic. In denying it its original form, his reconstitutions often ended up appearing visually similar to a pile of debris; objects akin to the by-product of the creative process rather than an end result. He once joked that in London's Docklands a work was mistakenly "collected" at the end of an exhibition, not by an art enthusiast, but by removal men who took it away as trash. The garbage collectors must have wondered

Installation for "Next Phase",
London Docklands, 1990

what exactly they had stumbled upon. Manipulated by heat and coloured by the red pigment that Gu Dexin loves to use, his work often impersonates spewed pools of guts and gore. In this instance more like the sloughed chrysalis of a leperous moth. For this work, he had used the type of clear plastic used as protective wrapping for machine parts as they come off the production line: a pristine skin he tortured with a flame, transforming it into a textured, diseased curtain of magnificent proportions.

Art or not, he had now embarked upon a career as an artist. To members of the foreign art community—curators and writers more than dealers—now making inroads to the Chinese art scene through the early 1990s, Gu Dexin's art was rich in social and political connotations, cultural polemics, visual metaphors, human emotion and psychological implications. Paris-based curator and art historian Fei Dawei, who had played a significant role in the early development of the avant-garde both in China and abroad, views Gu Dexin as "simply the best Chinese artist". High praise from someone in a strong position to judge. Before he emigrated to Paris in 1989, Fei Dawei had watched Gu Dexin grow through the 1980s, and he was instrumental in bringing some of the more challenging of Gu Dexin's works to western audiences.

In the early 1980s, as Gu Dexin developed his unusual approach to art, he was not working in complete isolation but in contact with a small group of individuals in similar situations and with similar upbringings to his own. These were shy, self-taught laymen for the most part, drawn from amongst the ranks of local factory workers. All enthusiastically embraced new ways to paint pictures permitted in the changing circumstances of the times. By 1985, he had become acquainted with Wang Luyan, who worked in the publications department of the Ministry of Transport. As their association grew, Wang Luyan introduced him to Chen Shaoping, the Beijing-born son of a former Nationalist pilot who had refused to leave the Mainland amidst the general flight to Taiwan in the late 1940s. Chen Shaoping had worked as a miner in the remote coal hills of Shanxi province for more than five years in the mid-1970s—a place so remote he actually lost track of time—before being freed from the pits and assigned the job of art editor for the Ministry of Mining's internal newsletter. The three were initially united by an interest in painting, and discourse for their opinions about style and content differed enormously. The more time they spent together, the more their discussion of what to paint, and how, intensified.

The eruption of the New Art Movement across the country in 1985 invigorated their already spirited debates. Progress, advance, was becoming almost tangible: the content of paintings they saw reproduced in the nation's art magazines attested to that. Compared to the atmosphere in which they had been raised, the society surrounding them was moving in a brave new direction. Still, it was not easy to be self-taught. Harder still for self-taught artists to mingle with academy graduates

∧ New Analysts, Project 4, 1995

who tended to view them as little more than painter-decorators. The persistent awkwardness in gaining a foothold in the emergent art world aside, Gu Dexin's work had earned enough respect to be included in the 1989 "China/Avant Garde" exhibition.

The new art proved not to be as new as imagined. Too much had clearly been gleaned from external cultural sources. Certainly an intuited sense of these factors now contrived to lead Gu Dexin, Wang Luyan and Chen Shaoping to a decision in January of 1990 to form a collaborative collective, a blunt parody of socialist art projects executed by committee, named XinKeDu, or the New Analysts' Group. Each of the three members was obliged to contribute to the creative process. In this regard, the concept was humorously political: not least because it resonated with the tale of *Why Three Monks Will Have no Water to Drink*.[3] One wonders if they were trying to prove its tenets wrong. Yet, coming as it did just months after the "China/Avant Garde" exhibition was shut down, against the rancorous discord that existed within the intellectual camps of the educated elite, it offered an ironic jibe about the ability of workers to unite (or not) and work harmoniously together (or not).

"The New Analysts' Group," Fei Dawei explains, "represented a radical rejection of the trend towards romanticism which dominated the New Art Movement from 1985 to early 1989, although from the start, Gu Dexin, alone and together with the group, had clearly placed himself in apposition to this trend." Amongst the elite,

3. One monk carries water for himself; two share the work equally; three monks can't operate a fair rota so all go thirsty.

Wang Guangyi was most vehemently opposed to romanticism, yet in his quiet, effacing manner, Gu Dexin had already picked up the same idea. He was about to start running with it faster and farther than any other artist of his generation. In the meantime, he devoted himself to the activities of the group, and their goal to "unite, develop and advance".

The works the group produced left many people dumb-founded. Aside from an initial New Analyst statement in 1990, its members made no further public proclamation. Instead, exploiting a common vein of humour, this tight clique of like-minded musketeers adapted a truly socialist approach to making art, within which each agreed to subsume all individual traits beneath a common identity. The equal contribution to the creative process, defined in accordance with a proscribed principle, was achieved by awarding each of the three artists a specific task, upon which all were agreed. Each task functioned in the manner of a fixed move, as for a chess piece, and all assigned moves were carried out within the realm of an invented formula, which was unnecessarily and deliberately complex. The group's analytical process meant that anything, even recipes, could be deconstructed and reconstituted according to the set criteria of a predetermined formula. The resulting artworks took the form of either a single sheet of paper covered with fragmented graphic markings, or a book filled with mathematical texts and diagrams that documented the process by which the application of the formula resulted in the final reduction of signs. The non-sense of the images was a distinct inference of the bland approximations of ideas that resulted from subverting individualism to

the common cause, which was a core notion of Mao's theory on art. This lent humour and irony to the group's activities. In the early 1990s, the New Analysts represented the leading edge in commune-style labour, as one lone collective, beavering away at anti-art art projects like a regular production brigade. Ironically, this was one Chinese commune that truly out-performed itself.

As part of the New Analysts' anti-art art agenda, the only philosophy to which they adhered deliberately was aimed at eschewing the sphere of conventional exhibition formats. However, it was this very attitude, and the group's determination to stick to it, that won them the increasing interest and respect of foreign curators, as well as those in domestic art circles. Their refusal to join a game invented by someone else—i.e., the western world or the local artistic elite—set up an irresistible challenge from which people simply could not walk away. Invitations to exhibit poured in. Thus, there came a day in the mid-1990s, when the New Analysts found their work subject to overwhelming demand from the art-world system from which they had sought to remove themselves. As success threatened to draw them into a realm they vehemently opposed, it seemed the right time to conclude. On August 3, 1995, the three artists announced the disbanding of the New Analysts' Group. And that was the end of that; irreversibly so, for all agreed to destroy all physical evidence that the group had ever existed.

Throughout the five-year run of the group, Gu Dexin, Chen Shaoping and Wang Luyan each continued to produce work independent of the collective. Gu Dexin was the most prolific and distinctive. He is a master of immediacy. In conversation, he denies any intent to shock but the works do so, unambiguously. Remaining consistently non-committal about his intent, he further avoids letting anything potentially Freudian slip by differentiating each work via titles that say no more than the date upon which a work is completed, or the duration of the particular exhibition for which it is

≪ Laying out his installation at ddmwarehouse, Shanghai, 2000, for the exhibition "The Lights are on, but Nobody's Home"

Gu Dexin's installation for ≫
"Corruptionists", Beijing, 1998
(detail)

created. Aside from the evidence of the work itself, he provides few facts to go on in distilling the theory, concept or inspiration behind it. Two points were always clear: Gu Dexin is committed to his art, to exploring his materials and potential forms with a serious, deliberate and thoughtful intent. Second, critics and curators have consistently found substance in his art to confer the title of artist upon its author. In the twenty years since 1985, the consensus has not changed. Gu Dexin reflects truths about reality that are as sensual as they are nauseating, as mesmerising as they are stripped of any rose-tinted glow.

"Plastic" is not what was expected in art from China by the outside world in the early 1990s, which made it appear to be extremely reactionary. Certainly far more challenging than the daring bits of Political Pop, which garnered most of the media attention. But through time, as, internationally, art became ever more radical, plastic became less shocking as a material or in the forms it took under Gu Dexin's instinct-guided hands. However disgusting he can make it look, viewers intuitively know that it is not real intestines. Whilst initially, this allowed audiences to put appearances aside and grapple with what exactly the artist's concept entailed, in 1994, Gu Dexin introduced lumps of raw pork in his work. Since then he has expanded his range to include slabs of prime rump, lakes of brawn, and disturbing photographic images where flesh meets meat, animal on human. Plastic approximation had been replaced by the real thing. These lumps of meat are frequently adulterated to put a sexual spin on form and visual content that it was not exactly possible to achieve with plastic to the same degree of immediate and arresting effect. Gu Dexin did not forsake plastic, but flesh proved a powerful tool that demanded centre stage, so the plastic components of the work are increasingly ready-mades, like the mould-made poppies, roses and tulips employed as the softer elements of big, bold, and meaty installations. The reddish hues and vibrant pink tones that run through the work, either as plastic or flesh, insist that the audience is aware of its own physical being. The works also test the depth at which conventional social values are embedded in each individual. Are viewers embarrassed to be confronted by a

vibrator? Or by clitorii sculpted from pork strips? Are they repelled by rotting flesh or disgusted by mounds of fresh, ripe fruit left to spoil? None of these questions occurs to Gu Dexin. In public and private, he masterfully eschews a specific source of inspiration or implied meaning. There are those who instinctively feel his work to be sick, not deigning to call it art at all, which Gu Dexin applauds. But, a significant group of viewers find it sexy. At least, that is the adjective most frequently applied to descriptions of the works. A number of contemporary critics, gallerists and curators, both in China and abroad, uphold his work as anything from merely intense to take-it-or-leave-it nihilism, which substantiates their interest and, importantly, sustains Gu Dexin's career.

In the 1980s, Gu Dexin's works were anti-art in a time of limited cultural tolerance in China, arguably even more so in the mid-1990s as opportunities to exhibit in domestic art venues increased and culture crept into the viewing range of the State's modernisation programme. Against seams of bright oil painting, mixed-media works that were oriented towards social and environmental issues, and a general trend towards vulgar, gaudy images, Gu Dexin's creations exhibited an unequivocal, deeply disturbing, dark side born, one imagines, of pent-up frustration. Arising from what exactly is anyone's guess. It might be a dark shadow from his past as much as an exquisite empathy for fin-de-twentieth-siècle forthrightness that permeated global cultural trends. In contrast to his explosions of desire rent with contagious carnal leanings, Gu Dexin presents himself—entirely self-effacingly—as a lone philosophical visionary. His every disinterested retort or clever insight implies a cynically pessimistic view of the modern world in which the drive to possess, to own, and to consume the finest attributes of the material world renders society impotent, because enough is never enough and the pursuit of impossible rewards is cripplingly addictive. If there is any element of Chineseness in Gu Dexin's work it lies herein: by a simple process of osmosis, Gu Dexin was absorbing all the elements that were feeding the socio-political climate through the 1980s and 1990s, and spitting them back out as he saw fit. One wonders if, disturbed by what he witnessed as China blindly embraced consumer-based capitalist values, Gu Dexin was not righteously driven to provoke. There is an element of this, which the artist refuses to substantiate verbally. The question then arises, what is more disturbing, the fact that Gu Dexin produces works in this vein, or that they are accepted and reviewed as art? "If people want to be shocked they will be," he observes. "My art is not shocking to me; it's just a job. I really never think about how people will react. They see my work, to which they bring their own ideas. I don't believe that it is meaningful for an artist to try to give them ideas."

The transition that took place from the works Gu Dexin produced in the 1980s to those that appeared through the 1990s suggests a mirroring of the darker aspects of human nature being unleashed in China in the increasingly relaxed, open and frenetic society burgeoning around him. Moreover, as he pushed further and further into the realms of tortured, masochistic destruction and sexual deviation he had begun to question the morality of so-called civilised society.

Chinese urbanites may not have been sophisticated by western standards; their values were tied to government slogans in which the word "civilised" appeared fastidiously. Gu Dexin's art challenges all definitions of civilised one might care to name, and all the while observed it being praised by the art-elite of civilised western societies. In its own way, his work is a safety valve that releases aggression. Whilst this allows him to retain a sane, gentle nature within daily life, it makes the disparity between the work and the man who creates it almost as disturbing as the work itself. Affecting an unassuming demeanor, he constructs startling forms, yet the next moment, as he walks away from them, they are the furthest thing one would associate him with. His silence encourages wild speculation. "I don't care how people interpret me or the work, with what they make connections or how they draw conclusions. I make a work, put it in the public arena for all to see. I can't care what people will say about it. I certainly can't complain about points of view I don't like. Critics are just another audience."

On the subject of social or historical issues, Gu Dexin is extremely vocal, yet he remains quick to withdraw from any discussion that involves himself or his art. In the city of Breda, in 1997, Hangzhou artists Zhang Peili and Geng Jianyi, together with Gu Dexin, were amongst those participating in "Another Long March", a survey of conceptual art from China. One night, to Zhang Peili Geng Jianyi lamented that the audience did not seem to understand or respond to his work: "I don't think my message is getting across. Should I have to explain it? Is this work a failure?"

Zhang Peili laughed: "You see Xiao Gu? He doesn't say a word about his art. No matter what people ask, he avoids responding directly. No matter how much he's pushed or cajoled he never provides a satisfactory explanation. His silence becomes a mystery ... everyone believes there must be something to [his art] that he is keeping from them. Eventually, they convince themselves that it is great, deep and meaningful work. Xiao Gu still remains silent. He's very smart, is Xiao Gu ... "

"Making art is what I like to do but I put no more into it than the thinking time required to conceive a plan for a project. The idea comes out, I assemble the parts and forget about it. The audience is free to think what it will, about me as much as my work ... "

The endearing charm of Gu Dexin's attentive, generous and self-effacing manner, so at odds with the pulsating physicality of his work, ensures that people are comfortable with him. He is good at maintaining a placid surface, although there are times when tension escapes, enveloping him in a haze of uncertainty; times when his hands visibly tremble—due perhaps to an amazing capacity for alcohol, which he exercised regularly until quitting cold in 2004—certainly a hint that he is not as calm on the inside as he wishes the outside world to believe.

∧ Installation for "Asiana", Venice, 1995

He gives little outward sign, but anticipating how audiences will react to his next transgression engenders a degree of nervous tension.

Gu Dexin first employed a substantial quantity of meat in 1995 for the exhibition *Asiana*, an adjunct to the 46th Venice Biennale, and curated by Fei Dawei.[4] It was sited in the opulent splendor of a Venetian casino, which was commandeered for art during the period of the exhibition. Gu Dexin ordered three glass coffins constructed to strict specifications, each of which was to be filled with one hundred kilos of raw beef. Naturally, in the heat of the Venetian summer, it did not take long for fresh to turn foul. The process of decay unfolding within the coffins formed misty internal patterns on the glass, denying the audience a clear view of the actual contents, but by day three of the exhibition the fumes had gone beyond being tolerable. Supposedly airtight, the seal of the glass containers failed to prevent the vile odour of rotting meat escaping. Increasingly fearful of the noxious gases building up within, officials acted swiftly: the meat was removed leaving only the empty, now sanitised glass coffins. Gu Dexin was not unduly troubled by the turn of events: as Fei Dawei pointed out: "This was a work violent in language, yet one the public would never forget."

The following year invited to participate in the exhibition "Shelter", in the Netherlands, Gu Dexin gave the disruptive problems of using fresh materials further thought, and approached his project from a more sophisticated angle. The exhibition was to take place in the grounds of Wolfslaar, a country estate. Gu Dexin chose to create a mirror reflection of the nineteenth-century villa at the heart of the parkland: a one-to-one scale replica of the façade laid out perpendicular to it, and made of mirrored-glass panels. In addition to the constructed reflection, viewers were also presented with a field of five thousand plastic flowers planted in the earth, and which gave off a strongly perfumed aroma. Hidden from view directly beneath the mirrors spread over the lawn was fifty pounds of raw meat. Picking up where he left off with Chanel in 1989, Gu Dexin's despoilment of what appeared a beautiful response to the house and its environs mocked the decadence of the aristocracy which once occupied such estates. Here was a metaphor for social rot, of the type denounced by Mao, who like Marx and Lenin before him, proclaimed upper class privilege as sullying society to its core; a rot obscured by the trappings of wealth, status and power. To wit, the reflection Gu Dexin created could be described as physically kow-towing before the façade of the estate which represented the very altar of status.

The work remained in situ for two months, although the fresh meat disappeared faster than anticipated—apparently serving as ready meals for the local fauna. Prior to the opening, Gu Dexin disguised the odour by sprinkling bottles of the Dior perfume Poison on the surface—a choice of scent that was as incidental as it was ironic. The perfume permeated the entire park for days, but did not diminish the appetite of the indigenous wildlife. The reaction to the work was so positive that the following year, as "Shelter" curator Chris Driessen planned a new show for a

4. Organised by Milan-based Foundation Mudima as part of that year's Venice Biennale.

former military site, the Chasse-Kazerne, in Breda, Gu Dexin's name topped the list of anticipated participants. The project, "Another Long March", was the first survey of conceptual art from China to take place abroad. This time, Gu Dexin chose to deploy fruit to illustrate a process of disintegration. The result was as visually rich and tantalising as Derek Jarman directing a Caravaggio tableau. In a small garden area enclosed by the barrack buildings, he laid out three fields of lush, fresh fruit. But not immediately: having gone to great lengths to fund the raw materials for Gu Dexin's proposed work, Chris Driessen was driven to insufferable frustration as the artist apparently ignored them: "For days he did nothing except occasionally assisting fellow artists with their work. Two days before the opening I summoned him to start work, he continued to sit in the sun."

Driessen was suspended between faith in the weird and wonderful ways in which artists approach their work, and a pressing sense of time ticking rapidly away. Then; "On the last day he worked from dawn till dusk, spreading out the fruit almost like a painter laying in blocks of colour. He completely transformed that rather ugly, nasty patio into a mind-blowing composition which most visitors and reviewers referred to as a garden in a fairy-tale. I also was struck by the naked eroticism it radiated, even as the fresh aroma gradually changed into the stench of rot."

Gu Dexin, meanwhile, had his reasons for waiting until the very last minute. "It was important to me that the fruit was as fresh as possible for the opening. I often run into misunderstandings like that. It's the language barrier ... "

Viewers were invited to eat the fruits at their leisure provided they replaced cores, peels, stalks and pips, exactly whence they had taken them. In this manner, one thousand kilos each of apples and bananas, and a hundred kilos of strawberries were consumed. Uneaten fruits were left for nature to embrace in the course of a richly coloured organic disintegration.

Gu Dexin was now on a roll. In the course of the next few months, a similar exercise was repeated in Belgium, for the exhibition "I Never Promised You a Rose Garden". Here, five tonnes of apples were deposited into two rectangular perspex containers placed on a lawn in the grounds of another former private estate. This time, the apples were left to stew sultrily in their own fermentation.

Gu Dexin's fruit garden at "Another Long March", Netherlands, 1997

Simultaneously, in a vertical silo sited between them alternating layers of smoked bacon and fresh roses melted down into a sensuous orgiastic goo. The large vats, like the fruit fields, were strikingly beautiful, sating visual and olfactory sense with their colour and aroma, although this was far from being a conventional cornucopia. Aptly dovetailing with the exhibition's title, the work negated any notion of harvest festival. It was a site of wastefulness in a world where waste is often veiled by beauty or a superficial appeal. Given the location, in Belgium, home of the European Union's governing body, it alluded to the mounds of food that go to waste annually as a result of international trading surpluses born of treaties and quotas that protect as they discriminate. Gu Dexin, it seems, is not shy of making a point, however much he might protest a strategy or goal. Curiously, where meat features in his works it inspires different connotations, less waste than shock. Consumers have become less used to buying pieces of pork as a part of a pig from a butcher. More know meat as pre-packaged cuts processed for supermarket shelves. In an era of permeated by violence, the visual impact of raw meat is, therefore, much more horrifying to the unprepared.

By the late 1990s, with numerous invitations to participate in exhibitions abroad, Gu Dexin was able to realise experiments on a monumental scale. A small but significant number of new art spaces and temporary sites for ambitious exhibitions were also emerging in China. In January 1998, he was selected to participate in an ambitious exhibition in Beijing. "Trace of Existence", as it was titled, was

Gu Dexin garden of earthly delights at "I Never Promised You
a Rose Garden", Belgium, 1996 (detail)

to be held in a former people's commune, an open courtyard surrounded by successive outbuildings on the north-eastern outskirts of the capital. His proposal represented his biggest meat-fest yet. His plan was to fashion a vast bas-relief of female genitalia sculpted from minced pork, with a dousing of blood for added impropriety. Curator Feng Boyi intuitively sensed this would be problematic with the authorities, even in this remote location beyond the gaze of the general public: as a taboo, pornography ranked right up there with defaming ideology. Eventually, and with much careful exhortation, he persuaded Gu Dexin to reconsider and come up with an alternative plan. The artist simply changed the form. The installation was now a hundred kilos of pigs' brains spread out across a large trestle table covered by a red tablecloth. As a measure of mystery or protection, he screened the work from the environs with a pristine white curtain. This also blocked from sight a red cloth hanging on the wall above the table, which at first glance seemed suspiciously analogous to the national flag. Feng Boyi described the work graphically: "Visitors instantly recoiled at the smell. It was like a bad joke, an assault on the senses and a blasphemous outcry against the language of power all rolled into one."[5]

Power magnetises as it inspires fear and awe. This is what makes it fascinating, for Gu Dexin, who had witnessed power being wielded around him all his life. The work was an obviously politicised piece, paralleling a personal experience of the dominance of the red flag and the Communist Party, the grand tableaux of leaders (represented by the profusion of brains?), the scale of the system and the State. Above all, it adulterated the patriotic, emblematic nature of red in China, which traditionally encapsulates joy and celebration, latterly Communism and Maoist ideology. That it was spread over a tabletop referenced negotiating tables, over which deals are cut—in the Chinese convention, a dining table—at which complex issues are resolved. Whilst indicating the fatuous nature of power, Gu Dexin also pointed out how abstract and helpless all those on the receiving end of decisions taken were. Brawn was equally a substitute for a sea of anonymous humanity. The use of pigs' brains intelligibly echoed the metaphor invoked to signify the abuse of power in George Orwell's *Animal Farm*, where pigs rule the roost. A work of such harrowing intensity has yet to be tested on audiences in Europe or America, although scale is not always the most disquieting factor of Gu Dexin's art.

Gu Dexin's next few projects saw the artist replace quantity with quality, so to speak. Small pieces of specifically selected cuts of meat were positioned, manipulated, and adulterated to form intimately intense objects of a highly sexual nature. A series of photographs—produced for "Asian Artists' Installations" at the Mattress Factory in Pittsburgh in 1999—showed the back of the artist's newly shaved head, 'scarred' at the base of his skull by the superimposition of female genitalia sculpted from meat. The photographs were hung the length of a red-carpeted corridor that led to a wall of red plastic drapes enclosing a large bed. As if stumbling onto the set of a David Lynch film, viewers were lured along the carpet, the borders of which served to define a safe zone from which to regard the photographs. The content of

5. Feng Boyi, "The Path to the Trace of Existence: A Private Showing of Chinese Contemporary Art '98", *Trace of Existence*, p. 14.

Brains and brawn: installation for "Trace", 1998 (detail) ∧ ∧ Installation created for "Trace", 1998 (detail)

the photographs was unmistakably clear, and as they progressed along the carpet, viewers must have experienced apprehension of what lay behind the drapes. Nervous at being shocked or seduced, were they disappointed to find nothing? Gu Dexin did not need to put anything there. He had already succeeded in communicating to his audience: stirring imaginations to ideas they would otherwise never have entertained. Here, he played with the control individuals exercise over mind and perceptions, manipulating the moral values imparted by a particular social framework. Levels of tolerance are adjustable in accordance with each cultural paradigm. The sexual metaphor that Gu Dexin employed here was powerful because it was absurd, ugly, yet instantly recognisable to the audience on many levels: and not least, as an extreme satire of the phrase, often applied to men, as having "women on the brain".

Once Gu Dexin opened himself up to confronting issues of sex in public, all the barriers of prudery that the shyness of the artist encouraged interlocutors to anticipate slipped away. He began in 1998, in the dark basement of an apartment building, used to house a dynamic—and controversial—exhibition entitled "Corruptionists". Here, in a twenty-square-meter concrete bunker, he dispensed with the cold glare of the utilitarian fluorescent lights and installed low voltage red tinted bulbs that radiated the weakest of glows into the penumbra. Those who did not allow their vision to adjust fully at the entrance ran the risk of stepping on the small breast sized mounds of raw meat, shaped like female genitalia that he had laid out at regular intervals on the ground. A fresh rose stood proudly erect in each mound. Few visitors stayed long. Most fled, fearful perhaps of what awaited further into the space. Telling them that nothing lurked there did not prove reassuring.

If he was at all perturbed by reactions, Gu Dexin's grin masks it well. In 1999, in another Beijing venue, for a show on the subject of manmade materials, he used,

in the words of curator Li Xianting: " ... plastic sexual organs and flesh [raw meat] imitating intercourse to arouse the spectators' cheap thrill of fakes."[6] The translation should read "simulation" or even "voyeurism" instead of "fakes", for what grabbed audience attention was the meeting of vibrators and dead meat in a simulation of the sexual act, for which the gaze of the audience was made voyeuristic.

Man-made plastic sex aid thrust into prime rump, competing with a lean length of brisket stuffed into a receptive plastic passage was not run-of-the-mill, family viewing in art. Batteries charged, switches flicked, the two assembled entities, plastic instruments servicing and being serviced by flesh, wobbled around in full public view, reducing the oldest human fantasy to the bare bones of its components: an implement and a receptacle. There was, however, nothing remotely romantic about it, especially given the putrid odour rising from the meat, as spring heated up to summer in the airless environment of the space. It was the most talked-about piece of the entire show. How could conventional media compare? What it actually meant no one was quite sure, but all agreed that it was the most blatantly sexual of Gu Dexin's works to that time. With the artist then just three years shy of forty, there was much snickering amongst his peers about men approaching a certain age. But none of these friends probed the issue deeper with Gu Dexin. He has always been accepted as he is. He might sound like a Chinese Hannibal Lechter, yet he remains one of the most beguiling members of the avant-garde.

As he turned forty, Gu Dexin had lost none of his boyish charm. Only the strands of white hair streaking the black—worn swept-back—gave the years away. He remained tranquil and casual, typically dressed in faded jeans and sports shoes, topped by one of a collection of patterned jumpers. He wears clothes in a way that leaves no one deluded about pretensions to image or style. His only concession to material possessions is a powerful computer, which he employs to create small drawings that he once produced with watercolour on paper, and an extraordinary series of Flash animations. Maturity affords greater confidence, yet in spite of being palpably more relaxed with people, most of his days are spent in relative solitude, in the company of books, his computer and his wild imagination.

Gu Dexin is less consciously alternative than a conscientious dropout. His works continue to win affirmation, yet he is no more inclined to become involved with any sphere of the world around him than he was when he started out. He never visits art exhibitions—except to attend openings in support of friends. He avoids all reading matter pertaining to art or culture and neither catalogues or magazines nor critical tracts can be found in his home. Even on trips abroad, he does not idle away time visiting landmarks or exploring the environs of an exhibition venue. He holds tight to a close group of friends, maintaining a distance from mainstream contemporary art circles. Yet, his air of disinterestedness is innocent and uncontrived. His conversation, however, is not as artless as it is designed to appear. Gu Dexin deliberately confounds the logic of a discussion at every turn,

6. Li Xianting, "Curator's Notes", *Poly Phenolrene* exhibition catalogue, published by Bow Gallery, Beijing, 1999, p. 8.

Installation for "Poly Phenolrene", Beijing, 1999 (detail)

Installation for "Poly Phenolrene", Beijing, 1999 (detail)

inverting questions upon the questioner, challenging rationale and conventional thinking. With a deft surety, his tactics illustrate the depths to which formulating thoughts is a dangerous art for the assumptions and generalisations it is apt to encourage. He is fond of pointing out the ways in which words are loaded with ambiguity. "I don't like fixing things in words. When I began, it was to paint, then I became interested in social questions, people, difference … I felt there was work I could do here, but whether it is art or not I can't say. I prefer to occupy myself with my own thoughts and leave those concerning art to others."

Gu Dexin's seemingly nonchalant dismissal of general notions of what being an artist is about, of how works of art are viewed, and the manner in which art theory is articulated, is extremely persuasive. Perceptions are shaped by habits, often those that are imposed subliminally upon us within our cultural framework and national history. These proclivities propagate habitual ways of seeing. Breaking such habits is Gu Dexin's ultimate goal. "It doesn't matter what the form of control is, or the socio-political pressure applied, everything comes down to the habits of each individual society. I don't believe there is a fundamental difference between people in the East and West. It is just a matter of the [social] habits to which they have been subjected. These habits are usually explained as traditions, but I don't like the word tradition, I prefer habit. Tradition relates to the system, the social pressures of each society. It distances the problems from the individuals. I don't like that. If we say habit, then the problem is simple, something everybody can understand. As individuals, we each have the power to change our habits if we choose ... "

No matter what the weather outside, at home in his studio, Gu Dexin prefers the shades pulled down. Silence suffuses the apartment, made weightier still by the plumes of smoke Gu Dexin exhales in the course of a day: his appetite for tobacco is insatiable. This, together with the half-light, the white walls and bare concrete floor, is an appropriate setting for his art. The dim shade cossets the shelving unit loaded with abstract and gruesome plastic lumps one side of the room, the beloved paintings nailed elbow deep to the wall on the other. Here, Gu Dexin whiles away the hours fashioning small figures from plasticine, and animating drawings on the computer. He keeps a small wooden stool in the middle of the space, a board balanced across it, upon which he works the plasticine from block to figure. The resultant bodies, intricate and little, are the antithesis of his installation works: smooth-skinned, multiple-breasted beings, in a clustering of embraced and entwined limbs and lips, as individuals grow out of the main mother, like self-perpetuating Siamese twins, pair after pair, all bonded together. As a mass of breasts and voluptuous curves, worked to a sickly marzipan finish, the impression is every bit primitive fertility goddess. They are also illustrative incarnations of the steamy eroticism insinuated in the installations. Their diminutive scale requires tremendous patience and no small skill, for the details are extraordinarily fine and make for highly refined pieces of sculpture by any standard, albeit in this instance with that strange obsessive quality one associates with people who carve entire poems on a grain of rice.

It is hard to resist the temptation to pop-psychoanalyse Gu Dexin. After all, the environment of his home and studio, and the art he produces there, suggest a fantasy world of escapism, and of a distinctly fetishistic nature. This suggestion is further given credence by the lovingly crafted objects concealed within the

cupboards—these are subject to change, for aside from his photographic series *Meat*, they represent the only tangibly collectable portion of his output. Through 2001—this group was collected in 2004—carefully locked away in the end unit lived a colony of tiny worm-like figures, replete with oversized and apparently functional genitalia. None of these miniature beings was more than an inch in length. The majority was sunshine yellow, but there were also a blue gang, a red race and a green tribe. These communities of sculpted midgets were as tailored to their shelf space as Teletubbies to Teletubbyland. One imagined them only falling silent and still when the door was opened and daylight blinded their eyes. In the darkness, with the door safely closed—and Gu Dexin always locked it after he gave visitors a glimpse, as if the figures might otherwise escape—you could almost hear them frolic.

The inspiration behind these little flights of fancy is as intangible as that for any child making a drawing. "They are just things, little people I was painting before ... Making these paintings is a way of escaping reality ... it's a kind of freedom, a relaxation. There are many problems in society. Between men and women ... of sexual difference ... social pressure ... habits, the system ... The problem of sexual difference between men and women continues to produce social problems. These things are interesting to me. I don't believe that people are born with awareness of these differences. They are inflicted upon us by social conventions. It is people who create these, make a habit of them, foster them on others and call them inalienable parts of tradition, pointing to tradition as the root of the problems."

On the next shelf along, also locked in, the plasticine fertility figures meditate in a perfect state of Nirvana, all protrusions, holes and nurturing teats hinting at an unremitting state of Tantric excitement that never spills over into climatic exhaustion. Gu Dexin describes their evocative shade of red, of which he is so fond as "strong, imbued with multiple meanings across different cultural backgrounds. Red is charged with emotion but at the same time, when it is used as a monochrome, it has no colour at all." Red strikes the eyes with sensuality be it related to a life force, violence, birth, death or love. Across a multitude of cultural frameworks, the colour invokes the rawness of humanity at its most base and primitive. The crimson hue of the fertility figures is echoed throughout the decor of Gu Dexin's apartment: the open pipework in the kitchen and bathroom is daubed red, there are red towels and a florid pink toilet cover. There is a profusion of fluffy details and home-made toys like the families of ping-pong balls laced on strings. Shaggy teddy bears are lined up on a shelf to watch a group of wood and mixed-media models engage in a robot-style war on the floor. There is even a dolls' corner, replete with every conceivable type of doll available on the market: black, white, dark- and golden-haired, dolls that cry, dolls that can be fed, and dolls that pee their pants. In the absence of children, Gu Dexin and Shi Quntian regularly play with their brood; each one is named and tenderly ministered to. The sincerity of their playacting is at least as bizarre as any artwork Gu Dexin has ever produced.

Computer drawings, 1998–2003

Flash animation, 2002

Flash animation, 2002–2003

Hungarian writer-philosopher and physician Max Nordau once wrote: "Sexual psychotherapy is the single greatest factor in determining the popularity and success of unhealthy art."[7] By Chinese standards, Gu Dexin's art falls into the category of unhealthy. The sexual allusions determined some of the success of his art at international level. "Naturally there's a sexual element to my work! To some degree there's a sexual element in everything. In my drawings it is tied to attitudes towards freedom ... which pretty much goes for the other works too. I don't think that the two [sex and freedom] can be separated ... " More than that he's not prepared to explain.

No matter how much of an alternative existence Gu Dexin leads, and in spite of all his efforts to drop out completely, fame came, courtesy of the system, and clearly has its benefits. The most practical reward is the computer. For almost a year between 2001 and 2002, he dropped out of sight, so fascinated by software programmes that they occupied all his time. Audiences were rewarded in 2003 when the fruits of his labour were presented at the 50th Venice Biennale. Here, in Hou Hanru's Zone of Urgency, Gu Dexin presented twenty Flash animations, almost all under ten seconds duration. The subject is sex but the means of presenting it is as a comic strip brought to life: James Thurber meets South Park. They are sweet, intense, poignant and achingly funny. Most poignant because they seem to be a direct and bravely honest portrayal of abiding humans fears of failure, rejection and humiliation. The fact that they took the form of a joke made them one of the most refreshing pieces in the entire biennale.

≪ The artist with one of his "fertility" sculptures
photograph Liu Heung Shing

7. Max Nordau (1849–1923), "Degeneration", 1895, in *Degeneracy—The Explanatory Nightmare*, R.B. Kershner.

the LIGHTS are on but nobody's HOME

9 november 2000 SHANGHAI

artists
Chen bing
Gu dexin
Jin ang
Shao yinong
Shen xiaotong
Wang lixin
Wu shanzhuan
Yideer
Yue minjun
Yu youhan
Zhao liang
Zheng weimin
ziwei Wang

warehouse if you have any information please contact

exhibition sponsored by
THINK

3F 713 dong da ming road, 200080 shanghai, china tel: 021-3501 3212 fax: 021-3501 3340
e-mail: info@ddmwarehouse.com

Invitation for "The Lights are on,
but Nobody's Home", 2000
Gu Dexin's installation is the
large red square on the right
hand side: almost a hundred
pounds of minced pork blended
with a suitably sanguine hue
of cadmium oil paint

Gu Dexin instinctively understands how the emotion of his generation was propagandised and politicised in its formative years. This does not make it easier to deal with his own emotions openly or healthily, although he does them fair justice in his art, determined to toy with the sensitivities of individual audience members in the most public way he can achieve, confronting them with shocking, out of the ordinary images and materials. As the 1990s drew to a close, a number of works produced by younger artists served to demonstrate the profound impact Gu Dexin's art had exerted in China.

By manipulating forms and introducing radical juxtapositions of materials once considered incompatible with art, he questions the nature of power and all that we hold as civilised and intelligent. The artworks are thus a mirror in which reflections of all societies are held up for inspection. In that context, Gu Dexin's propensity for destruction is no more than a deliberate approximation of the atrocities of which mankind is capable. Here, in the name of art is an empty validation; he does not take it as an excuse to act without impunity, but he certainly seeks to leverage the powerful role that art can play in disseminating a message. Therefore, he also elects to locate his action within a system—the art world—that ironically both recognises and supports it. "I'm not anti-art, really. As I explained before, I don't like to see art defined by a system and myself confined by its vocabulary and terminology. But if a person wants to express ideas, and I do, then they need a channel. For me now that channel is art. An exhibition situation enables me

The red tribe of plasticine figures,
2003, in Gu Dexin's studio

With his collection of ≫
manmade muses
photograph Liu Heung Shing

to put my ideas in a public space to communicate those ideas. However, to participate in an exhibition and to respect the system are very different things. In China, the system demands professional artists with professional outlooks. I find this totally uninteresting."

Gu Dexin consciously shrugged off his immediate social environment to create his own world, in which he can and does do as he pleases. He will never be Peter Pan, but in truth he doesn't wish to be, not with all the freedom he has to fantasise, and all his invented creatures to succour him. What more does an audience need to know? As far as Gu Dexin is concerned, not much: his art says it all, or nothing, as the case may be. An example of this, that he repeats at regular intervals, is found in the catalogue to a group exhibition at the Galerie de France in Paris in 1996. Three of the four participants, Fang Lijun, Zhang Peili and Zhang Xiaogang, present brief written assessments of their concepts, inspirations and intentions. The section on Gu Dexin features only a very brief resume and the words "Gu Dexin". The rest of the page is tellingly blank.

LI SHAN:

NOWHERE WITHOUT MAO

Li Shan in his studio, 2001
photograph Liu Heung Shing

"Call it a personal history, if you will. In 1989, I felt able to look back at this time [growing up under Mao]. The result in painting was my reaction towards this experience. This is why for me Mao is a cultural symbol and not a political one. I derived so much from that time, from that period of history. I would have been nowhere without Mao ... "

Li Shan is a painter: one of the handful of Chinese artists who, from the early 1990s, produced work that, within the flourish of new Chinese art-speak, was dynamically labelled Political Pop. This set Li Shan's art in the same category as that of Wang Guangyi, although the work each produced was radically different. An ongoing pastoral-naif aspect to Li Shan's painting—mostly those works that were not shown abroad—is closer to the early folkloric style of Zhang Xiaogang than to anything strictly avant-garde. This sensibility is not easily dispelled, being discernible today in his appearance: his hair a tousled covering of pin-stripe curls, natural and unkempt, and the casual mid-west dress, from his sneakers up to the thick cotton shirts that habitually hang loose outside faded jeans. The essential difference between Li Shan and other Political Pop artists lies the variant formative experiences engendered by the subsequent eras into which they were born. Li Shan was born in the 1940s; Wang Guangyi and Zhang Xiaogang in the 1950s. Each era asserted an especial influence upon those who experienced them, one that individual character could not expediently deny.

Political Pop pivoted on a highly stylised—albeit at times simplistic—re-invention of popular icons central to the experiences of China's avant-garde during its impressionable youth. The most prominent of these was the many faces of Mao

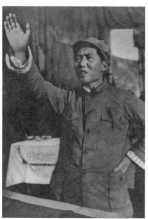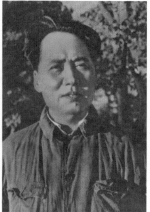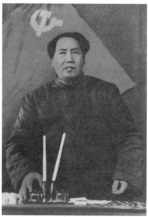

Zedong, a motif deeply implanted within the visual understanding of the masses from the late 1930s, and one that China's propaganda bureau idealised to perfection long before Andy Warhol went to work with his paintbox. Li Shan was not the first artist to appropriate the image of Mao Zedong to art—that honour goes to Wang Ziwei, closely followed by Wang Ziwei's teacher Yu Youhan (all residing in Shanghai)—and, of course, Wang Guangyi. But Li Shan was one of the first, and one whose primary-coloured paintings of Mao were worthy of the attention accrued to the images as they circulated abroad. Their appeal for collectors proved enormous and, by 1994, as Li Shan personally notched up a half century, he had amassed a small fortune from what he described as his painted response to the Mao era. The specific nature of the response was perceived primarily from within the paradigm of a foreign audience and, therefore, interpreted accordingly. But that didn't matter too much. The compositions are striking, bold, harmonious: very "pop" and all the better for coming out of China with the accompanying political edge.

That notwithstanding, despite the critical and commercial success Li Shan garnered through the mid-1990s, in 1995 he decided to conclude his business with Mao and allow tantalising new questions about science—in a manner of speaking—to draw him back to nature. Come 1996, as the apparently political elements of Li Shan's paintings evaporated along with Mao, the possibility that audiences might lose interest in his work—a distinct possibility given that which was poised to take Mao's place—was apparently of little concern to the artist. If nothing else, his name was assured of its place in Chinese contemporary art history and he had secured enough means to retire. Li Shan prided himself on modest needs, yet there was more to his apathy towards the rewards of commercial success than the modesty of his existence. He was convinced that the true path of his artistry lay with an intuitive response to his experience, not in creating what appeared to be rationally reasoned reactions to political dogma or the practical failings of a theoretical system of social organisation. All of which, to the outside world, his evocation of Mao implied.

As Li Shan put Mao aside, reinstating nature as his muse, he brought to the new paintings cumbersome creatures, human and equine, adorned with butterflies: tormented, as it were, by lepidoptery. He had embarked upon a search for personal expression that returned to an Arcadian vision of the natural world. There was no harmony as yet. Sensing the genetic distortion that had overtaken their familiar human form, his painted figures insisted they are more artless than blissfully innocent; poor, mutant beings with butterfly wings where their ears ought to have been. The man/butterfly theme was closely tied to the mysterious wonder of nature's inventions, over which Li Shan would seek to exert control in a series of faux-scientific experiments. By the early 2000s, as the subject of cloning and the unravelling of the mysteries of DNA swept into China, he had developed a fascination with creating new life forms, abandoning his brushes to gather dust as he pursued abstract, ostensibly conceptual ideas about biology. To be captivated by the possibilities of altering states of nature might be expected from an avant-gardist, yet throughout Li Shan's most politically iconographic period, he had continued to paint lyrical pastoral scenes in a primitive style that bore little relation to avant-garde approaches. Even the perfunctory aspects of the butterfly-eared-men paintings, such as the clumsy imbalance of their form, reflect a lingering early love of the gentle affectations of Henri Rousseau and Gauguin. The Mao works single-handedly brought Li Shan fame within the international context, yet audiences familiar with them would have been astonished by the contrast between them and the new paintings, had they been shown together. To date they have not, which rather points to the efficacy of Mao, above and beyond Li Shan's artistic style. And the prominence the Mao paintings achieved, beyond the broader *Rouge* series, which extended over a number of years (1988–1995), and of which the Mao compositions are but a part (1992–1994), is misleading. It is the *Rouge* paintings as an overall group of which Li Shan remains most proud. They come closest to expressing the "personal history" he seeks to recapture, and dominate the humble photo album he keeps as a memento of his work.

The *Rouge-Mao* works are stunning. Familiarity with his subject—Li Shan had painted Mao portraits during the Cultural Revolution—imbue the paintings with a power of conviction that arrests attention. The poses and postures Li Shan appropriated are those he grew up with, that he saw every day of his life, many times a day, in all propaganda materials of Mao—posters, books, newspapers and magazines—right up to the late 1970s. Li Shan has repeatedly asserted that Mao was not the aggregate of his message. Unfortunately, where the Mao paintings dominated his public exposure abroad, the opposite appears true. As an icon and symbol, Mao is erudite and apt to confuse viewers, Chinese or otherwise. To the external world, politically and ideologically, Mao was a dictator, not as maniacal as Stalin or Nero, but one crazy enough to have made one fifth of the global population the subject of a socio-political experiment that led his empire to the brink of spiritual, cultural and economic bankruptcy. The attitude of a domestic audience, had the people been afforded a viewing of Li Shan's works, would

have been more equivocal. Mao was great; the revered liberator of the people. But as he was human, so he was flawed. Power has a hypnotic fascination, as Gu Dexin demonstrates in his unique and contrary fashion, and the success of the Mao paintings—abroad—is largely due to the daring parody that underscored Li Shan's appropriation. The images are those most characteristic of the propaganda bureau's stylistic fixing of its leader during the Mao era: Li Shan did little more than give them a fresh makeover, retaining even the familiar palette of strong cobalt blues and army greens. Only the pink tones he introduced were at odds with the cultural preferences of the people's art; that, and the distinct homo-erotic undertones that suffuse the paintings. In the 1990s, to depict Mao of one's own volition and invention was surely an act of political subversion, but to do so in an unmistakable aura of burlesque was also slightly weird. For Li Shan, that weird bit was all that counted. To critics and the art world in general, he began to emphasise the broader *Rouge* anthology: Mao had become a distraction.

Nonetheless, when Li Shan painted Mao he became eligible to join the avant-garde. Almost simultaneously, the local art community's awareness of the sexual connotations in the paintings elicited an awkward response, such that compelled Li Shan to take an equivocal stance towards his subject. For Li Shan, Mao was an icon that represented an era which had had an immense impact upon the subtext he was actually pursuing in his painting. All the same, when he stopped painting Mao in 1994 and reinstated the lyricism of his earlier styles, a significant chapter of Li Shan's life closed. His work lost something of the avant-garde-ness that had become associated with the Political Pop and Cynical Realist schools. If personal experience is, as Li Shan states, the focus of his art, then the *Rouge-Mao* paintings are closer to Scar Art than a radical avant-garde agenda, for they reflect how Li Shan was made to feel living day to day in the monumental shadow of one larger-than-life human being. Look closely and you see they are not so tangential. Mao serves as a visual decoy, permitting Li Shan to explore an "otherness" in human nature—homosexual or not, is left to individual debate. Where his response to life is primarily emotional, Li Shan is not given to sophisticated allegory. Furthermore, in coming to study art in the mid-1960s, at a time of intense socio-political upheaval, the technical training he received was inalienably tied to Socialist Realism imported from the Soviet bloc, and came with an inhibiting and self-censoring

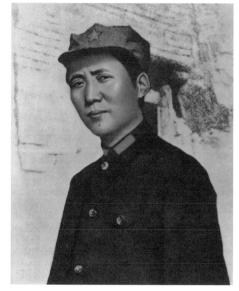

spike that stymied individual innovation. Therefore, to describe Li Shan as avant-garde does not equate with its meaning in a western context. Instead, the use of the term represents an accurate reflection of Chinese cultural attitudes in the 1980s and 1990s, for following the pattern established by the communists in entrusting ideals to words, usually in the form of slogans, artists of the New Art Movement believed that by declaring themselves to be avant-garde, they would so be.

In determining the influences that shape personal history, location is as relevant as era. Li Shan was born in Heilongjiang, China's far north-eastern province, which sits on a higher latitude than North Korea, its northern boundary reaching up along the far western border of Siberia. He is dismissive of Shanghai—Paris of the East, Pearl of the Orient, city of glamour, lights, and cultural and economic sophistication—where he has lived and worked since 1964. It is surprising, therefore, that in almost forty years, aside from infrequent visits to his family back in Heilongjiang and brief sojourns abroad, Li Shan has rarely left Shanghai. He speaks of other northern cities like Beijing with a yearning that moistens his eyes: "The cultural life is so much better in the capital ... " he suggests. If this is a man who spent his life dreaming of greener pastures—as implied by his landscape paintings and his dismissive attitude towards Shanghai—they were apparently not to be found in China. Certainly not in the north, for no matter how Li Shan might claim to abhor Shanghai, the pull of Heilongjiang was never strong enough to lure him back: Li Shan found his hometown emotionally repellent, as the painting *Hometown* suggests. He infers that he harbours experiences to account for his resentment towards Shanghai—with a lowering of the eyes to indicate a subject too painful to be broached. But like all big cities, even where for his generation the specifics of location were generally overshadowed by the socio-political climate,

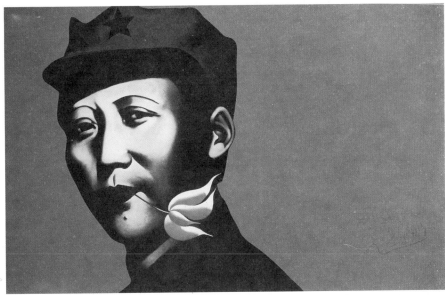

Rouge 57: Young Mao, 1994 ≫

Shanghai offers a degree of anonymity, which is ultimately a plus for a person of Li Shan's retiring character.

By the end of the 1990s, Li Shan owned a luxury villa in one of the city's affluent suburbs. In a densely populated city where space commands an enormous premium, he occupies studio space that is more than adequate for his needs. He enjoys a good standard of living, if humble by preference: "I know that some young artists in Beijing lead wild bohemian lives", he asserts. "It doesn't matter how you live if you don't create good work. For me money merely provides a chance to make better work. I have no interest in leading a lavish social life. I have a good home but it is no different in essence to my studio, just bigger. If I can do a satisfactory day's work, I could sleep on the floor and sleep well."

His fame as a leading Political Pop painter—Political Pop enjoying the most public international profile of the various seams of Chinese avant-garde art—further enabled the purchase of a modest apartment in New York and funds enough to put his daughter, Li Yang, through college there. During annual paternal visits to New York, to a nation he does not cherish, whose language he does not speak, he passes

his time indulging in an unbridled passion for basketball and the NBA—the only subject upon which he ever becomes animated in public. Even with the NBA and his close relationship with a daughter residing there, New York never holds him away from Shanghai for more than a month at a time.

Shanghai was once the most industrial city in China, thickly populated with a working class that far out numbered the rich. For this reason, it was also liberally sprinkled with political radicals, spawned and nurtured within the factory ranks and keen to better the system, for they knew its short-comings intimately. Thus it was, that come the—Cultural—revolution, it was Shanghai's workforce that ignited the sparks of revolutionary struggle across the city, sparks that ignited into flames more ferocious than anywhere else in China. However, even that was done with inimitable Shanghai style. Mao Zedong might have given the directive, but the interpretation was a self-styled response verging on pure insurrection, pointing to an independent spirit that was necessarily curtailed by subsequent Party directives sternly issued from the capital.

Through the 1990s, transformation was set in motion as the city revamped and revitalised the old dream: Vaudeville made Hollywood. Basking in the style and the glamour of a history of internationalism that the rest of China admired from its cloth shoes up, the Shanghainese looked to the world where all other Mainland citizens looked to Beijing. Which other city could be so bold? This dare-to-be-different élan gave rise to inalienable cultural one-upmanship that even the Cultural Revolution did not eradicate. In part, by dint of its cosmopolitan past, life in Shanghai had inlaid provision for certain social freedoms of which other cities could not yet conceive. In the era of opening and reform, flames that had been doused by Mao were rekindled—age-old inclinations that neither Communism nor social stigma managed to suppress—and Shanghai's gay community flourished. The city's social ambience played a part in permitting Li Shan to become the artist he desired. It would have been impossible to realise many of the works for which he is recognised today in the capital: Beijing remains both more brut and less tolerant, while nationwide, the cultural enlightenment of lesser urban sprawls lag several decades still further behind. In point of fact, Li Shan's malevolence is not so much directed towards the city as at the local Shanghainese character, obdurately defined as "sharp", smart to the point of arrogance, and, long ago, it was universally agreed that locals were blessed with fine business acumen. Socially, Shanghainese people are sophisticated, cultivated, and refined. Yet; "... the Shanghai people can be very closed", Li Shan confides. "To live in a society you cannot avoid having contact with people ... here it is difficult." One imagines an artist can retreat into their studio: "Sometimes, sometimes not", he stresses.

An individual's desire for solitude is not a common component of social life in China: gregariousness is actively encouraged. Of course, through the long dynastic history of the Middle Kingdom, solitary hermits did seek enlightenment in caves for years on end, whilst wandering monks and retiring scholars adopted measures suited

to their goals, but they were few in number. Tales of lone, itinerant souls, idealised men who shrugged off the trappings of the material world, were tales geared towards impressing moral standards upon the masses. And given the predominant convivial clustering of clans through history, a preference for solitude was perceived as a sign of malintent or discontent. Even when Deng Xiaoping dismantled the commune system in 1979, the group remained a powerful, demanding patron, against which Li Shan steadfastly maintained a preference for a handful of close friends. A predilection for his own company is as much part of his character as the type of art he produces. He is awkward and insensitive in public as only those who spend too much time alone can be. So, for all the reasons cited, Li Shan never made a serious attempt to transfer out of Shanghai. The experiences he endured through the period of socio-political upheaval under the communists and then, that wrought by his painted renditions of Mao might have made him bitter, but even he agrees that Shanghai is not without allure. The complex and layered nature of the city is an apt simile for the man.

It was a dream come true when, at twenty years of age, Li Shan was accepted into the department of stage set design at Shanghai Drama Academy. His artistic aspirations were rooted in early adolescence, but at the time he completed high school in 1962, gaining a place at an art academy was extremely difficult; many were not simply recruiting students. He did, however, win a place in the English department of Heilongjiang University, which was considered a significant achievement. His parents and teachers were thus surprised when, six months into the first semester, and professing a "deep unhappiness", he withdrew from classes. Li Shan's parents were simple farming people. They wanted to see their children better themselves. A good education would significantly increase their chances of being assigned to a respectable *danwei*. Fortunately, Li Shan's father was, in Li Shan's words,

"an open-minded man". He told his son to follow his inclinations to do what he felt best. "I wasn't interested in becoming a translator. I loved nature. All I wanted to do was paint nature, to carry my easel to the countryside to paint. What a beautiful, free idea! I wanted freedom very much."

Thus, in 1964, when Li Shan was accepted at Shanghai Drama Academy, he was freed from the leaden tedium

of English in Heilongjiang and the prospect of what he perceived as an interminably mundane future as a teacher or, if he was lucky, a translator. Initially, he found comfort in Shanghai; for a fleeting moment, his longed for fantasy of becoming an artist was tangibly within his grasp. But Li Shan had the misfortune to enter an academy just as all institutions of higher education were poised to cease functioning, as the people's energies turned to the Cultural Revolution and, under the political dominion of the times, the social atmosphere acquired a nervous, unpredictable ambience. Over the next two decades the reality for an aspiring artist was shockingly adverse to all desired outcomes, but, in the brief period before politics took over, Li Shan embarked on an education that "distilled those portions of Soviet Socialist Realism that suited Mao's political ideology" and turned these techniques into the workhorse of oil painting, sculpture and printmaking. Entering the academy, Li Shan describes himself as a blank piece of paper, but this was not entirely true, for his proclaimed blankness already contained an intrinsic inclination towards wide open spaces—"nature wild and free"—that was at cross purposes with what he was expected to pursue. "The Soviet style did not sit well with what I intuitively wanted to create. I wanted to express what was within me, not to record mechanical observations of what lay without. My early painting was very close to Expressionism."

Attesting to this are small, softly coloured landscapes from the late 1960s, the 1970s, even the early 1990s, examples of which hang on the walls of his villa. The childlike arrangements of sky, earth, tree and, on occasion, animals, in perfect, harmonious and unthreatening worlds suffused with peaceful innocence, point to a pure Utopian idealism. Flora and fauna are sketched out with only basic reference to essential structure and form. Here, the romantically naive primitivism of Gauguin and Henri Rousseau merge with Li Shan's brushstrokes, shaping the reflection of nature he brought to his painted scenes. There are also hints of Paul Cezanne and Jean-Baptiste Corot in the pastel shades of colour and dry, slightly chalky texture of the paint. Li Shan frequently diluted the paint and applied it in a washy consistency—hence its chalky texture—as if this was his response in oils to the Chinese tradition in ink painting. This attempted fusion of two painterly styles and techniques would be the subject of further exploration in the coming years.

Li Shan's Fairy Tale 3, 1992
Image courtesy Alisan Fine Arts

If, as befitted the tradition of ink and wash, the small paintings did represent an idealised slice of nature into

which those disillusioned with the real world could escape, that would account for the volume of sprawling, flat, middle ground that dominates the majority of the compositions. Scholars note that within the conventions of Chinese ink painting, "middle ground" represents a kind of wilderness, a limbo if you like, where the restless can roam; a space to which those dissatisfied with aspects of their own social environment can abandon their troubles—cerebrally if not physically.[1] Where Li Shan stresses the importance of personal experience in his art, it would seem a plausible connection. However, although he used symbolism widely in his work, his allusions are usually not as complex as the interpretations subsequently read into them.

Initially, life at Shanghai Drama Academy offered much that was new and exciting. In 1964, the school was a series of colonial-style buildings set around a leafy garden. Later, aside from the gardens, only the original theatre remained—used only by students for rehearsing earnest excursions into stagecraft. The original rows of hard iron seating remain, painted the same sky blue as when they left the factory. Riveted to the concrete floor, they sternly face a simple platform of seated audience eye-level height, which served as the stage. In the 1960s and early 1970s, the space was in constant use for screening films, presenting propaganda plays, and for students and staff to study Mao Thought en masse and to plan their participation in each new campaign—and of course, for struggle sessions and denunciations.

As Li Shan enthusiastically embarked upon his studies, here at the Drama Academy was pure art, not tedious hours of grammar and syntax. Of greater satisfaction, he was now one of a group of like-minded fellow students. Together they sketched and painted, revelling in the relative freedoms life afforded them, for what was to be a little less than two years. Li Shan was barely halfway through his studies when the Cultural Revolution began in 1966. Initially, the announcement was received to a buzz of excitement in the major cities. In what was a feverish period of butt-to-butt socio-political activity, the May 16th proclamation promised to be the most exhilarating—radical—campaign yet,[2] investing power in the nation's youth. As such, it differed from the majority of previous movements in the projected scale envisioned. Mao's 1956 decree to Let a Hundred Flowers Bloom, a Hundred Schools of Thought Contend, and the Anti-Rightist Campaign that followed swiftly on its heels in 1957, alerted the artistic community to the potential restrictions the Cultural Revolution could place upon them. Yet no one was in a position to predict the quagmire in which the arts community was about to become entrenched. Overnight all hell broke loose as Maoist ideology took on a whole new life of its own.

As the Cultural Revolution proceeded classes at the academy dwindled until the day came when they were suspended completely and the students' talents firmly harnessed to the revolution. Li Shan graduated, of sorts—given the chaos of the moment—in 1968. His graduation certificate was almost a consolation prize. However, he was retained by the academy and assigned a teaching job in his former

1. Freda Murck, "Viewing Landscape Metaphorically", Association of Asian Studies Annual Meeting, 1998, *Panel 94: Place, Territory, and Landscape in Song China.* p. 2.
2. May 16th decree was issued in Beijing following a reshuffle of the Beijing government.

department of stage set design. With theatrical drama being an effective means of making revolution—the most direct form of marketing the Party had—there was much work to be done. What was a good revolutionary opera without splendid sets? For those selected to be involved, it was a busy era (most of the revolutionary operas—commissioned by Mao's wife Jiang Qing—were created in Shanghai). As the existing film versions demonstrate, it was a time of extraordinarily resourceful ingenuity in stagecraft, using what were limited means.

By the early 1970s, no one could evade their duty to the revolution. Enthusiastic participation at all moments, in all campaigns, was mandatory, and by and large, amongst the proletariat youth, commitment was genuinely heartfelt. The Red Guards, as Mao's young pioneers were known, held in the sway of idealistic goals in which they could palpably play a part, were happy to turn the hormonal fires of adolescence to changing the Chinese world. "Respect for peers, superiors and teachers was seen as fostering bourgeois class attitudes. We had to criticise all the values of the "old" society: to put these things in the garbage." For cultural practitioners, this was not easy. Many owned a genuine respect for their teachers, as Li Shan now was with all the attendant vulnerability. "Not appearing to disown these things enthusiastically was interpreted as condoning the old, or bourgeois ways."

As a teacher, Li Shan was unable to depart one inch from State specifications for instilling students with the criteria they were expected to meet. Everything was proscribed, but for this romantic nature-lover there were advantages. "For our department, the study of landscape was accorded greater importance than in fine art academies." Li Shan's particular liking for the painting style of Henri Rousseau centred on how Rousseau "filtered out the mundanities of daily life to express an idealistic harmony between man and nature." This resonated with Li Shan's experience of life, especially in the countryside around Heilongjiang where he grew up—that is often compared to the Russian Steppes, and was powerful enough to have made a lasting impression on even rational minds like Wang Guangyi. "I believe Rousseau's work comes close to what classical Chinese philosophers aimed to evoke: a pure and simple existence at one with the world. For me, his paintings are like pure, untainted memories of my childhood."

Li Shan's love of nature, à la Rousseau, was evidence of a bourgeois sentiment that he had clearly not dispatched to the garbage and, as a result, he came in for severe criticism at the academy. Yet he was loath to change his style of painting or negate natural subjects that intuition impelled him to paint, even if this meant contravening the ideas Mao laid out in his principles for an art to serve the people. Surreptitiously, from the late 1960s, Li Shan's personal style began to find form. By keeping a low profile he managed to sustain his trips to the countryside: under the guise of learning from the peasants he could escape the laborious intensity of political life in the city, and fully exploit an opportunity to imbibe landscape.

Imagine a day in the countryside under a clear blue sky. Ripening corn sways in fields that stretch to the horizon with the merest nudge of hillocks visible. Two

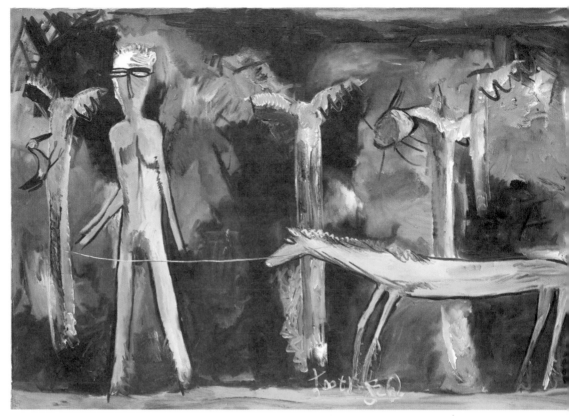

Origins: What is This?, 1982
image courtesy Alisan Fine Arts

young men—Li Shan and his closest friend—trail home, back towards the city, along a dusty path that divides the flanking yellow plains. Canvas bags slung over their shoulders are filled with the day's sketches of a small copse, an oasis of green in the yellow, now receding into the distance behind them. Small oil paintings are clipped to primitive wooden easels strapped to their backs, the slow-drying surfaces glisten in the light. The two amble along in the fading heat of the day, an unspoken camaraderie in their conspiratorial absence from the city in favour of nature. The only sound is the purring of crickets, which they let be for it is too nice an evening to bother with trapping the insects.[3] And then in the distance, they see a gaggle of children. As they near, the two notice that the children's reddened cheeks match the scarves around their necks, the emblem of the young pioneers. As the distance between the two contingents shrinks, the children's expressions become serious, making to greet their older comrades. But then they see the easels and demand to know what the two have been doing, pulling the tacky oil boards free for inspection. In a brutal inversion of age-old social order, juniors now had no fear of confronting their seniors in matters of questionable revolutionary conduct. The country children are not old enough to be too clever, but they know landscapes are not pictures of Mao, nor are these

3. The catching and keeping of crickets was a favoured pastime, and a long held cultural tradition.

preparatory sketches of hard-working peasants in the fields at their labours. Either way, this is not the kind of propaganda that good revolutionary comrades should be producing. The two young men sense that trouble is imminent. Without a word, they begin to run, running and running until the children are left behind out of sight, the contents of their flapping canvas bags spilt along the path behind them, sticky oils now slathered with strands of wayward weed and dust. The pair return to the city empty-handed. It is a memory Li Shan retains—and retells—with a cast of tragic romanticism. He harbours a wistful pity for the ignorance bred by revolution—a profound sign of those times—and pain that what should have been beautiful experiences were tainted by the atmosphere of the moment.

Born in 1944, Li Shan is practically the oldest member of the avant-garde. In 1989, participating in the much anticipated "China/Avant Garde" exhibition in Beijing, he was already forty-five years old, whilst the majority of exhibiting artists were around fifteen years younger. His main contribution to the exhibition was a performance; a ritualistic washing of his feet. Photographs show him seated on a stool, swathed in a red cloth, feet sunk into water in a red plastic bowl, his facial expression is intense and worried. His style of performance followed a local trend instigated by those artists within the New Art Movement inclined towards performance: the demonstrable preference was for wrapping themselves up in great expanses of red, white or yellow cloth, invariably explained as metaphoric appraisals of bondage—spiritual, physical and political.

For Li Shan, instant notoriety ensued, both within the art circle, which was already familiar with *Last Supper*, a performance piece done in 1988, which involved the entire contemporary art community in Shanghai, and the immediate audience. Certainly on the part of the circles of new artists, the notoriety Li Shan owned at that time is perhaps better phrased as the quizzical regard of youth towards age. Whilst the fact that a middle-aged man was participating in what was largely a young artists' event came as no great surprise to any of the twenty almost-thirty-something artists at that time—as China began to advance and open up, everyone was scrambling to make up for lost time—acceptance was not total. The ranks of recent graduates felt that being avant-garde, by its very nature, demanded the rebellious energy of youth. The difference in age was easier to straddle than the difference in experience—even for staunch Red Guards, the traditional reverence for elders could not be shaken that easily and continued to encourage a certain respect. This was a dimension of social interaction that avant-garde artists struggled with. The act of showing reverence for elders arose from a belief that elders knew more or were more skilled—as is the belief within ink painting circles. Li Shan came to art in a world of constant change and contradiction, where nothing was immutable, not the facts of history, nor those of culture or politics: a society in which individuals hid opinions behind rote-learned verses and the formulae of political rhetoric. Transgressors were rewarded with unreserved retribution.

Compounded by his retiring character, Li Shan's articulation of thought processes and received influences upon his art and life does not begin to approach the lyrical sense of the picturesque in his landscape paintings. He struggles within a mode of speaking that conceals more than it conveys, in a tone that is resolute but circumlocutory; if it is possible to be both at the same time. How much is intentional, how much incidental is hard to appraise. It is customary within Chinese culture to be less than direct, to leave space for the listener to interpret nuances in meaning and implication. In this, Li Shan is masterful, coming at a point from every possible angle, herding it into form like a sheep dog rounding up a gaggle of sheep, and to many ears, the effect is equally woolly. He can be momentarily frank and precise but like many creative thinkers and doers, he has never been lucid about his work. Perpetually punctuated by a smacking tut of air and tongue against teeth, his delivery comes in a limited and repetitive vocabulary, which sounds more limited and more repetitive because of the measured, emphatic pace of his bass-pitched vocal tone. He clearly takes extreme care to think through his ideas and, although they do not always make immediate sense, the reams of cleverly non-committal dialogue make it sound as if he is on to something profound. What that is appears to be clear in the Mao works, but goes beyond the surface of the paintings. Li Shan's evasiveness is necessarily well practised. By virtue of his age, he was more fully acquainted than younger members of the new art scene with the strong-arm tactics of the State and the pressure that was exacted against anyone who fell foul of conventional protocols.

In the 1980s, as other leading new artists explored concepts and wrote manifestos, Li Shan began punctuating his ponderous landscapes with compositions exhibiting a lighter sense of the pastoral. In addition to having married in 1973, in 1976, he also became father to a daughter, Li Yang, which had brightened his future considerably. As the years began to place a distance between Li Shan and his personal experience of history under Mao, he began to look forward, experimenting with Picasso-esque line and planar reduction of anatomical form, in both portraits and romantic idylls. Here, instead of flat middle-ground, we find sheltered clearings within dense woodland where animals graze, human figures drift like ghosts and the vegetation contrives to protect all from external interference. Around this time, Li Shan also produced the first renderings of works he would group under the title *Origins*, and which would assume various forms through the ensuing decade. These took their direction from a desire to trace the origins of mankind in forms that paid homage to pre-historic cave painting. By the mid-1980s, he was working on a group of paintings that took as their starting point freehand elementary shapes, evolved into increasingly abstract essences of themselves. This was also the period in which he collaborated most closely with members of the New Art Movement in Shanghai, participating in two exhibitions organised by the artists themselves, one in 1986 and the other in 1987. The reductive juggling between colour and form evident in the paintings Li Shan produced during these several years was characteristic of local Shanghai artists. Yu Youhan was already exploring abstract

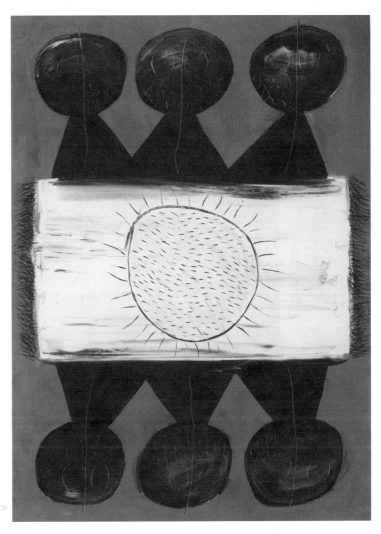

Continuation of Extension 1, 1987 ≫
image courtesy Alisan Fine Arts

forms of painting in ink and oil on paper and canvas. In 1988, Ding Yi made his first "cross", a mark that has become synonymous with his art. In fact, until the end of the 1990s, Shanghai was the centre of abstract art in China.

Swimming along with the general current, Li Shan also appeared to have exhausted his interest in the unabashed appropriation of western styles—of imitating great masters in the earnest hope that some of the mastery would rub off on the apprentice. As the *Origins* series unfolded, he became embroiled in a nebulous world of painterly abstraction, of a "spiritually informed" abstract expressionism to be more precise, in which ominous black blobs of paint circle around each other like Sumo wrestlers about to engage in collision. Two series of paintings, titled *Kuoyan* and *Chusi* (which art historian Julia Andrews defines as Start/Begin

and Extend/Expand respectively[4]) are most distinctive: black and white, oil on canvas works, "after" the style of American abstract expressionist painter Robert Motherwell, but far from being so black and white. They imply an attempt to translate the abstract elements of Chinese ink painting to oil paint, but without the exhilarating accidental accents produced by splash techniques. Conversely, these works feel highly controlled. The sense of manoeuvring suggests the posturing of two forces—simultaneously attracted and repelled—as if the balance of the entire universe rests upon maintaining a status quo between them. It seems imperative that the forms do not collide, although their apparent desire to do so is equally incarnate in the compositions. Continuing through the mid-1980s, Li Shan's abstract phase marked the process of change as he rejected corporeal occidental philosophy and all taints of western Modernism in favour of more ethereal oriental thought; part of an indignant groundswell of opposition to the hegemony of

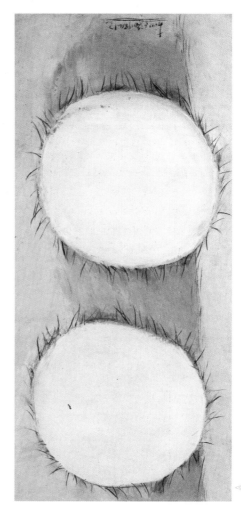

≪ Extension 1, 1984
image courtesy Alisan Fine Art

western cultural constructs that was stirring nationwide. One might imagine his goal being to arrive at a style that was more distinctly Chinese, although this was not entirely the case. Li Shan preferred to put personal experience before national interests. And dwelling upon this experience, the works entered a dark, heavy and almost deliberately obtuse phase. Had he stuck with landscape, he might plausibly have had an easier time in the early 1990s, but the ground-breaking *Rouge* series, especially the *Rouge-Mao* works, would shock the orthodoxy into outrage, although they did indeed succeed in being hailed as representative of a distinctly Chinese avant-garde aesthetic. Li Shan decided that the abstract works had been too ambitious for the time, too loaded down with weighty philosophical ideals and pictorial elements that pertained to the aesthetics of traditional Chinese culture, yet still did not take him where he wanted to go. "I felt there was no way to go forward with western art," he recalls. "I needed to work with my own culture."

4. Julia F. Andrews, "Black Cat and White Cat: Chinese Art and the Politics of Deng Xiaoping", in *Word and Meaning: Six Contemporary Chinese Artists*, catalogue to the exhibition held at Buffalo Art Gallery, 2000, pp. 19-29.
5. Edgar Snow, *Red Star Over China*, Left Book Club Edition, Victor Gollancz Ltd.,1937, London, op. p. 224.

The confusion in his questing at this time was pronounced enough to be remarked upon even by his young daughter Li Yang: "When I was a child, I thought my father's paintings were strange and heavy. They were not like those of any other artist. People usually offer praise to artists at exhibitions of their works but when they looked at my father's paintings, they couldn't say anything. I think it was because the paintings were too different. Few people understood him; even my mother was unable to grasp what he wanted to express." As Li Shan confirms, "It wasn't until I began the *Rouge* series that I found my true personal expression."

The *Rouge* series came into being in 1988. The first trace of Mao's features is manifest here, although Li Shan had yet to start working with specific well-known photographs. The double schlocks of hair, thick convex curves either side of a clean parting atop a broad forehead are unmistakable. Especially when seen against American journalist Edgar Snow's historic photograph of Mao in Yan'an in the early 1940s: here is communist guerrilla Mao in jaunty Red Army cap that Li Shan satirised so well.[5] But the trace was as yet faint. Foremost were myriad disembodied whitened faces, floating in circular formation around clusters of lotus flowers and linear tendrils. The term rouge is a direct reference to face paint, which Li Shan applied to features in the manner of Chinese operatic convention. Over the next few years, the crimson-cheeked rouging of the Mao-inspired figures evolved into a motif that extrapolated a cultural symbol to an exaggerated extreme. "Why did I make this kind of work? We have to return to my personal

Rouge Empire 15, 1990
image courtesy Alisan Fine Arts

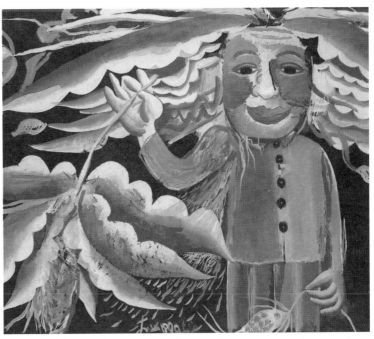

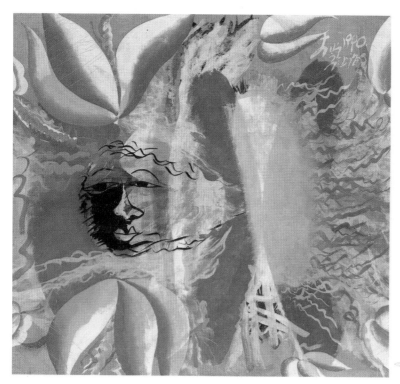

experience ... The reason I talk about Mao as cultural motif is because after liberation [the creation of New China in 1949] his presence was felt in all aspects of life. Mao decided everything, from politics to culture. He was an extraordinary figure, full of beauty."

But even as Li Shan paid homage to conventional renderings of Mao, from the outset the underlying reference to *xiao bailian* was uppermost in his mind. *Xiao bailian*—"little pale faces"—are pretty young boys at the disposal of other, usually wealthy, men, and aligned with the type of character movingly portrayed by the late Leslie Cheung in *Farewell My Concubine*. The term *xiao bailian* does not strictly apply to men only. It also connotes a "frivolous lover"—a "cream puff" as paraphrased by *China Pop* author Zha Jianying. "It is important to discuss this issue against the Chinese cultural background," Li Shan emphasises, "and not to look at them from a western context that merely emphasises restrictions. *Xiao bailian* are special people ... that existed, that exist, within the ranks of ordinary people and were—are—members of ordinary society." Unperturbed by the possibility of a censuring public rebuke from within his immediate social group, Li Shan made the

6. The reference is to Catholicism, although Communism had its own means of penalising transgression.
7. Bret Hinsch, *Passions of the Cut Sleeve: The Male Homosexual Tradition in China*, (Ph.D. paper), University of California Press, 1992.
8. Ibid., introduction, p. 4.
9. Ibid., introduction, p. 2 (the quote is originally from Jonathan D. Spence, *The Memory Palace of Matteo Ricci*, 1984, New York, p. 220).

xiao bailian the focus of his art. In some ways similar to Geng Jianyi and Zhang Peili, he imagined the avant-garde to be as open-minded and forward-thinking as it pretended to be, and would also discover himself to be mistaken.

The sexual allure of the Orient is mythical. The classic Chinese novel *The Golden Lotuses*—a reference to tiny, bound feet—is a veritable compendium of erotic sexual caprice: a high art of which the Chinese populace is fiercely, if not always openly, proud. Within a culture excused the promise of hellfire and damnation intoned by strict religious morality[6], for centuries society indulged carnal pleasures with little thought to strict or exclusive male-female coupling. Concepts of homosexuality belonged to austere western societies. Historical writings offer evidence that "In many periods homosexuality was widely accepted and even respected"[7], right through to the twentieth century when "it fell victim to a growing sexual conservatism and the westernisation of morality"[8]. In the mid-1580s, Italian Jesuit Matteo Ricci (1552–1610) recorded seeing in Beijing "public streets full of boys got up like prostitutes. And ... people who buy these boys and teach them to play music, sing and dance. ... then gallantly dressed and made-up with rouge like women, these miserable men are initiated into this terrible vice"[9]. In the early twentieth century, cross-dressing remained a feature of performing arts, specifically Chinese opera. As in Elizabethan theatre in England, in Chinese opera men—or boys—played the female roles. And, when a performance was over the male actors would be asked to join the wealthy patrons in the audience, as depicted in *Farewell, My Concubine*. Clad in feminine gowns and still assuming female

Rouge Mao, 1990
collection Jean-Marc Decrop,
courtesy Loft Gallery, Paris

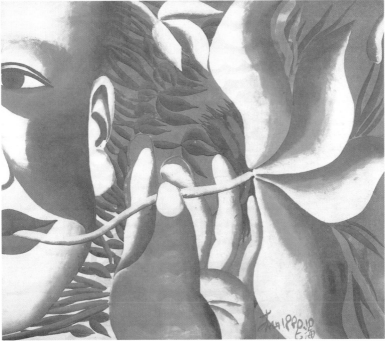

roles, they would engage with the male patrons as "women". However, these were usually androgynous interactions, intellectual or spiritual in nature, as the affections between scholars, to which no stigma was attached. By comparison with western culture, China's tolerance of single-sex interaction was far in advance of its time.

As the twentieth century unfolded and China strove to enter the modern world, official attitudes towards sexuality were forced to change, although opinions were never specifically defined by law as they were in Europe or America. Where, in accordance with conventional social (Han Chinese) mores in China, the direct naming of things is frequently avoided, euphemistic measures are brought to bear: the term "mentally ill" was an easy resort: the prognosis, an inherent genetic fault. Thus the steps required to remove the problem was phrased as curing what was surely an illness, rather than punishing a crime against human nature. Sexuality per se was inhibited under Mao, less for moral reasons than as a mark of subjugation of emotions then directed towards a higher desire of passion, spiritual in nature, for building a new China. Yet Mao's regime saw suspected gays placed under heavy scrutiny and, if caught engaging in any kind of lewd act, subject to damaging bodily and psychological punishments to countermand the suspect's genetic or psychological flaw. Scientific findings were enthusiastically embraced in China. Genetic knowledge was "not only relied on to solve social problems ... it provide[d] a legitimate basis for unequal treatment and exclusionary practices."[10] Thus, from the 1950s to the 1980s (and even in the present), where homosexual inclinations were ascribed to a genetic flaw, same-sex relations were less a sin against god than against the advance of a healthy socialist society. Defined in patriotic terms, government propaganda habitually reminded the masses that only disease-free genetic strains of bloodlines would ensure the health of future progeny and the nation. The germ of Li Shan's interest in genetics can thus be traced to the State's propaganda on eugenics from the mid-1980s.

Fen-Ma Liuming, 1994,
Ma Liuming

Even though social conditioning is a powerful force, human chemistry is remarkably resilient. By 2000, gay culture was an effacing, discreet and yet tangible reality in China. Against its cultural heritage, Chinese people remain generally less prejudiced towards same-sex love than towards race, colour and creed. Through the 1990s, homosexual communities sprang up in most major cities across the country, and individuals found solace in an increasing number of single sex—*tongzhi*—bars,

10. Frank Dikötter, "Reading the Body: Genetic Knowledge and Social Marginalisation in the PRC", *China Information*, p. 13, Volume XIII, Nos 2/3, Autumn/Winter 1998–99.

clubs and meeting places. "Although this "other" sex has been around for thousands of years," Li Shan reiterates. "No matter how many people have been that way inclined, no matter how open it has become, it remains true that there is no shame as long as it happens in the dark ... " Where being forced to live in the dark might leave many individuals fraught with despair, it is a far cry from the underground, seedy public toilet focus of China's fifth-generation filmmaker Zhang Yuan's film *East Palace, West Palace*, made in 1996. The association between homosexuality and public toilets is typically a western one. Still, homosexuality exists in China on the unstated condition that it remains on the periphery of the social horizon. "If it were to be openly recognised life would be awkward for the people involved and for society in general. It is therefore, unnecessary to force an open discussion in China," Li Shan asserts.

One of the first major western art events to come to Shanghai was a retrospective of the work of British duo, and gay couple, Gilbert and George, in October 1993. Within China's new art circles, Gilbert and George's work was discussed in terms of its celebrity rather than its content. And if discussions were superficial, it is for the same reason that the sexual element of Li Shan's *Rouge* series is habitually glossed over by critics. "Critics find it hard to discuss my work. No one wants to touch the subject, which is why most people prefer a political interpretation. Mao is political ... but I painted him as a cultural figure not a political one. To date, no one has grasped this idea." Perhaps, no one appears to have done so, but it is hard to concede that not a single person perceive Li Shan's true intentions. It is in fact untrue, for there are references in a number of texts by non-Chinese writers.

Timing was an important factor in terms of when knowledge of a Chinese avant-garde art began to filter abroad. Its discovery coincided with renewed commercial and political interests of individual nations towards China and

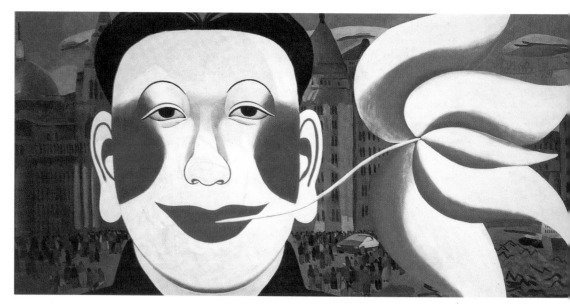

a general rethinking about the nation within the global context. The political aspects of Political Pop fired imaginations and implied a profound change in the general climate that was welcomed for the reassurances it carried with it, feeding aspirations and allaying fears that China was the next Russia. It took time for audiences to be interested in more than superficial motifs, which did not occur until towards the end of the 1990s, by which time Li Shan had shifted his focus somewhat. Equally, as the 1990s drew to a close, younger Chinese artists had begun to dabble in topics relating to sexual behaviour; inevitable as gender politics and sexual imagery achieved an unprecedented level of acceptance on the international cultural scene and Chinese art circles gained ever wider access to western publications. In China, performance artist Ma Liuming launched his career with a series of cross-dressing, gender-bending performances. At the 1994 São Paulo Biennial painter Liu Wei fell foul of the local Chinese community—and following protests made to the Chinese government of the Mainland authorities, too—for a monumental and arresting series of paintings, which depicted a middle-aged couple cavorting in the sea, the poses drawn from the pages of *Penthouse*. Painter Xie Nanxing, who hails from a younger generation still, first caught attention in 1998 with a dark series of paintings apparently on the theme of self-abuse of a distinctly disturbing, masochistic form. But where pornography is generally more acceptable than homosexuality, art which references titillating, even masochistic activities was not perceived as being as challenging as that devoted to exclusive male emotions. In focusing on single-sex relations Li Shan's *Rouge* paintings explored sexual taboos that even the younger, ostensibly more open generations eschewed.

Li Shan came to the subject of single-sex encounters in contemporary China, not to expose its repression, but to extol "the special nature of friendship it spawns.

In China, these asexual boys occupy a special place, and are not even the same as Chinese gays—the boys who work as male companions are not always gay," he stresses. "Yes, they accompany men in private, and one imagines that all kinds of services are provided, but not necessarily because they are gay, but because they take this role, this job and have no other way to make a living." The *Rouge* paintings are, in a real sense, Li Shan's attempt to explore a period of his life that was directly affected by Mao's directives; not, however, communal history, for his is not the common perspective on Mao and Maoist ideology parodied by Yu Youhan and Wang Guangyi. This is private history, an attempt to extirpate emotions in wry visual renderings of a personal world in the convenient guise of political commentary. When Li Shan felt able to look back at the impact of this period, mocking Mao was all the rage.

In 1992, in *Rouge No. 21*, Li Shan depicts a solitary figure against the skyline of Shanghai's famous Bund. Gender here is clearly ambiguous although one intuitively senses that the yang is proportionately stronger than the yin. The width of the forehead and the casual manner in which the lips are drawn back to a grin again suggest Mao, but the effect is closer to Jack Nicholson's characterisation of Batman's foe The Joker than the cultural idiosyncrasy to which Li Shan refers. But here is a true *xiao bailian*, a smiling, decorated, geisha-white face, with alizarin plums falling from the corner of each eye to make flattened planes of the cheeks, and luscious lips pumped with erotic allure. Conventional standards of beauty in China include a plump roundness, which for the hand-to-mouth masses traditionally characterises health and good fortune, and a soft paleness, which symbolises the preserve of youth and purity. The lines used to shape the eyes, the ears, and the magic flow of nature from stem to lotus tip, are similar to traditional ink painting, where images of the Buddha are rendered in stylised perfection from brow to neatly turned nostril. The emphasis is not on sexual identity, but on an aura that transcends the erotic, physical sensations associated with gender. The stem of the lotus that flows from these lips is buoyed up on a breeze that dances along the riverbank. This is significant, because here Shanghai appears as a specific location: from the mid-1980s, the Bund became a landmark meeting place for gays services—primarily after dusk, but one could spot them pretty much any time of day. "The fact that I chose a sexually ambiguous person to relate my paintings to personal experience had much to do with being in Shanghai", Li Shan reveals. "It's special here. *Xiao bailian* may exist in other places, but Shanghai is a more developed city and their presence is far more open. Other artists perhaps don't have this kind of direct personal experience." The disparate proportion between the figure in the foreground and others milling around in the background hints at the *xiao bailian*'s social status quo: concealed from those to whom he has his back—the common folk—but presented directly to us, the audience.

The first presentation of works from the *Rouge* series was in Hong Kong where a number of paintings featured in the exhibition "China's New Art, Post 1989". Here, viewers saw how Wang Ziwei played with graphic pictorial devices and obvious

pastiche, whilst Yu Youhan preferred his Mao decorated, in a manner evoking the folk arts, using floral patterns familiar as fabrics used in daily life. Both employed flat, bright skin tones such as those achieved with chalks on community blackboards. Li Shan's works were injected with a generous shot of playful, erotic sensuality that tweaks the corners of painted mouths, lends insinuation to bodily inclines and fosters a cosseting intimacy on the gestures of the hands and the slant of the smooth-lidded eyes. The combination of pigments Li Shan put to Mao achieves a powerful juxtaposition of primary hues, and together content and colour strike an extraordinary chord. Most striking to those familiar with the history was Li Shan's audacious decision to place himself in the paintings next to the Mao, which was a privilege reserved for revolutionary heroes, leaders, model workers and idealised common folk.

The first painting of this format is *Mao and the Artist I*. Here is a mature Mao, coyly posed, hips swung to the left with all the graceful verve of a Tang figurine.[11] He has high cheeks, granny-apple round and rosy, yet highlighted to the taut sleekness of a supermodel's refined glow either side of a nose that approaches the bulbous proportions of a young Rembrandt, the eyes rounded and finely lined under perfectly arched brows. Li Shan and Mao stand back to back, relaxed and comfortable, hands aloft holding lotus flames. Li Shan holds his flower confidently higher than his former oppressor, his awe of the Great Leader conquered. In this ingenious yet succinct way Li Shan appears to question the propagated myth of the beatific helmsman, the probity of his ideology and the rectitude of his regime. Yet, verbally

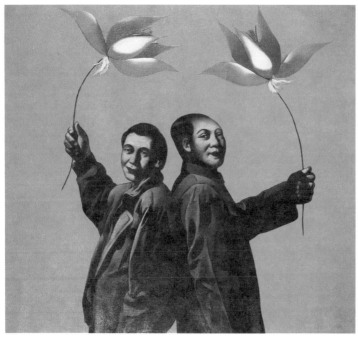

◁ Mao and the Artist I (Rouge No. 60), 1994
collection Hanart TZ Gallery,
Hong Kong

Mao and the Artist II
(Rouge No. 69), 1994
collection Jean Marc Decrop, Paris
courtesy Loft Gallery, Paris

Li Shan cannot be drawn to criticism: "Mao was a great man. Whatever his own preferences and interests, he stands as a great Chinese figure. When I painted myself together with Mao, it was a statement of position. I had painted big Mao portraits in the Cultural Revolution, so I knew all about the regulations. As China began to change and open up, I felt free to express myself, my identity. Putting myself together with Mao was a cynical way of realising an idea that would of course be impossible in reality."

Mao and the Artist II, which features a similarly striking pose, sees Li Shan come at the idea again, appropriating the flawless image of Mao as a young man from one of the most famous photographs used in the production of countless badges and propaganda materials. Li Shan sways in a pose that mirrors Mao perfectly. Encumbered by an oversized jacket and the bulk of a scarf of the type mothers wrap around weak-chested offspring, he stands less naturally than Mao, yet beneath a curious beatnik hat pulled firmly down around his ears he stands his ground. In harmonious, lip-pursed monochrome, the two figures nestle against their emerald background, clutching lotus blooms like adults nursing candy floss for otherwise occupied children ... or the olive branches of a peace finally made.

In *Rouge Series No. 59*, a lyric-eyed Mao, betraying the arrogance of youth, wears the familiar grey-blue Eighth Route Army cap against a flat field of pure cobalt doused in rose madder. The finely etched brows and cartoon droop of the eyes suggest a pin-up idol. Li Shan's rendering is close to the original photograph, and does not incorporate any of the cynicism expected from Political Pop. Li Shan appears to believe Mao to be as beautiful as he says, except for the hatred that seeps forth from the eyes, and which is directed at us. This hooded, unfaltering gaze flows but one way—out. The painting demonstrates Li Shan's ability to capture that all-seeing sense of omnipotence which haunted China's creative protagonists to Mao's death. Whilst superficially the *Rouge-Mao* series appears to pass irreverent comment on Mao's status, it also insinuates "other-ness" about the Chairman's sexual identity: patently, where the artist appears at Mao's side. The bashful smiles suggest complicity, that something has occurred off-stage, beyond the bounds of the picture plane, or will do as soon as the viewer moves along.

11. A Tang lady represents the full—curvaceous—figure for women which was favoured during the Tang Dynasty.

◁ Rouge B, 1991

Yet if sexual identity is the game, why did Li Shan feel compelled to present it through the image of Mao? "When you think of Mao you don't think specifically of a man or a woman but a person with "Mao" characteristics. My approach expressed the experience I sought to convey. It was not important for me to depict Mao in a strongly masculine vein. It is only if you see my works from this perspective that you understand what I was doing."

Li Shan explains the *Rouge-Mao* paintings as embodying his attitude towards this period of history as "the fantastic and absurd story" it was. So, what kind of history was it? "Simply said a "Mao" history. As artists, we didn't look at this history from the perspective of an historian but from personal experience. I chose Mao as a symbol to represent this experience. What else could do the job so well? Nothing even comes close." Initially at least, where Li Shan did not contest interpretations, viewers were not actively encouraged to look beyond the image of Mao. As the Political Pop paintings received their first showing abroad, the Chinese avant-garde's appropriation of Mao elicited a delicious thrill of dissidence in foreign audiences, and provided much meat for the press to chew on. It was after all 1993; the year marked the centenary of Mao's birth and the height of the biggest Mao craze since the Chairman's mortal mandate expired. The most recent impression China had exerted on the global public was of brutal repression on June 4, 1989, which froze an image of the State's iron-fisted control on the collective foreign memory. Against this, Political Pop seemed a brave stand. Few people who saw the paintings were in a position to bring a broader understanding of the individual artists to their viewing.

To focus so pre-eminently on the sexual aspects of Li Shan's work might seem disproportionate to the aesthetic or even to the political considerations contained in his art. Yet one group of works in particular indicates the experience upon which Li Shan drew and how he struggled to alight upon suitable means to convey it. Due to their explicit nature, this series of three works produced between 1989 and 1991 caused a furore in local art circles. It was a brave man who depicted muscular torsos cropped of their head—and thus their identity—in compositions

Rouge C, 1991

dominated by an enormous throbbing penis, tipped with the flowering bloom of sensual lotus petals. But that is what Li Shan did. Visually, viscerally, *Rouge A, B* and *C* are like being confronted by a Mapplethorpe figure study photograph for the first time, with the attendant magnetising hold. Firm, muscular male torsos proudly hold up their erect and overblown manhood. Viewers could be forgiven for not discerning sexual overtones in Li Shan's flocks of geese or the steeds that appeared from the mid-1990s, which, ignoring the Priapus proportions of his well-hung stallions, were discreet to a point. But there was no avoiding it in this series, which are pure paeans to masculinity. In *B*, a Samsonite pillar of a man squarely faces out from the painting—although the boundary of the canvas stops at the base of his neck—occupying the picture plane like a statuesque column. He is athlete-thighed, a strong-bellied David—more man than god—stomach muscles a fleshed-out version of Leonardo's crucified prototype. Forearms culminate in thick, sculptor's hands holding out great lengths of male prowess, snaking penises that are proportionate to fabled tales of African potency. The huge snaking penis is slit in two, each head issuing forth a spray of elongated pink and white corolla, like an ejaculated bloom of lotus petals.

But all is not conjugal pleasure. The white undulations along the edge of each petal evoke parallels with crab claws, carnivorous pinchers, man-eating Venus flytraps that well-know how to seduce their prey. These shapes are echoed in the thorn-lipped vagina eyes Li Shan had previously accorded that image of Mao in which he stares out so hatefully and invokes a hint of misogyny. The fragrance of the forbidden is most explicit in *Rouge A*, where an unidentified male—the artist?—buries his head in the bloom of a tumultuous lotus-styled ejaculation that sprays upward from a huge fantasy-sized penis protruding from the open zipper of the figure's slacks. The sense of self-absorption is neither about masturbation nor titillation. The image suggests wishful thinking in the vein of a sexual ideal, and which possibly contrasted a sense of impotence at work in society post-June 4. Marxist critic Leng Lin, one of the few Chinese writers to address the broader implications in Li Shan's *Rouge* paintings, suggests: "These images, often deliberately misogynist

◁ Rouge A, 1991

or misplaced politically, symbolise a kind of spiritual confusion in China."[12] The exaggerated symbol of manhood was one way of reasserting the power of the self, yet, Leng Lin's remarks are a polite way of denying the distinctive nature of the personal history upon which Li Shan chose to draw. "Spiritual confusion" does not explain *Rouge C*, where the silhouettes of two males face each other, their heads lowered, their eyes turned down towards the promise of sexual fulfilment: at this pictorial moment slack and impotent. Perhaps the fat man is Mao—there is a sense of his presence in the slouch, the paunch, even though all the usual features, which so immediately characterise him, such as facial expression, his style of dress, the gestures of his hands and the steady gaze of his eyes, are absent. Perhaps the second man is Li Shan—the lips are similar to those in *Mao and the Artist I*. Is the idea to compare manhood, or to redress one individual's corrosive sense of injustice at the hands of a former oppressor?

"It is true, the three works about sex were rather overt. I was compelled to write an article about them because people didn't understand them and I felt some explanation was needed." The essay offers the following statements:

... What I am exploring is an alternative ["other"] area of sexual behaviour. All I did was to use my own approach to draw on attitudes found in everyday behaviour, speech and relationships, yet, the act of referring to it makes people uncomfortable ... My use of sex derives from my interaction with society. I am not trying to educe a moral evaluation of sex per se within our culture or to pass comment upon the relationship of sex to moral values. I am motivated by the delicate balance that exists between perversity and power, power and perversity. This is the rationale behind the Rouge *series ... Power must have an object over which to wield its strength. Within the grey areas of morality, alternative sexuality is doomed to be the target of those in power. They will not destroy it, since power without a target*

12. Leng Lin, "Nine Chinese Artists", chinese-art.com, Vol. 1, Issue 5, September 1998.

has no way to demonstrate its power. Thus, the object becomes a plaything in the hand of power ...

As the avant-garde made its advance on the international stage through the 1990s, Li Shan had to dodge several unanticipated confrontations. Following the public exhibition of *Rouge A, B* and *C*, some pockets of the art community looked at him askance: no one had previously seen anything so graphically explicit, not even in the western art to which they has access. Then there was the response of the authorities to those works presented at the 1994 São Paulo Biennial. Although the full force of this response was primarily directed at the series of paintings exhibited by Liu Wei, Li Shan's works from the *Rouge* series, specifically the *Rouge-Mao* paintings, also prompted investigation, and the imposition of a penalty. Li Shan continued to hold his position at Shanghai Drama Academy until he retired in the early 2000s, but from the mid-1990s his teaching hours were drastically reduced until in the end he was teacher in name only, the students presumably kept out of harm's way. Li Shan was not unduly perturbed by the turn of events. He was almost finished with Mao, and was looking to new artistic avenues. More time to himself meant more time for his art. Following the *Rouge-Mao* works, and before the next series of butterfly hybrids, he painted a flock of geese, individually, as if parodies of portraiture. The works might seem to be unconnected, but the geese were, metaphorically speaking, almost more political than Li Shan's Mao. Where Mao was a pretext for probing a personal interest, the geese are a simile for the masses, brought to a numb, emotionless state by the tsunami of Mao's ideology.

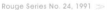 Rouge Series No. 24, 1991 ≫

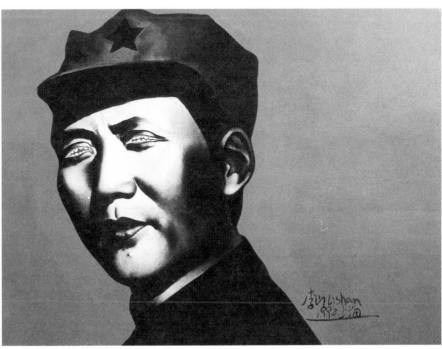

Since 1997, Li Shan has worked in a studio apartment within a newish building in the grounds of an older compound near Shanghai Stadium. It is a retreat in which he can work in privacy. He keeps it empty, bare. The only object of furnishing in the main room is a black PVC-covered sofa, dogged at the edges and spotted with indelible smears of paint. The sofa is highly uncomfortable; in the heat of summer skin bonds with it like shrink-wrap and, equally, in the damp cold of a Shanghai winter, when the non-absorbent surface redirects the dampness born of humidity to the sitter (situated south of the Yangtze River, Shanghai is not permitted State-supplied central-heating). In winter, the activity of painting is accompanied by copious mugs of tea. Other than the sofa, only the basic essentials of Li Shan's trade are visible: paint tubes, brushes, thinner, canvas, newspaper, and a pint-sized wooden stool ubiquitous to Chinese households. The only concession to decoration is in the dining-cum-bedroom, which is the most lived-in room in the apartment. A towel customarily lies folded at the head of an army-style plank bed, and a greenish cloth covers the fold-up table that serves as the platform for meals. Modest decoration but no comfort. Li Shan's generation is inured to such living conditions. All those years of abstemious dormitory living at the drama academy, the students bunked in together, prepared him well.

As Li Shan increasingly composed large paintings, he elected to dispense with stretchers, taping the canvas flat against the walls. The uneven surface of the walls contributes to the sketchy texture of the paint, which began to re-emerge as he moved away from the graphic *Rouge* style towards the more impetuous textures of his later figure paintings. In 2001, three paintings strapped to the walls of the inner room pointed to the direction in which Li Shan's thoughts were then heading. In two of the compositions, the figures face front, staring straight out of the picture plane, expressionless and lost in a sea of blue that only heightened the coolness of the rouge red on their faces, which had moved beyond Li Shan's famous crimson

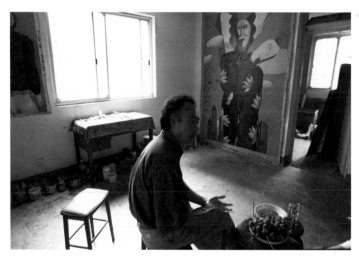

Li Shan in his studio, 2001
photograph Liu Heung Shing

towards a near violet purple. Where the earlier rosiness of red suggested health and happiness, the violet-mauves made these figures seem bruised. As the hues of pink and blue became less subtle, the acidity of the tone begins to bite.

The hands of these forlorn butterfly-eared men fall by their sides as if their jackets are too tight, too constraining, and they don't know what else to do with them. The twitch of an inane grin hovers behind their silent features, but that notwithstanding, they are undone by the aura of impotency in which Li Shan cloaks them. The delicate balance between power and helplessness they project apparently echoed Li Shan's current dilemma, which concerned reversing the impotency of "scientific" experiments he had been working on. Despite all his

efforts to the contrary, nature was proving immutable: the butterflies he had been attempting to transform resisted mutation, as did the fish. Li Shan was dealing with the realisation that the only beings he had the power to "alter" were the hybrid men in his paintings, and it was not satisfying. Paintings were but pictures, not the living, breathing creatures he dreamed of animating. Against their creator's frustration, the paintings emanate a sense that Li Shan is just whiling away time

rather than questing after new painterly effects. In 1998 they were the first visual rendering of Li Shan's bizarre interest in genetics. "This started about 1993, just after the Venice Biennale, when I began to think about life cycles and biology." He returned to China excited yet frustrated: "In the 1970s I was not allowed to show my works; [then] in the 1980s there was no market. The 1990s brought the opportunity to go abroad and to enter into a dialogue with an international art community. This made me extremely happy. But after going abroad, when I returned to China, I felt more unhappy than before: I had discovered the big world out there and the pressure increased proportionately as I placed higher demands on my art. I became interested in DNA, the nature of genes, the characteristics of chromosomes. Biology has so many cultural connotations ... "

The reference to "cultural connotations" is key. It derives in part from the China context alluded to earlier. Thirty years of propaganda rationalising the nation's guidelines on procreation, and the implications eugenics lent to the people's understanding of what a healthy, modern and productive society meant for China's future, and the means by which to achieve such a society. Somewhere along the line, Li Shan became fascinated by hybrids: human in his painting and animal in the practical experiments he instigated in 2000. The nature of this interest is inalienably tied to the nature of Li Shan's personal experience, rather than to a scientific or ethical challenge of established facts or mores. Li Shan had been repeatedly taught that "other" natures could be healed or restored to normalcy by the manipulation—correction—of rogue genes. In pursuing biological experiments, his desire remains to achieve a "beautiful crossbreed", free of the constraining moral codes embedded in local thinking on eugenics, and inborn human failings.

Li Shan's villa, like his studio apartment, is dim, sombre and resoundingly hollow. Light tiptoes across the dark shadows of the bougainvillaea that surrounds the house, hidden within huge elephant-ear palms: the flapping palm leaves invoking the ears of his painted figures. The ground-floor rooms are lined with dark wood-panelling and cumbersome furniture, and suffused with an empty, lonely atmosphere that Li Shan doesn't notice. In the gathering dusk one evening in 2001, he proffered photographs of his first biological experiment. "My initial idea was to make a winged fish," he explains. The photographs accurately recorded his trial: a fish—out of water—with the wing of an Admiral butterfly surgically sewn above its gill. So, yes, a winged fish, that much was clear, if banally illustrative in approach. In essence, Li Shan's experiment

7 Days of the Week, 1994 ≫ (detail)

with biology is more a Frankenstein-styled assemblage. "Human-fish crossbreeds or human-butterfly crossbreeds are pure and beautiful. They have no past [history] but will bring many magic experiences to this world in the future."[13] True, and to date, Darwinism or not, genetic restructuring or not, there is good reason why these "pure and beautiful" beings have yet to become a fact of nature. Not surprisingly,

13. Li Shan, exhibition statement accompanying the exhibition "Reading", ShanghArt Gallery, Shanghai, 2002.

Reading, 2001 ≫

none of the appendaged fish survived; a disheartening event in terms of the possible future development of his theory, which he intended to apply to humans too. But whilst body piercing has pushed back the boundaries of self-expression and physical autonomy, and cosmetic surgery reshapes vast numbers of people across societies, it is hard to see how butterfly wings enhance the human entity, other than as a fleeting fashion trend. Again, Li Shan is not alone in his interest. It came under the auspices of a general interest in genetics manifest in China at the end of the twentieth century against a worldwide debate on genetic engineering. Li Shan's endeavours are hampered by his idealistic naivety: "The enchantment of butterflies and fish is that they will shake up human biology, [alter] its long history and tear down its dignity … human beings [are no longer equated] with other species; our arrogant way of … walking vertically [is] beyond the tolerance of living things." Putting issues of science, function and morality aside, it is hard to term the act of attaching butterfly wings onto a fish as the cloning of a new species, beautiful or not.

◁ Rouge Series: Three Stars, 1992 (detail)

A second bat at the success Li Shan continues to enjoy with his *Rouge* paintings remains elusive. These are acknowledged as one of the formative symbols of a Chinese avant-garde, and certainly some of the most eye-catching, easily enjoyed and readily understood works produced. As icons of their time, their place in history is secure regardless of where Li Shan goes next in his career. Without Mao he would not have been accepted into the ranks of the avant-garde and, where his work was classified as Political Pop, and drawn into the hype of the moment and all the benefits it rewarded him with. With hindsight, for a number of those from the New Art Movement who made it, art alone had very little to do with the success of their paintings. Mao had a value that out-performed all else. Li Shan also had the necessary credentials of age and experience to imbue his work with an extra measure of credibility. Subsequent paintings and photographic composites can hardly compare.

In one unassuming group of *Rouge* paintings, produced in 1994, Li Shan reworked the seminal image of a five-pointed star to a sequence of fleshy geometric shapes that align themselves with the five stars on the national flag but are more immediately suggestive of primordial putty. From one painting to the next, the stars struggle to mould themselves into being, as if attempting metamorphosis, to break free of the straitjacket severity of their ten-sided periphery. But no matter how they reconfigure themselves within, they never quite transcend their own boundary lines: a poignant metaphor for Li Shan's evolution as an artist.

What direction might Li Shan have pursued in his art if China's political history had not intervened so strongly? He would probably have continued with landscape, lyrical and naive (as in primitive), and almost certainly would not have had recourse to paint a political leader. But although his personal history might have been quite different, it is unlikely that his ultimate subject matter would have digressed too far. Although the *xiao bailian* motif deployed in the *Rouge* series is pronounced as an example, questions about gender, coupling, genetics and the force of nature are embedded in Li Shan's entire body of work.

Perhaps it is right that in terms of the history of avant-garde art in China, Li Shan is synonymous with satirising Mao under the banner of Political Pop. He was unquestionably damaged by the personal experience he endured during the Mao era, but he also redeemed this misfortune by turning Mao into that silver lining hidden in every proverbial cloud. He himself says it best: "I derived so much from that time, from that period of history. I would have been nowhere without Mao ... " So now, having got somewhere courtesy of the success Mao afforded him, Li Shan can devote himself to nature: in ways as free and wild as the natural world impressed him as being before Maoist politics inserted an entirely different vision of natural selection into the picture.

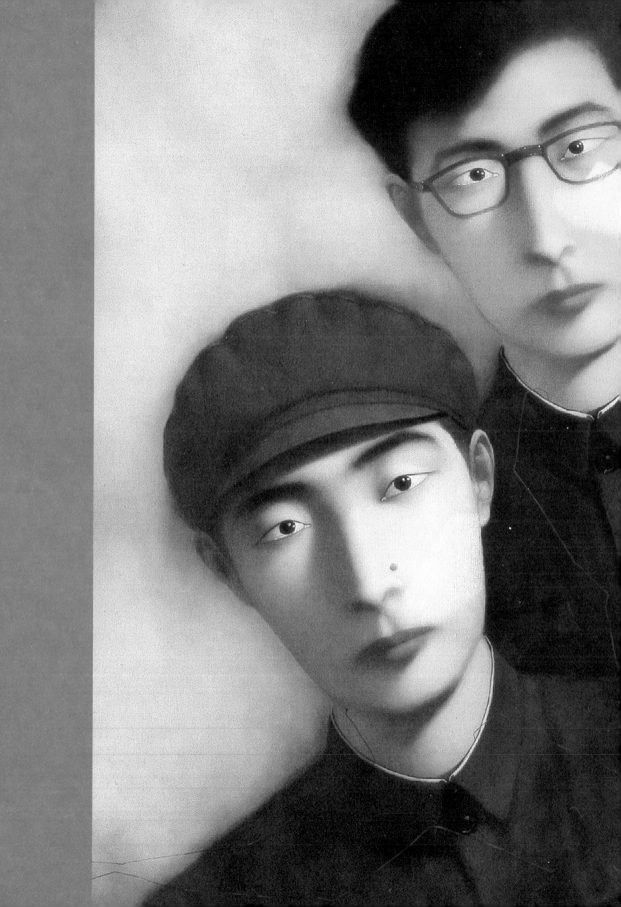

ZHANG XIAOGANG:

IN THE GENES

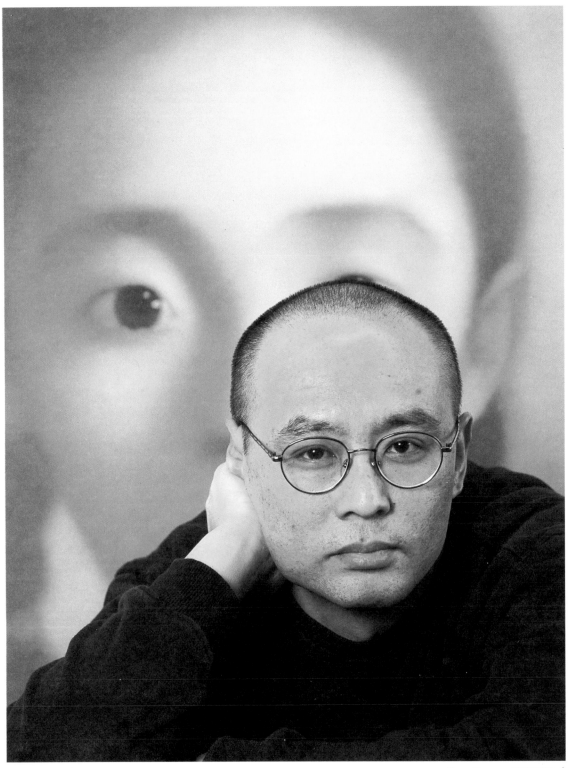

Zhang Xiaogang, 2001, Beijing
photograph Liu Heung Shing

"So many souls struggle under the weight of social norms: seemingly calm faces hide a multitude of internal complexes ... "[1]

Zhang Xiaogang is a haunted man. Through the 1990s, he exclusively painted headshots of Chinese figures, singly and as groups. But far from seeking to portray his people in a particular time and existence, he was privately concerned—almost to the point of obsession—with what lay behind the face, with questions pertaining to the body and its physical, genetic make-up. Put the man beside his paintings and the canny viewer will see that the faces that appear in his various portraits are almost universally his, or so close in their petite, irregular features as to be unquestionably kin: just one big family.

The artist closely identifies with the physique he accords his subjects. Like them, he is of average height and build. He was thin in the ardour of youth, skinny even, to judge by photographs from the early 1980s. At the end of the 1990s, as he entered his forties, he had filled out as middle-age dictates, a fullness also brought on as the effects of success, comfort and a good appetite worked their vice. Since the mid-1990s, mirroring the male figures in his compositions, he has worn his hair close-cropped, of the almost razed-clean style that came into vogue as Fang Lijun's paintings and persona enjoyed increasing exposure. It makes Zhang Xiaogang's round face seem rounder, as do the thin-rimmed wire spectacles he latterly prefers, that replaced the expansive possum-eyed lenses which were in keeping with the fashion of the 1980s. Again, as one might surmise from the gentle and silent forbearance

1. Zhang Xiaogang, "A Statement", reproduced in the exhibition catalogue *Image is Power*, published by Hunan Fine Arts Publishing Press, 2002, p. 268.

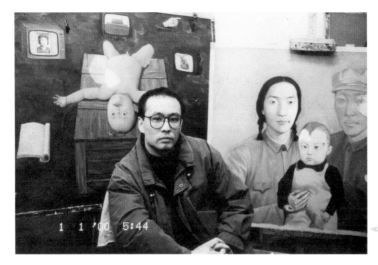

of the figures in the paintings, Zhang Xiaogang himself is softly spoken. Yet his retiring demeanour is an outward face of calm, at times unmasked by a violent, raging temper. Close friends have been privy to the ways in which his anger spews forth at moments of insurmountable frustration. It used to drive Zhang Xiaogang to drink. His fleshy hands, which are rarely without a cigarette, carry a deeply troubled purple-red tint; blotches that betray their owner's former passion for alcohol.

By the end of the 1990s, China had changed and Zhang Xiaogang, like many fellow artists of his generation, had seen his anger ease and with it his frustration mellow. Drinking was now for pleasure in the world not escape from it. As their careers blossomed and stabilised, this generation of artists realised that not only had they truly set an avant-garde in motion in China, but they were now enjoying a productive and unrestricted life on the proceeds of very healthy sales of their works. For some, the stains of the past, however, remained indelible.

The 1980s photographs of Zhang Xiaogang also hint at an introverted nature, which accounts in part for the ferocity of his indubitable temper: the result of bottling up emotions born of taunts that had dogged him as a child, when he was as yet unable to stand up for himself. Through those early years, his introspection was beyond question. But as he entered his twenties, its intensity gave way to a potent melancholy that was displayed in a distant and romantic gaze of the eyes, evidenced in photographs. Here, perpetually preoccupied, he stares at the camera lens but never quite makes contact with the viewer. The romantic and the melancholy are equally evident in the mystic nature of small intimate paintings that Zhang Xiaogang produced from the early 1980s through to the early 1990s. These are steeped in a personal symbolism that was unmistakably private, at a time when the main thrust of the New Art Movement was propounding forthright public demonstrations of intelligent and rational thought as the keys to Modernism and modernisation. Against the slogan shouting about avant-garde creation, and in contrast to the deliberately

belligerent posturing of other artists, as a diffident, reserved character whose heart was some place else, Zhang Xiaogang was enveloped in an emotional cloud he could not dispel.

Still, on the surface, Zhang Xiaogang appeared to be no different from an ordinary Chinese individual, groping for a way forward in the swelling current of change and necessarily negotiating all the obstacles thrown in his path. But Zhang Xiaogang was never ordinary. His paintings would make him one of the most successful painters in China's modern history, as widely known as Qi Baishi or Xu Beihong, just to vastly different segments of local and foreign society. Today, they certainly enjoy a comparable market value. And the pain and confusion that inform his talent is as inalienable as it is pivotal to the power of the work.

As with Wang Guangyi, Zhang Xiaogang's formative works—those poetic, personal peons mentioned earlier—were not destined to be known widely outside of local art circles. As we will see, in their adoptive use of surreal nuances and symbols, the individual components of the works were perhaps too parochial for the sum to have been of great interest to foreign audiences. Equally, they were strangely unnatural—*bian tai* in Mandarin, which literally translates as exaggerated or distorted, and implies an unhealthy mutation of form—for the immediate art world to embrace. Instead, it was the group portraits of Chinese families begun in 1994 that pushed Zhang Xiaogang to prominence. Success came first outside of China, although in contrast to the greater majority of avant-garde artists, when museums and art spaces became bolder in their activities from the late 1990s, local audiences were given numerous opportunities to become acquainted with Zhang Xiaogang's "family members".

The atmosphere these portraits evoke perfectly encapsulates the mood of a critical juncture in twentieth-century Chinese history. Conjuring allusions to received impressions of China under Mao and through the Cultural Revolution, they are eloquently, poignantly, Chinese in their sensibilities. Since the format is derived from conventional black and white, occasionally hand-coloured photographic

Zhang Xiaogang's Big Family has proved an alluring cover story and put a memorable face to the features of avant-garde painting from China

snapshots of the proletariat post-1949, these are sensibilities that Zhang Xiaogang renders accessible to all. Of equal importance, these works are extremely pleasing aesthetically, of their own merit and independent of the cultural context upon which a large proportion of early avant-garde art relied. That said, the pathos that accrues to them from the uniforms, accessories and haircuts of the comrades, and which fixed them to the Mao era, has a decidedly intriguing political undertone. It was primarily this which fast-tracked their creator along the path to international recognition. Uniquely, at home and abroad, and almost instantaneously, Zhang Xiaogang's nostalgic, heart-rending portrayals made his family members the most recognised face of contemporary Chinese art to date.

Zhang Xiaogang's acclaim began with a series of paintings titled *Comrades*. Earnest young figures of serious, innocent intent, who stare out bashfully from the canvas, some singly, some as siblings, and some as young families not yet fully confident in all their social obligations and the responsibility of parenthood, but pleased to be there in a self-effacing kind of way. These works, which place the figures in a nebulous space against a solid, almost pitch-black background as if created in a photography studio, were a radical departure from the magical and clearly illusionary world of his previous painterly style. They were far more realistic in terms of anatomical form and specific identity than anything he had produced before. Zhang Xiaogang was fully aware of the irony of embracing the academic techniques he had spent years trying to eradicate. At the Sichuan Academy of Fine Arts, where he studied, he consciously resisted the conventions of Socialist Realism that had been promulgated for only a moment in time compared to the centuries-old practices of ink painting.

In spite of new departures instigated by fellow students Chen Conglin and He Duoling that bent hyper-realism to their own vision, Zhang Xiaogang rejected standards for art pivoted on anatomical accuracy and ideological alignment. He preferred to let intuition guide his hand in shaping spiritually emotive forms. So, his return to realism in the early 1990s also suggested a decision to confront his own demons. To those who knew him well, the first portraits recapitulated all that he had striven for through the 1980s. They had little to do with imagination or imaginary worlds in the way that Zhang Xiaogang's earlier works on paper did, yet they were not exactly about surface either.

Having at last alighted upon a style he could claim as his own, Zhang Xiaogang was forced to consider how to proceed. In 1991, he had been signed to Hanart TZ Gallery in Hong Kong on the strength of his surreal-expressionist paintings: a style he had wrestled with for years before it took firm shape. So, the dilemma was strung across a choice between that, and the new figurative work. To phrase this as a black and white decision makes it sound arbitrary, which was not the case. Zhang Xiaogang was well aware that elements in his previous work carried clearly identifiable frames of reference and sources of inspiration in the work of other artists, both western and within his circle—of Picasso and Ye Yongqing. He was beguiled by the portentous functions of symbols and motifs; their ability both to speak of—depict—and yet effectively mask what one wanted to express from overly direct interpretations. The new paintings promised uncompromised absolutes: there was no abstract symbolism to confuse or distract viewers from his central focus.

The surreal-expressionist-metaphysical and folkloric sensibilities he brought to the early mystical works were also a deliberate contra-stance vis-à-vis the academic establishment. However, by 1990, having come at symbolism from every angle for almost a decade, Zhang Xiaogang was bogged down in metaphysics. In the face of the frightening reality of June 4—and although any attempt to pass painterly comment upon the incident was best dressed in a veil of some form—he was also beginning to see a need to state his personal position with greater clarity. The decision to drop all former approaches was dictated by his head rather than by his heart. In the family portraits, Zhang Xiaogang clarified his language and message in one brilliant image.

To an isolated artist in the provinces in the PRC in the early 1990s, an enthusiastic response to his work heralded by Li Xianting and Hanart TZ Gallery director Johnson Chang, as well as the potential international recognition and future hinted at, was received with heartfelt gratitude. Later, once the first bloom of fame had passed and those things had become second nature, Zhang Xiaogang revisited the paths he had formerly trodden, and which he still cherished. In the early 2000s, a number of former motifs resurfaced in his paintings, albeit via his later style of composition and preferences for colour. He was no longer tied to his families.

Tomorrow Will Be Brighter, 1989

But back in 1994, he chose to continue with his new-found approach, to shift the emphasis towards the basic family unit, with

its individual members tangibly related by blood. This was invoked in the title *The Big Family*, to which Johnson Chang cleverly added the succinct phrase bloodlines. *Bloodlines: The Big Family* was to become the most widely known series of Zhang Xiaogang's early mid-career works and in all probability marks his most enduring contribution to the evolution of new art in China. The addition of the word bloodlines was particularly apt given the descriptive red lines which appear on the surface of the paintings; finely drawn red veins that run from figure to figure and, in a metaphoric sense, tie the family members together concretely and physically. As the series evolved, the vermilion lines acquired prominence against the dark solid backgrounds. Zhang Xiaogang naturally intended viewers to see them, but painted them so finely that they did not become obvious until the viewer had first been touched by the pathos in the eyes of each and every family member. Thus, having established a rapport with the figures, the viewers' gaze suddenly alights upon the thin red lines, as if an understated piece of jewellery, which only reveals itself at an intimate proximity to its wearer. And having broken the ice by engaging with the eyes of the figures in the paintings, instinctively viewers lean forward to trace the path of the lines. Each is abruptly punctuated by a curious patch of light which segments a specific portion of a figure's features or body, as if this bit of them had been caught in a reflected pool of natural light. At first these patches register as something of a curiosity—a decorative element perhaps, or truly a play of light—but instinctual reaction insists that they are also intended to be troubling. Anyone familiar with the kind of painting Zhang Xiaogang had produced prior to this point, with its attendant riot of metaphors, symbols and motifs densely convened within the picture plane, could also add that Zhang Xiaogang was never about anything as simple as surface. These figures were always meant to stand for much more. Equally, the bloodlines are key to that which ultimately refuses to remain hidden: the genes. Genes have a habit of giving themselves away; they simply can't help it. Thus, in *Bloodlines: The Big Family* Zhang Xiaogang had established a painfully potent metaphor, the ultimate metaphor, for all that his art is about: a personal quest for untainted bodily wholeness and undiminished spiritual peace.

If Zhang Xiaogang had construed *The Big Family* paintings merely as a comment upon the destructive aspects of China's era of revolutionary struggle, he would not have needed the bloodlines—unless, bloodlines are to be interpreted in a supra-historical sense as indicating the radical dismantling of traditional social order that Mao's vision for China had required. This trouncing of the indomitable family hierarchy and obeisance, which had been in place since China's ancient philosopher Confucius (551–479 BC) conceived it as a set of social laws, was, objectively speaking, an horrific idea to all but the most set-upon members of a Chinese family or household. Ancestors, heritage, and the unbroken branches on family trees that stretch through dynasties are sacrosanct. But steeped in melancholic remembrances of his own indelible childhood experiences, Zhang Xiaogang was addressing an ominous fact of his life that had lent him his haunted air, which is the machinations of faulty genetics, and the power of individual genes to transmit, if not a disease itself, then the potential for disease from one generation to the next. His concerns sprang primarily from those "cultural connotations" Li Shan identified,

with which attitudes towards human biology are imbued, and where, especially in China, ignorance made the people superstitious. That deviation from a norm was attributed to the wrath of heaven, habitually made it taboo. Zhang Xiaogang's obsession is, however, with a different manifestation of genetic deviance from that which fascinates Li Shan but that was, in China circa the middle of the twentieth century, just as much of a taboo as same-sex tastes.

Anyone already following Zhang Xiaogang's career would have uncovered a first hint of this in the catalogue to a 1996 exhibition titled "Reckoning with the Past". Here, curator Johnson Chang makes passing reference to an incident in Zhang Xiaogang's life that occurred in 1985: "Zhang Xiaogang was made aware of the frailty of human existence early in his career when serious illness caused a brush with death."[2]

In terms of the exhibition, the implication here was that rather than "reckoning with *the* past", Zhang Xiaogang was reckoning with his own past. But in what way? The illness was to some extent self-inflicted, more of a willingly embraced addiction than a contracted sickness. It was however serious: a bout of heavy drinking that caused a dangerous physical collapse. Yet, the alcohol binge was neither wanton nor deliberate. Under the circumstances of the times, alcohol was merely the easiest resort to hand in fending off mental exhaustion and despair that had accumulated through several intolerably difficult years where nothing had gone smoothly. "I was depressed," Zhang Xiaogang recalls, "and completely unable to find myself." He drank because that seemed to be the preferred means by which people prevented themselves from thinking too much about their cirumstances in anxiety-making comparisons with peers. It certainly relieved him temporarily of horrendous levels of anxiety and mental agonising over a past he could not forget and a raison d'être he could not remember.

What had happened to bring an obviously talented artist to the edge of darkness and self-annihilation? Given the dramatic climate of social change in the early 1980s, in which Zhang Xiaogang found himself locked into a dull, dead-end situation in Kunming, unable to see a future for himself in art, and having recently lost in love, one might find reason enough. Broken heart aside, this scenario was hardly different from that of any other member of the massive population at that moment in time. On the one hand, Zhang Xiaogang's interest in art distinguished him from the run-of-the-mill Kunming inhabitants, as it did his friends Ye Yongqing, Mao Xuhui and Pan Dehai. Creativity, the escape route into the imagination was not a door open to the general public. Zhang Xiaogang had a particularly sensitive nature and, in addition, once back in his native town following four years at the Sichuan Academy of Art, the skeletons in his particular cupboard began to rattle. Boredom, frustration and the claustrophobic ambience of his isolated circumstances—cut off from his family and electively maintaining a distance from society in general—toyed with his mind. It made him feel that the naturally non-mainstream nature of his character was abnormal. This would have been nerve-wracking for most, and was particularly unhinging for a would-be modern artist, struggling to find his feet and self-affirmation. Second-guessing as to how the world saw him stirred a vein of paranoia. Lack

2. Johnson Chang, *Reckoning with the Past*, catalogue to the exhibition "Reckoning with the Past", p. 13, published by The Fruitmarket Gallery, Edinburgh, 1996.

of regular employment orchestrated long periods of time in which little occupied his mind other than to dwell upon Zhang Xiaogang vis-à-vis the rest of the world. His uneasy childhood caught up with him and, in reflecting upon the past, he conjured ghosts that tormented him.

In the same catalogue essay, Johnson Chang reveals an intimate secret of Zhang Xiaogang's private family life in a reference to his mother's schizophrenia. At what point in her life this condition was diagnosed only Zhang Xiaogang's father was privy to, and a subject he remained unwilling to discuss, which proved one cause of a damaging rift in family relations when Zhang Xiaogang was in his late teens. This illness was to have a lasting impact on all her children, but in particular on Zhang Xiaogang, her fourth and youngest son, to whom, in spite of everything, she was closest. It was an impact that only the years could quell, as the magnitude of all tragedies diminishes with time: Zhang Xiaogang remained haunted.

"I was very young when I became aware of my mother's illness," he begins. "She would be fine for days and then change, one minute crying inconsolably, the next laughing hysterically. She attacked people verbally on the street and would go out and get herself lost for days. But then she would be normal again. Although she was always so very nice to me, as a child I found it terrifying." Initially, and to society at large, Mrs Zhang's condition was tactfully consigned to the inflicted turmoil of the Cultural Revolution, during which many sane people lost their minds to the intensity of class rectification and force of the struggle they endured as a result of being ostracised under the new social classifications. However, at some point between the end of the Cultural Revolution and Zhang Xiaogang's unwilling return to Kunming in 1982, the latent fear that his mother's torment had spawned was exacerbated by his discovery of a history of mental illness running in her side of the family. "My father had always insisted that my mother became ill after I was born. When I discovered this was not true, and realised that schizophrenia could be hereditary, I was devastated."

How much easier it would have been to blame it all on the Cultural Revolution. The awkward subject of mental illness would simply have been aligned with the misfortunes brought to so many otherwise normal people who were literally driven mad at that time: the family as victims of an imposed tragedy for which they would be blameless. Certainly, until he learned more details of his mother's case, Zhang Xiaogang's self-preserving reaction was to perceive it through this prism. The stigma of congenital defect was harder to swallow.

Although he is known as an important artist within the new Sichuan School of painting, Zhang Xiaogang was actually born in Kunming, Yunnan province, in 1958. His parents were native to the region but were transferred to Chengdu in Sichuan province when he was four years old. They remained there for ten years until 1972, returning to Kunming to retire. Zhang Xiaogang was the youngest of four boys, but aside from his mother's erratic affections, he was not treated as the treasured baby. Some years later, mental illness would disbar a woman from having children, a policy that, in fact, came into force with the introduction of the one-child policy in the early 1980s, although the specific directive on eugenics was not implemented until much later.[3] Zhang Xiaogang's mother was desperate for a daughter. Following the birth of three sons, she determined to give it one more try. Delivered of a fourth son, Zhang Xiaogang, she was finally persuaded to desist, which probably was another destabilising factor on her mental health, for it denied the peace she hoped for from the comforting alliance between mother and daughter. Thus, one of the more subtle stigmas of Zhang Xiaogang's formative years was the innate sense that he was not exactly what his mother had wanted. The desire to force attention or assuage a sense of guilt produces dramatic responses, often encouraging children to be brashly demonstrative or shyly withdrawn. Consumed by hurt and puzzlement, Zhang Xiaogang was made the latter.

By the late 1990s, Zhang Xiaogang could make light of some aspects of the past he had carried so long: joking about his mother's yearning for the daughter that never came saying, "and they just ended up with me ... " but he was not comfortable discussing intricate details of his childhood. He had grown up, and moved on. Yet, it clearly was a debilitating experience. Specifically for a young boy dealing with all the natural complexities of youth and feelings of guilt for his mother's obvious distress, and haunted by a home life, which per force spilled out into the public arena and was known to all in the transparency of the stock local neighbourhood. On the positive side, in the long run this first-hand experience would alert him to the complexities of human affairs and how different individuals deal with them. But that did not alter the fact that his childhood was lonely and isolated. Life in the family residence was unpredictable. In the light of his mother's illness, guests were rarely welcome at home. Father and sons were fully aware of the prejudice that mental deficiency fomented, as well as the fear, the gossip, and the disparaging gazes to which they were subject on a daily basis.

Communist society in China had limited space for less than perfect individuals: the Marxist-Leninist dogma promoted by Mao penalised individuals who were less than whole persons. All people were ostensibly to be treated equally, but the able-bodied amongst them were indisputably more equal than the less able. Each person could expect rewards from the system commensurate with the contribution they were considered to have made to it. So if a disabled body could only do half the work of a full-bodied person, then they assumed half the rations assigned. Anyone with a mental illness that could not be adequately monitored, or was at best unpredictable in its manifestations, was almost impossible to place within the social mechanism or set to even the simplest of routine tasks. Thus perceived to

3. See at "Li Shan: Nowhere without Mao", p. 242.

be unproductive, the person was also seen as a drain on society and a waste of precious foodstuffs at a time when rations kept the able bodied workforce in a state of perpetual hunger. Under the auspices of the times, the masses could hardly be blamed for holding a medieval attitude towards the mentally and physically infirm, coerced as they were into following an unforgiving political protocol. There were certainly strong cultural and political forces at work to keep the people in fear and ignorance, and ultimately prejudiced.

"From as early as I can remember, I felt our family was not normal. Eventually relations broke down completely under the pressure. In 1982, when I got my own place in Kunming it was only a ten-minute walk from my parent's house but they never came to see me, even when I was in hospital. It was only the loneliness of old age that changed them."

A confused and reticent child, Zhang Xiaogang became a bitter, anxious adolescent. At the age of twenty, putting the past behind him as best he could, he concentrated on studying for the entrance examinations to Sichuan Academy of Fine Arts. This did not help matters at home either, because his father remained unconvinced about the study of art, and refused to take an interest or to support his son in his application. When Zhang Xiaogang persisted, his father's anger at being disobeyed was inconsolable. With the loyalty of like-minded friends like Ye Yongqing and Mao Xuhui, Zhang Xiaogang stuck to his guns and his determination paid off. He passed the exams at his initial attempt in 1978. He was the only one of his siblings to pursue university-level education, but this was not an argument or defence that would alter

Comrades in arms in Sichuan,
Front row: Zhang Xiaogang, Wa
Chuan, Zhou Chunya
Back row: Ye Yongqing, critic W
Lin, Mao Xuhui

his father's contempt. Since discovering a passion for painting in his youth, Zhang Xiaogang had been forced to hone his skills in private, and it was partly the secret nature of how he spent his time, locked into his room making pictures, that made parent-child relations so tense and strained. Art morphed into an acrimonious hurdle to harmonious father-son affections, and Zhang Xiaogang's departure for Sichuan Academy in 1978 caused a major rift with his father. As indicated above, for years afterwards communication was confined to a bare minimum. Against this, and as the first of his friends in Kunming to enter a prestigious academy, it was with mixed feelings of joy and sorrow that Zhang Xiaogang departed for Chongqing. At the time he did not intend to return.

Student life was an eye-opening experience, and one within the embrace of a close community of teachers and students, a handful of whom would become friends for life. Importantly, it offered Zhang Xiaogang the chance to start afresh as his own person and to leave the past in Kunming. As with his childhood, the details of his years at the academy as a student are something of a blur. At least, nothing occurred that Zhang Xiaogang dwelt upon or cared about enough to file away for future remembrance. The problem was that when he graduated he was not assigned to the academy's teaching faculty as he had anticipated. He decided it had rejected him. Being denied a position wrecked his hope of remaining in Chongqing with friends, and of being able to continue to paint freely. He subsequently chose to erase this moment from his mind, and has little recollection of the extraneous details of the period. What would remain with him were impressions of the western art to which he had been exposed. Certain elements had already informed his painting as a student. Now it would provide a focal point to the exclusion of all else. "The first modern art I saw at the academy in 1979 was a catalogue of Impressionist paintings. Prior to this, we had only been permitted to see books containing Soviet Socialist Realism and classical French painting."

The Impressionist paintings struck him as being incredibly fresh, in particular those of the early period, the sensual colour of which flirted wildly with his tender emotions. Here was a sweet, romantic, warm and ideal portrayal of the world in which one could immerse oneself and forget the mundanities of quotidian reality. In 1980, Zhang Xiaogang turned to the paintings of Gauguin and van Gogh, whose colour and brush marks offered possibilities for expressing all the pent-up emotion he harboured. Then in 1981, he discovered Expressionism, which allowed him to take this one stage further. "It was clear that western art was not judged in line with the standard of the realism of an individual painting, as was our own experience. The individual or personal element to the works had enormous appeal."

When Zhang Xiaogang graduated in 1982 his paintings revealed how all such inspirational elements had filtered into his work in clearly identifiable combinations. The style was less than innovative in its own right. What is most visible is the blend of Jean François Millet (1814–1875) and van Gogh. From the former he borrowed compositions, depicting minority peoples bent to earth as in *The Gleaners*, which Millet painted in 1867. From the latter he appropriated technique, in fluid brush marks incised into thick impasto oil paint, employed to generate a humming motion

in the physical presence of the figures, as much as to circumscribe their form and the shape of the landscape. The subject, at least, was local in its cultural specificity. His chosen theme was the daily life of Tibetan people living in the region.

Incrementally, through four years at the academy, against the mainstream of Soviet-styled realism and the transmutation of this into Scar Art, which was emerging in Sichuan, Zhang Xiaogang's preferences for modern art pushed him out on a limb. At that very time, in a slight departure from the strictest tenets of Revolutionary Realism, students at Sichuan Academy extended the brief of realism, its focus on workers and peasants, labour and its fruits, to produce compositions arranged from their own daring intellectual perceptions. In particular, Chen Conglin and Gao Xiaohua were considered to have made breathtaking departures from Mao's Yan'an line. Increasingly these featured the minority peoples. But all their work remained pivoted on technique, and an acclaim that was credited to the degree of realism achieved. In tandem with fellow students from his close circle, Zhang Xiaogang was interested in exploring a new, emotive, and personal way of portraying these people that followed the genuine social and human concern apparent in the paintings of the western masters he favoured. "Our question was how to reconcile what was emerging as Country Life Realism with a more meaningful modern approach to painting. I travelled to Aba[4] and lived pretty much as the local people did. During six weeks there, I discovered that the lifestyle, habits and traditions of the community did not interest me as a subject for art alone. I did not want to report what I saw

4. Aba is region between Sichuan and Tibet largely inhabited by a Tibetan community.

but to use colour and form in terms of the landscape and the clothing the people wore to explore their state of mind in relation to life on the land. It was a wildly natural place and the people struck me as being very spiritual, which appealed to me. I realised that to express this in paint it was necessary to push the cultural aspects into the background and bring the emotion to the fore."

As he attempted to do this Zhang Xiaogang was made aware of the full force of the prevailing ideological doctrines on art. The response to the resultant paintings deemed them deviant, maverick. Even though Sichuan Academy was forward-looking and revolutionary in the narrow margin of permitted subject matter, it remained highly conformist in the manner of execution it expected from the students. Regulations stipulated that within a painting the faces of figures depicted should show clear and positive expressions. In his preparatory work in Aba, Zhang Xiaogang had made numerous drawings from life—as was expected of him—observing the people as they were absorbed in any one of their numerous daily chores, which often meant from behind—which was not. This was an accurate vision of how he saw the people: locked into a routine dictated by the land and environment, bent to the earth, consumed in back-breaking activities denoted by unrelenting agricultural tasks. However, such poses naturally obscured individual features and expressions, which were at best preoccupied and without conscious thought: and certainly not portraying the blissfully contented demeanour that Socialist Realism customarily accorded them. That which most genuinely portrayed the nature and life of the people, the academy professors found as unacceptable as the style of brush marks Zhang Xiaogang adopted. Where doctrines of ideology infiltrated every area of individual and communal existence, instructing every action and informing every thought and impulse, the power of such centralised, uniform control weakened all but the strongest individual resolve. Oftentimes in such an insidious manner that individuals were hard pushed to rationalise an argument for even the slightest departure from proscribed exactitudes. They were further subject to local peer pressure not to bring disrepute to the group. Herein, too, can be found the horns of Zhang Xiaogang's dilemma: part of bearing the burden of a sick mother included the shame the family was regarded to have brought to the neighbourhood. He had spent his whole life wanting to be normal and to fit in, yet by choosing art he made himself different, and worse did not even conform to conventional practices. Submissive resignation in the People's Republic was so natural that the majority of people it affected were not even aware of the self-censoring instincts they had developed. Those that were suffered immensely for their awareness, as did Zhang Xiaogang did in his final months at the academy.

Aside from the support of friends, the only outside encouragement Zhang Xiaogang received at this time was from Li Xianting, who visited the academy in early 1982. Intrigued by the new direction he perceived students like Zhang Xiaogang to be moving in, Li Xianting brought his understanding and enthusiasm to their cause and persuaded the academy's director, Ye Yushan, to allow Zhang Xiaogang to continue with his approach and complete the graduation project he had embarked upon. It was an important start, and an all-important injection of confidence. However,

following his graduation in 1982, the next two years were to prove a testing time. The academy let him follow his whim but then it turned its back on him, because at that time, all university graduates were obliged to take up a place in a work unit assigned by the State, which for Zhang Xiaogang meant by the administration governing the academy. He naturally hoped to be assigned to the academy's teaching faculty, but instead was given a choice between two factory placements, both of which he refused—if not the academy, he had at least hoped for an organisation that had some relation to culture. On this count the administration drew a blank, and Zhang Xiaogang unexpectedly found himself unwanted, displaced within his own community and society in general.

Being born in Kunming, Zhang Xiaogang's residency papers tied him to Yunnan province, so it was to there that he returned with the hope of gaining introduction to a work unit with a cultural function. As a Party cadre controlling administrative finances, his father had a respectable level of personal connections. Zhang Xiaogang felt it would be easy for his father to make an introduction on behalf of his son, but the elder Zhang refused. Ironically, the reason was not the fear of being accused of nepotism or of leveraging *guanxi*—politik personal relationships or connections—to secure preferential treatment for a family member, which had proved the downfall of many less than scrupulous Party members. Nor did this father refuse in the belief that his son should stand on his own two feet in the world rather than relying on a back-door route to a goal. That was alien to the way things in China were done: everyone was familiar with the backdoor. The stumbling block remained Zhang Xiaogang's chosen field of study: art.

Back in Kunming, Zhang Xiaogang found himself with four months to find a work placement and no support at home. No placement meant nowhere to set his personal dossier, no way to calculate his position in society, and therefore no allocation of social benefits, including the necessary ration coupons that were still in force for all basic foodstuffs, without which, a person couldn't even procure rice. Without a job, he might well end up in Kunming forever. The State ruled that any individual who did not find work after an initial four-month period would be reassigned once and for all by the State with no choice as to where they were sent or of the job presented to them.

In late 1982, after the satisfying murmur of acclaim that greeted Zhang Xiaogang's graduation works as they made their media debut courtesy of Li Xianting in *Fine Arts Magazine* (*Zhongguo Meishu Bao*) in 1983, Zhang Xiaogang felt himself sinking into oblivion in Yunnan. The little name and confidence the publication of the paintings afforded him was like a firework that boomed and faded. For an aspiring artist without a job society was a closed door. Affiliation to a cultural institution at least made a person eligible to present works to the selection committees for national exhibitions. Zhang Xiaogang was effectively excluded. To add to his woes, he had fallen out of a relationship and was nursing a wounded heart and injured pride. Rejected on all sides, he slowly succumbed to hopelessness, which sucked him into the escapist oblivion of inebriation.

Upon Zhang Xiaogang's return, and faced with the possibility of his living on the streets, Zhang Senior grudgingly consented to let his son stay at home. He could eat there and sleep but was not to anticipate any financial support. The atmosphere that engulfed his life was tense. It was not that there was an overriding need for money—there was little to buy, except painting materials—but after experiencing four years of relative independence Zhang Xiaogang was now tied to familial problems as an adult just as he had been as a child. As society moved forward, it felt as if he had taken one enormous step backwards. Fortunately there were some opportunities for menial work and Zhang Xiaogang spent a first month labouring on a building site. He used his wages to go straight back to the academy and visit friends who had remained in Chongqing. It signalled the beginning of a trend: any money earned was spent on travel, to Chongqing, to Beijing, and out into the countryside; any place he could escape the desperation that pursued him like the Furies in Kunming.

Fate was to be kind. Just on the cusp of his fourth-month period of grace, with the help of his friend Ye Yongqing, Zhang Xiaogang found a job as a scene-painter with a local song and dance company. He returned to Chongqing on March 31, 1983—his eleventh hour—to fill in the paperwork required to transfer his personal dossier to the new work unit. The period of floating in society was over. Yet although he could now enjoy his own living space out from under the dominion of his parents' house, and a relatively light workload, he yearned to return to the academy.

In another country, the then long-haired Zhang Xiaogang would have been just another normal rebellious adolescent, eager to find independence and indulging in the chaos of freedom from responsibility without any concept of regulated time. But Zhang Xiaogang remained anxious and frustrated at the hand fate had dealt him. As long as he remained in Kunming, it was everywhere he turned.

The several ensuing years he spent in Yunnan were critical. He travelled as much as he could. With his salary a meagre fifty yuan each month, he was motivated to supplement his income drawing cartoons and illustrations for local newspapers. These earned him the princely sum of between twenty and fifty yuan each. In this way he was able to save 100 yuan (then about USD 30) a month, which would carry him through several months on the road. A few yuan purchased a train ticket, a seat on a bus cost much less, and a few mao would ensure a seat on a cart heading into the mountains and to the remote villages that lay within. Cumulatively, he garnered such a large sum for the times that he took the highly unusual step of opening a bank account to keep it safe.

The minority peoples that inhabited the mountain regions were habitually welcoming, embracing strangers as a kinsman. The sense of camaraderie was comforting, and one of the main reasons that, in travel, Zhang Xiaogang found something approaching the solace he yearned for. He appraises the hospitality he enjoyed as characteristic of the peoples in the south-western provinces. "The minority people have many ways to counter reality. Life was always hard in remote areas, which nudged the people toward escapism. They had traditions, beliefs, a faith, and myriad cultural customs, which included a love of celebrating that habitually involved drinking heavily." Through this period of his life, art became almost irrelevant as Zhang

Xiaogang developed a deepening interest in how people lived, how they survived. He pushed himself to extremes as if striving to grasp why, if life was also hard for other people and they didn't admit defeat, he felt it to be so futile. "I wanted to struggle and persuaded myself that I wasn't afraid of anything."

Zhang Xiaogang was fortunate that the song and dance troupe demanded little of his waking hours and did not take issue with his long leaves of absence. At least, not in the beginning, but as his absences increased, there were rumblings of dissension from co-workers who objected to the liberties he took in his comings and goings. None perceived his growing reliance upon the company of strangers who knew nothing of his past. Aside from this and the intimacy and support of reliable friends, for Zhang Xiaogang, there was little else to fall back on. As his days at the academy receded into the past, the confidence that accrued to him there began to ebb away. Outside an art-centric environment, his painting lost all direction. After two years struggling alone, he attempted to study western art, culture and music, of whatever form he could find. It was thus he stumbled across Surrealism. "It struck me as being so modern. But also, with its mysterious, introspective quality, I felt it evoked emotions with which I had common sensibilities."

Within the safe paradigm of the small world he carved out for himself in Kunming, Zhang Xiaogang reacted to the alienation of his childhood by becoming overtly sociable and gregarious. The door of his tiny eight-square-metre room at the dance troupe was always open, the space habitually filled with a regular cast of painters, writers and poets, whose discussions often lasted until the sun came up. The sense of futility that most bore—their minds and talents denied an active cultural environment that could nurture and apply them and offer opportunities for growth—was destructive. "I felt I was different, unusual in my ideas. But although I knew I didn't like the kind of art that was being made, I couldn't see my way forward. Few of us could." When these misfits descended into the habitual sorrowful musing which the gatherings incited, they drowned their laments in large volumes of locally brewed alcohol. This continued month after month until, following a particularly heavy bout in January 1984, Zhang Xiaogang simply couldn't get up. He lay in bed for a week, unable to move, unable to eat, growing steadily weaker. It was time to get help. He was immediately hospitalised by a doctor who advised a strict daily regime and a course of Chinese medicine. Initial treatment lasted two months.

Although the cost of medical care had not reached the inflated sums that had become standard by 2000, they were high enough to be a burden. A portion of the costs was covered by his work unit. Zhang Xiaogang still had some savings in the bank, but even together it was not enough. When approached, his father agreed to lend him 500 yuan (approximately USD 320 at 1985 exchange rates, with salaries of under 100 yuan / USD 70 per month) but Zhang Xiaogang recalls that being the extent of the concern or aid; neither parent visited him in hospital. Fortunately, his physical condition stabilised quickly—little consideration was given to addressing the patient's mental state or the possibility of depression. Thus, the "brush with death" to which Johnson Chang refers was not so much Zhang Xiaogang's own imminent demise but that of other patients on the ward. "The ward I was put in was right

next to the mortuary. Every time someone died, I'd see them being wheeled in. I developed a morbid fascination with death, with its physical manifestations in the body." Blessed with the same helpless—and appealing—aura as the figures he would paint in the *Bloodlines* series, the hospital staff instinctively liked the hapless artist and went out of their way to make his stay easier. Even rewarding his request to learn about death. "The first time a doctor called me to see an old man dying. I could hardly look. It was a horrifying experience but one that, for some reason at the time, I was compelled to witness."

Trauma is frequently a catalyst for powerful creative outpouring. It was now that Zhang Xiaogang began to produce small drawings imbued with a dark, threatening quality that sprang directly from his situation. They have a surreal, metaphysical quality balanced by a brut reality as electric as one of Goya's *Black* paintings or a Gothic horror illustration. All the earthy freshness of life had evaporated from what are dark, disturbing little pictures that pack the terrorising, haunting punch of Picasso's *Minotaur Suite* etchings. The singularly most relevant pieces form a series of sixteen images that he dramatically—desperately—titled *Dialogue With Death*. The sense of Victorian melodrama the series inspires via a palette of muted greys—murky shades of white and black that never achieve purity—is immediate. Each image contains subtle shorthand for physical landscapes through which Death and a lone soul travel, but one instinctively understands that this is the territory of the mind more than an identifiable location in the physical world. The ghostly figures trudge from one non-specific destination to another, weighed down by swathes of robes and dodging random piles of skulls, without resolve or arrival, neither escaping what they flee, nor finding what they seek. One scene, orchestrated as a deathbed visitation, sees good and bad duel over the bed, presumably for the soul of the afflicted. With this image, the dialogue terminates. The result surely that "good" wins, because Zhang Xiaogang arose from his bed and walked, refusing to succumb to despair, and having recognised that such themes were too traumatic for a person of a fragile mental disposition to pursue. Throughout history, alcohol has ruined many an artist's health; Zhang Xiaogang was lucky. He had one brush with collapse, was pulled up and recovered, whilst others around him, who never got to the point of collapse, were never given pause for thought. Zhang Xiaogang continues to drink but does so mindful of the damage it wreaks.

This was a second important stage in Zhang Xiaogang's life; a destructive phase during which he had little communication with the art scene he had left behind in Chongqing. In 1988 at the Huangshan Conference he saw Li Xianting for the first time since 1982. Li Xianting was naturally curious as to what he had been doing. Zhang Xiaogang could only say that he had been thinking about what to paint next. It wasn't far from the truth for as he recovered, he realised that the spiritual elements of the drawings, his *Dialogue with Death*, had thrown light into his tunnel.

As the New Art Movement exploded across China in 1985, Zhang Xiaogang was convalescing, and very much on the periphery of the scene. The most vibrant and influential centres of activities were those close to the art academies where groups of

Dialogue with Death, series of 16 drawings on paper, 1984 (detail)

artists enjoyed common approaches, philosophies and ambitions. Fortuitously, as Zhang Xiaogang was restored to health, in 1986 Mao Xuhui represented the Kunming artists at the conference organised by Wang Guangyi in Zhuhai. This gave them access to the new circle of critics that had begun to emerge, and who were eager to receive information about activities and artists around the country. At the behest of these critics, art magazines were slowly publishing works that represented new trends. For artists like Zhang Xiaogang whose work did not qualify for official exhibitions, this was a good way to get exposure before a local audience.

Previously, in mid-1985, the Kunming artists had been invited to participate in a show in Shanghai titled "New Concrete Realism" (xin juxiang) and organised by Yunnan artist Zhang Long who was living in Shanghai.[5] The reaction of artists, critics and the general public to the work was positive. Zhang Xiaogang showed his graduation paintings alongside a selection of the new mystical paintings he had begun earlier that year. When they were returned to him, he was shocked. The time away had afforded a much-needed critical distance: their reflection of a life he described as "too bitter, pained and despairing" was disturbing. "My ideas underwent a change, not exactly a turnaround but a definite shift. I needed a philosophy, a theory."

Forces were at work to assist him. In 1986, he was invited to return to Sichuan Academy. Ye Yongqing had transferred to a newly established teacher-training department—which was in need of teachers—primarily to get away from the heavy teaching hours in the oil painting department. Suffocating in the claustrophobic aura of staunch academic style, Ye Yongqing needed a like-minded ally on staff to counter the tight-knit community of serious, conservative oil painters. Knowing how much Zhang Xiaogang wished to return to the academy environment, Ye Yongqing

5. At the Cultural Palace of Jing'an District. It afterwards travelled to an unrecorded location in Nanjing.

put his name forward. Zhang Xiaogang's application was formally accepted and he was returned to the embrace of what was a familiar, comfortable and ideal environment.

During his convalescence, Zhang Xiaogang had taken to reading classical Chinese treaties on philosophy and Buddhism. They soothed his state of mind and provided a rich source of thought that he transposed into the mystical aspects of small watercolour drawings and oil sketches. At the academy, he reread these books with relish and in his free time began painting; small paintings because his room at the academy was even smaller than that at the song and dance troupe in Kunming. Here, he combined myriad new elements: native folklore, African-style masks, and figures styled after Yunnan's minorities. As his interest in Chinese tradition grew he was forced to the conclusion that as western Expressionism had little to do with his own cultural framework, his attempts to apply its tenets to his own work did not sit naturally. The form and colouration of his work thus shifted to local sources.

From 1987, as these new elements began to assimilate and weave seamlessly together, the paintings took on an almost religious aura. They were in many ways similar to those produced by Ye Yongqing around the same time and heavily flavoured with folkloric motifs emblematic of the south-western region. One composition might combine images of Buddha, Guanyin and Christ, in harmony, in meditation, on the cross, respectively, in nebulous backgrounds of softly washed colour. Even Yorrick's skull makes an appearance—and the comparison with Hamlet is succinct given both his and Zhang Xiaogang's melancholic dispositions. It is one of several depictions of dismembered body parts in close proximity to threatening knife edges. Several strains emerged at once, which would all be picked up and redefined in the coming years. It was in this constructive mood that Zhang Xiaogang began to

shed the mantle of depression that had plagued his 1980s. But when the events of June 4 occurred in 1989, the sense of anxiety and sobriety returned. "It felt as if we had come full circle back to the mood of the late 1970s."

In response to this traumatic event, Zhang Xiaogang produced a handful of works on paper, in watercolour and oils, which reference the tragedy indirectly through a conglomeration of personally ascribed hieroglyphs. The colours were dark and dense, the pigmentation strong. In this period of true "spiritual confusion"[6], the aura of religiosity was invoked almost as a prayer for inner calm, an act of meditation, of which he frenetically begged the strength to overcome the fear and loathing that was unleashed with the State's suppression of the student demonstrations. This need succinctly reflected the lack of anything solid or true that this generation of idealists could cling to as their ideals hung in tatters. "We were forced to consider how our experience was relevant; how to evaluate it in the light of the moment. It wasn't easy."

In 1991, Zhang Xiaogang produced only a handful of paintings, but the thinking he did was to make 1992 a pivotal year. He also completed marriage formalities, making Teng Lei, his fiancée of three years, his wife. Re-examining the distinct strains of Expressionism and Surrealism he had drawn upon, he decided that Surrealism was closer to his heart. He began to toy with perspective in oddly angled focuses on corners of familiar interior spaces. The palette he employed would be fine-tuned as time passed to form the basis of that used for *Bloodlines*. In 1992, Teng Lei was studying in Germany. In June, Zhang Xiaogang left China to visit her. Overwhelmed by the opportunity to see so much art by artists with whom he was familiar only

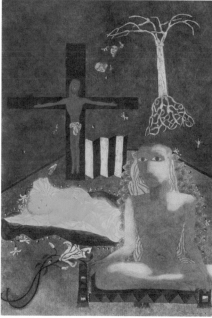

≪ The Last Supper, 1989
≫ Martyr, 1989

6. Leng Lin, see at "Li Shan: Nowhere Without Mao", p. 249.

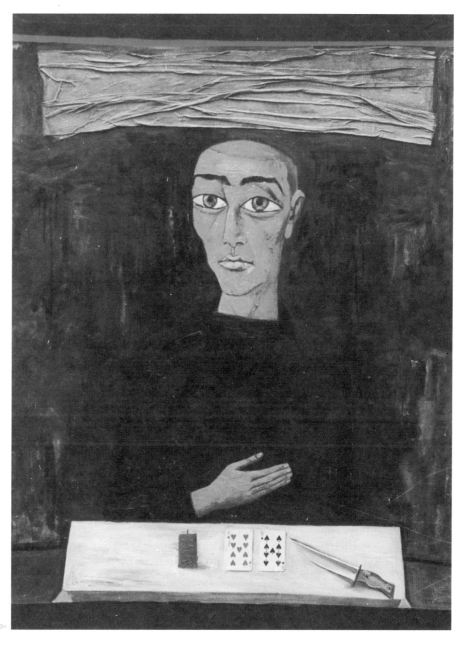

New Year's Eve, 1989–90 ≫

from books, he spent the bulk of his time in museums. Far from finding a solution to the questions he had been asking himself in China, he returned home announcing his retirement from avant-garde circles, citing as his rational his acceptance of himself as a conventionally conservative artist who could only paint what instinct instructed him to. Concepts, he decided, were for other artists. "Most [Chinese] critics had a preference for the modern aspects of Expressionism, which they discerned

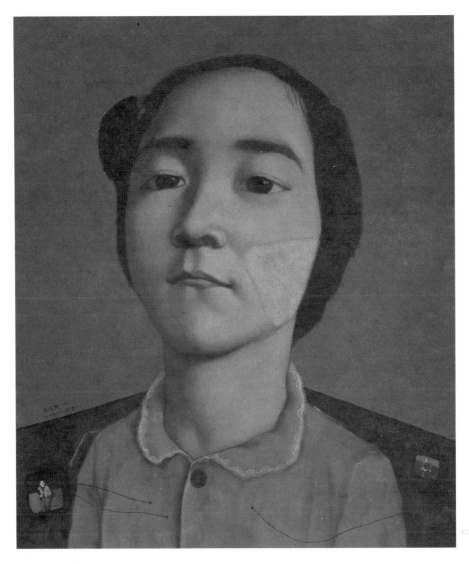

in contemporary Chinese art. This was the criterion by which they judged the contemporary-ness of the art being produced. If I was not an Expressionist painter, how could I be a contemporary artist?"

One discussion that took place in Germany made a particular impression: "That the art of western artists related directly to their life experience. I suddenly felt that the Chinese were too academic in their approach. We needed to seek art in the fundamental essence of life and living, not in theories. What I had painted before was less about my life than fantasies of my inner self. So I began looking at what was around me, the people, the friends."

Before going to Germany, Zhang Xiaogang produced two paintings that were exhibited at the First—and only—Guangzhou Biennial, in 1992. In addition to drawing together all the elements previously mentioned, they indicated an emergent interest in old photographs. "I had no idea how to express the feeling they imparted to me within a painting until I saw the work of Gerhard Richter in Germany. Before going to Germany my favourite artist was Anselm Kiefer, Yet next to that it was Richter's work that I found thought-provoking, in particular its flat, smooth qualities." Zhang Xiaogang now began to incorporate a painted border to frame the image at the centre of his compositions as if it were a photograph. A repeated, unifying feature first seen in 1987 was the strongly angled corner of a room, which pushes the perspective deep away from the sitter, further emphasising the convex distortion. There were scrawled lines of song lyrics and small semi-transparent floating motifs. And here is the first instance of the visual element of red lines, used to connect the sitters to favourite objects or items that Zhang Xiaogang felt expressed their personality. The portrait of Ye Yongqing's daughter provides a good example: the red lines leading from the figure to two television screens represent the triangular relationship between the all-important single child and mum on one hand, dad on the other. With the birth of Zhang Xiaogang's daughter in 1994, this painting also describes how genes had become relevant to his life: which part of which parent gets passed to the child? The question was daunting.

In 1993, he mounted a small exhibition of the new works in Chengdu and was distraught to hear his approach pronounced a backward step: " ... [people said] I should return to the disjointed knifed style of the mystical-spiritual paintings." Here was evidence of that preference for Expressionism he had identified in local critics, who were baffled by the intense nature of the clearly personal new content. By this time, Li Xianting and Johnson Chang had selected a group of his metaphysical paintings to participate in "China's New Art, Post 1989", which were aptly titled *Private Notes*. As suggested earlier, each individual motif gave the viewer exactly that sense of being a private note from Zhang Xiaogang to himself. When the chosen works were shipped off Zhang Xiaogang retreated from Sichuan to Kunming for three months to nurse his wounds and unravel his thoughts. Looking through old photographs at the family home, he stumbled upon a correlation between the sensation they evoked and the paintings of Gerhard Richter that he had seen in Germany. Tentatively, he began to copy photographs in his paintings, but the effect was not as satisfactory as he had anticipated. The philosophy had yet to fall into place. It was a chaotic but gripping period of development, which, like all crises, achieved an unanticipated result. One composition depicts him in the foreground, his mother behind him, rendered in mannish weight and features, and looking daggers at his back. A small photograph of her in the prime of youth is adhered to the painted television screen on the right-hand side of the composition. Inserted into the pictorial space between them is the reproduction of a letter that he had written to his mother—when he was in hospital perhaps?—assuring her he was fine. Working through the personal emotions that strained his family relations was, for Zhang Xiaogang, painting made therapy.

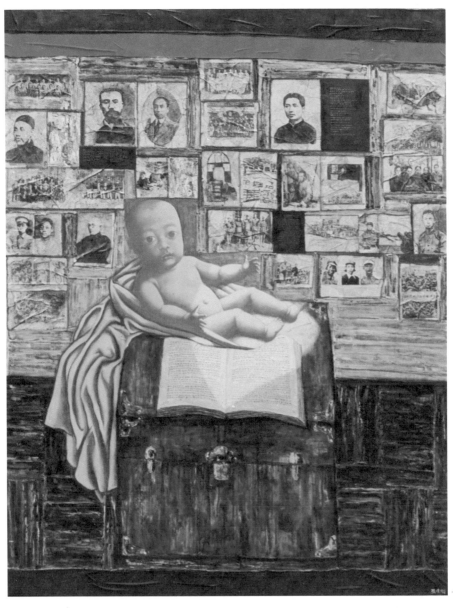

In one painting, that heralded a second breakthrough into a more direct challenge to his past, a red baby lies on a wooden chest surrounded by small objects, which suggest the unassuming possessions that become so consequential in a life. The chest represents a private space in which to secrete sacred possessions, personal skeletons. The red baby is immediately striking but there are other subtle motifs in the background, such as the fragmented musical notation that do not go unnoticed. The motifs infer a private set of hieroglyphs decipherable only by the artist, of which

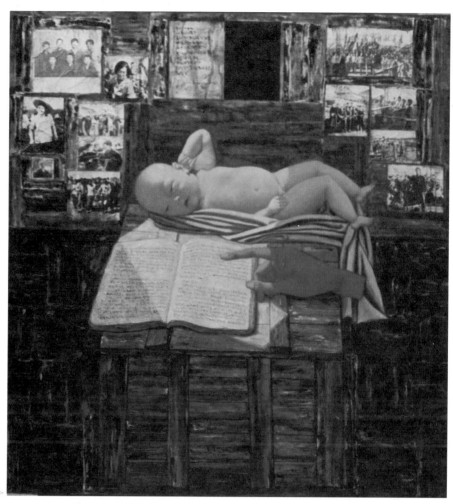

Creating an Era No. 2, 1992 ≫

the notation is a good example. It represents the score of the most popular song of the moment in which the painting was made, and for those who could read it, served to create an ambience; mood music for a picture plucked from memory, its action frozen for all time. The painting, *Red Baby*, struck the right chord and encouraged Zhang Xiaogang to go with the emotion, the language, the format, and see where they led. The second work was already more grey, smoother in texture and discernibly less real. This time the baby was yellow.

The return to an unmasked realism demanded a reinstatement of paintbrushes, which he had forsaken for palette knives for a brief period. Zhang Xiaogang was coming closer to his own truths and he no longer needed to cloak his meaning in distracting textural expression. As 1993 drew to a close, he produced the first *Bloodlines* painting: a father in army cap with a magenta-coloured baby, which was in fact

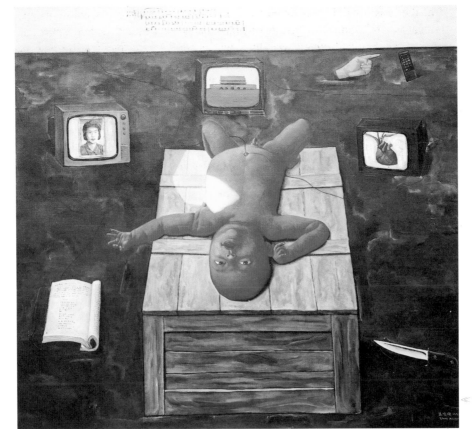

Red Baby, 1993
collection Johnson Chang,
Hanart TZ Gallery, Hong Kong

one of Zhang Xiaogang's elder brothers. He was born with a slightly crossed-eye, and is recognisable in subsequent works by this physical trait. Interestingly, at this time Zhang Xiaogang also produced a portrait of a fellow student and close friend from the academy, Chen Weimin. Chen Weimin had a delicate mental disposition. His nerves had been tested as he negotiated the world, leading to mental weakness in the form of manic depression. This was evident in the obsessive canvases he painted that repeat images of a simple array of possessions common to all in the 1970s: thermos flasks, Red Guards' satchels, Little Red Books and blue-grey Mao jackets. Human fragility was manifest around Zhang Xiaogang, like an invisible network of threads intricately woven into his existence.

Back in Chongqing, he now produced a painting which was to be the turning point. It was almost a straight reproduction of a photograph in paint, with all extraneous motifs removed, guiding total concentration to the figure in the picture. By 1994, a new theory was coming clear in his painting. Inspired by the flatness that overwhelmed him in Richter's work, Zhang Xiaogang rid the surface of all painterly effects. He would paint photographs as photographs, removing all emotion and any intrusive

sign of the artist's hand. And repetition was presenting itself as a succinct means of reiterating and adding weight to potential danger concealed within. Rather as visual Russian Roulette: where was that next explosive gene hiding? The type of photographs he employed were those that had been orchestrated to commit the best of the sitter to posterity: the kind memories are made of. The multiple *Comrades* series could easily be read as the tongue-in-cheek parody of the dream each sitter harboured for an unblemished immortality as they presented themselves to the camera lens, creating an ideal picture of health that propaganda invested in the Mao era. "It expressed the mood of people at that time. I no longer felt the need for exaggerated expression. The flatness captured what I wanted to say. Photographs brought me back to painting."

Through Zhang Xiaogang's formative years the word "comrade" was a unifying concept across Chinese society. Everyone was a comrade. Or, familial circumstances permitting, was forcibly required to become one through self-criticism and re-education. There was only one image of a true comrade and that dictated everything, from the haircut to the garments that could be worn to the expression that a happy commune dweller-worker-soldier-peasant was required to don. Superficially, Zhang Xiaogang took this and played with it. Yes, here was the surface unity all Chinese

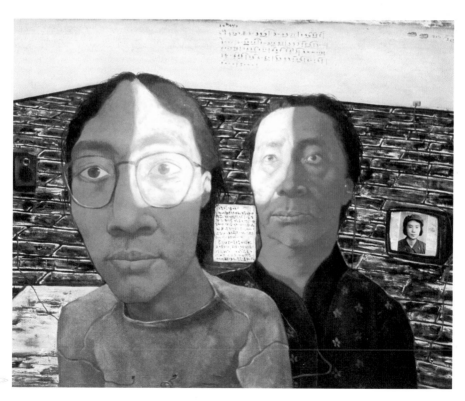

Mother and Son, 1993

289

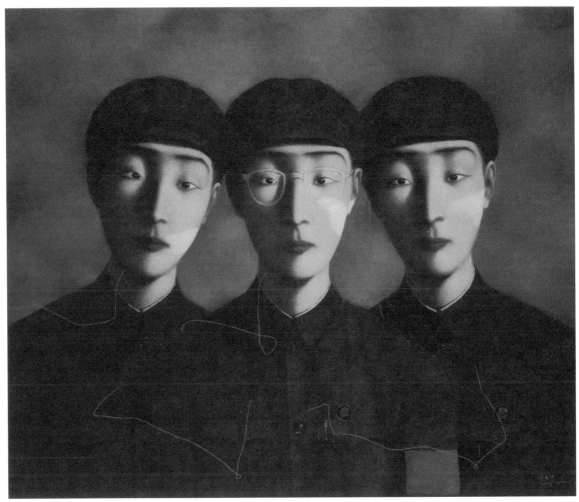

△ **Bloodlines: Three Comrades,**
collection Queensland Art Gallery
Brisbane

people were obliged to adopt. Here, too, the contrived similarity of appearance that led western peoples to believe the Chinese masses all looked the same.

The uniform image of the Chinese people in the 1960s and 1970s, which Zhang Xiaogang turned to his advantage, made a deep and lasting impression on the outside world. It was the singular image reported from the early 1970s, when diplomatic and foreign relations were normalised and journalists gained access to the long-closed world within New China. Political satirist P.J. O'Rourke produced a startling description of China's leading fashion trends garnered from press reports published by journalists travelling with the Nixon entourage in 1972: "Unisex is the very first thing that hits you in China. Not that ersatz continental garçonette haircut business or high heels for men, but real unisex. The clothing that they wear—it's

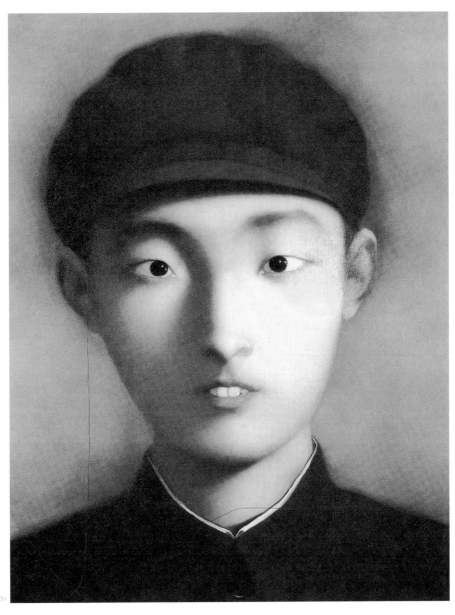

Comrade No. 1, 1996 ≫

not masculine or feminine, nor is it as dumpy and sexless as it looks in those *Daily News* centrefolds, it's just the same for everyone. And the effect of those millions and millions dressed alike without regard for age or station is more spectacular than any Ken Russell outrage."[7]

O'Rourke's 1972 article was pure invention on his part, for he was neither a member of the entourage as he claimed nor had he ever been to China. His point was to illustrate that "the press coverage of Nixon's China trip was so shallow and

7. P.J. O'Rourke, "The Boxer Shorts Rebellion", *Age and Guile: Beat Youth, Innocence and a Bad Haircut*, p. 14, published by Picador, New York, 1995.

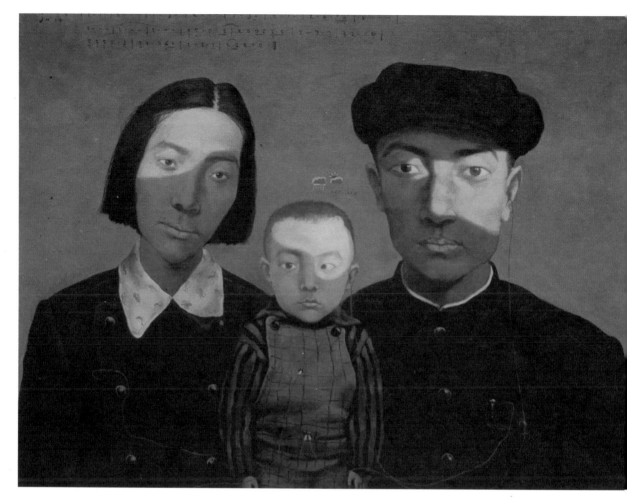

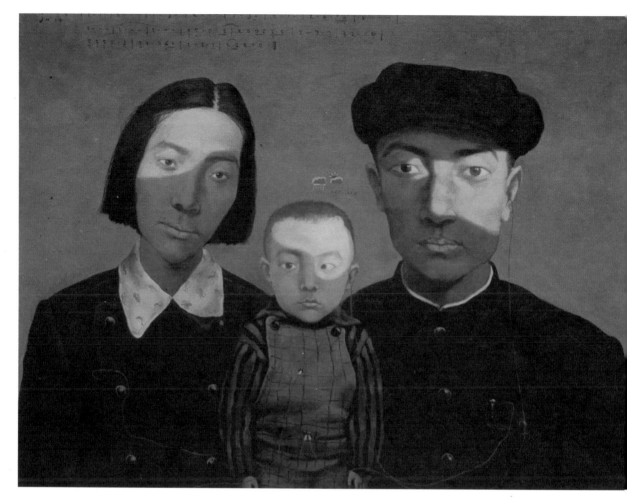
∧ **Bloodline: Family, 1993**
collection Asian Art Museum, Fu

predictable you didn't need to be there to write it."[8] His spoof illustrated the impact that Chinese dress in the early 1970s made upon the visiting journalists and that is obviously retained in the mass subconscious of their readers. Media coverage of China evolved, but as it largely focused on business, economic and political reporting the image that O'Rourke gleaned of the Chinese people lingered. It explains much of Zhang Xiaogang's phenomenal success abroad. When his paintings first grabbed foreign attention, it was this unified, innocently asexual undertone that resonated with the audience, for here on the surface at least was something they expected to see from a Chinese artist, something clearly familiar. Indeed, the ambiguous sense of androgyny interested Zhang Xiaogang. It represented a plainness that he equated with Chinese standards of beauty, circa the 1920s, and embodied in the chic yet folksy image of modern people used in the advertising posters of Shanghai's first heyday. This was the first time that foreign ideas and elements of a different lifestyle,

8. Ibid., P.J. O'Rourke, p. 13.

a different aesthetic sensibility, had entered China and fused with its culture. "I'm not concerned with sexuality in the sense of being heterosexual or gay, just something completely ambiguous. In 1995, I started to seek a Chinese language. I quickly felt the need to evolve the genderless feel of androgyny. This is a sense close to classical Chinese painting, ancient images of Buddha, Guanyin ... "

When you look closely, you discover that Zhang Xiaogang does indeed paint the men in the same way as the women. In removing all the individual traits of a personality, to seek an androgynous being—a middle way—he also seems to question the maleness/femaleness of genes carried through bloodlines: is the distribution of perfect and vagrant genes irrespective of gender? Is it random? Here, just at that moment when the proletariat tried to be exactly alike, their unrestrainable inherent differences became apparent; those natural flaws in the human genetic make-up that refuse to allow people to be exactly alike.

Comrades blended seamlessly with the ranks of *Bloodlines*, and the title was dropped as they became integrated into *The Big Family*. Zhang Xiaogang increasingly looked to the specific familial relationships between parent and child, husband and wife, brother and sister, sister and brother. The colour of these paintings is soft and harmonious. The forms are hypnotically uniform, and the dark eyes ruefully haunting. Imbued with a liquid film of moisture, so glassy are these big, round, penetrating eyes that, up close, viewers almost expect to find their reflection there. In what was a subtle shift, the details of clothing, neckerchiefs and collars became secondary to the faces of the individuals who wore them, as their expressions occupied the pictorial space with a compelling intensity. Zhang Xiaogang did not abandon the familiar style of Cultural Revolution dress. That continues to be a necessary element in fixing his

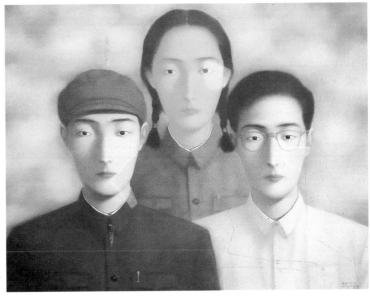

Bloodline: Big Family (Siblings), ≫
1996

issues to a complex and reprehensible period of history, as he attempts to fathom the nature of its impact upon the family circumstances of his childhood.

The public premiere of the works took place at the São Paulo Biennial in October 1994. Instantly, Zhang Xiaogang was inundated with attention from curators, critics and collectors. Hailing from a multitude of nations, they rightly recognised the innate power of his paintings to convey both where new art in China was in the 1990s, and the mood under which it evolved in the wake of Mao's passing and the ascendancy of Deng Xiaoping. Participation in events such as the 1995 Venice Biennale, "Out of the Middle Kingdom" in Barcelona, also in 1995, and the Second Asia Pacific Triennial of Contemporary Art in Brisbane, Australia in 1996, was

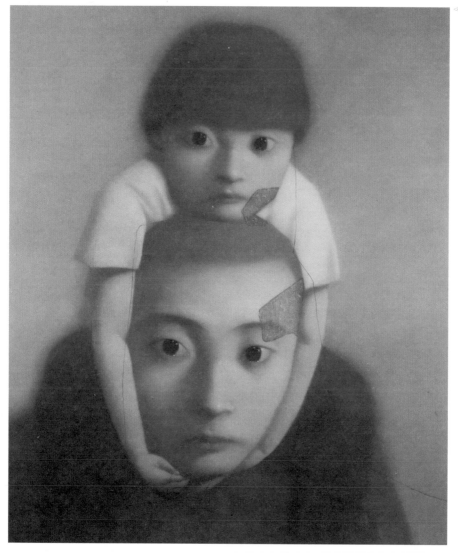

instrumental in spreading the word about this extraordinary painter from China. By the early 2000s, Zhang Xiaogang was, in international terms, the most commercially successful painter to have emerged from the avant-garde in China.

Much has been written about Zhang Xiaogang's family portraits. All the obvious statements have been made. *Bloodlines* do allude to the indefatigable importance of family in Chinese culture. Carrying forth the family name is no less salient for the Chinese than for any of the royal houses in Europe. With the rise of Communism, the family metaphor was repeatedly applied to the nation. It was to be the new family to replace the broken homes that Mao's regime was busy smashing up. The generic anonymity of the features has been noted. Zhang Xiaogang's families can be read as a metaphor for the entire Chinese nation. History has thus been implicated. Critics have analysed the bloodline as an examination of the self in the aftermath of an era of enforced equanimity. They have questioned the future of the family, subtly mooted by the one-child policy that denies children siblings and extended family members. What will be the result where one bouncing baby is awarded disproportional prominence in life, as reflected in Zhang Xiaogang's compositions? To use a contemporary expression that enjoys much currency, his overview was both local and global. It set out from his own backyard and trawled his neighbours' troubles in his net. In this way, he managed to protectively conceal his world, even as he sought to lay it bare.

The question of genetics remains a fundamental element of the paintings beyond the characteristic Chinese-ness they reflect in the features, dress and sense of the historic era out of which they are shaped. With a daughter possessed of a delicate spiritual nature to whom he is adoringly devoted, Zhang Xiaogang became anxious to the point of paranoia at the idea that he could be responsible for passing rogue genes to her. Medical research confirms that mental illness can be passed through the genes. Medical research has demonstrated that: "If one family member has schizophrenia, the closer you are to that individual in genetic terms, the more likely you are to get schizophrenia too. Relatives of patients with schizophrenia have been noted to have mild features of the illness themselves to a certain degree."[9] Where the subject of mental illness was taboo in China, information was neither public nor available. We see Zhang Xiaogang's fear in the genetic quirks and nuancical defects that touch each one of the family members in his paintings, the lazy eyes, wayward pupils, protruding overbites, lopsided lips and wonky brows. These adulterations add an element of humour to the images, making those portrayed more endearing, more charming; imperfection is closer to humanity, and infuses the ordinary and imperfect viewer with a greater sense of compassion for the subjects. In these paintings where everybody does look almost the same despite their marginal quirks, one becomes highly sensitive to the nuances at work. We come away knowing more of the intimate details of the features of Zhang Xiaogang's family members than is retained when ten people of radically discrepant appearance are viewed.

Through the 1990s, as international art audiences were becoming acquainted with the idea of a Chinese avant-garde, due to the inevitable limitations of space for the majority of exhibitions in which Zhang Xiaogang participated—whether internationally

9. Dr B Green, Hon. Senior Lecturer, University of Liverpool, UK, *Review of Schizophrenia*, 1991.

or within China—the number of works that could be shown together was frequently restricted to two or three. Where superficially the paintings seemed to be so similar, it is possible that many curators felt this an adequate number in representing the artist. Yet, the result for the audience was that from one exhibition to another it was hard to achieve a sense of from where the creator of these paintings came and to where he was going, encouraging the view that seeing one painting meant seeing them all. The sense of repetition invoked in the paintings was, at odd instances, tentatively levied as a criticism. What wasn't so obvious is that Zhang Xiaogang produces his paintings at an extremely measured pace. In the late 1990s, when interest in his work hit its first peak, Zhang Xiaogang experienced a period where, unable to slow the helter-skelter pace imposed upon him, he became locked into one rhythm and pattern. "The force of the market dominated my life. None of us had ever worked with a gallery before or had any idea what it meant. Suddenly I would find myself in nine or ten shows a year."

But when he managed to put the brakes on, he also discovered that the volume of works had amassed a new autonomous power. This realisation saw Zhang Xiaogang joke that the close similarities between works should be of satisfaction to his collectors—after all, no collector has to worry that their work is less of a masterpiece than another. No one can claim one painting to be less representative of his style, less characteristic in theme or execution than the next. It amuses him to take such reassurance, yet the fact that purchasers are guaranteed complete satisfaction is no a joke. Zhang Xiaogang was drawing upon a vision of Chinese society, an image of the masses, physically and in the abstract entwining of ideology and social values, that had dominated his entire life experience. It is only when one has an opportunity to see a large group of Zhang Xiaogang's *Bloodlines: The Big Family* hung together that one really begins to feel there is more at work in them than a recap of history wrapped up in a cynical or sentimental gesture.

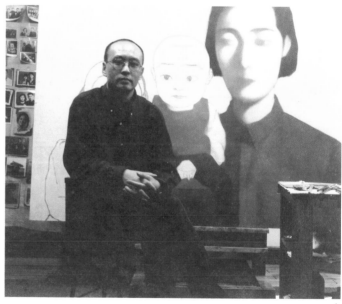

"When I returned from São Paulo in 1994, I felt compelled to be repetitive. All too often the market drives demand. Collectors may want a unique work but I didn't want to make many different kinds of paintings. When the differences in mood or style are great, works are open to being judged as one better than another. I wanted to remove this possibility. My approach was not about each individual painting, but a body of work. I want to leave viewers with one, strong

In his studio in Chengdu, 1999

impression, not many different ones. I did wonder if this would influence the sales of my work, but quite the opposite proved true. Collectors were at ease with the quality of the paintings: instead, when they met, the discussion was always about who got the best deal."

In 1997, the Beijing audience was the first to see a significant number of paintings assembled together for Zhang Xiaogang's maiden solo exhibition. In the single figure-of-eight space of the Central Academy's city centre gallery,[10] nine large works occupied the space authoritatively, and just as when those "unrestrainable, inherent differences became apparent" in the revolutionary proletariat, here the delicate individual nuances of Zhang Xiaogang's family members were movingly revealed. The impact of seeing similar compositions, which varied only in minutia, was overwhelming: uniform colour of warm and cool greys, with light rose patches picking up on particular features, against the rich green of a faded army coat, a blue Mao suit, a pale pastel collar and fine lines of bright scarlet that signify the bloodlines. Further, the paint applied in such a way as to leave no trace of the brush. The backgrounds are consistently flat. No part of the work employs the kind of devices that would give volume to the human figures. Yet these figures have an eerie, undeniable presence. Hung side-by-side, the recurrent features, attitudes and gazes, distinguished by subtle variants, inspired viewers to scrutinise the paintings closely. Their endeavour was perfunctorily rewarded. The exhibition revealed how repetition was indeed a conscious and deliberate action at this juncture. The volume of Zhang Xiaogang's *Bloodlines: The Big Family* was, therefore, not the result of an exhausted imagination, as some of the more ardent young critics claimed, but a profound comment upon the plight of the self in the face of the crushing weight of the masses, in beautifully executed paintings of gentle-looking young Chinese people, innocent and shy. But what about the curious patches of colour that hover like indelible stains over these faces?

As Zhang Xiaogang explored how his mother's illness had affected his perception of her, from its earliest inception, *Bloodlines* harboured his tangible fear of the incipience of hereditary disease. Was the potential for imbalance lodged within the genes he carried? The fear is an ominous subtext to the paintings, besmirching the patches of light that touch those of the same bloodline, a secret fear about the health of genes that are passed from one generation to the next. The red lines highlight the potential channels of transmission. The patches are X-rays that penetrate the almost-perfect surface to emphasise the random ways in which genetic problems strike. Fatality is made all the more tragic by the innocence in the eyes. Zhang Xiaogang's portrayal of young people implies a game of roulette that all parents play in starting a family. The affect of Zhang Xiaogang's mother's illness and the disturbed family relations overshadow his life. Where illness is not understood, ignorance is the breeding ground for future repercussions. In many ways, the figures in his paintings are victims of several generations of exactly this kind of ignorance. This series of works remains one of the more candid and uncontrived expressions of one person's experience that neatly dovetail with the broader psychological trauma of an entire generation.

10. Located in Xiaowei Hutong, south of the original academy and adjacent to the main exhibition hall. It was demolished in 1999, although the hall was retained.

As Zhang Xiaogang's paintings evolve, they become less about his personal history and more about his emotional state today. Time has, to a large extent, exorcised his Furies, as have independence, success and the distance between the past and his present. His studios in Chengdu, Beijing and Kunming have walls covered with tiny portrait photographs of his family, but they also include others that he found, garnered through the years from flea markets, books and magazines. Carefully taped, row upon row, within viewing range as he works at his easel. The overwhelming monotony of the expression that eclipses their features dilutes Zhang Xiaogang's innate sense of being different.

In the early 2000s, Zhang Xiaogang made a conscious decision to return to the motifs he had carried—"in my heart"—as a starting point for a new departure. The resultant paintings were the body of a sell-out solo exhibition at the Galerie de France in Paris, in June 2003, reflecting the extraordinary demand for his works—the gallery's director, Catherine Thiek, suggested that she could have sold them twice over in spite of the fact that some of the new ideas are unpolished, self-conscious, and less convincing in form than his masterful *Bloodlines* series, as Zhang Xiaogang himself acknowledges. "In 1994, I had many ideas that I did not realise or use then. I was too busy with *The Big Family*. Those ideas have not gone away, but it is hard to get back to the emotion and essence of what inspired me, and to reconcile that with the language I evolved. I am trying. Now, it is time to catch up with myself."

In 2001, he embarked upon a series of large paintings in which he seemed to have caught up with his past. He was now addressing specific childhood emotions directly; ones that were increasingly pertinent to the general mood of Chinese society as change enacted dramatic cosmetic surgery on the environment. For the first time, he permitted himself to be selfish. "I can say that now everything I produce is based on personal experience and not collective ideals. How can you live now if you can't forget the past? I have always been good at things past: not at imagining my future. In the Cultural Revolution everyone looked to the future. Chinese people find it so hard to live in the moment. Today everything is being knocked down,

Amnesia and Memory: Telephone, 2003 ∧ ∧ Amnesia and Memory: Wine, 2003

erasing individual and collective pasts. People seem to love this idea of building a brand new future, yet they sit in their brand new buildings obsessively watching TV dramas about the past, about Chinese history, or talk about days gone by. I want to explore that feeling."

In these paintings, the head of a single child dominates the space. Only the eyes are clearly distinct. The rest is as minimal as can be. Clothing is dispensed with—not that his figures can be described as nudes, for we only see the heads. It is a conscious focus on internal emotion, which as well as being his, is yet equally applicable to the children of his daughter's generation. Here, the gaze is turned in upon itself in intense introspection, invoked in the title *Remember and Forget*. But more than just a recherche, one senses that these works pay homage to the injustices he experienced as a child; poignant now that he is a father and his daughter is the model for so many of the paintings.

The stains of the past are indelible indeed. This must include the consistent symbols and motifs that Zhang Xiaogang evolved in his art and that against critical and friendly advice have proved so persistent and succinct. Those new works at his 2003 solo show in Paris, which coincided with "Alors, La Chine?", an exhibition of contemporary Chinese art held at the Pompidou Centre, contained recent reworkings of metaphysical symbols from the late 1980s which appeared in paintings like *Private Notes*. The feel is tentative, exactly in the way of all those of his paintings that heralded a breakthrough at a critical juncture. Zhang Xiaogang's art is the antithesis of all that Wang Guangyi preaches and that has become mainstream—in terms of the art circles—avant-garde art in China. It requires a strong will to stand alone against a flow, which perhaps he learned as a child. "Inner Strength" is the title of an article he wrote in 1993, and a phrase that he defined as the confidence to examine the self honestly. Within his generation and the early generations of the avant-garde, this quality and ability makes him unique. "A personal or individual style in art should be a given. To be profound is not necessarily to be philosophical. It is born of an artist's deep sensitivity to their personal experience, which they draw upon to unveil a highly specific and especial sensibility. That's why the best description of my paintings is "inner soliloquies".

Amnesia and Memory: Diary, 2003 ⋀ ⋀ Amnesia and Memory: Bed, 2003

SECTION 3

CONQUER!:
NEW GROUND AND TECHNOLOGY

This section explores the work of three artists whose success and recognition arises from the combining of pure personal aesthetics with succinct socio-political and cultural commentary—both local and global in form and linguistics. And in so doing, they ushered in multimedia practices that countered conventional artistic praxis within Chinese culture of the 1980s. Whilst their individual approaches sound not dissimilar to those of the avant-garde painters included in this book, the art of Xu Bing, Zhang Peili and Wang Jianwei differs in that they rely upon the skilful application of technology as a conduit for the messages they seek to express, in a language that is rational, detached, almost clinical in execution. Initially, they broke ground by contending with primarily western art forms that were without precedent within their own cultural environment. But what lends weight to the reputation each has achieved is that they came to their medium intuitively, on a search for the most appropriate medium for expressing that which they wish to communicate. They had no models to guide them, beyond a handful of technical manuals.

What they accomplished is particularly astonishing given their chosen media and tools, such as video which Zhang Peili took a pioneering role in establishing in China. In the 1980s, beyond studio space and reams of academic treatises, academy facilities were meagre. Photography was categorised under journalism or design so fine arts academies did not possess photography departments. Filmmaking was the exclusive domain of film schools. Equally, there was neither funding nor a perceived necessity to provide even basic video equipment for the use of art students. In the 1980s no independent artist owned a camera of any real description, which is the main reason why so much of the art produced by the avant-garde from 1985 through to the "China/Avant Garde" exhibition in 1989 remains scantily documented. The acquisition of single-lens reflex cameras (SLRs) did not become possible until the early 1990s, with the

advent of an art market (largely for painting) and a US dollar revenue stream (US dollars traded at a good rate on the black market). SLRs were prohibitively expensive and remained beyond the means of the majority until the technology was overtaken by digital imaging, which had a decisive impact upon the pricing of SLRs. The same was true of the video camera, although by the early 2000s, a massive leap forward in digital technology had enabled even the most humble artist to afford a Sony HandyCam if he or she chose. The cost of computer technology dropped dramatically during the 1990s, assisted by an enormous volume of pirated software priced dirt-cheap. Learning home-editing and composite picture making, as well as producing professional proposals and presentations, became easier and more prevalent than drawing by hand, which as well as being time-consuming was not viewed as cool. Information was still largely transported by hand, on foot or by post: China did not get on-line until the late 1990s, and then only in restricted circumstances and protected environments. However, by the early 2000s the Internet had created a communications revolution. It had become an indispensible part of life for artists like Xu Bing, Zhang Peili and Wang Jianwei because the nature of their art and the projects in which they participate are heavily reliant upon the swift exchange of the specifications of exhibition sites and the detailed plans of proposed works. Email allows them to be simultaneously in touch with curators, art spaces and a world of art beyond China that was previously inconceivable.

The market was swift in embracing and affirming paintings by Wang Guangyi, Fang Lijun, Li Shan and Zhang Xiaogang, and those by artists who fell into the schools which these artists had inspired. From the late 1990s, wealth was as much a factor in determining artistic success as the critical discussion of the work. Yet, against the overwhelming human urgency to get rich in China, Xu Bing, Zhang Peili and Wang Jianwei elected to work with media that, within the climate of the times, initially at least, was devoid of transparent commercial advantage or sales potential. Beyond commercial expectations, Xu Bing, Zhang Peili and Wang Jianwei focused their energies on exploiting dexterity and skill in technique and execution that set standards to aspire to, not least of which was a succinct measure of intellectual comment. They produced works often on a scale—as with Xu Bing's *Book from the Sky* or *Ghosts Pounding the Walls*—or of a format—Zhang Peili's video works and Wang Jianwei's life-sized incubators enmeshed in miles of tubing and cables—that deterred all but the most serious of collectors and institutions. They do, however, represent three avant-garde artists from China who have garnered serious international reputations, unmatched by other artists of their generation, with the exception of Cai Guoqiang and Gu Wenda in New York, and Huang Yongping and the late Chen Zhen—both in Paris—all of whom have made their careers abroad.

From the outset, Xu Bing, Zhang Peili and Wang Jianwei produced works of art that responded to the socio-political circumstances of their upbringing and the culture in which they were entrenched. Each has a distinct personal agenda rooted in a questioning of meaning, perception and audience awareness, and the resultant works test these faculties using means similar to that which the majority of Geng Jianyi's early works do. Interestingly, one common denominator is the lack of credence each of them awards the ideology that prevailed through their formative years. In ways and by means more or less direct, they judge their oppressors with astuteness, yet endowed with such critical insight that the works transcend the specific cultural episodes that inform them and can be transposed to the universal face of human foible and failing. Thus, one does not find immediately obvious Chinese motifs in their work, such as is swiftly identified in the political symbolism of Wang Guangyi's paintings, or in Zhang Xiaogang and Li Shan's evocation of an era; although, as we shall see, Xu Bing has been accused of prostituting the same Chinese wares in his invented calligraphy, as scripts and fonts. Yet in the grander scheme of things, in one very real sense, Xu Bing, Zhang Peili and Wang Jianwei arrived at their aesthetics, primary outlooks and views of the world, through addressing an innate sense of marginalisation, by virtue of being Chinese, historically excluded from the greater world, and arising from their sense of disillusion fostered on them by the questionable results of Mao's policies. Yet, this was no less than the moral-less urgency that overtook society as Deng Xiaoping's about-turn policies propelled social change and advance. All three artists possessed the skill and vision to lift themselves above the impediments of the immediate scene, artistic and socio-political, without fading from it in presence or influence. Through the 1990s, opportunities to see their work in China were rare but individual pieces regularly appeared in local art magazines and their careers were closely followed by art world peers and, to a greater extent, the emergent generations seeking role models close to home.

Born in 1955, 1957 and 1958, respectively, Xu Bing, Zhang Peili and Wang Jianwei are of the same time but very different family backgrounds. Xu Bing's parents were the typical well-educated, financially fortunate, and socially responsible offspring of families characterised by generations of imperial scholars, with a strong allegiance to education. Xu Bing is often referred to as an intellectual. Both his mother and his father threw off their superior status, material comfort and assured positions in life, to devote themselves to the communist cause in the 1940s. After a momentary reprieve when Mao first came to power, all their sacrifices were thrown back at them as, across the nation, in a damning parallel with Old Testament rhetoric, the sins of the fathers—for being

landlords, for being gentrified, educated and wealthy—were visited repeatedly on the children. Xu Bing could but observe his family flounder from persecution to persecution at Beijing University. He took refuge in the countryside where educated youth were sent to learn from the peasants, as he was sent to do in the early 1970s, and subsequently in art, as he was welcomed into the embrace of the Central Academy of Fine Arts in Beijing. Here, history repeated itself: Xu Bing, the academy's golden boy, who devoted himself to the cause of art for the people, fell from the "model worker's" wagon with one extraordinary work—*Book from the Sky*—for which the State did not readily forgive him.

By contrast, Zhang Peili hailed from a nobly ordinary background, nondescript in a way that proved best for a stable existence during the three decades of Mao's regime. His parents, standard workers of their day, were employed at a local hospital. This provided endless food for thought as hepatitis epidemics ravished the south-east of China periodically through the 1980s. Zhang Peili, too, was a victim of the virus, fortunate in so far as he caught it, rather than inheriting it—a situation that could be redressed. For millions more, like Geng Jianyi, who inherited the disease genetically, there was only a protracted battle against the inevitable weakening of the liver.

Where his childhood and adolescence progressed untainted by political stigmatism, Zhang Peili was afforded a healthy attitude towards life and art. He also acquired a cutting sense of humour, a trait that he shares with Wang Jianwei. The difference is that Wang Jianwei's humour is not so easily grasped. It has a bitter after-taste that hinges on the hardship that accompanied his upbringing, and portends a cynical presentation of reality that outstrips any of the paintings placed under the umbrella of Cynical Realism. In fact, next to Wang Jianwei's work, Cynical Realist paintings appear as harmless as a comic cartoon, for they lack the pathos and frustration that colours the prism through which Wang Jianwei views the world. His childhood unfolded in the tough environment of Sichuan province—in southwestern China—which was, and largely remains, engulfed in poverty. This led him to follow the standard route out, which was to join the army, as his father had done before him. On one hand, this placed a protective boundary around him. Army boys were usually poor, but in joining the army they were viewed as patriots. Most were so young that they were not vulnerable to being struggled against unless they developed an outspoken manner, or aired unacceptable or radical views. Wang Jianwei acquired an emotional and mental detachment that latterly permitted him to put his full attention to art, to embracing all that standard video, and later digital technology, could offer an artist. But at the time, in the absence of personal or private space,

he spent his time observing the impact of the use and abuse of power within the social structure around him. Significantly, he would later bring these observations to questioning a multitude of accepted truths about China, its politics, history and social interaction. He did not grow up with a computer, or even analogue. Since the late 1990s, digital technology has come to occupy his life's work. All he had access to was rudimentary photography, offered by random photographers at whatever tourist site or photography studio set up he encountered. Tiny thumbnails represent the only visual mementoes of his early life.

These three artists are not united by themes in their art but by attitudes towards practice. A meticulous approach and profoundly wise concerns dominate the work as a whole. Each has transcended the subject matter of revolutionary or reactionary response to the political background initially anticipated by foreign critics and audiences to make extraordinary art. Each has participated in exhibitions in major art spaces around the world—museums like the Whitney and the Museum of Modern Art in New York, the Smithsonian in Washington DC, the Asian Art Museum in Fukuoka, the Venice Biennale and Documenta in Kassel. They have won prestigious prizes, too; Xu Bing received the MacArthur Award in 1999, Wang Jinwei was awarded the Video Cube prize at FIAC, Paris in 2002. In contrast to the works of the other artists profiled here, which are by a majority in private collections, the works of Xu Bing, Zhang Peili and Wang Jianwei are also found in a number of public collections.

Significantly, at one time in their careers each of the three has produced highly politicised art works, examples of which represent the most cutting of comment upon the local socio-political situation and China's recent history. Xu Bing's *Book from the Sky*, Zhang Peili's *Document on Hygiene No. 3*, and Wang Jianwei's *Living Elsewhere* invoked State displeasure, a public furore or consternation within art circles by turn. They are pivotal works in each of the artist's oeuvre produced at critically early junctures in their individual careers. In 1990, Xu Bing took up a visiting fellowship in the United States, and within a year—and against all the odds—was attending the opening of a solo exhibition at the University of Wisconsin-Madison's exhibition space on a scale rarely accorded a single artist at the venue. Zhang Peili was showing in Paris together with Gu Dexin at the prestigious Galerie de France. By 1991, Wang Jianwei—who was a soldier right up until 1984 with little in the way of formal education and who went straight to post-graduate studies in 1986 where he immersed himself in Heidegger—was showing *Reproduction*, a highly complex installation piece inspired by Chinese attitudes towards procreation, in a solo exhibition at Hong Kong Arts Centre.

Ironically, that their work has been rarely seen in China relates less to its political aspects or to issues of constraint than to international demands placed upon their time. Time spent in China is time only for conceiving ideas, finding the appropriate means to express them and attending to family duties, which all take particularly seriously. In 2002, Xu Bing showed his first works in China for more than a decade: in Beijing, Guangzhou and Shanghai, in private and public events. In 2001, Zhang Peili was appointed head of a new media art centre at his alma mater in Hangzhou. Even Wang Jianwei's plays, reworking classical themes and exposing cover-ups, were performed in public theatres to full houses. The artist was profiled in *Esquire* magazine (Chinese edition) in spite of being characterised as the author of "plays no one understood". The influence of all three is palpable: Zhang Peili affected a more directly immediate influence when the new media centre at the China National Academy of Fine Arts in Hangzhou became a full department in 2003.

The words of Xu Bing sum up an underlying common philosophy: "The culture we inherited was Mao's adulteration of tradition. Whether it was good or bad is another question, but it was neither traditional nor western. We have to find a way to use and implement this. Naturally, there are bad aspects or there wouldn't be so many problems in China but this is what our generation was presented with. We can't forget it or we would have nothing. We have had to identify ways in which to rethink it and use it."

XU BING:

IN A WORD

Word Play, 2001

"The problem with contemporary art is that it relies entirely upon [cultural] context and requires knowledge of the artist's place within the art world, in time and in his/her career. My aim is to avoid this and to make an art that truly serves the people ... "

"Cultural context" is a concept that doesn't usually occur to European or American audiences looking at contemporary art from their own countries. Even where it is a specific or essential component of the work, in which references invoking the cultural context are integrally embedded. However, bring on artworks from an unfamiliar culture—which do not conform to local formats, content or styles—and the response changes: evidence of references to an unfamiliar context throws a spoke in the wheels. Almost instinctively, that which is unfamiliar is subconsciously categorised as foreign, with the result that an artwork might be good, or it might be bad. It's often hard to tell. In terms of China's cultural heritage, the hieroglyphs of its calligraphy blend with those of Japan and Korea to become simply Asian or Oriental. The broader context is lost. Or not quite: of all the members of the so-called diaspora of Mainland artists, none negotiate context quite as successfully as Xu Bing. And negotiating context is perhaps the greatest on-going challenge to avant-garde or contemporary artists in China; greater even than a distinct aesthetic, because without a knowledge of the fundamental context—social, political, ideological and even economic—of the culture that precipitates the work, how do audiences appreciate the aesthetic? Given the enormity of this challenge, to remain afloat the choppy waters of the international art world unscathed *and* lauded arouses a jealous, fighting spirit in other competitors—the latter being a good example of one context that is universal and knows no barriers, either linguistic or aesthetic.

July, 2002, in Kunming, the provincial head of Yunnan province, southwest China. The fourth location of a contemporary Long March that retraces the path across China taken by beleaguered members of the emergent Communist Party between October 1934 and May 1935. The original Long March determined the course of twentieth-century Chinese history: it was the walk that carried Mao Zedong to victory. In 1934, marchers started out from Ruijin in Jiangxi province in southeast China and, at its height, Mao led a 100,000-strong crowd that marched primarily on the promise of a full stomach and escape from the tyranny of serfdom and civil division. Few of the marchers lived long enough to test Mao's word. Nine tenths of those who joined the trek lost their lives to fighting, starvation and exhaustion. Yet even those who survived were not all rewarded with good fortune: life in the new People's Republic was far from the sated Utopia so eagerly anticipated.

The original Long March culminated in Wuqi,[1] Shaanxi province. Those who made it survived almost entirely on revolutionary zeal. Hardships en route were mitigated to a modest degree by the meeting that took place at Zunyi, Guizhou province, in January 1935, stoking the marchers' fervour as Mao outlined the military strategy that would defeat the KMT (the Nationalists). This powered the marchers on to Yan'an, where Mao outlined his vision of a new socialist state, and delivered his culture-altering Talks on Literature and Art; a combination of politics and aesthetics that consumed the nation over the coming four decades. Now, a little over fifty years later, in a previously inconceivable turn of events, Xu Bing was plundering Mao's doctrine, and commandeering his poems and thoughts to avant-garde art, a realm Mao despised. Worse, Xu Bing was doing so in the name of an art that served the people.

From start to finish, the conceptual retracing of the original Long March route had complex motives. The one most frequently cited was to re-visit a journey pivotal to Chinese socio-political history, that of retracing the roots of its over-arching ideology. It was as much ambitious intellectual exercise as an attempt to take stock of the impact of "then" on "now". Above all, the goal was for contemporary artists to re-connect

1. There is some discussion as to whether the journey ended in Wuqi or in Yan'an.
2. *Square Word Calligraphy* appears in some translations as *New English Calligraphy*.

with the people in the manner of post-modern intervention. It was a brave vision, too, considering the vast majority of regions and communities to be visited were some of the poorest in China where literacy remains lowest and culture, as urbanites understand it, almost non-existent.

There are several common links between the new Long March and Xu Bing's art: first, in its desire to bring art to the people, the march echoed exactly that task which, from the late 1990s, Xu Bing had set as the goal of his art. Equally compelling is how history, sparked by the original Long March, touched Xu Bing and moulded the artist he became. The root of this lies in the Maoist vision of art, encapsulated in the Yan'an Talks, which set the parameters for all cultural activities from that moment forth: Xu Bing was unwittingly enfolded in the embrace of these parameters from the instant he first put brush to paper in the mid-1960s. Thirty years later, in the early 1990s, he began to develop a system for writing English, which uses the twenty-six-lettered alphabet but subjects it to the structure and appearance of Chinese characters. This is *Square Word Calligraphy*,[2] which in its most widely seen form is presented as the subject of a classroom lesson with copybooks for visitors to follow, guided by an instruction video. For Xu Bing, this was both a means of serving the people a little light entertainment in the heavy world of high art and a conduit for interlacing, or helping to erase, the boundaries between the two prime cultures: East and West. It also helped unravel the veil of context that stood between Chinese art and a non-Chinese audience. In July 2002, Xu Bing's services as the people's tutor were exactly what the Long March needed. *Square Word Calligraphy* was to be presented as part of an event pivoted on the theme of contemporary takes on the Chinese education system. With a reputation for subverting written language, appropriately for the Long March project, Xu Bing decided to subject a number of quotations from Mao to his invented text.

The night before the classroom opened its doors to prospective students in Kunming, at the Upriver Club—a notable artists' hangout—project organiser Lu Jie (curator, and director of the New York-based Long March Foundation) gave an overview of the project thus far. This contained one particularly poignant fact about Xu Bing's calligraphic invention in relation to its own national framework, and its role as a conduit for bringing contemporary culture to the masses, Lu Jie had printed a set of postcards to distribute en route. The sixteen cards carried a

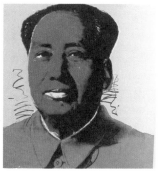

range of images: artworks that are pivotal to the development of twentieth-century western Modernism or to China's new art, and images reflecting the prevailing social environment in China and the global economic situation. Tatlin's *Monument to the Third International* followed a cartoon describing the plummeting Nasdaq index, which followed Andy Warhol's *Mao*, and a page of Xu Bing's *Square Word Calligraphy*. Along the route thus far, the people's choice clearly rated the reproduction of Andy Warhol's portrait of Mao highest: this postcard was unfailingly snapped up first. No one had the first idea what Nasdaq was: the card was viewed curiously and passed over. Xu Bing's *Square Word Calligraphy*, meanwhile, was met with active refusal. One might assume that this calligraphy—which was incontestably the most Chinese in appearance of all the images in the group—would be readily familiar to the locals, especially given that many were not entirely literate and therefore not in a position to seek meaning in the individual characters or the text as a whole. So, perhaps the image was too familiar to be interesting against a choice of curious and hitherto unseen foreign artworks. Yet, for most of the rural people encountered along the way, this was a secondary consideration. What repelled them was an uneasy sensation of being confronted with a script that was, they intuitively sensed, in fact quite unfamiliar. Suspecting some sort of duplicity at work, Xu Bing's calligraphy was shunned in favour of a work of modern art that no one was really expected to understand anyway.

Such a reaction marks, perhaps, the profoundly innate superstition that continues to hold sway over the rural population. As Lu Jie's Long Marchers discovered, within these remote communities culture had made little advance since the early 1980s. In fact, even the impact of Mao Thought was shallow compared with that of the centuries-old pantheon of spirits and gods believed to have a hand in individual fates in the farming-led provinces. In terms of Xu Bing's art, the irony was especially pronounced because since he first began experimenting with language in the late 1980s, and especially following the creation of *Square Word Calligraphy*, his desire had been to break down barriers between audiences and contemporary art, or at least give people a way in, via written and spoken language. This is what he achieved in America, Europe, and even Japan, amongst the educated ranks of museum and exhibition-goers. *Square Word Calligraphy*, embraced and praised by foreign audiences, permitted people an illusory grasp of Chinese characters, which would have been impossible using actual Mandarin texts. Meanwhile, within the

framework of his own culture, Xu Bing's approach to word play—commencing with *Book from the Sky*[3] in 1988—generated an affront more profound and lingering than Cynical Realist Liu Wei's typically outrageous painted depiction of the female figure, sucking on a banana, with 'Do you like pork?' scrawled over the canvas. While the saucily sexual overtones of Liu Wei's chosen subjects might have offended social mores on occasion, they did not violate three thousand years of traditional culture. As the aesthetic pinnacle of Chinese cultural heritage, the mastery of writing skills has enjoyed an uninterrupted stream of admiration, almost from Neolithic times. Edicts in the form of calligraphic scrolls brushed by an emperor were viewed as sacred, and allowed the people as close an intimacy with their ruler as was seemly between Heaven's chosen agent and earthly mortals. In general, calligraphy was expected to exude a spirituality that reflected the noble character of the calligrapher.

The event organised for the Long March presence in Kunming, as previously mentioned, was designed to parody a classroom that was to be sited in the Jiangwutang, formerly a military academy, established in 1910. There Xu Bing's *Square Word Calligraphy* shared a room with two permanent exhibits: an uplifting lyric of Mao's poetry—authentically styled and cast in bronze—and a bust of Chiang Kai-shek, nationalist president of the Republic (1911–1949). Neither leader would have been amused to see the remainder of the room hung with decorative strips of scarlet paper, each bearing a familiar Marxist slogan, which Xu Bing had produced to endorse the event: "Long Live the Long March"; "Marchers of the World Unite", and variations on such themes. In the middle of all these red banners, projected on a large bare wall, was a video recording of Xu Bing in his New

3. *Book from the Sky* is called *Tianshu* (天书) in Mandarin, and at times in translation.

York studio instructing pupils how to write the slogans that now hung from the ceiling in Kunming. The atmosphere was decidedly festive and initially visitors would have been forgiven for seeing anything cynical or contrary in any of the endorsements. In addition to the banners and projection, Xu Bing's *Square Word* copybooks had been laid out in each

Visitors practising Square Word Calligraphy in Kunming, 2002
courtesy Long March Foundation

of the deep windowsills together with ink and brush for visitors to try their hand.

As a former military institution the Jiangwutang was a sensitive site and an enormous amount of negotiation was required to get permission for the event. The organisers were seeking approval for a display of the work of an artist who, in 1988, had been the cause of the greatest outrage of the avant-garde's brief history—an avant-garde with which Xu Bing was not especially affiliated, but whose thunder he managed to steal with the first exhibition in Beijing of *Book from the Sky*. In 1990, Xu Bing had emigrated to America where he neatly hopped from one rung to the next, up and up in the art world to become, next to Cai Guoqiang, the best known of China's avant-garde artists living abroad. Meanwhile, in China through the 1990s, the art world lamented western attitudes towards its artists as being too colonial in outlook and too oriental in taste, or too political in orientation and too exclusive of Asian artists. Above all, too quick to qualify the creative profession of Chinese artists with the word "Chinese", which at times served to question their credibility. As Xu Bing found acceptance and support abroad in the tough, unforgiving western art world centred on New York, so he again drew criticism from envious peers at home as pandering to external prejudices and foibles, to western tastes[4]. For a time this had been the subject of heated debate amongst critics and artists (who cared enough to have an opinion). Now, in 2002, the issue flared again.

"Art for the People", Square Word Calligraphy banner

On this July day in Kunming, predictably the audience present was largely drawn from the local and regional arts community. Pan Dehai, a skeletal figure in his mid-forties, who in defiance of his frame paints fat, Botero-inspired people, was first to take a brush to a *Square Word* copybook. "I wrote *dazibao*—literally "big character posters"—in the seventies. Of course I can write calligraphy!" he announced, dipping the brush forthrightly into the ink. There was a momentary pause above the page as he contemplated where to start, before plunging the brush down as if guided by a sudden rush of inspiration. At first, he appeared to be following the outline of a character; that is, as far as the first radical (a component part of a character). However, that completed, he proceeded to deface the entire page with characters that bore no relation to either English or "Square Words", and that trespassed wildly over other boxes and outlines like a Red Guard smashing bourgeois sentiments, and obscuring the characters, clearly with some satisfaction. Where foreign audiences had been unanimous in their delight in testing their hand-to-mind co-ordination, Chinese people did not see the fun at all. Failing to see Xu Bing's chirography as interactive art and an exercise in perception and communication, they were further oblivious to the genius of invention that had brought Xu Bing to the attention of the anonymous MacArthur jury in 1999, and won him the revered award. The consensus within the local art circle described Xu Bing's calligraphy instead as "mock calligraphy invented for foreigners". It was a narrow analysis that had little to do with specific critical discourse but neatly negated Xu Bing's conceptual writing. In spite of his desire to reach the people, in his own country, the masses were far from being on the same page as the artist. Ironically, too, the sharp reaction of the art community in Kunming echoed Xu Bing's entry into the contemporary art world in China in 1988: when *Book from the Sky* was shown at the China Art Gallery. With the exception of a handful of young artists excited by what they saw, Xu Bing was censured from all quarters, his work excoriated as a pseudo-intellectual attack on high art.

Xu Bing was born in Chongqing, Sichuan province, in February 1955. The Korean War, which concluded in July 1953, was still fresh in the collective memory. The North Korean victory, aided by the Chinese army, vanquished US troops, imposing an unimagined defeat of American forces, and thus continued to feature in national propaganda, richly praising the heroes and martyrs it spawned. The People's Republic was a youthful five-and-a-half years old, and the ship of State, crewed by the masses, was still powered by the wave of joyful thanks that helmsman Mao Zedong had unleashed when the PRC was born in October 1949. This force of emotion would continue as he steered the people out of the abyss towards a better life—although as the 1960s dawned, the

4. Similar accusations were levied against Huang Yongping and Chen Zhen in Paris, Gu Wenda in New York and the nomadic Cai Guoqiang, these being the most successful—Huang Yongping represented France at the 48th Venice Biennale in 1999.

people found themselves plunging into quite another fire. On February 27, 1956, Mao instigated a campaign titled Let One Hundred Flowers Bloom, and a Hundred Schools of Thought Contend, which by June had backfired against the flowers—intellectuals who voiced their thoughts—blowing many right off their stalks.

The mid-1950s was also a time of joyous unity with the USSR. Touted as China's benevolent big brother, the Soviets were accorded thunderous praise:

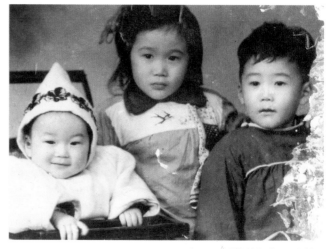

With his brother and sister, Chongqing, 1956
courtesy the artist

> The superiority of the socialist system has become apparent in every field. Not long ago, the Soviet Union made its first inter-continental ballistic missile, and recently it has successfully launched the first and second artificial earth satellites, opening the way for human flights to the planets and the conquest of outer space. ... This outstanding contribution of Soviet science has thrown into the shade the scientific achievements of the most advanced capitalist countries and dismayed the imperialist ... Today ... we pay our most profound respects to the Soviet scientists, the entire Soviet people and the Soviet Communist Party, which is successfully leading towards a Communist society.[5]

Celebrations were cut short when, in the late 1950s, Mao began promoting his own brand of Communism, and by 1963 the brotherhood between the two vast nations had been acrimoniously rescinded. The impact of these events would reverberate through the next three decades, dramatically altering life within the PRC.

Xu Bing's parents originally hailed from Zhejiang province: his mother, Yang Shiying, from Sanmen, and his father, Xu Huaming, from Wenling. They met in Shanghai where they had both been sent to study. Xu Huaming was enrolled at the Shanghai Painting Institute (Shanghai Meizhuan); Yang Shiying was training to be a teacher. Neither completed their course: Xu Bing's father was actively involved in underground communist activities, and was a protagonist of the 1946 student movement. The Shanghai Painting Institute, then a Nationalist-run school, was swift in cleansing itself of all communist elements. Xu Huaming was forced to flee Shanghai, and with its gathering of communist believers, Chongqing was the safest refuge. Here, Xu Huaming found a job with the United Front Work Department (UFWD)[6] to which he dedicated himself for the next ten years. A model worker, in 1956 at the UFWD's prompting, he was accepted at

5. Chou Yang, "The October Revolution and the Task of Building a Socialist Culture", *Chinese Literature Magazine*, January/February 1958, p. 123.
6. United Front Work Department (Tongzhan Bu) looked after democratic parties, which were political parties co-operative with the Communist Party of China (CPC) and, in 1949, was placed under CPC control.
7. Mao Dun, "The Key Problems in Art and Literature", *Chinese Literature Magazine*, November/December 1956, p. 228.

the Institute of Foreign Affairs in Beijing. After graduation, he was assigned a teaching job in the history department of Beijing University. At the end of 1956, Yang Shiying finally joined him, bringing their three children—Xu Bing's elder brother and sister and Xu Bing, who was one-and-a-half years old.

The family's arrival at Beijing University coincided with the run-up to the Anti-Rightist campaign spawned by Mao's Hundred Flowers campaign. It would soon affect all aspects of university life. At that moment, Xu Huaming's star was rising at the university, and he was swiftly appointed head of the history department. Yang Shiying was assigned a position in the department of librarian studies, which was of great significance for Xu Bing—a child who developed an obsessive fascination with books. Under Mao, personal careers were commandeered to the collective workforce and people steered towards roles as cogs in the machine. Intellectuals anticipated more: to participate, to have a voice. Almost as an initiation test, the Hundred Flowers campaign homed in on intellectuals who voiced opinions about the better governance of the nation: opinions which resulted in their downfall. The people were relentlessly reminded that: "It is absolutely necessary to publicise the spirit of "Letting flowers of all kinds blossom and diverse schools of thought contend" amongst the broad masses and to guard vigilantly against anything, whether in word or deed, that runs counter to this spirit."[7]

Even as Mao's disdain of intellectuals grew, he knew that for the Party to turn the nation around, it needed smart, well-drilled and ideologically sound helpers. Beijing University was identified for a key role in the strategy: "The education it offered was excellent," Xu Bing recalls. "There was a kindergarten, a primary, middle and high school within the university precinct. As the schools were governed by one streamlined system, the teaching standard in each was high." The system was termed *sanji huojian*, a three-stage rocket meaning "a firm base from which to fire off brave new missiles".

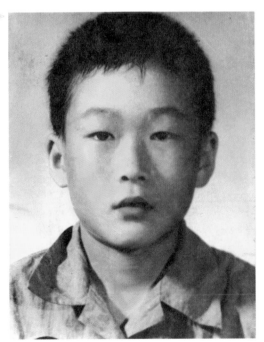

Portrait, 1965 ≫
courtesy the artist

By the time Xu Bing started school in 1962, the majority of the teachers who now taught in the schools had been downgraded from the university faculty during the Anti-Rightist campaign. "They were extremely intelligent people, which was of enormous benefit to the school students; certainly a great help to me." For a naturally scholarly mind such as Xu Bing's, a further advantage of growing up in the university was being surrounded by revered scholars.

His father's friends were amongst the most respected in their chosen fields. They included Zhou Yiliang who wrote *World History*,[8] and Jian Bozan who penned *Chinese History*[9]: both regarded as authoritative texts. Another advantage of being surrounded by scholars was the legacy they passed to Xu Bing: "As a child I had copybooks made directly from the calligraphy of Chen Zhongfu.[10] My finest brushes came from Jian Bozan. My seal carving knives and ink blocks had belonged to Zhao Boxu. These scholars had the finest examples of these objects."

When the Cultural Revolution began these items were categorised as bourgeois. "There wasn't really a problem for me because I used the knives to carve woodblocks of Mao—applying bourgeois accessories to revolutionary ends," he explains. Also, Xu Bing was only eleven years old. The family's offspring now numbered five. Xu Bing was the middle child with an additional younger brother and sister, two and four years his junior respectively. He spent most of his time playing with his brothers, digging for worms to go fishing in former Yuanmingyuan Palace, raising chickens, and keeping birds and crickets. "The environment was so natural, the garden of the emperor, scholarly like an estate, not real countryside." Yet the atmosphere of the immediate environs was sensitive and tensely political, for a number of important political activities were initiated by students at Beijing University. Xu Bing remained there through the first half of the Cultural Revolution, from 1966 to 1972, and as a result experienced the sweeping change and turmoil first hand. It imbued in him memories of events of which he would otherwise have been oblivious, confronting him with a sharp dose of

马克思主义、
列宁主义、
毛泽东思想万岁！

"Long Live Marxism Leninism, and Mao Zedong Thought!"

— 90 —

伟大的、
光荣的、正确
的中国共产党
万岁！

"Long Live the great glorious, righteous Communist Party of China!"

— 91 —

要抓意识
形态领域里的
阶级斗争。

"Develop Ideolog Class Struggle"

reality—a predicament which, in general, he prefers to skirt. "My father's friends were very sensitive to the situation. Whenever he returned from an important meeting they would drop by to analyse the wording of new directives, the specific characters in which decrees had been couched, and deduce reams from the slightest nuance in a phrase."

Xu Bing had only been in school for three and a half years when the Cultural Revolution began in August 1966. Three years later, classes had all but dwindled to a halt and students commandeered to making revolution. "Not long after this, my father was denounced. That was the end of our family's fortune."

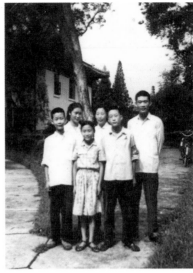

With his family at Beijing University—but missing his father, 1970

courtesy the artist

The *dazibao* which triggered the Cultural Revolution was produced at the university in June 1966 by Nie Yuanzi, widely recorded as being a student, but who was in fact party secretary of the philosophy department.[11] When Mao applauded the sentiments it contained, placing enormous power in the students' hands, the Cultural Revolution was set in motion. From this moment on, any person with an outlook contrary to its tenets was made to see the error of their ways; re-educated through self-criticism and struggle. "My father was labelled a member of the "black gang", a bad person, and sent straight to the university prison"—to solitary confinement known as the "cowshed"—"where he stayed for a very long time." Xu Bing had always been extremely fond of his father. "I couldn't understand what was going on, least of all that my father might be a bad person. Yet, I allowed myself to be convinced that I had bad blood running in my veins, was born with it and thus born bad. It was the way society perceived these things at the time: "If the father is a hero, the son will be brave and true; if the father is a counter-revolutionary, the son will be nothing but a blackguard"."[12] Slogans like these were inscribed on posters pasted everywhere. "When you are young, you don't grasp the implications. Overnight I became bad because my father was bad ... there was no logic to it. The only choice was to appear to change yourself and prove that you were good, which meant carrying out all work with abundant enthusiasm and devotion." It could also be done proactively by working to become a model Red Guard, but even if an individual was determined it was almost impossible if his or her family background was bad, unless they first denounced and

8. *Shijie Tongshi* (世界通史).

9. *Zhongguo Tongshi* (中国通史).

10. Chen Zhongfu, usually known as Chen Duxiu, founder of Communist Party of China, was a person of excellent integrity and great scholar on history, literature, philology and art theory, whose major work is *Duxiu Wen Cun* (Collected Works of Duxiu).

11. Nie Yuanzi put up a poster—"My Poster" (*wo de yi zhang dazibao*)—denouncing the heads of the university (Lu Ping, Song Shuo and Peng Peiyun), and asserting that they were "suppressing the mass movement". It is suggested that Nie Yuanzi did not have such "foresight" to reach this conclusion and to initiate such an act herself, but that Jiang Qing's associate Kang Sheng had given Nie information pertaining to the struggle between Mao and his opposition. In early August, Mao indicated support of Nie's statements.

12. *you qi fu bi you qi zi* (有其父必有其子)

disowned their offending family, which only the most desperate or committed person could bring themselves to do. In 1969, when his father was denounced, Xu Bing was fourteen years old. "We were subject to a lot of pressure; other kids bullied and abused us. Our family had been of good standing in the community. Our home was large and we lived comfortably; we had an ayi[13] and were one of the first households to have a private telephone." All of which changed with the Cultural Revolution. "When my father was thrown in the cowshed, my mother had to undergo re-education, so she wasn't allowed home either. My father's salary was cut and our staple rations drastically reduced. Our home was divided up, the rooms reassigned to workers. We were told that only we were to blame for our suffering!"

Xu Bing's deepest impression was of the demonstrations and denunciations that took place in the street: "Of seeing my father beaten down and paraded with other "black gang" people. Once I was with friends when in a great commotion on the road ahead of us, we saw shouting people marching with banners, and with a big crowd following behind. My friends thought it was terribly exciting. The first "black gang" member I saw was my father. I couldn't bear to look. He had been made to wear an enormous pair of shoes, which weighed him down so that he almost had to be dragged along. None of my friends knew it was my father; in the state he was in he was hardly recognisable."

Even in the early 2000s, Xu Huaming was still remembered fondly at Beijing University. It is evidence that his situation was not as grave as it might have been. "If it had not been for his character he would have been subject to real atrocities. As it was, the Red Guards were relatively lenient." Subsequently rehabilitated, Xu Huaming returned to work in 1976 following Mao's death. His health never entirely recovered, and succumbed to cancer in 1989.

At the doorway to his village home, 1975
courtesy the artist

Enveloped in the chaos of another moment of socio-political upheaval as repercussions of the student demonstrations reverberated through Beijing, Xu Bing mourned the loss of his mentor and role model.

After a troubled and tumultuous start to his teenage life against the background of the Cultural Revolution, in 1974, at the age of nineteen, Xu Bing was sent down to the countryside, to Huapen in Yanqing County, a remote mountain region on the border between Beijing and Hebei. As part of the educated youth that was required to learn from the peasants, Xu Bing was expected to

13. A maid or home help.

do "every kind of farm work imaginable". Many found the hardships of physical labour distressingly hard to bear, but for Xu Bing it was a vacation from the mental anguish he had endured at Beijing University. The tiny village was home to just thirty-nine families. The group of educated youth to which Xu Bing had been assigned comprised three girls and two boys, all from Beijing University. They became the fortieth household—an inauspicious number in China, where four is the equivalent of the number thirteen in western culture. In the first years of re-education, the government gave money to the peasant communes towards the cost of providing housing for the students, who had to earn their keep. "The peasants in Huapen were so poor they had divided the money between them and ignored the issue of housing. We were assigned the pig house—at least, from spring to autumn the pigs stayed in pens outside—which didn't even have a door. Dust blew in all the time, there were mouse holes everywhere. In winter it was so cold that even potatoes and corn [their staple foodstuffs] froze." In circumstances Xu Bing describes as dire, the five cooked when they could—for there was little coal, and almost no kindling—on the stove that the peasants used to make pig food. The cold was slightly alleviated by the warmth from a pipe that ran from the stove under the mud bed—a *kang*, which was simply a raised platform with a fire placed underneath around which all family activities were centred in the winter months. "There was nothing we could do other than tough it out. I wore a sheepskin vest permanently but it offered little in the way of insulation."

Xu Bing was to spend almost three years in Huapen. In spite of the physical hardship, his memory of his time there is surprisingly positive: "... in the way that my impression of the Cultural Revolution was "good" for being at Beijing University, meaning that I was able to learn and experience many things that others never saw, however bad."

Xu Bing felt comfortable in the seclusion of the mountain village, as he had done in the shelter of Beijing University prior to the political upheaval. Simple rural life suited his character. "That's not to say it wasn't exhausting—the physical exertion was unbelievable—but at least I was not required to think too much. My greatest relief was that I was not constantly reminded of my political background. The peasants didn't care about that. If you worked well and respected the people they would be good to you. I liked their simple way of life. The countryside brought me in touch with nature and allowed me to understand what China was really about: the struggle to survive on the land." Outside of the major cities in China in the early 2000s, almost seventy per cent of the population was still classified

as rural farmers. "It showed me the degree of privation and poverty the majority of the population endured. And, to my amazement, the extent to which the Communist Party sought to manipulate a group of people who were living an unenviable way of life governed by the punishing daily tasks of farming."

Hebei province almost entirely surrounds Beijing: it is the equivalent of the Home Counties around London, or the relationship between New Jersey and New York. It is an indication of the stilted development across the greater part of the People's Republic at that time that Xu Bing could refer to a place so close to the capital as remote and backward. The peculiarities of the vernacular language used by the Huapen people made an especial impression: Xu Bing can cite numerous words that have retained a similarity to their Tang-dynasty origin. Spoken language enjoyed prominence over the written character and against shamanist superstitions, characters acquired a multi-layered mysticism, in particular those characters invoked at festivities and celebrations. It was the peasants' practice to amalgamate the four characters that typically formed a phrase into one emphatic unit. "The region of Yanqing county had profound cultural traditions, tied to specific words [that were pasted either side of the main door when someone died, was born or married]." One family in the village was entrusted with preserving a copy sheet, which would be passed down from generation to generation. It was a task accepted as a ritual, and with little broader comprehension of what was actually embodied by the individual characters. "I couldn't read the characters," Xu Bing reveals, "they were more like talisman." And all the more fascinating for it: they demonstrated a level of creative invention that impressed Xu Bing.

Xu Huaming had set his son a daily calligraphic task from a young age. This involved copying characters from an exemplary poem, rubbing or copybook—mastery of the brush and knowledge of language was the core of a traditional education. Xu Bing took with him to the countryside calligraphic skills he had developed from middle school: the devotion to calligraphy far beyond that which Xu Huaming had envisaged for his son. When formal studies ceased, students were still obliged to participate in the relevant young pioneer activities, and Xu Bing's talent for painting and writing characters was recognised and put to work. "I wrote an enormous number of banners and posters during this time. It seems I was writing characters right up until I arrived at the Central Academy. I could work freehand on a huge scale and still produce characters that were strong, clear and precise. It's hard to say if I had always liked writing calligraphy, or that because I wrote so much I acquired a fascination for words. I certainly had a lot of practice; I was prolific, but that was what revolution required." Being able to write characters well did not mean that Xu Bing's artistic interests lay in pure calligraphy nor tradition. "My dream was to study art at the Central Academy of Fine Arts; because it was the best art school in China."

When universities across the country began to re-open in 1977, the art academies sent school or Party representatives to provinces, counties, towns and cultural palaces nationwide to pinpoint talented students who were deserving of a place. Talented students were first and foremost defined as exemplary revolutionary workers. In terms of art, an actual ability to draw took second place. In the second year of his sojourn in the countryside, Xu Bing's creative skills were tested at Yanqing County Cultural Palace.

He was assigned the task of creating propaganda materials. This exercised his drawing ability in tandem with his political attitude. His main job, however, was to organise the community's literary and cultural activities, which involved producing a blackboard of information, slogans and news for the villagers, and a small newsletter, all printed by hand. "In the countryside almost no one could read, so part of the revolutionary youth's job was to read aloud the news and teach characters." It was Xu Bing's nature to take these tasks seriously. "We were a good group. We worked hard, promoting the required ideas clearly in a hand-produced newsletter." Their execution of this newsletter won high praise from commune leaders and was eventually brought to the attention of Liu Chunhua, then head of the Ministry of Culture, and Hao Ran, a recognised writer. They undertook a trip to Huapen to see the five students' commendable work for themselves. From this time on, Xu Bing was singled out for special assignments. In tandem with a campaign to Beat Down Deng Xiaoping (1976) he produced a print, which propelled him to a position of even greater admiration. It was a standard assignment for the times, but one to which Xu Bing brought masterful technique rather than ideological vision, although, as was his forte, the timbre of the message matched the mood of the times. The print was selected for a regional exhibition and caused such a stir that "I was asked to redo it on a grander scale for a national exhibition."

It was in Beijing, working on the task at the Central Academy, that Xu Bing was first made aware of the fine impression he had made in relevant circles. "One day I saw Wu Xiaochang"—a teacher who would later be responsible for selecting suitable candidates for the academy—"and asked what course of action I might take to gain admission. He told me if I worked hard in the countryside, I would have a chance. I remember that he used my name and that I wondered how he knew it. Later, I discovered that It was because of my anti-Deng print."

Back in Huapen, Xu Bing became fixated upon how to prepare for the day a selection committee from the academy would come. In September 1976 Mao died and the Cultural Revolution came to an end. Shortly after, towards the end of the year, the academy's selection committee made its way to Huapen, arriving only after representatives from many other schools had passed through and selected students. By this time, against the new political situation, Xu Bing had almost given up hope, and took his parents' advice to opt for the first opportunity he was offered to leave the countryside: "The situation seemed hopeless, so when representatives from Beijing Film School arrived I accepted their offer. My dossier was immediately sent to their administrative offices."

Almost the next day representatives from the academy arrived. "They accepted my application, but by the time I received subsequent notification of the date for the entrance examination, the day was almost upon me. The only way to leave the village was on foot, and to try and hitch a ride as I got nearer the city." It took Xu Bing thirty-six hours to reach Beijing. After the examination, he was told to go home and wait. This time it was a confident wait supported by a quiet conviction. Having produced numerous prints and drawings in the countryside, "When I saw the other exam works, I knew I would get in because my works were so much better than anything anyone else had done." However, it took several months before his personal dossier could be retrieved from Beijing

Film Academy and transferred to the Central Academy of Fine Arts—in March 1977. Then ensued almost six months during which, due to the turmoil caused by the arrest of the Gang of Four, the first students were unable to do much of anything. The sense of urgency and frustration was compounded in September 1977 by the arrival of the next year's intake.

Woodblock prints produced in memory of his time in Huapen, late 1970s

Xu Bing was placed in the printmaking department; not by choice, for he initially wanted to study oil painting. "It wasn't that I didn't like printmaking, more that I felt ordinary people viewed prints as germane; the functional illustrations of propaganda. Oil painting was held in higher esteem." However, the printmaking department faced a severe lack of teachers and was thus allowed first choice of the new student intake, which it intended to groom for the faculty. The departmental heads were determined to have Xu Bing and, after he graduated in 1981, they took pride in retaining him as a teacher.

The early 1980s saw the emergence of Scar Art, as those art students who had done their time in the countryside, attempted to explore their experience in paint, mitigated by the genuine spirit of idealism with which they had left home. The countryside possessed a certain beauty—it was certainly cleaner and more orderly than in the early 2000s, following two decades of rabidly ruthless advance. Equally, there were few rich farmers that could be compared to the landowners of Europe and North America. But just as Marie-Antoinette imagined playing with fluffy sheep was farming, China's earnest urban youth perceived the countryside to be fresh air, rosy health and surroundings resplendent with the poetry of traditional *shan-shui* (ink—literally mountain-water—painting) landscapes. What they found when they arrived was poverty and hardship beyond their wildest imaginings, and a near crippling workload that began well before dawn and ended at dusk. The majority of students who subsequently elected to deal with the problems in painting—in particular, the artists of the Sichuan School—did so in an illustrative fashion whilst apparently remaining within the desired bounds of officially proscribed creation. Within a short period of time, such representations became increasingly banal and repetitive.

From the start of Xu Bing's course, and in spite of the number of intimate woodblock prints he produced on a detailed, miniature scale, Xu Bing was little inclined to reveal personal emotion. His experience was hardly different from—and perhaps even harder than some—others of his generation, but he clearly had no interest in mapping out emotions in visual form. With hindsight, one can see he was already doing something quite different from the artists around him. That something was discernible in both the aura of the work and in his approach, of an emotionless, cerebral kind that would reach a pinnacle in the work produced by Geng Jianyi and Zhang Peili between 1984 and 1987. Meanwhile, preserving a sheltered path in Beijing, Xu Bing put his initial reluctance towards printmaking aside, and conscientiously applied himself to exploring the woodblock technique.

Xu Bing was greatly influenced by Gu Yuan (1919–1996), a professor at the academy and one of the leading printmakers of the revolutionary Yan'an school, who devoted his art to themes of real life and labour. For Xu Bing, this focus inspired hundreds of individual works. Following almost thirty years of socialist propaganda art, Xu Bing's tiny prints presented simple responses to a real, physical experience of life within Huapen's peasant community. He depicted the houses, simple items of furniture, collections of

odds and ends, the utensils they used, and quaint vistas of the local environment. The incised lines are extraordinarily concise and reflect absolute confidence in their precision. Texture is given profound depth through an exceptional range of density and mark. In Xu Bing's hand, the knife was capable of the subtleties of a lead pencil. The images dovetailed seamlessly with the healthy and untainted vision of socialist existence that had long been propagated, and they were seized upon by the establishment, exhibited and published widely. Equally, they drew an overwhelmingly positive reaction from within the art circles. "My woodcuts were a record of an absolute reality that said a lot about me too: that I could be moved by such simple things is the best expression of me."

The sweet, rosy intimacy of the prints is surprising, especially against the base austerity Xu Bing admits to having endured in the country-side; he visibly flinches at the recollection of freezing mornings and frozen vegetables at mealtimes. Contrary to their appearance, these prints are extraordinarily innovative for their time. To non-Chinese viewers or younger generations of Chinese

people, they appear steeped in a simplistic folk tradition, tempered with the styles developed at Yan'an. Yet, the strong lines in the prints also echo the positive/negative contrast of line and space in Chinese paper-cuts. Key is the subject matter he chose, which eschewed the prevailing ideology, even where it appeared to eulogise life in the country as wholly idyllic. The focus on landscape or objects at the expense of people suggests an almost bourgeois sensibility. These were not topics that had been taken for art, even by the Yan'an woodcutters who so keenly illustrated the hardships of the poor. The prints are constructed of a multitude of rhythmic abstract shapes, some formed in the manner of complex characters, enclosed within a clearly defined boundary line. They are almost geometric in places as circles and squares enfold courtyards, fields and activities. To see many together—as reproduced in the one small book published officially by Hunan Fine Arts Press in 1984—invokes a strong aroma of the loneliness and isolation present in many paintings by van Gogh: Xu Bing, too, is always outside the scene, never part of the community, of the work party, of the household—a sense reinforced by the aerial perspective.

The early prints impart information about two crucial aspects of Xu Bing's character: firstly, as one would imagine from viewing the images, he liked being in the countryside. He was not an exemplary young pioneer, nor did he imagine himself as a martyr to a cause. Rather, he desired to escape the negative traits of social advancement as guided by an inflexible political dogma, especially where it was wielded against his family. No amount of rural adversity could seem worse than life as it had evolved within the exuberantly politically correct regime at Beijing University. Secondly, this was the first unfamiliar place Xu Bing turned into a comfort zone, and embraced as a sanctuary, finding peace and composure amongst people he did not know, and with whom he could scarcely communicate—just as he would in America. As fellow émigré Gu Wenda commented wryly in 1990: "Xu Bing is not much good at talking, but he's fluent in body language." Earnest and serious from childhood, Xu Bing's creative preferences lie in precision and craft. Frivolity has no appeal. This explains how a person of such Chinese sensibilities as Xu Bing could settle in New York, a place where—before he began to win major international art awards—he could be blissfully anonymous, focusing on his art to the exclusion of all else. Meanwhile, back in the early 1980s, dividing his time between teaching and post-graduate studies, Xu Bing was promoted as the academy's golden boy, a model artist whose written word—"On How My Personal Experience Inspires My Work"—was made required reading for all students going on field trips to the countryside to sketch from life.

Gu Yuan did not live long enough to provide his impressions of Xu Bing at the academy. Fortunately Wu Biduan, born in 1926, and also one of the Yan'an-educated printmakers, did. Before retiring in 1997, he taught at the Central Academy of Fine Arts: "I didn't teach Xu Bing in the beginning but I knew of him. My earliest impression was that every term this student won an award; always first, never second. He was known to everyone in the academy as a realist who drew and carved extremely well, not good in the ordinary sense but exceptional."

He claims that it was when Xu Bing embarked upon post-graduate studies that "he started to deviate". The choice of the word "deviate" illustrates the relativity of language that Xu Bing would seek to illustrate in just a few years time. What Wu Biduan read as deviation from conventional styles of academic realism—the printmakers from the Yan'an tradition owed much to German Expressionist Käthe Kollwitz—is, to more enlightened minds, the necessary eccentricity of an artistic mind; such as in the sketched impressions of watermarks on walls and the abstract ripples of cloth observed by Leonardo da Vinci. Xu Bing began to make prints of stones, pebbles from the riverbank, which he wrapped in string, entwined in rope, and smeared with clods of silt. On one occasion he even used a truck tire to effect a print not unlike that produced by Robert Rauschenberg.[14] Xu Bing's goal was to explore the surface and texture of pure substances. "The works were excellent in the accuracy of the representation," Wu Biduan recalls, "but the faculty swiftly reacted against the approach. He had apparently been devoted to socialist expression and then suddenly started off on a peculiar tangent. Although I didn't openly support him, I couldn't negate what he was doing either. I appreciated that he had to explore his own ideas."

Those who owned positions of power at the academy at this time were entirely products of the Cultural Revolution, victims as well as disciples. They had been indoctrinated to believe that art should be content-based. Xu Bing's new departure clearly left content behind. On this count alone, his approach was deemed an unsuitable pursuit for a post-graduate student. Of particular contention was a series exploring texture, which took as its focus sections of earth, not as a landscape with river, mountain and trees, for Xu Bing randomly selected a piece of land marked with the stalks of maize where it had

14. In collaboration with John Cage, in 1963, and one that Xu Bing knew of following Robert Rauschenberg's solo exhibition at the China Art Gallery in 1985.

been harvested, and viewed from an aerial perspective as in his Yanqing prints. Titled *Five Series of Repetitions*, the work recorded the process of producing the print, First, Xu Bing carved part of a block and took an impression on paper. Then he carved another portion and made another print. Ultimately, each print reveals the changing features of a block as an artist puts it under the knife, and how an image takes form. In one way, *Five Series of Repetitions* alludes to film: by being mounted together in sequence, the prints form a frame-by-frame sequence of change. Furthermore, the content of the print focuses on the detail of images and does not set out to describe a scene, which Xu Bing saw as similar to a roving lens, homing in on close-ups that become abstract in quality. *Five Series of Repetitions* made faculty members distinctly uncomfortable. To them process was taken for granted and certainly not a fit substitute for content. Nonetheless, after completing his post-graduate studies, Xu Bing was retained as a teacher again; although, "whenever I was scheduled to give a talk or a seminar, the head of department would remind me to say as little as possible, and not to stray from my brief."

Undaunted, instead of conforming to the regulations and insisting that students draw the objects stipulated, Xu Bing brought large sections of tree root to the studio. Understating the consternation that this drew, Wu Biduan remarked: "This suggested he was moving away from the set academic curricula." The palpable nervousness underlying the comment reflects the salient concern with which the State administration viewed the insurgent nature of modern non-Chinese ideas and practices. Who could predict where would it end? It was already visibly changing the face of Chinese culture: "That I began to make avant-garde art was a direct result of the cultural atmosphere as China opened up. In the 1970s, all people were the same. There was no real difference in education levels. All young workers had grown up in a politically sensitive environment and were full of ideas and social theories. Those of us who had been in the countryside were much slower and more ignorant of politics. I often attended the gatherings of the Stars artists"—poetry readings in Taoranting Park, and activities at Democracy Wall—"but I didn't actively participate. I was too numb. It wasn't that I feared the consequences. I just didn't have a broad perspective of the scene or where the future might lie. In truth I envied them. They had ideas. They did things. They were heroes. I merely made art. I had become obsessed with finding new approaches to printmaking. We desperately needed to move on from the absolute conventions of academic style. I wanted to be the one to initiate this."

An exhibition of oil paintings and prints from North Korea, held at the China Art Gallery in 1984, provided the catalyst for change. Pivoted on a glowingly radiant Socialist Realism, the artworks were little more than peons to national advance and its precipitator Kim Il Sung. "It was like looking in a mirror that reflected the cultural situation in China, pulling the narrow outlook of our approach to art into sharp focus. Such contrived realism seemed grossly stupid and naive. Proscribed technique and attitudes were suffocating the cultural environment. There had to be other approaches. I knew I wanted to make new art. But what was new art? It wasn't clear. After all, I was a worker/peasant/soldier student: I wasn't supposed to think for myself."

Carved block for *Book from the Sky*, ready to print, 1987

Layout of printing block from
Book from the Sky

Against the adverse reactions to his post-graduate experiments, Xu Bing read a multitude of books and attended innumerable aesthetic discussions, lectures and salons. All these were new to China. "I was most interested in what people were thinking, like Gao Minglu, Zhou Yan, and Wang Mingxian—people involved in art theory." Both the discussions and the experiments paved the way for his monumental avant-garde woodblock print *Book from the Sky*.[15] After long and considered contemplation, Xu Bing retreated from the scene. In the face of on-going derision of his experiments and his approach to teaching, he began to spend an increasing amount of time contemplating the carving of an immense woodblock work whilst locked away in a tiny room that he called his studio. The State's fears of the incendiary language of modern art were soon to be demonstrated by the widespread denunciation of the resulting work, for *Book from the Sky* was no ordinary print. The blocks—about two thousand of them by the time the work was first exhibited in 1988 at the China Art Gallery—had been corralled into a mammoth classical book, the text of which was formed by the two thousand mis-composed characters, each of which Xu Bing had individually conceived and carved himself: "The idea formed slowly. It required a great deal of research. I read everything I could about calligraphy, and then about the history of books. I spent an enormous length of time in the library at Beijing University studying ancient characters, calligraphic styles and carving techniques. Then in 1987, I began carving. I would first write the character onto a block—backwards—to see what it would look like—in a mirror. Only

15. Also initially titled and translated as *A Mirror in which to Analyse the World* after the artist's revelatory experience at the North Korean art show.

when I felt it was perfect did I begin carving. Having begun with a desire to make characters I quickly decided a book would be more interesting. I had no idea how long it would take. Once I began carving I couldn't stop and, because I liked carving, I took my time over it. Initially, I carved for one year, every day just eat, sleep and carve. People thought I worked too hard but they didn't know how much I enjoyed being by myself. I found comfort being in my small space with the door locked, away from external activities and contact with people. I felt completely at peace. After reading so many books and listening to so much talk, my mind was a mess. The act of carving was like meditation, no thought needed, just the motion of the hand, the technique of the craft."

Xu Bing had carved seals (chops) as a middle-school student. His training in the printmaking department had honed his technique, yet, this kind of block carving required different skills that were more traditional. Hence the research Xu Bing deemed necessary. When the work was first exhibited in October 1988—in conjunction with a solo exhibition of works by fellow academy professor Lü Shengzhong—*Book from the Sky* was only half completed. Nor was it finished for the "China/Avant Garde" exhibition in February 1989. In 1990, the final number of characters totalled four thousand. In spite of the obvious precision and calligraphic skills with which Xu Bing had executed his book, *Book from the Sky* provoked consternation within the official art world. It was perceived as a blatant effrontery to classical culture by officialdom's own golden boy. This fact alone provoked debate beyond art circles and within the masses media mouthpieces:

from *Book from the Sky*

"When Xu Bing began this work no one suspected what he was doing," Wu Biduan recounts. "Many students were looking to western art but Xu Bing was different. He quietly carved all these characters, each one composed by himself, and not a single one recognisable. And he claimed to be building upon the history and methodology of printmaking in China."

There was no question that the indefatigable carving of so many characters was a piece of brilliant and creative ingenuity. Even the manner in which Xu Bing chose to display the work was entirely new; draped across the ceiling in giddily flowing reams, the monumental scale of which was awe-inspiring. "It had enormous strength," Wu Biduan recalls. "But critics swiftly opposed it, as did individual professors and faculty staff at the academy."

This ought not to have come as a surprise. Art had never before been exhibited in China in the way Xu Bing adopted. Ordinary people gazed upon it and felt compelled to ask: What exactly is he doing? What does it mean? "It was impossible to explain what Xu Bing was doing in lay terms," Wu Biduan ventures. "It was a concept, an idea." Meanwhile, in art circles the question asked was: Why do you want to do this? "What pained the academicians most was that Xu Bing had been a model student: the model for realism in the school. Why else did he get an award every term?," Wu Biduan asks. "His transition was not acceptable."

Initially, Xu Bing produced the individual volumes of books himself, from the setting of each panel to the bindings. As the number of characters grew he enlisted the help of a professional bookbinder. But it was not the quality of his presentation that was at issue with his audience. *Book from the Sky* was read as a mockery of the mystical and munificent tradition of language in the Middle Kingdom, the intricate and elitist qualities of the classical tongue. Although it was not immediately apparent to native speakers of Mandarin in Mainland China, whose general levels of education had been held down by Mao's doctrines and policies. When it was unmasked as being "fake", Xu Bing was deemed guilty of making people appear foolish, slapping their face in the mud of their own ignorance. It was thus read as a reminder to Mainland officials and the general audience—which was huge at the time—of their limited levels of education, for all initially perceived Xu Bing's text to be real.

Book from the Sky came into being at the exact moment that Xu Bing began to feel ambivalent towards all the discussions and the books he was reading: this was his nemesis. "It occurred to me that my generation had an abnormal relationship with books and

culture," he offers. "In my early childhood, at the university library, and surrounded by my father's library, I spent hours looking at books—I was fascinated by bindings even then—and then when the Cultural Revolution began books disappeared." During this time, there was but a handful of fiction and non-fiction titles deemed acceptable for the people to read. When the Cultural Revolution ended and with the culture craze of the late 1980s—the *wenhua re*—hundreds of books flooded in, engendering myriad discussions and debates. "It was then that I suddenly became frustrated with books. I was like a starving person who gorges themselves at the first opportunity, and then feels bloated and sick as a result. This extreme sense of discomfort turned me off the cultural discussion. It seemed that people were talking and talking but still weren't clear about anything. We expected books to spell out the world clearly, but the contents only confused things further. *Book from the Sky* was my means of escape, absorbing hours of time carving meaningless words ... "

It was certainly a time of conflicting ideals and impulses. In the academies, students were embracing all manner of modern western styles and genres. In *Book from the Sky* Xu Bing successfully injected a modern sensibility into a classical convention—the book. The result shocked people, but at the same time, ordinary people found it hard to articulate exactly what it was that bothered them about the work. Younger people were more impressed and there was an underground feel to the appreciation that did not work entirely in Xu Bing's favour. *Book from the Sky* was criticised because it was clearly a serious work. There was nothing casual or reckless about the way it had been put together. One critic even pronounced it too academic, too perfect, deciding that "avant-garde art ought to be more direct, dynamic and impulsive." "I wanted people to look at my book and find it formal, academic, and serious. I designed every detail of every chapter to look serious, from the printing to the binding. I wanted people to feel about it as they do magnificent editions of the Bible." On the surface it appeared to

A volume from Book from the Sky

conform to a revered and respected form of presenting written discourse, which compelled the authorities to criticise it all the more harshly, because where all it contained was meaningless, no repository of knowledge could exist. How, critics asked, could there be art without content? In fact, the nature of the work was less of an issue than the rapid degrees of cultural change, which the State recognised it no longer directed. "Officials decided that if my works had no meaning then I was deliberately not saying anything, which made them uncomfortable. Their argument was that meaninglessness was the biggest problem of modern art as they saw it. When I entered the Central Academy the avant-garde had yet to emerge. I was greatly respected by officials: even a jury member for the national art exhibition, a position I held up to the time I exhibited *Book from the Sky*—that "bad work by a model teacher". Of course, the fact that it had no meaning made it ridiculous, humorous even, like black humour. I came to feel that I'd devoted four years just to make one joke: now that is humorous."

In the aftermath of June 4, criticism acquired a political tone as the issue of protecting Chinese ideology from damaging external pollutants gained urgency for the State against the example of the student demonstration. Pre-June 4, the best of the reactions pronounced *Book from the Sky* a fine example of avant-garde art developed out of Chinese traditional culture, as a Chinese way of resolving a cultural problem, for there was almost no discernible trace of western art in it. "That is why it had such a great impact on the latter part of the New Art Movement," Xu Bing asserts. "The influence of western art had become overwhelming. Artists had not found a way to push their art beyond it. *Book from the Sky* showed that there could be a Chinese way to move forward." But then came June 4, as a result of which all new ideas were per force denounced as having led the students' idealism astray. Just over a year later, in July 1990, Xu Bing would leave China, and not until 2002 would Mainland audiences have the chance to see his work on native soil again. In mid-2003 a sample volume of *Book from the Sky* and some of the original blocks were exhibited at the China Art Gallery when it reopened following extensive refurbishment. By this time, society had advanced the most delicate of steps forward and no storm of protest or controversy arose. But perhaps that is worse, for it indicates that the viewing public—the educated at least, and not the peasants the new Long Marchers encountered on their journey—has become visually numb. Unlike the first audiences in 1988, are present-day ones unwilling to admit they couldn't read the text? Have the classics really been destroyed as Mao intended: did the twenty-first century audience not even recognise the manipulations of characters enough to prompt them to question it?

Prior to Xu Bing's departure from China to the US in 1990 there was one work he could not leave without completing. This was *Ghosts Pounding the Walls*, a monumental rubbing of one section of the Great Wall. It was a tough project that required the construction of scaffolding on either side of the wall's steep inclines. "But," as Wu Biduan recalls, "Xu Bing was always happiest with challenging work. And so many young people were so willing to help him."

Xu Bing spent a total of thirteen years at the Central Academy. Although he tried to keep the classroom and his art separate, students knew of his private activities and

were intrigued. His classes were eagerly attended and ran to capacity, hence the large, dedicated crew Xu Bing was able to draw together to produce *Ghosts*. The idea for *Ghosts* predated *Book from the Sky*, arising directly from Xu Bing's experiments with printmaking as a post-graduate student. "I felt print could be expanded upon. Two-dimensional work could be produced using three-dimensional objects. Or even become three-dimensional themselves. Ink rubbing is a traditional Chinese approach to recording surfaces. I decided to bring it into the modern age." The desire to record the physical properties of surface texture and space echoes the approach of contemporary British sculptor Rachel Whiteread in recording the space around an object via immediate contact with its outer skin. "I was interested in putting a real object on paper to preserve its existence and form. A photograph or video image of an object is very different. When people want intimacy they touch or hug to experience each other. A rubbing also results from direct contact with an object, which is why the effect is so strong. I wanted to convey this experience in print."

In the stunned hush following June 4, and in the knowledge that he was soon to depart China for America, Xu Bing decided that a stay by the Great Wall, beyond the city limits, in the countryside, was just what the moment required. "I didn't know when or if I would come back, so it was imperative that I completed *Ghosts*." The actual title was taken from a defamatory article written about *Book from the Sky*,[16] in which its critical author lamented Xu Bing's misguided divergence from the right path to wander like a lost soul in ever-narrowing circles, spiralling in upon himself like a "ghost pounding the wall". A metaphor for a senseless, meaningless act replete with a deal of futility, and which

16. After the showing of *Book from the Sky* as part of "China/Avant Garde" in 1989 in more complete form, Yang Chengyin (a teacher at the Central Academy) published an article in *Cultural News* (*Wenyi Bao*) in which he referred to Xu Bing as a ghost pounding the wall.

paraphrased Chinese academia's attitude towards Modernism. Xu Bing's willingness to see challenging projects through was again confirmed in this monumental gesture that provoked the question: in beauty and art what constitutes futility?

Preparations for *Ghosts* began in March 1990. In May, Xu Bing led a team of twenty assistants to the wall, where they spent twenty-five days making a rubbing that required 15,000 sheets of rice paper and three hundred bottles of ink. Again the critics were dubious. Traditionally, rubbings were taken of remarkable pieces of calligraphy that had been carved on stone stele or incorporated into architecture, or of precious objects. For all its grandeur, the Great Wall was considered crude, and the rubbers—being students from the academy and volunteers—unprofessional. Thus, again within official art circles, this work could have no merit, for like *Book from the Sky*, it totally contravened tradition.

When Xu Bing left China in 1990 it was to take up the position of visiting fellow at the University of Wisconsin-Madison. Reluctant to leave familiar territory, he had already passed up several opportunities to go abroad, but the desire to find a calmer environment in which to pursue his work was increasingly cogent. "I knew it would be hard to survive as a contemporary Chinese artist in America—almost impossible, friends had said. I had no idea what it would be like, other than to try." But Xu Bing was lucky. Against all conventional wisdom, within less than a year he was attending the opening of a large first solo exhibition at the Elvehjem Museum of Art[17] : "Landing this seemed remarkably easy to me at the time." The exhibition was pivotal because it included the magnificent rubbing of the Great Wall incarcerated in *Ghosts*. To 2004, this was the only complete showing of it; other spaces could only accommodate portions, like that shown at the First Guangzhou Triennial, in 2002—though in 2005 it was shown in its entirety in Beijing. To great acclaim, *Ghosts* was displayed alongside *Book from the Sky* and *Five Series of Repetitions*, launching Xu Bing's career in America.

17. "Three Installations by Xu Bing", Elvehjem Museum of Art, University of Madison-Wisconsin, 1991.

Moving abroad marked a new life with a clean slate for Xu Bing, but he did not find peace. The academic art world was enthralled, and a trickle of invitations to exhibit, requests for interviews and lectures, quickly swelled to a torrent—amplified by his successful nomination for the MacAthur Award in 1999. Producing art also took on new complexities. The shift in location had engendered a change in cultural context and introduced Xu Bing to a new realm of artistic discourse defined by unfamiliar theoretical boundaries. "As a child I simply liked drawing, but in America art is definitely not just drawing. This led me to an awareness of cultural problems. Art needs a cultural context: it relates to everything. From the early 1990s many [American] people became interested in China but saw only political problems. I was labelled as Chinese first, and people were less interested in what my art was about than looking at the message they felt I carried from China."

To émigré artists, the issue of being Chinese was both beneficial and detrimental. It aroused fantasies and excitement about China, but did not allow Chinese artists to

≪ Ghosts Pounding the Wall, 1990
Shown as part of the First Guangzhou
Triennial of Contemporary Art,
Guangdong Art Museum, China

forget their place in respect of the American art scene, which they followed rather than led. Actor John Lone once decried (during an interview in Hong Kong in 1991): "We do not want to be thought of as exotic birds in a white man's garden." The sentiments were common to the community of avant-garde artists in China too. It took socio-economic advance within China, and broader coverage of its politics and culture within the more powerful organs of the mass media abroad following the end of the Cold War, to help soften and erode the sharp prejudices that were held. But through the 1990s, notable Chinese artists—and there were few that were considered noteworthy in American eyes—were lumped together. For Xu Bing this meant a "gang of two"; himself and Shanghai-born émigré Gu Wenda. They had not met prior to the summer of 1990, but in one way or another, had been pitted against each other via various exhibitions and critical comparisons. Especially since Gu Wenda, trained as an ink painter at Zhejiang Academy in the early 1980s, had also employed characters as a means of formal expression in his work. In 1991, in Hong Kong, where the work of the two was being exhibited side-by-side, Xu Bing let slip a rare moment of unreserved directness that revealed his frustration: "Gu Wenda still thinks in words, he hasn't gone beyond their meaning. *Book from the Sky* had already eclipsed literal meaning."

From the mid-1980s to the early 1990s, Gu Wenda immersed himself in language—visual and calligraphic—and philosophy. In America—he arrived in 1987—he first became fluent in English, demonstrating an astute understanding of the need to articulate his work in a language with which American (western) people were familiar. Simultaneously, the focus of his art shifted to the tactile substance of materials, such as human hair, redirecting familiar matter to unfamiliar usage. Language was but one element of his work. Xu Bing, on the other hand, who in 1991 was not as beyond literal word play as he implied, remained willingly entrenched in a field he felt had much to offer him. "Words are abused in daily life," he says. "I pluck them out of a quotidian context and rework language as art. Out of this comes an inherent spirituality that transcends the meaning of words as individual entities." This is particularly true of *Book from the Sky*, for since its inception it has taken on the aura of a sacred text.

Though he chose not to consider them thus, Xu Bing did play with literal readings of language in several projects in the early 1990s. These were largely prompted by the difficulties he faced in communicating effectively in America. The first work, *A, B, C, D, E, ...* , was simplistic, beautiful, and imbued with the same degree of black humour he brought to his carving of characters. *A, B, C, D, E, ...* arose from Xu Bing's attempts to grapple with the fundamentals of the English tongue. Problems with pronunciation called to mind the Chinese phonetic approximation of sound—such as are applied to foreigners' names: Smith in Mandarin is enunciated as shh-mi-surh. Out of this evolved a series of carved blocks, like children's learning blocks that have letters embossed upon them. Here, one found only the Chinese characters that approximated them. For example "shee" (c) means west (西) in Mandarin. The "ai" used for "a" means sad

 A, B, C, D, E, ..., 1992 ≫

(哀). "X" required three characters; "ai"-"ke"- (short sound) "surh" (very short sound curtailing the "r"). "I wanted to express different cultural traits, the strange feeling when two cultures meet, but are insensible to the nuances that actually keep them apart."

More than just exploring two cultures meeting, Xu Bing became aware that language evolved within its own specific cultural framework from one generation to the next. Communicating across time was as complex as communicating across cultures, a situation clearly in evidence in China, where a reading of classical language required skills that were no longer at the disposal of the broader, contemporary Mainland populace, but also revealed by the challenge for modern readers of reading *Beowolf* or Chaucerian English. Xu Bing identified the ultimate example in the Bible, the texts of which, through the centuries, have been subject to various politicised re-workings of the earliest translations, and that also—via the language brought to specific translations—embody the ideology of succeeding historical contexts and regimes. In April 1993, he returned to China for the first time since his departure to source materials for his own version of the King James' Bible; a work that is a more profound intervention in language, linguistic inference and taboo than it is usually given credit as being.

Titled *The Post Testament*, the use of "post" immediately places Xu Bing's bible within a post-modern context. This handsome volume was bound in the finest chamois leather, the cover embossed with gold leaf and the opening of its chapters marked by illuminated script. In form it paid homage to the great tradition of bookmaking even as its content subverted readable meaning and the reverence accorded the "good book". Within, the sections of the New Testament were interlaced with texts culled from contemporary literature, income tax declarations and pension schemes. The brutality of the language—New Testament circa the King James era against citations from Brett Easton Ellis' *American Psycho*—together with a commanding authority of tone—the Bible compounded by US State Department tax and public policy rhetoric—confuse, shock, mock and question in one fell swoop. It is not easy reading, but it is not intended to be. In *The Post Testament*, Xu Bing conjoins these elements with the goal of disrupting complacent attitudes towards the lexicon, tone and style in which the world is couched, the vocabulary via which information is conveyed.

The Post-Testament, 1994

Back in New York, Xu Bing took this in another direction with a work titled *Brailliterate*. This was presented as an installation in the form of a reading room filled with multiple copies of just one book: *New World Translation of the Holy Scriptures*, the title of which was printed on the cover in

The Post-Testament, 1994 »

English. Again forestalling easy reading, Xu Bing filled the volumes with texts printed in Braille—texts, which bear no relation to the Holy Scriptures at all. With this work he kept two types of readers—sighted and non-sighted—apart by a divide of ignorance. A sighted reader has no idea that the Braille text is not as that described on the cover, whilst the non-sighted reader is made ignorant of the fact of the contents at their fingertips differing from the title on the cover. These works gave Xu Bing an appetite for harmless deception. His next work—a semi-collaboration with conceptual artist-turned-architect Ai Weiwei, also then living in New York—aligned a text about a known American painter, culled from a magazine, with a group of paintings they found abandoned in Fifth Street—from which the work took its title—near Ai Weiwei's home of the time in the East Village. The magazine article was translated into Chinese and passed to the editor of the Chinese art magazine *World Art* (*Shijie Meishu*, Issue 2, 1994), and duly published alongside other features in that issue. Xu Bing soon expressed disappointment that no one got the joke. Yet, one feels that beyond highlighting the blind acceptance and adoration of all things western that was then current in the Chinese art world, here, Xu Bing really was muddying faces with their owner's ignorance—the charge that had been levied against *Book from the Sky*. The publication of *Fifth Street* in China paralleled *Book from the Sky* being presented to foreign audiences, who were as unfamiliar with the Chinese language as Chinese artists were unfamiliar with the more intricate, or local, currents in western art. Xu Bing demonstrated the absolute faith people have in the system, and its conduits—here the art magazine, taken as a bible on the scene—and the authority of these as a mouthpiece.

The trip home alerted Xu Bing to the changes that had overtaken the Chinese environment in the big cities during his absence through the early 1990s. In early 1994, he decided to test a new avenue of creative process that would have been almost impossible in America. On 22 January, in what was then the Hanmo Art Centre located just behind the Beijing Hotel, he orchestrated the trial run of *A Case of Cultural Transference*, involving two pigs, and a whole lot of language. For the viewers, it was an opportunity to witness an extraordinary event.

In the early 1990s, Hanmo Art Centre served as an alternative exhibition space in a city where any kind of independent exhibition space was rare. Up a flight of exterior steps, a length of bland corridor led to the studio in which Xu Bing's work was to unfold. The whitewashed space covered approximately ten square metres. In the centre a square space had been cordoned off, and looked exactly like a cock-fighting pit on the floor of which a melange of books had been scattered. The cluster of viewers crowded around the perimeter of the pit, which contained a rather disgruntled pig, was understandably apprehensive. Compounding the bizarre nature of the scene, the male pig had clear lines of beautifully formed Roman letters printed over his freshly preened body in rich black ink. Distrustful of the numerous cameras flashing in its direction, the people, and the strange and unfamiliar sounds, the pig step-toed clumsily from corner to corner over the rumpled piles of books, snapping at pages turning as it passed. Chewed pieces of paper were then spat out, presumably part of the metaphor for irreverence towards the written word. Viewers were first amused. Animal rights were clearly not an issue.

Eventually, from the back corner of the room, a section of the iron cordon was opened and a hefty sow lurched into the arena. Scrubbed equally pink, her body was covered with an elegant coat of Chinese characters of the kind Xu Bing had created for *Book from*

the Sky. As she blinked in the spotlight, the male launched himself upon her in a frenzy of instinctive animal attraction. She squealed ferociously, and the sound was profoundly disturbing. The male was oblivious of the crowd whilst the female seemed acutely aware of the eyes upon her. The room became claustrophobic reducing the crowd to a hush as the pigs copulated. Placed within this human context—made sport for a crowd—it was difficult not to project human emotion onto the act taking place. Did the male really experience the satisfaction of climax that he appeared to? Did the sharp line of his mouth succumb to an inane post-coital grin? Climax over, the pigs were led out and the crowd released its breath. The lights came up to reveal the flushed faces of the audience. It seemed Xu Bing had made his point. In nature pigs fuck pigs as the opportunity arises, but what happens when it is made spectacle, inculcating human spectators? In electing to tattoo the Roman alphabet on the male and Chinese characters on the sow, the inference was a comment on dominion and forced subjugation; a reference that meant much within the China context, where people were still bitter about the forced colonisation that had taken place a hundred years before. On one level, with hundreds of books trampled under trotter, the pigs represented the senselessness of the written word as a form of communication under belligerent regimes—in reference to the PRC, culture crushed by ignorant masses. More generally, it was undeniably an apt comment on the march of the brash modern world (the pig) over culture (the books strewn on the floor).

In 1994, Xu Bing was non-committal: "I don't want my works to be too clear" was his only comment at the time. He had yet to acquire the skills of self-promotion that Gu Wenda was so quick to read as necessary abroad, and was somewhat shy of making specific, definitive statements. Why bother when critics do it for you? as he subsequently came to realise. By the late 1990s, he would say that: "The multiple possibilities that works suggest make people view them in different ways. It enriches them." Clearly, context is not always exclusive. More pertinent is the level of cultural sophistication which viewers bring to the experience of looking. In this regard, *Book from the Sky* has been discussed as calligraphy, in terms of philosophy, perception and, of course, art in multiple cultures around the

≪ Xu Bing working with silkworms
at Massachusetts College of Art,
Boston, 1995

world. "The ambiguity that exists in the work allows people to interpret it from almost any angle or in relation to anything. Some might blame that on a Chinese preference for being convoluted, or even just me for avoiding clarity—there is that tendency in my character. But I like different people having different interpretations. It means that I have succeeded in denying the work a single emotive "answer" and made it something everyone can connect with."

Xu Bing's concern to go beyond meaning is critical for an artist who plays with words as art. The challenge is to do so without allowing any hint of personal expression to creep into the work. "One reason I avoid personal sentiments is because strong emotion and formalism are too obvious. Both reply on specific language that is exclusive because it is personal to its creator. Of all my works, only *A Case Study of Cultural Transference* was aimed directly at audience emotions, specifically their attitudes towards the boundaries that demarcate what is accepted as civilised. What you see is not what you expect to see, not what you think it is or should be, rather a distorted concept of Chinese and English. Just as in *Book from the Sky* and *Square Word Calligraphy*, it goes against the visual habits brought to reading and perceiving events."

Xu Bing continued working with animals occasionally. He tethered sheep with a chain of links fashioned from *Square Word* characters. He turned two donkeys into zebras in Guangzhou in 2002, which followed the debut of several piglets dressed up like pandas in New York. His pleasure working with animals derived from their inability to speak and, therefore, being incapable of offering opinions or making demands—although he did once train a parrot to repeat blasphemies against art. The quietest of them all are the silkworms, which he used for several works in the late 1990s. "*Tsan* was really about the nature of the silk worms, and this work is more personal. I like the character of silk worms, their oriental spirit and sensibility. They work hard, spitting out silk diligently, at a regular pace, soundlessly. Their life is analogous to my personality: we both have a clear objective for which we work hard, in silence ... "

Aided by techniques invented by Hangzhou artist Liang Shaoji, Xu Bing cajoles silkworms into laying their eggs on surfaces they usually spurn. Silkworms take 25-30 days from egg to larva, then three days to spin their cocoon. Xu Bing's worms are born onto books, which they then wrap in their silk—once, he even used a computer—then, job well done, they retreat into their cocoons to become the moth nature intended, leaving behind a potent metaphor of the survivalist instinct, in the face of even the most covert manipulation of nature.

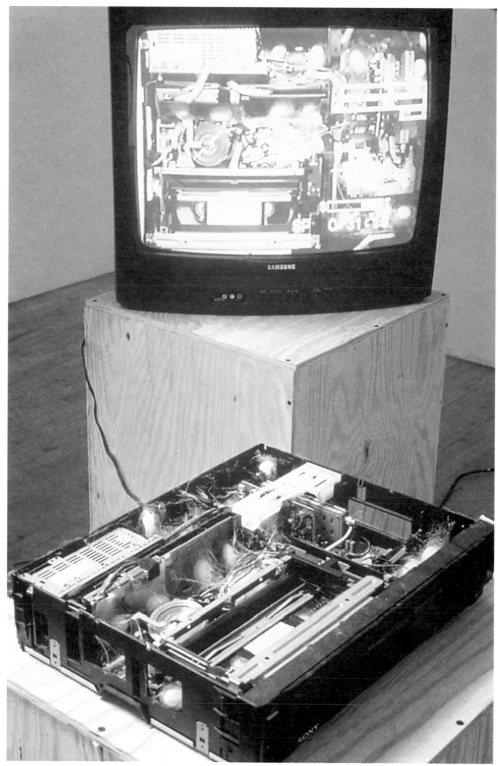

American Silkworm Series: Silkworm VCR, A
1995, at Seattle Art Museum

1994 was in many ways a pivotal year for Xu Bing. As the year came to a close, he embarked upon a course of experimentation that was to result in *Square Word Calligraphy*, by which he was to become most widely known within international art circles. Having captured the imagination of art circles in Beijing with *A Case Study of Cultural Transference*, he revealed to friends a plan for a dictionary. All the definitions were to be written in an invented script—the first version of *Square Word Calligraphy*. As explained at the beginning of this chapter, *Square Word Calligraphy* is a systematic restructuring of the twenty-six letters of the alphabet in the manner of individual radicals used to compose written Chinese characters. From the first, Xu Bing felt it had "enormous potential", which he has repeatedly demonstrated to great effect. The dictionary did not materialise. Instead, the first incarnation of the script was presented in the form of an interactive classroom, as presented on the Long March exhibition of the work, where members of the audience could study *Square Word Calligraphy* with a instructor—recorded on video—and practise in the copybooks provided. In 1996, Xu Bing hooked up with a Japanese software designer to create a programme that would allow audiences to use a standard computer keyboard to write *Square Word Calligraphy* texts. It is an ongoing project—to build a word bank on the scale of a standard dictionary. Where the software programme is cheap and easy to distribute, it proves a perfect vehicle by which art for the people can be achieved. *Square Word Calligraphy* represents a breakthrough in Xu Bing's art. The applications are almost infinite. Museums, publishers and galleries were just as quick to recognise the efficacy of Xu Bing's extraordinary script, engendering hundreds of requests. As former assistant Alexa Olsen commented: "He never turned down a request. He's extremely generous with his time and talent."

Square Word Calligraphy banner for the Museum of Modern Art, New York, 1999

"Promoting *Square Word Calligraphy* is like the large-scale mass literacy campaigns in China shortly after liberation," Xu Bing suggests. "The further my work moves away from concepts, the closer it gets to the real point of art." Xu Bing's promotion campaign includes banners for the Museum of Modern Art, New York, Queensland Art Gallery, Brisbane, and Hong Kong University Press, which had him redesign its logo. *Square Word Calligraphy* permitted him to penetrate private homes in the form of the English translation of a book of Chinese poems. Even restaurants asked him to bless their business. "I am asked to do a lot of calligraphy, just as calligraphers traditionally are. I don't refuse because I want my work to be accepted by society. Art is divorced from most people. My approach is definitely related to my cultural background, to Mao's line on art and literature. It is ironic that the problems facing western modern art made me look back at the ideas Mao had about art and the way he attempted to deal with it." For Xu Bing, hanging a banner outside a museum or creating signage for a public space creates the strange sense of being between two worlds that he inhabits. It was largely for his work with *Square Word Calligraphy* that Xu Bing was granted the MacArthur Award in 1999. "It was only after the press release went out that I discovered what an enormous thing this was." His New York studio was inundated by the press and letters of congratulation. Few came from China. Amazed by the size of the purse, which ran into several hundred thousand dollars, most artists could not unravel the reasons for the high regard in which Xu Bing is held. One reaction, that of Shanghai-based artist and critic Wang Nanming, was unequivocal: "Xu Bing's approach to the creation of *New English Calligraphy* makes increasingly evident his neo-colonialist status as an overseas Chinese artist ... [It] is nothing more than a product packaged as contemporary art ... an empty exercise, in as much as it will never achieve any recognition or acknowledgement within the hierarchy of linguistics. Allowing westerners to use calligraphy brushes to write English calligraphy is nothing more than Chineseness made into a game of sorts. This kind of contrived classicism not only fails to directly address issues in the West, but is also far removed from China's contemporary situation."[18] Wang Nanming, an

18. Wang Nanming, "Why We Should Criticize Xu Bing's New English Calligraphy and Acknowledge Liu Chao's Machine Calligraphy", chinese-art.com, Volume 4, Issue 4, April 2001.

ink painter and calligrapher who has yet to achieve Xu Bing's level of recognition—hampered by exactly the traditional elements that foreign people believe Xu Bing reveals to them—was playing Devil's Advocate. Still, his words encapsulate the same frustration that drove impassioned displays of destruction across Xu Bing's *Square Word Calligraphy* copybooks in Kunming in 2002.

"[The critic] Li Xianting once described Chinese artists working abroad as being spring rolls at a western banquet," Xu Bing recalls. "I don't think this is bad. The work of Chinese artists living abroad does contain a number of Chinese symbols. We have to use these; they are our symbols, and if we can't use these then what can we use? Having lived abroad I know that even good work can't always stand alone. People need to understand the cultural context of an artwork in order to grasp its full implications ... This is a problem. I still feel *Square Word Calligraphy* is my best work. On one hand, in *Book from the Sky* I said about everything I could say. It's funny that it is so popular when it doesn't actually say anything. Having seen it repeatedly through the years, it still appears new in different places, yet it has also become unfamiliar to me. In turn, that unfamiliarity provokes new ideas."

Essentially, what Xu Bing achieves with *Square Word Calligraphy*, and on a par with the legacy of *Book from the Sky*, is a space in which people can discuss ideas about human expression and interaction that are universal, as well as timeless.

Xu Bing always knew he would become an artist: "I was not brilliant at other subjects; anything else just didn't feel right. With art, I had the desire to work at it, and make it perfect." This desire equipped him with the forbearance to work in isolation for protracted periods of time in the course of producing a piece. It makes him obsessive about the way in which his works are displayed, often to the point of dismantling and reconfiguring entire installations at the eleventh hour, and reducing curators and technical staff to a state of

intense, nervous panic. For Xu Bing, works simply don't exist in isolation, unlike an oil painting which can be transported from wall to wall with little detriment to the viewing pleasure it gives. So Xu Bing is always involved, everywhere. This partially accounts for the scholarly disposition he is frequently ascribed. He is contemplative, but he's also ambitious, with a fine propensity for grasping at a concept and bringing it to life. However, here's the conundrum, for in spite of aiming to appeal to ordinary people, his art is rooted in intellectual thought as opposed to gut emotions. "My work hasn't really changed since China. The train of thought remains unbroken because I am much of a loner. Life is the same everywhere for me. I do what I enjoy most, and do it well... This is the pleasure of what I do as an artist."

The reference to being scholarly begins with Xu Bing's concept but extends to the extraordinary refinement of the works, particularly his calligraphy, but including the *Living Word* series, which is his most decorative. Skilful execution automatically commands respect. Whilst the points of critics such as Wang Nanming are not without their logic, criticism pales in the presence of a Xu Bing installation. From *Ghosts Pounding the Walls* to the many manifestations of *Square Word Calligraphy*, and diverse application of actual characters as "written" landscapes, termed "landscripts", the physical scale and magnitude of his skill is stunning. Stark and yet rich, his works turn the minimum of elements into simple, rich forms. For example, the landscripts combine calligraphy with Chinese painting to use the written character that stands for each object in a landscape—a tree is *shu* (树)—to literally "write" out the scene—characters being returned to their original points of inspiration in the physical world.

None have been quite so minimal in their evocation as Xu Bing's prize-winning film of dust, a work was specifically created for the inaugural Artes Mundi art prize in Wales, 2004, for which Xu Bing was short-listed in 2003. Titled *Where Does the Dust Collect Itself?*, the piece comprised an accumulation of dust from the carnage of around 9/11's Ground Zero, blown to an even film across the floor and inscribed with the following line from a Buddhist saying: "As there is nothing from the first, where does the dust collect itself?" Given the materials and the context of the moment—as things began to seriously unravel in Iraq, a direct response to 9/11 that was keeping the tragedy very much alive in American minds—it was not without controversy. A cool unemotional reading might discern a clever strategy for leveraging a specific context: an American tragedy and the empathetic relationship between America and Britain in the aftermath of the terrorist attack. There

Drawings produced while developing the Landscript Series, late 1990s

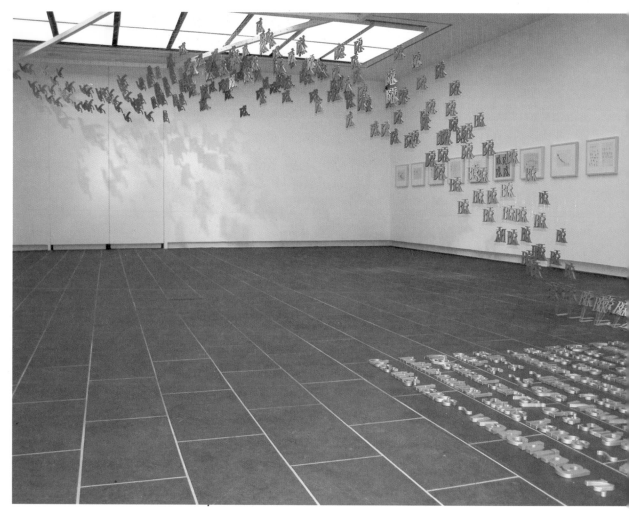

was also the poignant and spiritual element of Zen Buddhism, which is widely followed
in America, and holds an equal cachet for sectors of the British public. Xu Bing
perceived this work from a single perspective, invoking collective memories that he
believed would prompt the public to reflect upon whence violence springs—violence
here being metaphorically referenced by dust. A poetic reading is a questioning of how
hatred gathers—like a coating of dust—in the heart and minds of people, and which,
by obscuring the original nature of a loving heart or an objective mind, leads to acts
of violence, terrorism and war. Equally, one might ask if the Buddhist phrase doesn't
call attention to an innate aggression in mankind which can only be controlled by
the social mores of a civil, democratic society. Buddhism after all has to be practised;
individuals have to work at being good. Xu Bing is not a practising Buddhist, yet both
his appropriation of the saying and the use of 9/11 dust, were intended to question

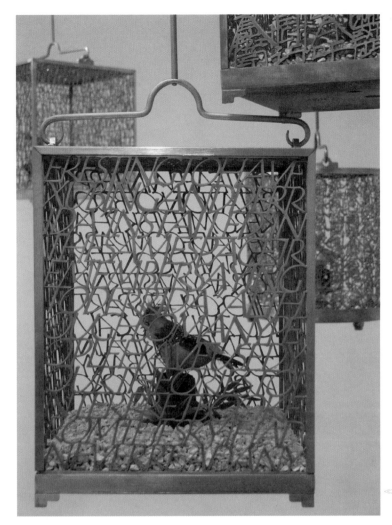

the climate and events initiated by the attack, made more poignant in the light of subsequent revelations of both American and British brutality in Iraq. If there is truth in the saying "out of bad comes good", then this underlines the action involved here in creating this work: yet it is undeniably an astute move on the part of the artist at a crucial moment in which context was all.

Significant to an historic moment, the work was also a turning point in Xu Bing's own direction. The exhibition opened in Wales just prior to his first solo show in Britain—the inaugural event at the Chinese Arts Centre, Manchester. Coming at the end of a year in which Xu Bing had participated in almost forty exhibitions, the installation of *Living Word 2: Bird* was delicate, ethereal, yet unable to take command of the space in the manner audiences have come to anticipate of Xu Bing's work. The fault did not lie with the space—which was brand new, having just been completed to exacting

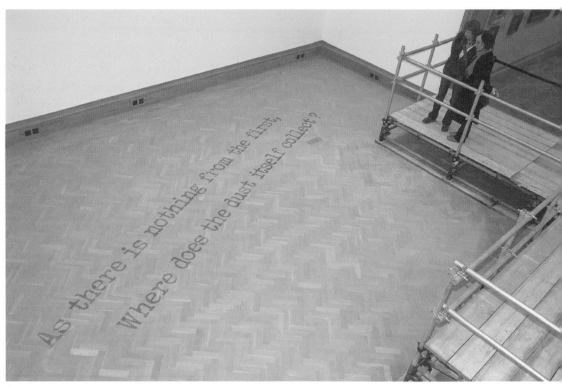

ᐱ Where does the dust collect itself?, 2004
Xu Bing's award-winning work for the Artes
Mundi International Art Prize, Cardiff, Wales

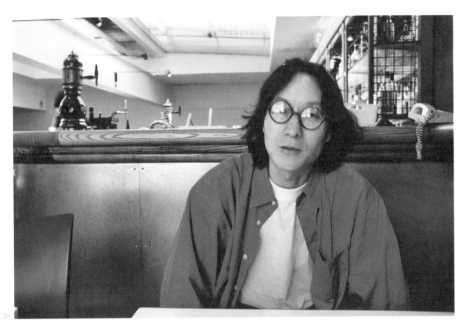

exhibition standards made possible by a substantial government lottery grant—but with the overload of commitments which laid claim to most of the time and energy Xu Bing reserved for new work. His pursuit of an art for the people precipitates a precarious position, negating the usual arguments an artist can invoke to tactfully decline requests to participate in an exhibition or to produce a work. With the phone ringing off the hook at his studio, Xu Bing pines for the solitude in which he prefers to bring forth new ideas. His creative process increasingly unfolds in transit between exhibitions. It is not surprising that in the hushed, subdued atmosphere on the streets post 9/11 that he found inspiration for *Where Does the Dust Collect Itself?*. The pause for reflection the event engendered was as significant for Xu Bing as it was for all Americans, prompting a stock take of individual priorities, and the value of individual contributions to society. In July 1999, in presenting Xu Bing with the MacArthur award, the jury of the John D. and Catherine T. MacArthur Foundation declared their choice was made in recognition of Xu Bing's "originality, creativity, self-direction, and capacity to contribute importantly to society, particularly in printmaking and calligraphy". It is as solid an affirmation of achievement as an artist could wish for, certainly acknowledging that context is less of a barrier than Xu Bing once imagined. Equally, it is a barrier that Xu Bing can take credit for helping to dismantle. Amongst his peers, Xu Bing's work is distinct in being accessible to all, and giving local context a truly global reach.

ZHANG PEILI:

CANDID VIDEO

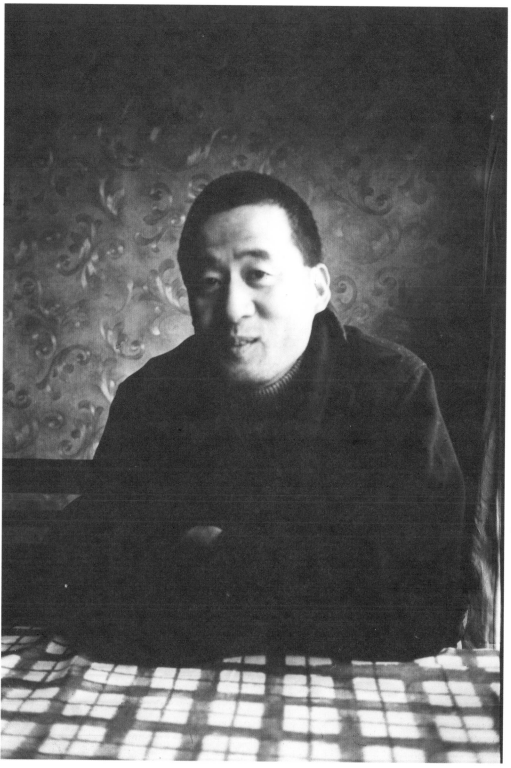

Zhang Peili in his favourite Hangzhou coffee shop, 2000

"Avant-garde art in China ... once served as a sign that marked the beginning of Chinese art's march towards freedom. Then it shifted its combat ground from the Chinese circumstance to the West. ... What should we do today in the name of avant-garde?[1]"

In March 2001, the directors of the China National Academy of Fine Arts in Hangzhou marked the beginning of what the Chinese calendar determined to be the new millennium with a decision to establish an art centre devoted to new media. It was a milestone for the academy's history; and for the academic system of governance in art schools across China since 1949. An equally radical decision was to invite Zhang Peili to accept a principle role in the centre in the position of director; which also required convincing a leading avant-garde artist to join the establishment.

At that moment, Zhang Peili was not only the most respected and proficient video artist in Hangzhou, he laid claim to the greatest experience in the field across China. He had been creating video sequences and projections since the late 1980s and by the time young artists of sibling generations began adopting the moniker of video artist in the 1990s he owned a status and acclaim that might be likened to that of pioneering American video artist Bruce Nauman, with whom the tone and approach deployed in Zhang Peili's works enjoys a distinct degree of correlation. Yet even in the 1990s as the popularity of video art grew, it remained subject to indomitable limitations, beginning with the main stumbling block; that equipment was not widely accessible within the art academies or without (although towards the end of the 1990s artists increasingly alighted upon the means to possess their own video camera). In part, this situation provided the China National Academy (CNA) with the impetus to pioneer the establishment of a new media centre, and it swiftly became clear that it had unleashed a powerful, and popular, tool. In 2003

1. Zhang Peili, "At War with the West", *China: Aktuelles aus 15 Ateliers*, published by Hahn Produktion, Munich, 1996, p. 133.

the centre was expanded to become a fully fledged department within the academy, and a new media art competition initiated by Zhang Peili, drew more than two hundred entries from students and local artists. The CNA had long prided itself on innovation, accrued vicariously on the backs of such graduates as Huang Yongping, Wu Shanzhuan, Wang Guangyi, Geng Jianyi, Zhang Peili, Yan Lei and Yang Fudong, to name but a few of the major contributors to new art in China. It is also part of the academy's veritable tradition, reflected in the choice of Zhang Peili, Geng Jianyi, woman curator Wu Meichun, and the eccentrically brilliant multi-media artist Qiu Zhijie—also a CNA graduate—to join the teaching faculty.

Although reticent at first about resigning his freedom, Zhang Peili was in fact easily swayed. He has a streak of philanthropic social idealism, as was instilled in his generation from its childhood. In the ensuing decades, as the more politically overt of Mao's socialist ideals crumbled, the simple, germane, and largely universal desire to contribute to society endured—though this was not necessarily imparted to subsequent and current generations. Zhang Peili was brought up to believe he could, and should, make a difference, with the means placed at his disposal, with art as his conduit. As a student, he had been keenly aware of a lack of inventiveness and experimentation within the training he received. At the point when he graduated in 1984, continuing through to the watershed created by "China/Avant Garde" in 1989, avant-garde artists experienced a fervent, and intuitive, need to collaborate in order to maintain any sense of what they were each collectively striving to achieve. Hence the number of manifestos proclaiming a group intention of producing a new art for the people, for a new China. Even as reform and opening began to allow space for individual roads forward in commercial enterprise, within the art world solidarity was the best form of self-encouragement and self-preservation. From the emergence of the New Art Movement, as one of the most respected members of the avant-garde, Zhang Peili's presence in Hangzhou would provide the younger generation with a point of focus and inspiration. He was always generous with his time and advice. Yet, through the 1990s, where the careers of most Chinese artists of Zhang Peili's generation—his included—were being built abroad, opportunities to interact with or learn from him directly were dramatically diminished in number. However, by the end of the decade, change in China had led to a shift in offensive, as internationally acclaimed individuals realised it might soon be possible to bring their art home, and stirred hope that their work might be able to achieve the kind of public profile that contemporary art enjoyed in other cultures. The tentative steps taken in this direction had proved that the road leading to this goal was best travelled if the artist secured an affiliation to a socially recognised platform. Openings were few, so positions were invariably hard to procure. Success was almost entirely dependent upon personal connections. In the late 1990s, for the multitude of Chinese artists now returning home from abroad, the academy environment fast became the perfect place to begin laying foundations. The very environment that Zhang Peili viewed with suspicion and contempt from his years as a student through to the late 1990s when, as change wrought by time incited a willingness to believe that the

system might have been altered by reform too. Significantly, as of that moment in the early 2000s, to be offered the headship of a prestigious new media department was without precedent in China. This did not go unremarked by Zhang Peili and played a part in persuading him to accept the post.

In respect of working with video in art, Zhang Peili was not privileged to special training. His inclination and aptitude was natural, innate, and his success with the medium was, from the first, extracted between his patience and the simplicity of the content he focuses upon. The combination makes his work unique. His videos are commonly characterised by clear concepts presented via precise visual images that are as ambiguously metaphoric as a Zen saying. Though less abstract than Zen conundrums, his concepts are equally rooted in collective experience. Zhang Peili's preferred themes and motifs circle around fundamental aspects of human existence, perception, and interaction. The majority of his works has required the involvement of people, either friends or random acquaintances, who are asked to perform a specific task, like pronouncing words correctly, scratching an imagined itch, preening themselves, singing, eating and even dancing. The simplicity of the action lends the resultant visual images a flawless quality. Nothing is permitted to distract audience attention away from the action, neither technical effect, nor subplot. Zhang Peili frequently relies upon a fixed camera angle and generally avoids imposing visual rhythms in the edit suite subsequent to filming. The mundane simplicity of the actions is a deliberate means of engaging viewers and coercing us into musing upon the nature and implication of habitual human activity. But whilst Zhang Peili taps relentlessly into universal experiences to challenge accepted conventions, his greater goal is to highlight the circumstantial peculiarities of the cultural norms and social values that shape attitudes towards human behaviour within the sweep of any society, anywhere. Naturally, there is a particular emphasis on China. The subtle nuances he unveils make his art intelligent without being intellectual, quiet without being vapid, relevant without being restricted to a specific time and even, on occasion, fun, but still without being inane.

By the mid-1990s, Zhang Peili had achieved an international reputation as China's foremost video artist. It is a reputation that also stands alone, beyond the "China" prefix, as indeed does the artist who never subscribed to the herd mentality that dominated the avant-garde across the Mainland through its first decade. Where so many would be artists were drawn to the opportunities in the cultural Mecca of Beijing, Zhang Peili, like Geng Jianyi, chose to remain in the contained environment of Hangzhou—his hometown. There, in the sedate and gentrified garden city on the banks of the famous West Lake, he channels his energies, his astute observations on life, into the production of enduring works of video art. And latterly, as head of the CNA's new media department, he has also emerged as a powerful affirmation of the future of experimenting with technology and of lens-based images in art.

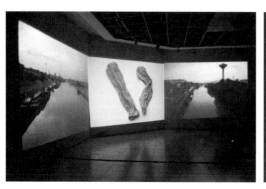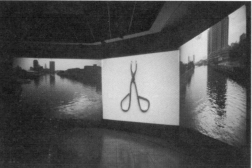

Zhu ni shengri kuai le, Zhu ni shengri kuai le, Zhu ni shengri kuai le ...

It is not easy to recognise the meaning of the *pinyin* spelling of the Chinese characters written above. The tune to which these are accompanied is, however, immediately nameable; in English, the same lyrics would read "happy birthday to you". The Mandarin version was the subject of a video work that aptly demonstrates the multiple levels upon which Zhang Peil's work functions. Ironically, Zhang Peili hails from a culture that, traditionally, is not given to commemorating the nascence of its citizens—with the exception of imperial personages in imperial times, and then not often. In the post-Mao era, as Deng's modernisation programme opened the door to globalisation, a number of unforeseen commercial spin-offs entered under the umbrella of consumerism, the celebration of birthdays was one among them. In particular, for the younger generations, the advent of fast-food chains turned children's parties into equitable business, offering white-collar urban parents a ready opportunity for treating their solitary treasure. Individual birthdays aside, a number of deeply embedded cultural traditions in China are pivoted on anniversaries. There is the Spring Festival, Chinese New Year, and a number of dates on the lunar calendar associated with the turning of the seasons. For individuals there are betrothals and weddings, the safe delivery of a child and its healthy passage through the auspicious first hundred days. Common to all such celebrations is the predominance of the colour red, which in China signifies happiness and prosperity. Through dynastic history, red provided a splash of colour in an otherwise colourless existence for the majority of the people. With the spread of Communism under Mao, the spiritually fortuitous association with red was leveraged as the masses' love of scarlet was grafted onto the vermilion signature of Communism. This was a "red" regime, literally and metaphorically, embodied in the immediately recognisable PRC flag, which ineluctably bound celebration to power politics and national pride.

In 1999, Zhang Peili was invited to create a work for the 48th Venice Biennale. He chose the Mandarin version of *Happy Birthday* as the featured karaoke tune for a people's chorus in video work he sardonically titled *Just for You*. The work was assigned to a space on the ground floor of the Italian Pavilion, and comprised

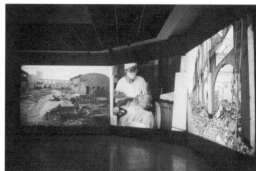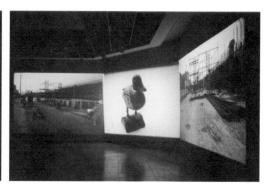

ten monitors on ten white, chest-high plinths arranged in a semicircle facing the audience. A format not dissimilar to Juan Muñoz' circles of diminutive cast figures, and provoking a similar dynamic between the viewer and the figures being viewed. Flanked by works from Mario Schifano and Louis Bourgeois *Just for You* was in good company. In the piece, representative members of all the social classifications that make up the population—worker, teacher, student, male, female, young and old—come together individually to form a group. As the work commences, on one monitor a single face fades gently up from black. After an anxious look into the camera and a split second of nervous hesitation, without audible accompaniment, the individual starts to sing. The voices, some pitch perfect, some flat and tuneless, accentuate the unvarnished human element in Zhang Peili's egalitarian choice of participants. In the sequence of the work, each person completes one verse before the screen fades to black and another monitor becomes illuminated, a new face but with the same quizzical gaze and aura. The various individuals appear in random sequence until the last segment of the work, when all resurface within their separate "frames" to join in unison for a final chorus, unaware that they now have the support of the group. Thus unaware, none is able to draw comfort from the cliché of safety in numbers or the anonymity of the crowd. The majority of the singers' expression is marked by the nervous quiver of what suggests a first performance before a camera. The unquiet hesitation is odd, and the expressions jar because by nature the Chinese people are surprisingly natural performers with little sense of inhibition and a great talent for song. Perhaps in this instance, their anxiety can be ascribed to an uncomfortable awareness of participating in a work of "modern" art—with all the negative connotations of the word in China—or the daunting idea that the recordings of them doing this would be replayed publicly in a foreign country. And where for a foreign audience self-consciousness tallied equally with notions of Asian shyness, as if the singer was physically present in the space, performing a turn, viewers were moved to heartfelt empathy.

As visitors waited for the sequence to go full circle, a group of Italian children ran from one screen to the next, their delight in this impromptu karaoke ever greater with each new and unfamiliar face. How amusing to hear *Happy Birthday* sung

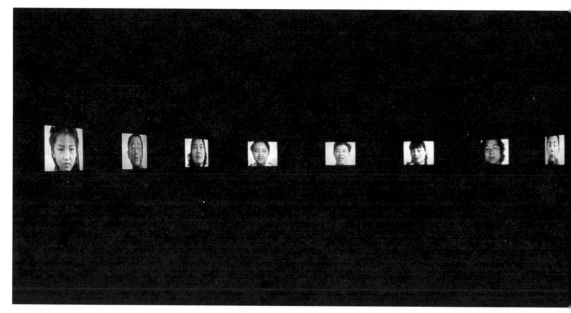

in Chinese, and by people who clearly had no idea that they were performing on one of the world's leading art stages. Moreover, contrary to the words they sing, the individual demeanours of the twelve guest stars in *Just for You* largely refute the celebratory nature of the lyrics. Interviewed by an Italian television crew, Zhang Peili said: "I wanted to find something that would touch base with an international audience, something simple and universal in image and sound that everyone could relate to, no matter where they came from." Then, as a seemingly jocular aside, he added: "China is celebrating a fiftieth birthday this year ... "

It was: October 1, 1999, marked the fiftieth anniversary of the founding of the People's Republic. It was also the tenth anniversary of June 4. For many residents of Beijing the extraordinary level of pomp and circumstance deployed to celebrate the milestone anniversary of the PRC—a loud and proud reminder of the achievements, benefits and ethos of a nation incontrovertibly moving forward—was a means of diverting attention away from recollections of the sobering dawn of June 4. Seen in terms of either anniversary, or both, such inference certainly expands the reach of *Just For You*, and accounts for several visual peculiarities about the figures. The dour expressions they bring to the singing of what is a joyful song rather negate the essential nature of celebration. The pronounced absence of red, with the exception of the red neckerchief worn by one school student—a lingering symbol of the young pioneer—or any hint of the intense jollity that dominated domestic media images in the run-up to the celebrations in Beijing, further suggested a link; implying that the people were going through the motions of celebrating, defiantly remembering a graver anniversary that still gave them pause for thought. The biennale neatly straddled the

two historic dates, opening in June and wrapping up in October. As we shall see, given the nature of Zhang Peili's earlier works, *Just for You* encapsulated a political comment in a succinct, almost self-effacing manner. In speaking at greater length to interviewers, Zhang Peili skilfully deflected the more penetrating questions that his mention of anniversaries prompted. On the one hand, he was clearly being guarded, but his was a practised astuteness, too. Undisguised provocation has never been Zhang Peili's style: "I was there to extend the profile of my art in an international arena and not to win fame [notoriety] for myself at home." Though pedantic, the distinction is important. Zhang Peili had learned that circumlocutory means made it possible for an individual to be far more effective as an avant-garde artist, at home and abroad, although he preferred to steer the discussion towards his practice rather than opting for an ambiguous "no comment". Mild circumlocution is possibly the only "Chinese characteristic" of which he can be accused of manipulating. Against the potential readings of political insurgence, Zhang Peili permits the work to offer manifold interpretations, thus allowing himself a plausible escape route out of even the toughest interview.

The pointed lack of dynamic action in favour of an intense focus on a slight gesture that is common to all the works, opens Zhang Peili's video art to myriad levels of understanding because simplicity is always more complex than it appears. In a contemporary world saturated with visual metaphors, with film and media images laden with cultural and socio-political inference, the scenes in his video works have all the sophistication of advertising campaigns: like stories reduced to a visual shorthand that everyone gets immediately. In advertising, this visual shorthand has to tell a story in the briefest of moments. Zhang Peili's sequences eliminate all conventional elements of storytelling from the works and pare this type of visual shorthand down to an absolute minimum. The story to be discerned in his work relies upon the viewers' capacity for mental association and lateral thinking, often after the viewer has walked away from the work. The absence of a self-explanatory narrative is unusual in the art of China's avant-garde artists because narrative of one kind or another is a dominating component of painting, photography and even video, from 1985 through to the early 2000s. Whether or not, in the absence of a broader context, one uncovers the underlying meaning of Zhang Peili's minimalist playlets never detracts from the pleasure of watching them. Confronted with *Just for You* numerous visitors to Venice did pick up on the subtle juxtaposing of two pivotal events in the history of the PRC—its founding and June 4. This made it possible to align one era with another, and nudge thoughts towards the nature of China's ongoing transformation; a connection that unveils a powerfully orchestrated comment, which at that moment, appeared to speak out against history, thus winning its author a quiet respect. Taking a leaf out of Gu Dexin's book, Zhang Peili remained non-committal, which drew a knowing sympathy from the media. His reticence was read as a necessary means of protecting himself. But was he? The answer is yes and no: an equivocation, true, but a strategy typical of a large number of avant-garde artists, and of the art produced from the mid-1980s to the mid-1990s, during which time

China's totalitarian regime was intractable. To some extent, China's avant-garde artists laid the foundations of their careers upon equivocation. It enabled them both to navigate the turbid waters at home and to build credibility abroad, encourage foreign audiences to believe the art to be more political than it actually was at times, and thereby to delight in its illegality.

Zhang Peili's foreign debut occurred in the early 1990s, at a moment of dramatic economic and political adjustment, not just within China, but in terms of China's relationship to the outside world. Given the tone of general public perceptions during that time, foreign interpretations were inevitably allied to the fraught political problems that scarred the end of Deng Xiaoping's reign. These interpretations were not entirely misplaced: as has been seen here in the paintings of Wang Guangyi and Li Shan, for example, the motifs employed were blatant—Mao, Pop, and an accentuated infusion of cynicism. Against a fragmented vision of China's cultural environment abroad, it was unavoidable that critical discourse would be honed to a political sleight by western people educated to read art that way—one of those "western cultural habits" that so amuses Gu Dexin. And like Gu Dexin—in not being one to follow general trends—Zhang Peili deliberately endeavoured to buck them. Yet, by the late 1990s China had changed, and to such a degree that self-protection was less and less necessary to any aspect of an individual career, a fact to which Zhang Peili's appointment to the CNA ultimately attests.

Just for You intelligently illustrated a moment in contemporary China. The cloak of dubiety that hangs over Zhang Peili's performers reflects the awkwardness of fostering non-native notions and practices onto a people before either have been suitably adapted to meet the cultural needs of the new environment. The people's urge to become modern is as arbitrary in its choices as its momentum is irrepressible. It is the clash between domestic and external ideologies, and the shifting sands of contemporary Chinese experience, which Zhang Peili perceptively observes. And in a format that, like the video's content, demonstrates how western influences have been assimilated into China's new art, yet adapted to individual expression. So, in *Just for You* Zhang Peili succeeded in succinctly lining a superficially innocuous work with a poignant political nuance. Whilst many members of the audience at Venice might not have registered the significance of the PRC's anniversary, they were touched by the piece. Every now and then, throughout the Giardini, the hummed strains of *Happy Birthday* stirred the air. Viewers might not remember the artist's name, nor have registered his Chinese origins—discussions held by Europeans standing before the work revealed the confusion caused by Asian faces: Japanese? Korean? Vietnamese?—but perhaps on October 1, when the grand parades in Tiananmen Square made the news, then by contrast, they might have recalled, the strikingly non-committal expressions of Zhang Peili's singers. In Venice, *Just for You* also demonstrated the ability of a contemporary Chinese artist to conquer new—western—technology and make it his own. To complete a trilogy of anniversaries, *Just for You* also neatly marked a decade since Zhang Peili began his own exploration of video art.

Continuous Reproduction, 1993—a typical propaganda image from the late 1950s
is photographed and the print re-photographed twenty-five times, causing the
original image to disintegrate frame by frame

Video emerged as a medium for art in China in the mid-1990s as artists began to embrace a broader vision of what might constitute individual practice. The expansion of creativity beyond approaches dependent upon readily available, and usually inexpensive, materials, such as painting, printmaking, installation and performance, in turn grew out of the increasing access to the tools of technology, made possible by booming domestic consumerism. Initial inspiration for making video art was taken primarily from Nam June Paik, Bruce Nauman, Bill Viola and Tony Oursler, to whose actual works the vast majority of Mainland artists had almost no first-hand exposure. With no tangible examples to follow—quite the opposite situation as that with western painting, which resulted in an abundance of derivation—video art was initially pursued by the most independent thinkers of the age. Following Zhang Peili's lead, artists who were pivotal in establishing video art, like Qiu Zhijie, Wang Jianwei, Li Yongbin and Wang Gongxin, like their mentor, prefer to practice alone. Their experiments with the medium resulted in a range of unique works. As general interest in video grew amongst the art community, the first generation of artists to get behind a video camera saw it primarily as a direct means of integrating space, time, ambience and human action: a visual experience in which viewers were still passive observers. Video freed artists from the constraints of a straight-laced academic education. Yet, although almost every experiment with the medium employed real people, images of the real world and real objects to convey a narrative of some sort, none were abstract in a visual sense. In playing with the poetics of motion, as ethereal and often aimless gestures—which paralleled the sense of cynicism, boredom and futility underlying the aesthetic mood of the moment—Zhang Peili's works came closest to breaking free of narrative and breaking new visual ground. In the glorious honeymoon period where video was as yet ungoverned by aesthetic or theoretical rules and regulations, the perceived applications for the medium were unlimited, restricted only by the imagination of the artist. For a portion of the art community, unleashing this imagination was a challenge. Against the powerful influence of western art, and the urgent desire to reach international standards, avant-garde artists could reconstitute the appearance of most two- and three-dimensional works from reproductions in catalogues and magazines. Conversely, it was impossible to imagine the experience of a video work from a solitary still. This acted as an important catalyst to creative invention. It also explains how, as artists struggled with the challenge, some video works acquired the semblance of music videos, art-house films or theatrical plays—the closest visual model to draw upon. That aside, once individual artists had propelled themselves over the technical hurdles of working with video, the applications they developed for the medium unfolded apace.

As previously mentioned, Zhang Peili had no special training for making video art. Having followed the standard four-year period in the oil painting department of the CNA, he came to video in a rather obtuse way. As television began to permeate daily life, he was amazed at how swiftly television sets became the centre of home life—for those who could afford them. He also noted how, in projecting an apparently

novel picture of the world that made everything appear interesting, television moved people to look at things they regularly overlooked in the course of a normal day. In 1988, in the midst of all of his musing came an invitation to travel to Huangshan for the first conference on the new art organised by art historian Gao Minglu. Zhang Peili, together with Geng Jianyi, was selected to represent Hangzhou and give a presentation on the creative environment there. At this specific juncture, he had become fixated by television's distortion of time. "I realised that as a means of recording moving images in real time, video made it possible to manipulate time." Just as Geng Jianyi chose to produce a work as the focal point of his presentation, the Huangshan conference provided Zhang Peili with the opportunity to challenge the relationship between fictionalised time and real time. Now he needed the means. Simple VHS video cameras could be found in China, but were largely the property of State organisations and that required privileged access. Exercising his talent for engaging with the right people in the right places, Zhang Peili secured the loan of a camera from Hangzhou Customs Bureau, on the condition it remained on the premises. Fortunately, for what he had in mind no set was required. In an unoccupied and sterile office, he and a technical accomplice set to work.

The aim of Zhang Peili's programme was to have those who viewed it focus on the experience of time passing. This was to be achieved by means of a sequence so tedious and laboured that the protracted elapse of three hours—that being the length of the video cassette used to record the action—would be an overwhelming challenge to even the most patient and engaged of viewers. The choice of the conference attendees as guinea pigs was deliberate, motivated by the aura of a preliminary meeting of the new artists in Beijing the previous year: "It struck me how eager everyone was to appear avant-garde. Yet, listening to them, I was not convinced. How avant-garde could they—we—really be given the circumstances of our environment? What did their definition of avant-garde art extend to? I sensed the boundaries needed to be challenged ... "

The Rolodex of those invited to the second conference promised an A-list of new artists from every province. For their viewing pleasure, Zhang Peili created *30 x 30*. 30 x 30 referred to the size, in centimetres, of a piece of mirrored glass that he smashed for the three-hour duration of the video work. The sequence begins with a shot of the mirror seconds before it is smashed—literally dropped—by the gloved hands that hold it. The hands then pick up the fragments and start piecing and then gluing them together, at which point the fixed pane is shattered again. The re-enacting of reparation, restoration and re-fracturing exhibits the same sardonic deadpan impulse that suffuses Andy Warhol's epic film *Empire State Building* produced in 1964.[2] Similarly paralleling the socio-political mood of its cultural context, *30 x 30* resonates Chinese pragmatism. Zhang Peili had created the dullest video production conceivable, and it certainly elicited the desired effect. After twenty interminable minutes of viewing, the audience's initial interest was exhausted. Attempting to placate rising waves of boredom with anticipation of some action bound to happen some time, the cream of the avant-garde retreated into polite silence, some quietly

2. *Empire State Building*, 16mm film, 8 hours, 1964. "It consists of a long shot of the Empire State Building, filmed with a telephoto lens from a neighbouring skyscraper, and held for eight straight hours. At the six-and-a-half hour mark, the floodlights illuminating the ESB go out, so for the remaining 90 minutes the subject is completely invisible." www.rotten.com/library/bio/artists/andy-warhol/ (August 2004).

30 x 30, 1988

wondering if there was a profound angle to the imagery that they were failing to grasp. As patience evaporated, the crowd grew restless. Finally, intolerant individuals demanded Zhang Peili fast-forward to the action, of which of course there was none. "I wanted everyone to watch it to the end but they couldn't bear to. They demanded to know what it meant, and what I meant by showing it. I realised my suspicions had been proved right."

To put the reaction fairly into context, this was the first work of video art that those present had seen. In the absence of comparatives, that Zhang Peili's approach was deliberate or that he had elected to eschew the conventional elements perceived as the formula for filming action, was not at all obvious. Critical response was equally cool. Critics present at the screening took a kindly tone in commending Zhang Peili's effort, at the same time suggesting "that I work on my technique, use different angles, close-ups, and edits for variety. Basically, helpful tips on how to make my video more interesting."

The format of *30 x 30* was a litmus test of avant-garde-ness, but that is not the aggregate of the work. The symbolic use of a mirror was not vacuous, rather a metaphoric reference to perceptive awareness of reality. Mirrors are commonly believed to uphold a truthful image of all that is reflected in them. Broken mirrors give out distorted reflections, fragmenting the physical world in fractured segments, which in their dizzying multiplicity become hard to read as a continuous whole. In *30 x 30*, as the broken shards are pieced together, we anticipate clarity being restored, an expectation shattered when the gloved hands drop the mirror again, and again, its function obliterated by incoherence. *30 x 30* alludes to the fractured facades of the political, social and physical realms as the process of advancement unleashed disruption across China. It also invokes the guiding visions of artists of the New Art Movement who were trying desperately to make sense of post-modern thinking—a concept tied to the evolutionary development of culture and thought processes in the West, and far removed from the doctrines and ideology governing their own cultural environment. *30 x 30* paraphrases Zhang Peili's conclusions that the harder they tried to see, the more confused they became, dazzled by the fragmented multitude of contradictory glimpses afforded them of the outside world.

Born in 1958 in Hangzhou, Zhang Peili is most at home in the local lip-twisting dialect. His Mandarin is faultless, but as he demonstrated in a work titled *Water: The Standard Pronunciation* in 1992, he leaves the perfect nasal tones to professional newscasters. Hangzhou's guttural vernacular is better suited to his sharp, but wry wit. Zhang Peili is much attached to his birthplace. A period of three months in New York in 1992—in tandem with an artists' residency programme at Omi, upstate New York—and another ten months during 1994 and 1995, provided a taste of living abroad adequate in sating his curiosity, and affirming his preference for his native environment. Specifically, Hangzhou, and indeed the surrounding region, is known for the variety and delicacy of its cuisine, often pronounced some of the

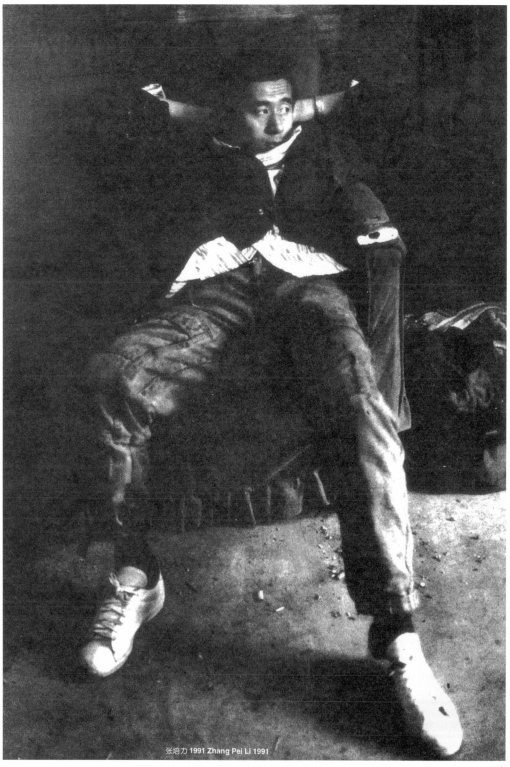

张培力 1991 Zhang Pei Li 1991

In his studio, Hangzhou, 1991
photograph *Luo Yongjing*

best in all China. An acknowledged gourmet, Zhang Peili has a reputation as one of the contemporary art community's best hosts, particularly among visiting members of the foreign art world. Dinner with Zhang Peili makes a visit to Hangzhou particularly memorable, especially where, by comparison with the increasingly frenetic pace of Beijing and Shanghai, the city's serene ambience and a succession of unusual and delicious flavours melting on the tongue inspires creative conversation to flow, which does not always happen elsewhere in China. For Zhang Peili, as for Geng Jianyi, life in Hangzhou is not lived on the edge of a seat, but it is free of the intense and competitive urgency that drives art in the capital.

Neat and petite in features, Zhang Peili is famously casual in dress. His image is one of practicality with no concession to vanity and, on account of this practicality, was once refused entrance to the opening reception of a museum exhibition in which he was participating—to the consternation and amusement of the other artists present. However, his style of dress is not the first thing people notice about Zhang Peili, it is his commanding presence and professional work ethic. He also has a formidable temper, which erupts when his patience is tested, as it was at the Venice Biennale in 2003—a contretemps with technicians, who failed to locate the technical equipment Zhang Peili had specified, prompted him to quit Venice, posting an angry letter of protest in the space where his work should have been.

To beat the challenge of working with video in a cultural environment devoid of role models or abundant professional expertise, Zhang Peili quickly developed a piquant skill of prevailing upon technicians and editors to assist in resolving problems. The completion of his works has required a range of technical post-production knowledge and resources, particularly as he graduated onto professional formats, and before he had the state-of-the-art facilities of the CNA's new media department at his disposal. Towards the end of the 1990s, as the cost of other artists' materials fell to market competition, video continued to be an expensive proposition. It was only in the early 2000s, with the gradual deregulation of government control over television and filmmaking that independent production houses came into being—and which provided services at commercial rates that artists could ill afford. Whilst video art rose to the status of a respected medium in new Chinese art, it was slow in accruing the kind of commercial value enjoyed by painting, and latterly photography, on the international scene. In spite of a solid reputation, funding new works remains the most stubborn part of the challenge of making video art.

Since the late 1990s, Zhang Peili has worked out of a small two-roomed apartment away from the main tourist sights of the garden city and out of its burgeoning commercial centre. The interior offers raw concrete floors and whitewashed walls; a perceived minimalist chic that was latterly adopted for studios and living quarters by the art community in Beijing. By contrast, Zhang Peili's decor is uncontrived. He keeps the apartment in the condition it was in when he bought it. Order rules. The main room is lined with shelves stacked heavily with videotapes and books, and a sofa bed at right-angles to a barrack-style dormitory bed completes the austere

arrangement of items. During the mid-1990s, the delicate balance of his finances kept him on the move in search of a quiet, affordable working space, and he learned to keep possessions to a minimum.

As one of China's most popular tourist destinations, Hangzhou is an expensive place to live. Through the 1990s, as domestic tourism grew and local business people enjoyed new levels of disposable cash (Zhejiang, Jiangxi and Jiangsu are three of the richest provinces in China, with the greatest saturation of personal wealth), local restaurants and coffee houses priced themselves accordingly. By 1996, the authentic Java blend Zhang Peili habitually enjoys in one of the better cafes cost 58 yuan (USD 7) a cup. In such a location, how to build and maintain relationships, and with whom, counts. The proficiency Zhang Peili brings to the task is how he is able to realise video works that would require many times more times the funding in a western environment. Industry acquaintances, whose intrigue he aroused to the point of providing services free outside of working hours, are now firm friends. The technical challenges he presents to them tests their creativity with their engineering skills, ultimately to mutual advantage. And, latterly, to the advantage of new media students at CNA, for not only did Zhang Peili bring his own experience to the classroom, he came with a network of tried and tested technical support.

Zhang Peili's parents both worked in a local Hangzhou hospital. The themes and imagery of his first forays into conceptual art paid homage to the experiences their jobs afforded him. As a child, he enjoyed privileged access to the hospital; a disturbingly fascinating environment that imbued him with an acute awareness of human frailty. His curiosity about the internal world of the hospital was a subliminal backdrop to his parallel interest in drawing, which unfolded as Zhang Peili approached his teens. These two apparently unconnected preoccupations converged in 1987, when he became infected with hepatitis.

Today, the monolithic structure of the rebuilt CNA stands on the site of the former Zhejiang Academy, a short walk from the undulating banks of the West Lake. In his youth, each time Zhang Peili passed the gates, a wave of baited anticipation ran through him. To his grave disappointment, when the academy reopened it gates to students in 1978, Zhang Peili was not eligible to apply. As a result of an accident in his mid-teens that left him with a damaged foot, he had not undergone the proscribed stint in the countryside that was the required duty of all educated youth in the early 1970s. Duty done was also the basic criterion for any applicant hoping to enter a university. To Zhang Peili's relief, the rule was removed in 1980 and he was accepted to the oil painting department, and a world he had idealised for as long as he could remember. "Before entering the academy, the only modern art I had seen was reproductions of paintings by artists like Modigliani and Picasso, and the images were very poor. Beyond Socialist Realism, I knew little; at that period it was even hard to know what was going on in China." But news did reach him of the Stars' exhibitions in Beijing. "It felt like the dawn of a new era."

In their first year, the students were set to drawing plaster busts and landscapes: an experience that for Zhang Peili removed the mystery of all he had previously imagined art to be. "The teaching staff required us to conform to the single vision and style of Socialist Realism dictated by the State and imposed through the academies. It was the only acceptable approach." Zhang Peili's contribution to the birth of avant-garde art came via the rather more conventional medium of oil painting in a series of compositions, which featured distinctly unconventional subjects that were rendered in a style that deliberately flouted his departure from "acceptable approaches". In a flagrant quashing of emotion—of Socialist Realism's emphasis on a healthy and uplifting spirit of positive exuberance for life in liberated, socialist China and a triumphant sense of the nation's advance towards a better tomorrow—Zhang Peili's paintings embodied all that Wang Guangyi vigorously demanded of the avant-garde in 1986. "Ridding art of emotionalism" was, in fact, first mooted by Zhang Peili in late 1983, as he and Wang Guangyi began preparing their graduation works. "I was really into '70s-style Photo-Realism, obsessed with painting perfect representations of reality, illusions [of objects or people] that looked as real as in photographs. This led me to consider the essential nature of illusion, and of the relationship between illusions and reality." He began reducing objects to smooth, flawless planes, as if subject to a Photoshop clean up to remove any hint of blemish or glitch. This aura of perfection disrupts any tangible sense of the images being real—they are simply too perfect, too squeaky clean. But the rendering of the subject is real enough to make you look twice, as if confronted with a form of trompe l'oeil. "I put all my energy into painting details within details, to creating the most perfect depiction of my subject I was capable of achieving. Such perfection was not intended to extol an unobtainable ideal, but to create a distance between the subject and the viewer, to emphasise that a painting is only a reflection of the real world, an illusion created by an artist

to communicate a specific message. My goal was to stop people in their tracks, for them to consider why a perfectly pictured ideal ultimately appeared so unnatural."

The underlying parallel drawn in these paintings was, of course, with the unblemished impression of life that Socialist Realism was designed to project. If manufacturing fantastic illusions was what the academy required of him, then that, Zhang Peili decided, was what he would do. Thus poised on the threshold of a tantalising new avenue, only a few months away from graduating, he decided to ignore the theme of industrial workers set for that year's graduating class, in favour of compositions that revolved around athletes. "I had a particular idea about painting figures [oarsmen rowing a long boat] depicted from an unconventional angle [as if they had been captured mid-motion in the freeze-frame possible with a camera lens]. There were to be no facial expressions, the features reduced to simple forms in the same manner as the figures." Even though as a subject sport was apolitical, Zhang Peili's proposal was rejected as being "too abstract". "By portraying rowers mid-oar, I thought I could get around the issue of [ideologically] correct posture and facial expression, but the answer was no. I was informed that an artist had to convey a spirit of positive engagement in meaningful activities. So, the joyful struggle of oarsmen to excel then, because excelling, winning, triumphing over the odds underpinned the national ideology, and was the goal of every cog in the modernisation programme!"

After four years of stringently guided instruction, Zhang Peili was striving to embrace independence. First, he had to deal with the formalities of the inevitable

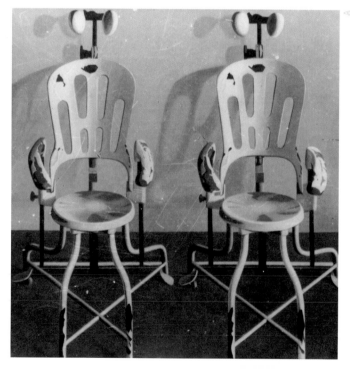

<<X?>>, 1987

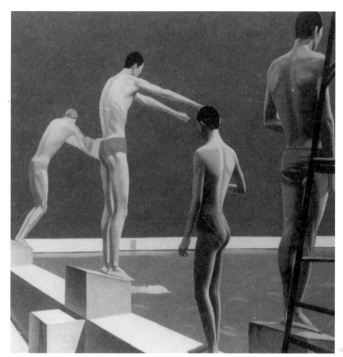

work assignment. He had been offered a teaching post in Anhui province, a not unacceptable distance from Hangzhou. In spite of the relatively good situation the university promised, he was reluctant to leave Hangzhou. Deliberation cost him the choice, for the university made alternative arrangements to fill the position. By chance, the School of Art and Design in Hangzhou was in the process of re-opening and, with the help of a friend, Zhang Peili was taken on staff. He maintained an affiliation with the school right through to 2001 when he transferred to the CNA's new media centre; back into the academy system, the narrow parameters of which had unwittingly inspired him to seek alternative possibilities beyond their confines.

Graduation over, Zhang Peili settled into his teaching routine, and mulled over what to paint next. At this moment between late 1984 and early 1995, the painting style of the Sichuan School was at its peak, dominating the themes and techniques of compositions nationwide: "The works merely reflected pain and melancholy as the painters' reaction to life in the countryside. As a phenomenon I found it quite disturbing: why were artists so willing to follow a trend? Another perspective was needed. I had always lived in a city, so I began looking at philosophical explorations of urban problems."

His "other perspective" would emerge in 1986 as he began working with other, somewhat unconventional materials for the times, but in 1985, Zhang Peili was preoccupied with issues about painting that remained unresolved. Rather than working through his frustrations on canvas he took to discussing them with Geng Jianyi. In

NINE LIVES **THE BIRTH OF AVANT-GARDE ART IN NEW CHINA** ZHANG PEILI **379**

mid-1985, he received a lucky break, when the Zhejiang branch of the China Artists Association (*meishujia xiehui*) invited him to help organise an exhibition of works by young local painters. Zhang Peili's first act was to set up a selection committee comprised of artists. It was a daring act, for official art associations were subject to stringent protocols, the purpose of which was to ensure that only artworks matching the acceptable criteria were selected. Zhang Peili's committee was a first, and the resulting exhibition "New Space" also proved unique in being sponsored by the CAA and hosted by the CNA's exhibition hall, thus having a semi-official status. The exhibition, which opened in December 1985, was ground-breaking too because it was the first officially initiated event to include paintings by non-CAA members, and of radical new styles, which led to enthusiastic coverage in the national art press.

Zhang Peili showed four compositions. Two featured swimmers gathered by and diving into a pool. The other two were parodic portraits of saxophonists. The technique carried echoes of Photo-Realism, but the blunt stylisation of anatomy and perspective, simplified still further and rendered in non-naturalistic hues, turned the ambience surreal. "I had no interest in telling a story. A painting is a painting, a composition with colour and form. It doesn't need to relate a narrative."

Western art history speaks of an evolutionary move from painting "pictures" in the pre-Modern age to painting "paintings" beginning in the Modern and developing through Post-Modern times. The latter pivots largely on the physicality of paint and its invocation of emotion, beyond its function as a means to preserve the external world and all it contains on canvas. On the one hand, Zhang Peili was painting pictures; paint was simply a conduit for creating a scene. On the other hand, in spite of the clinical accuracy of forms, which implied a skilled academic hand, the static poses and imposing lack of emotion, these compositions were clearly paintings in a conceptual vein. "I sought to deny any expression of personality, individuality, or emotion. I hated painting made the vehicle for emotional expression. I believed an artist had to preserve a distance from his work." This conviction, which would exert enormous influence on the development of contemporary art in China, owed the extremeness of its strength to the exaggerated emotion favoured for Socialist Realism. Representing a conscious move away from the past, from the cultural climate Mao imposed, and thus a new, modern age for art that looked to international—western—aesthetics, the principle of cool, philosophical detachment that Zhang Peili mapped out became a fundamental component of avant-garde art. It is a legacy that continues to permeate the art, as does the quizzical reasoning he subsequently brought to conceptual experimentation.

Interval, 1985 ≫
Please Enjoy Some Jazz, 1987 ⩔

In tandem with their discussions, Geng Jianyi was also producing paintings in a similar vein. Surveying the work, they decided that their approach was the perfect prism through which to look at ordinary life, taking the tangible common realities of daily Chinese social experience for their subjects, without the underlying ideological motive. "The paintings represented the first clear idea of a new direction." The

X? Series, 1987 Λ Λ Zhang Peili with a painting from the X? Series, Hangzhou, 1987

works, by both Zhang Peili and Geng Jianyi, prompted an enthusiastic response of unexpected proportions when reviews of the "New Space" exhibition appeared in *China Fine Arts*,[3] *Jiangsu Art Monthly* and *Fine Art Magazine*. But where the reaction to the paintings was, on the whole, positive, Zhang Peili discerned a polemic that was problematic. Surely it was unnatural for everyone to "like" the work, as he was repeatedly assured they did. If a painting did not arouse questions or point the viewer to certain issues—provoke them—was there not an inherent problem in its concept, form or approach? It occurred to him that the slick stylisation in his own works had inadvertently resulted in a superficially seductive appeal. Once again Zhang Peili took up discussions with Geng Jianyi, and a conclusion emerged; one that remains central to his oeuvre. Echoing Braque's assertion about the role art should serve—to disturb—Zhang Peili decided provocation was all; that the complacency society exhibited towards the visual arts had to be challenged. Through 1986, he continued to paint, pictures created by him, but not of him, which exploited the deliberate tenacity he brought to *30 x 30* the following year, when a breakthrough did occur. He repeated a composition over and over, with only minute variations to distinguish one from another, until finally convinced that his endeavours were no longer going anywhere.

The experience of realising the "New Space" exhibition by committee the previous year had entailed complex negotiations to reconcile the vastly divergent and conflicting opinions of its members. In an attempt to achieve a more intimate level of discourse amongst like-minded peers, Zhang Peili drew together a group of six friends all keen to collaborate on experiments. They called the collective the Pond Society, and set its focus on performance pieces that, where possible, would interact with the public at large. The initial idea was culled from the "theatre of life" theories of Polish dramatist Jerzy Grotowski.[4] "We were searching for ways of communicating with people, to make our art relevant to our society, with no clear direction beyond a belief that there were no limitations. We could try anything as long as it was creative in concept." Only a very few of their trials actually made

3. *Zhongguo Meishu Bao*, edited by Li Xianting, early 1986.

4. Jerzy Grotowski, *Towards a Poor Theatre*, Hans van Dijk quoting Zhang Peili, "Painting in China after the Cultural Revolution, Part II 1985–91", p. 3.

it into the public arena, or took place before what counted as an audience of the people. Experiments included wrapping Zhang Peili and Geng Jianyi in newspaper, and burying the deconstructionist prose writer Cao Xuelei in a mountain of paper—attempts to "reposition people as objects". They introduced life-size paper-cuts of figures in various tai chi positions to public spaces—along a street and in the dappled shade of wood. For the most part, the works failed to provoke criticism, let alone curiosity.

The relief of exchanging tedious academic doctrines for creative independence was now being consumed by emptiness and doubt, countered only by the intense level of discussion Zhang Peili maintained with Geng Jianyi. New art was almost entirely excluded from the authorised cultural scene. The freedom that artists were beginning to enjoy was proving to be freedom in a void. Under a growing cloud of apathy, Zhang Peili despaired on ever alighting upon a meaningful approach. The failure of the Pond Society, especially the lack of response to the works, could not go unanswered. He recognised that if contemporary artists in China were to develop a relationship with an audience, then the content of the work had to be relevant to the immediate cultural context. It was a subtle, but catalytic realisation.

Towards the end of 1987, Zhang Peili produced one last series of paintings. The subject was flaccid pairs of latex medical gloves floating in undefined space, and rendered in a particularly graphic, monotone style. Latex gloves were an

X? Series, 1988 ≫
Sigg Collection, Switzerland

image embedded in his childhood impressions of the hospital environment. A recollection that was prompted by the serious outbreaks of hepatitis A which occurred that year. The unnatural rubber skin, adopted now as a protective barrier, was a familiar yet jarring sight, especially when the outbreak reached epidemic proportions along the eastern seaboard. Due to the communal style of living and, in particular, with the large workforces that ate communally in *danwei* canteens, the spread of the disease was almost uncontainable. Latex gloves were first-line defence for people trying to insulate themselves against infection, for isolating victims was physically impossible. The gloves were brought to the first experiments Zhang Peili conducted with non-art-specific materials: he incarcerated them in resin, sandwiched between two panes of glass in the form of a scaled-up laboratory slide. They also featured prominently in his first video works.

In 1987, when Zhang Peili attended the initial planning meeting in Beijing concerning a proposed exhibition surveying the progress of the avant-garde from birth to date—"China/Avant Garde", which eventually took place in February 1989—the epidemic was on his mind. Emphatically so, when, in the spring of 1988, he became infected, and was left so ill as to be confined to home and bed. Isolation gave him time to think, his thoughts locked onto what he saw as the leading issue for aspiring contemporary artists in China: what was art? What was understood to be avant-garde in China was clearly very different from what was embraced outside the Mainland, where contemporary artists were free to do and use pretty much anything in the pursuit of creative innovation. If Chinese artists were to follow suit and appropriate non-conventional materials and forms to art, how would local people recognise it? Equally perplexing was a nagging doubt about the open-mindedness of even those artists who claimed affiliation to the New Art Movement. On the surface, the late 1980s was proving a period of unprecedented laxity, in terms of both the usually inflexible adherence to national ideology—a subject Deng Xiaoping deliberately avoided so as to allow his reforms to take effect—and, as a result, social and intellectual freedoms. Zhang Peili decided this mood presented an opportunity to put some of the current practices of those western artists he had read so much about to use, and try to forge a connection between art and life in the immediate environs. Initially, this would be done as a test of the New Art Movement's impact upon local perceptions of what the role of an avant-garde artist encompassed.

Tai Chi, 1986—a Pond Society
intervention with a Hangzhou street

Zhang Peili's concept pivoted on creating a written document, but included everything from the initial thought process to the distribution of the text and gauging audience reaction to it. To avoid the pitfalls encountered by the Pond Society, such as works going unnoticed, a vehicle was needed to ensure the document got seen. Zhang Peili turned to the postal service as the most public channel for directly reaching a target audience and for placing the document in people's hands. He envisioned this method as engendering a personal, intimate experience of the work, and an honest, gut response to its content. The subject of the text was the pressing social issue of public and personal hygiene and, as a "document", was formulated to prompt readers to examine their own habits and attitudes. In addition, enclosed in each document was a single latex glove.

Believing artists to be more savvy than the general public, Zhang Peili chose the student body of the Central Academy in Beijing as his guinea pigs. "I hoped they would be open to innovative forms of creativity, but I was also curious to know what students perceived and defined as art." In the event, all were confused. Some took it as a practical joke, but few gave it serious thought. "I thought they would immediately grasp the concept ... " Unfortunately not. Undeterred, Zhang Peili reconfigured his approach.

"A Chinese proverb says "xian zhan, hou zou": first "execute", then "report" [to the emperor]. It seemed to me that this was rather arse about face. Surely protocol is to first come up with a report and announce your intention to execute an action. This applies equally to art. I decided to present an exhibition concept as a written proposal. It was immaterial then if the exhibition was realised or not. In fact, sometimes the description of ideas stirs the imagination more powerfully than actual artworks, like a book, which is better not made into a film." In this manner, Zhang Peili consigned a strategy that he had been discussing with Geng Jianyi to an article titled *About X? Exhibition Chengxu*, and penned it with grave sincerity. It took some persuading, but an edited version of the plan was eventually published in *China Fine Arts*.[5] In exactly the same way that readers of *World Art* would accept the contents of Xu Bing's *Fifth Street*[6] as unremarkable fact seven years later, readers of Zhang Peili's prose were unable to distinguish it from the standard official outlines produced in

5. "About X? Exhibition Chengxu", Issue 45, 1987.

6. See at "Xu Bing: In a Word", p. 343.

conjunction with national art exhibitions. Within the context of the moment, and as the first of its kind. It was a sophisticated test, demanding as much of an audience as *30 x 30*. Being equally unorthodox, it ended up as another attempt that failed to register.

Still Zhang Peili did not give up. Determined to see how far he could push the idea, in 1988 he reworked *About X? Exhibition Chengxu* as a longer article titled *Art Plan No. 2*. Here, the language of Chinese law was brought to a precise and highly detailed description of a second exhibition plan, the kind of legal language or rationale that was used to negate art in doctrinal ideologies: and which Geng Jianyi would subvert in his work *Marriage Certificate* in 1993. *Art Plan No. 2* was included in "China/Avant Garde" in 1989. As part of its jocular premise, a number of the clauses it contained spelt out boundaries of exclusion reminiscent of mass rectification during the Cultural Revolution, and the strict demarcations of social categories that were applied to the masses. Its leading covenant was that anyone wearing red was automatically barred from viewing the works on display. Had the rule been enforced, the Chinese penchant for red would have excluded a large segment of the audience. For the children of families condemned as being a member of the "black gang" during the Cultural Revolution, who as a result were denied the all-important red neckerchief—the defining badge of communist youth—it was also a painful reminder of their ostracism. *Art Plan No. 2* reversed the situation: avenging the excluded by imposing an unexpected dose of exclusion upon others. It is human nature to seek acceptance from a group in all social contexts; exclusion breeds anxiety, especially where the regulatory grounds upon which it is based appear irrational. *Art Plan No. 2* is but one example amongst Zhang Peili's works in which he demonstrates how irrational most grounds can be. So here, at last, was a valuable breakthrough. Zhang Peili had uncovered a way to insert subtle references to history and Chinese consciousness into his art, manipulated to suit his agenda: complacency—towards regulations, which Chinese society had made to accept without question for so long—had been provocatively challenged, if only those who visited "China/Avant Garde" prior to its being closed down.

Art Plan No. 2 was not subsequently published in China but it was exhibited at Zhang Peili's first solo exhibition in Paris in 1993.[7] However, stumped by an unfamiliarity with Chinese characters, French viewers who didn't read Chinese were denied an opportunity to comment or to recognise the challenge it offered.

In 1989, as the "China/Avant Garde" exhibition loomed, the fame Zhang Peili's iconic aesthetic had accrued was wholly attributed to his paintings and documents, even where reaction to the latter was sceptical. Following the art community's dismissive response to *30 x 30*, even as curators of the seminal exhibition promised a microcosmic panorama of the concerns, practices and aspirations within the New Art Movement, it was never in with a serious chance of being selected. At the time, this seemed insignificant against the unparalleled importance of show: Chinese avant-

7. Solo exhibition at Galerie Crousel-Robelin, Paris, France.

garde art admitted to the domain of the nation's leading art museum. Although the majority of works selected were entirely avant-garde for China at that time, en masse, the impact was less dynamically arresting than expected. As is his wont, Zhang Peili surveyed the show with a cool, detached eye. "It was like a department store. There was no distinction between decorative, conventional styles, and works intended to be avant-garde. Innovation and creativity were clearly less important than metaphors for social context that critics extrapolated from them and used to illustrate their own art theory ... Art should evoke these things without illustrating them."

Document on Hygiene No. 3,
1991

The situation was complex. In its own way, the avant-garde, spearheaded by a curatorial committee of critics who, like Gao Minglu and Li Xianting, held editorial positions in State-run art magazines, were seeking to engage with society. There could be no more direct way than entering the public arena in Beijing, and nowhere more prestigious than the China Art Gallery (renamed National Art Museum of China in 2002). Working with the State, meant complying with its procedures and regulations, which was not all compromise as long as its proscribed definitions of acceptable aesthetics appeared to be upheld. That required enormous skill which, as the success of their lobbying indicates, leaders of the curatorial committee indeed possessed. What was not then feasible was an overnight change in policy or ideology. Where the green light given to the "China/Avant Garde" exhibition was read as signifying exactly that, it was but ardent wishful thinking getting the better of the sober-minded pragmatism that, of necessity, artists habitually brought to their dealings with the authorities and society in general. The main outcome of the clamp down, which activities during the exhibition's opening incurred—a live gunshot fired into an artwork, together with the enactment of a number of spontaneous performance pieces, which were expressly forbidden—saw contemporary art banished from the public sphere—a situation that continued through to the late 1990s. Zhang Peili, so concerned to provide Chinese society with dynamic, relevant new art, was effectively barred from playing in his own backyard. Thus, for the time being, he, together with the leading lights of the avant-garde community, had no hesitation in accepting foreign invitations to cultural playgrounds abroad.

In taking their art overseas, the Chinese avant-garde enjoyed mixed experiences, the best of which was the opportunity to see at first hand where contemporary western art was at. It was a process by which the weaknesses and strengths of individual styles were exposed. The impact on Zhang Peili was as much an affirmation of his thinking and the experimental approach he had embarked upon, as a challenge to extrapolate these western methodologies to non-Chinese cultural frameworks. Within Zhang Peili's work there was no radical change in theme. His preoccupation with mundane routines—an inalienable social plague in China, but equally apparent in all societies, as he discovered—continued. He also began to explore subtle evidence of change within the daily lives of Chinese people, such as changing habits in eating, self-awareness and pastimes. Nor did his fascination with the nature of individual existence and social interaction within a social group or a physical space diminish. What did change was the way in which he would present his innocent provocations: from this point hence, video was the single medium deployed.

Picking up from where *30 x 30* left off, Zhang Peili used the video camera primarily as a tool to record an action or activity, carried out by himself or another person. A stationary camera, with no change in angle or focus, established an emphatic focus on the subject. Even as his experience increased, Zhang Peili kept the camera firmly tied down, but not always to a tripod. Instead, the advent of light, compact digital video cameras allowed him to strap them to a body in motion, a sleeve, a hand, an ankle, which results in a strangely unfamiliar perspective on activities, objects and environments that we know to be as familiar to us as our own features. *Eating*, 1999, is a good example of how Zhang Peili exploits the various angles captured by cameras fixed to moving objects, imbuing this universal and primal activity with a whole new sensation. When simultaneously replayed on different screens, the unfamiliar angles effect an almost Cubist juxtaposition of a body in the act of eating.

In 1991, Zhang Peili produced the first work of his new phase; a video piece, naturally, titled *Document on Hygiene No. 3*. It remains a pivotal work, not least for the political symbolism it is perceived to contain, and which established a residual popularity for Zhang Peili amongst foreign curators. Here, he films himself, hands sheathed in latex, as in *30 x 30*, in the act of washing a chicken. Viewers are not required to know that the person—who looks rather like a convict—is Zhang Peili. The focus is centred on the chicken alone, which is prevented from fleeing by the sheathed hands, and thus restricted to a stationary position in a plastic bowl and a shallow pool of water. The usual reaction is amused amazement, followed by transfixed silence as Zhang Peili attends to the task of pacifying and washing the bird. The scenario is strange enough to keep viewers puzzled, while the rhythmic motion of his hands works its hypnotically seductive magic. It is hard not to revisit one's own experience of washing, being washed or massaged. The conjuring of individual sensibilities here is pivotal to the action being perceived as sensual or uncomfortably unnatural.

"I derive my ideas from personal life experience. This is a good example." The personal experience in question dates back to Zhang Peili's childhood. "Then life

Document on Hygiene No. 3, 1991

was simple and hard. Most households kept chickens and I took care of ours. They weren't pets—they were raised to be eaten—but they were the closest thing I had, so I played with them and in doing so observed their habits. Chickens avoid water, preferring to bathe in dust; it would never occur to anyone to wash them."

As Zhang Peili begins, the chicken recoils, but the flow of his hands along the nap of its feathers, as he works the soap into a lather, effectively subdues the bird. "Washing should be comfortable, but we cannot pretend to know how a chicken feels about contact with water: if it is joy or anguish? [The Chinese philosopher] Zhuangzi once said, "We are not fish" [meaning that man should not foster human emotion onto fish and assume how fish feel at any given moment]. People communicate what they feel in a holistic fashion through speech, gestures and expressions, yet at times we wilfully impose our own interpretation onto the expression or action of others. People don't experience things in the same way, which results in different sensibilities: for those obsessed with cleanliness, the sight of dirt can induce physical pain. That's what I was really trying to get at with the chicken."

Yet there is a further insinuation here, which relates to the symbolism of the chicken in Chinese culture. As a simple silhouette, the shape of this bird is seen as resembling the geographical spread of China's borders; a fact noted by almost every critical reference to this work. A plausible interpretation of the work is, therefore, a subtle allusion to the ideology in which Mao bathed the people, subduing the masses with his own brand of soap. Zhang Peili's response to this is typically equivocal: "I can't control the nature of interpretations that are brought to my work."

Against all the constraints that appeared to govern the public cultural sphere of the early 1990s, a number of significant events still took place. In 1991, Beijing played host to "New Generation" at the History Museum, a more sedately restrained exhibition than "China/Avant Garde" in the choice of works it presented although by many of the same artists. Meanwhile, in November that same year, Shanghai was the site of a progressive exhibition of experimental works titled "Garage Show", curated by Zhang Peili, together with former Zhejiang Academy classmate, Song Haidong. This show was not entirely aimed at the local populace. Zhang Peili had temporarily given up on that approach and with this exhibition was putting on a display for a visiting Japanese curator. Magnanimous as always about working as a collective, the exhibition was to include works by a range of established and emerging artists from Hangzhou and Shanghai. It was here that *Document on Hygiene No. 3* received its first showing and, unlike *30 x 30*, a positive response.

From this point on, Zhang Peili's career began to take flight. "Garage Show" resulted in an invitation to exhibit in Beijing—a two-man show at the Den in mid-1992—and most significantly, the opportunity to participate in the Venice Biennale in 1993. There were also solo shows in Paris, the artists' residency in upstate New York, and a string of group exhibitions—both "Chinese" and international—that ran through to the late 1990s, when he, as all contemporary Chinese artists, was finally sanctioned to enter the public arena in China.

By 1992 Zhang Peili had begun to achieve serious critical acclaim abroad. He slotted into the international scene seamlessly, and where the politics of his own cultural framework lent his work context as well as edge, the simplest of subjects gained exponential depth. Most rewarding were the opportunities this brought to observe public interaction with, and responses to, his work. One of these was *Water: The Standard Pronunciation*, produced in 1992, and shown first in Paris. Here, a professional newsreader speaks to us from what seems to be the typical newsroom set up. Instead of delivering the news, she patiently enunciates the definitions of the word "water" in the officially proscribed tone—like an exemplary sound byte of BBC English. Via a fixed lens and a single repeated activity—an anti-narrative that makes the monotony pronounced—*Water* plays at being one thing and actually delivers something else. A parody of a television newscast—a subliminally powerful mass medium with catholic human appeal—this work gently mocks official programming and the omnipotence of propaganda. The "standard pronunciation" of the title also alludes to the standardising of culture in the PRC; the investiture of Han culture (as embodied by the ruling regime) across a nation of diverse peoples comprising fifty-six different minority groups. The issue of a common spoken language, essential to consummating the unification of these peoples as one the nation, was solved via *putonghua* (meaning common language), which most western people know as Mandarin, but which is based on *guo yu*—literally, national tongue—established by Sun Yat-sen during the Republican era. In terms of the standard dictionary pronunciation, *Water* implies a fixing of ideology within the vernacular tongue. For non-Chinese speakers *Water* might easily be mistaken for a language lesson—except that the lesson never transpires—but for the Chinese people, Zhang Peili's emphatic reference to the definitive wording of the news has a provocative resonance.

Water: Standard Dictionary Pronunciation, Ci Hai, 1992, performed by television news reader Xing Zhibin

In addressing the communicating of ideas across cultures, Zhang Peili faced several challenges in elucidating the nuances of China's cultural climate to a non-Chinese audience. The chicken motif does require viewers to link the bird with its symbolic relation to China, just as *Water* requires a mental leap of faith to recognise an absolute ideology and the

≪ Children's Playground, 1992

means by which it is imposed. One early solution was found in *Children's Playground*, which also demonstrates that against the serious contemplation he brings to his art, Zhang Peili retains a sense of humour. The work comprises a looped piece of footage of a children's mechanical toy, in which idiosyncratic plastic penguins rotate mechanically to the top of brightly coloured plastic steps, and slide down a sky-blue plastic ramp that returns them to the queue at the bottom of the steps. It is a mesmerising metaphor for the mundanity of human existence, cycles, routines and ruts, and imperturbable nature of crowd mentality. Here, echoing the fundamental tenet of Marxism, individuals as cogs in the collective machine.

As Zhang Peili got into his stride, his work moved away from the simple form of one projector and one screen. The first to employ multiple monitors was *Best Before 8/28/1994*, an installation centred on a favourite Chinese reverie—the lovingly precise preparation of a sumptuous dish. The video element of the work comprised a recording of the preparations necessary for making chicken soup (a dish known for its nourishing and restorative properties), and was presented on twenty monitors that ran along the interior walls. Portions of soup were placed in pans on each of ten electric stoves placed on the floor, and were heated each day. The artist left instructions that a little water be added each morning, with the result that the essence of the soup was eventually distilled into boiled water; anihilating its efficacy by dillution, in rather he same manner that Zhang Peili had alluded to the weakening image of the Mao era in the photographic work *Continuous Reproduction*.

In turning to multiple monitors, the physical harmony of their placing was finely aligned with the visual harmonics of the motion and stasis Zhang Peili had selected for a work. "I don't like extremes: neither of simplicity nor complexity, although simple things tend to reach a wider audience. So it's important to strike a balance. Art shouldn't be too vernacular, a language that only a particular group of people speak. I want to speak to everyone."

The challenge for Zhang Peili was of balancing the Chinese background to each work with its relevance to western culture. The brilliance of his solutions lies in the

universal nature of the actions in the work, yet the specific references they make to his immediate cultural framework. "An artwork must communicate. It might have many things informing it—philosophy, religion, and politics—but those things are not art of themselves, and should not be given priority. Of course any artwork relates to the artist's education, knowledge and awareness, but nobody is impressed merely by how many books an artist has read, or how much philosophy they understand if the art they produce is unintelligible. The important thing is to touch issues that touch ordinary people."

The theme of anxiety initiated in *30 x 30* recurred again and again as Zhang Peili tried to clarify that which differentiated pleasure from pain, an exploration begun in *Document on Hygiene No. 3*. "I always believed that pleasure would be doing exactly what I wanted to do when I wanted to do it: not about having money per se but having enough not to worry. But as I was afforded more freedom of choice, I discovered that to choose is of itself painful. In the period of transition from no choice to free choice, you can't help but live in fear of making the wrong choice. So, the pleasure of exercising choice becomes questionable, or at the very least, relative."

In 1996, Zhang Peili put these thoughts into visual form in the aptly titled work *Uncertain Pleasure*. It features a number of monitors that each replay a person scratching a different, tightly framed part of their body, as if trying to relieve an itch that is apparently hard to diminish even when the skin turns red raw. "I have heard many interpretations about how this piece relates to Chinese society, or a specific

Uncertain Pleasure,
1996 (detail)

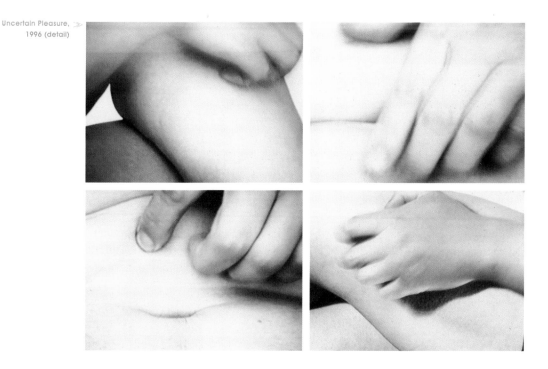

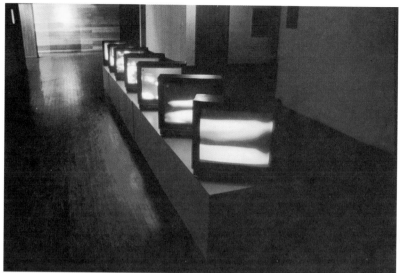

means of Chinese expression. For me it was a phemomenon with which people are familiar. The piece refers to contradictions: some people enjoy scratching while for others it's a discomfort. Small things in life bring pleasure and pain at different moments."

The idea of differentiating pleasure and pain was carried into *Three Views*, produced for the exhibition "Out of the Centre" (at Barcelona's Santa Monica Arts Centre) in 1995. Here, with a nod to *Art Plan No. 2*, Zhang Peili aimed to test the general threshold of psychological anxiety by placing individual visitors under enforced confinement. *Three Views* comprised two physical spaces closed off from the exhibition hall by a door that automatically locked itself for thirty seconds once a person had entered. On one level, it explored what people do when they find themselves stuck, albeit temporarily, in a small, confined space. A mirror inside appeared to provide a private moment for checking appearances, although as one of the three views, the mirror acted as a camera and the person's actions were simultaneously broadcast to the crowd outside. All in all, it was awkwardly voyeuristic.

Zhang Peili is skilful with words. The cultural polemic of being a "Chinese" contemporary artist is a question he ignores in his art, but it is one about which he openly speaks his mind, evidenced at symposiums and in articles. "What eventually emerges are interesting works or interesting artists, whether or not they are Chinese, and regardless of cultural background. If the art is good and can stand alone, then we seek to explore its background. If the work is not interesting, who cares where it comes from: an interesting context doesn't mediate bad art."[8]

In 1996, Zhang Peili was asked by the late contemporary Chinese art historian Hans van Dijk to put down his thoughts on the state of contemporary arts in China. The

8. Francesca dal Lago, "Contemporary Chinese Art: Neither Panda Bears nor Student's Homework. An Interview with Zhang Peili", published in electronic format in Chinese-art.com. Special on the 48th Venice Biennale, Vol. 2, Issue 3. August 1999.

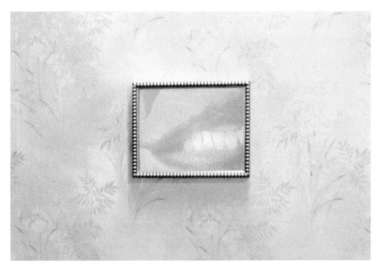

Screen A, created for "Another Long March", ≫
Breda, Netherlands, 1997

result was "At War with the West?", a pointed censure of the jingoistic attitude of critics and artists of the Chinese avant-garde in the early 1990s.

> During the period from the 1950s to the 1970s, as Chinese people were fed confidence by Mao Zedong's saying "The East wind prevails over the West", they saw themselves as the centre of the world. They believed China represented the heart of justice across the globe: justice that would one day rise above the West and change the world. This self-confidence collapsed in the late 1980s when it was discovered that China was not as great a force in the outside world as people had been led to believe ...
>
> ... The real, profound influence [of western art] felt by Chinese artists has been ... [producing] an art that is marketable. Many artists attach greater importance to making a name ... than to exploring art itself ... In China, Andy Warhol is widely regarded as an example of an artist who achieved both fame and fortune ... People love to quote his "fifteen minutes of fame", taking it as a bugle call for the march towards success. ... But what should we do today in the name of avant-garde?[9]

By now, the domestic climate was showing visible signs of change. In autumn 1996, curator Wu Meichun, together with artist Qiu Zhijie, produced the first video exhibition in China, significantly at the CNA, their alma mater. This was to be a milestone for avant-garde art in China, and for video art. The show was pioneering, not least because the curators managed to procure sponsorship from the manufacturer of televisions and video players, which lent the necessary mode of professionalism to the display. As a result, video finally achieved credibility as art, and was even enjoyed by a small local public. The majority of the artists included were from the younger

≪ Endless Dancing, 1999 (detail)

把我们假炼得
我爱大海的惊涛骇浪

9. Zhang Peili, "At War with the West?", *China: Aktuelles aus 15 Ateliers*, published by Hahn Produktion, Munich, 1996, p. 133.

generation who saw Zhang Peili as the master. His contribution was *Focal Distance*, a work that renewed his initial fascination with television and the truth or clarity of what is broadcast. Its especial focus is on the reading of physical space, here distorted, as one continuous frame of an urban vista was refilmed, and the refilmed footage refilmed through twelve cycles until the original scene was reduced to an abstract flickering of fuzzy lines and patches of light. Aesthetically, it remains his most painterly video work. This engendered a delicate shift in the focus of Zhang Peili's art towards an expression of more personal aspirations and interests: in many instances, a measuring of how achievable human aspirations are.

The summer of 1999 was particularly busy as Zhang Peili addressed the complex issue of media formats for works that had been selected for a string of exhibitions through the autumn, in locations that stretched from the Antipodes to the northern tip of Europe. Around him in China, change marched ever more swiftly on. The extraordinarily rapid growth of the consumer market for high-technology products made the latest digital technology both available and affordable. As analogue video was replaced by digital, the videocassette was being superseded by DVD discs, offering almost unlimited storage capacity and stability. However, the transition was not without technical challenges.

Zhang Peili passed the steamy days of August in Hangzhou in an edit suite, bare feet up on the console as he reviewed footage for his latest work, *Endless Dancing*. In what was proving a new age of ample leisure, encouraged by the greening of city centres and re-cultivation of public parkland, social dancing was all the rage. Nothing encapsulates the impact of reform and opening, of community and the general aura of confidence found within the sheer pleasure people derive from the pastimes they have embraced as relaxation quite like the open-air dance gatherings. This phenomenon provided a relevant and current subject, which matched the criteria Zhang Peili set for his work. *Endless Dancing* begins with sequences of local ballroom dancers, enthusiastic amateurs whose eager poise and wishful swirling were shot simultaneously from eight different angles. In the edit suite these were dovetailed with the glamorous contrast of a taped international competition. Against the amateurs, the sleek professionals, in puffs of foaming feathers and sailing tails, eloquently illustrate the gap between reality and the glamorous ideal to which ordinary people aspire. As the Chinese dancers glide, one senses a wistful air about their expression; the earnest efforts the fifty-something generation invest in mastering the steps suggests their unrealised dream of being professional themselves, a dream impeded by the socio-political circumstances into which they were born.

Zhang Peili stayed in the studio night after night, ironing out the complexities of time-based slippages caused by digital re-formatting. As the deadline for completing *Endless Dancing* approached, and in spite of the second round of problems he anticipated once it reached the technicians installing work for the second Asia-Pacific Triennial of Contemporary Art in Brisbane, he remained whimsical. Forsaking the

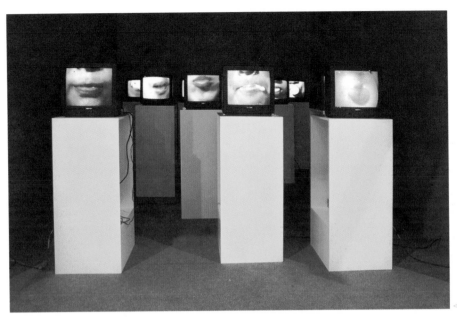

culinary standards to which he usually adhered, he sustained himself with Oreos and tea supplied by a junior trainee who, enthralled by his proximity to a famous artist, jumped to every task he was bid, allowing Zhang Peili total concentration on the task in hand.

Endless Dancing is typical of how Zhang Peili matches social comment and a beguiling expression of humanity to a rich visual impact, in which the components of colour, texture, form and composition are sine qua non. Perhaps the best example of this match is a piece about bubble gum, titled *Expand Constantly*, which was inspired by students under Zhang Peili's tutelage—who he subsequently filmed—whose bubble blowing techniques struck him as amazingly proficient. Using twelve monitors, which each run footage of different lengths at different speeds, Zhang Peili creates a field of expanding bubbles emerging from startlingly ruby lips, amidst constant popping as each bubble of gum collapses in upon itself. As with *Just for You*, the focus on a new phenomenon—in this instance, bubble gum, as a modern icon that is known and recognised globally, which has achieved a cultural status that is no longer aligned with a single national identity. *Expand Constantly* effectively points out just how far China's youth has come since Zhang Peili's student days in the early 1980s.

The approach of a new millennium added another dimension to China's national programme of advance. It acted as a watershed; the means to a psychological break with the past and to consign much of the political baggage of recent history to the twentieth century. The same dramatic social change that had given rise to China's on-line, wired-for-sound, and computer-game-obsessed youth saw the Shanghai Biennial win the support of city's municipal government, and in 2000 its organising committee took the initiative of turning the event into a truly international Biennale.

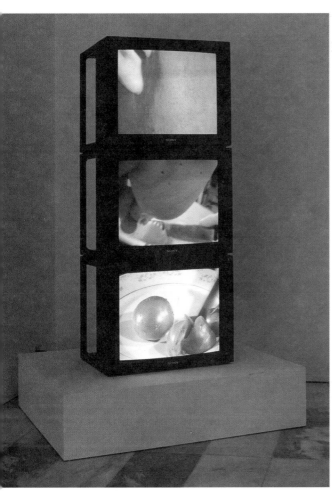

Eating, 1999

Alana Heiss, director of New York's P.S.1, and the influential Japanese curator Toshio Shimizu, were invited as guest curators; a progressive move that ultimately ushered in a new era for avant-garde—or contemporary—art in China. Both curators were switched on to the thrust of China's contemporary art scene, and their selection of artists included a number of Chinese artists, known internationally but who had yet to be introduced to the general public at home. Their efforts resulted in a landmark event which put Shanghai on the global art map, and established the Shanghai Biennale as a must-see event on the international cultural calendar.

Zhang Peili was one of the artists selected. The work he chose to show promised to fulfil his long-held aspirations for art, beginning in the late 1980s with his desire to engage Chinese society, to forge links between art and life, and break free of the restrictive, ideology-driven conventions that Mao had imposed upon creative expression. Furthermore, embedded in the content of the work was his most direct assault on complacency.

The openness permeating through Chinese society owed much of its impetus to the multiplicity of means by which information could now be disseminated. The internet afforded ordinary people almost unlimited access to information about world events and external cultures, and they embraced it enthusiastically, driven by a thirst for knowledge that, in spite of subsequent lock downs on undesirable sites, saw them become much more informed about the outside world than the outside world was about China. By now, Zhang Peili's international status as a leading exponent of the Chinese avant-garde had afforded extensive travel abroad. The experiences he amassed affirmed the assertion made in his 1996 article "At War with the West?" that "China was not as great a force in the outside world as the [Chinese] people had been led to believe." The Shanghai Biennale offered a powerful platform for comparing and contrasting the dominant characteristics of the divergent cultures of individual nations worldwide in a work he titled simply News. "The dawning of the millennium marked an important moment for China. What was presented as being of major importance for China on the domestic front was not in the least bit

newsworthy abroad. *News* was a means of examining different national agendas, cultural, economic and political, at this seminal moment in history."

Enlisting the help of the many friends Zhang Peili now possessed in the art world abroad, he distributed a request for volunteers to record the news broadcast of their country's national television network on the evening of December 31, 1999. The response resulted in recordings from twenty-seven countries. "It was a fairly even spread but there were less from the Middle East than I had hoped, particularly Iran and Iraq." Given the invasion of Iraq in 2003, this was an unfortunate omission although, ironically, news reports from the region broadcast on Chinese television gave the domestic audience a more profound insight to the national agenda of this totalitarian regime than the Iraqi news programme might have done. This aside, the twenty-seven recordings met the intended requirements of their role in encapsulating the driving concerns of their country and, together, laid out in broad strokes the global context within which China's presence was becoming key. In many ways, the issues at stake for each nation, the achievements, triumphs and the challenges faced—economically as well as politically—only made the efficacy of China's momentous advance more emphatic.

In terms of received impressions of *News* during the Shanghai Biennale's six-week run, Zhang Peili was forced to ask himself "if the audience got it ... " As he had theorised in the late 1980s, intelligent ideas that sounded good on paper did not always translate as clear, or powerful visual experiences. In this case, the plurality of languages was a major stumbling block, for none of the recorded programmes were subtitled. Foreign viewers familiar with a programme format that was largely universal could grasp the gist, but as with the showing abroad of *Art Plan No. 2* and *Water*, the all-important cultural conventions inherent in each recording were lost on domestic viewers used to television content driven by strict State control. To add to the confusion, staff at the Shanghai Art Museum elected to turn the sound off, reasoning that the cacophony interfered with the viewers' experience of adjacent works. The challenge of deducing the subtle signifiers that make each nation identity unique from the race, dress and facial expressions of the presenters alone, effectively silenced the message Zhang Peili intended *News* to communicate.

The mound of responsibilities that being department head accords has inevitably reduced the time Zhang Peili is able to devote to personal work. By way of compensation, the new media department's impressively equipped studios offer direct access to the most advanced technology in China. Overall, in spite of the tedious administrative duties Zhang Peili is obliged to perform, his position affords more freedom than constraint. After little more than a year in the job, the academy's decision to turn the new media centre into a full department was a direct result of the centre's overnight success. Being left alone to develop his own curricula has led to a change of heart about the academy environment, to the extent of championing the establishment that previously filled him with frustration. "Teaching has changed dramatically since I was a student. I always found the system fascinating: you can't

Actors' Lines, 2002 ∧

get round it [in China]. The only way to change it is from within, when opportune moments present themselves. In that respect, I have been fortunate in gaining the academy's full support in organising the department as I see fit."

In mapping out the goals of the new media department, the flexibility of the curricula has proved to be Zhang Peili's major breakthough, specifically, in its emphasis on inviting practicing artists to teach blocks of classes, during which students complete personal projects, suggested and guided by the varying interests of the visiting artist. "It's about letting the students experience different disciplines and approaches. I also encourage them to visit other departments. Video is a tool, but it is one of many, many out there. To impose any model is wrong; to adopt "conceptual art" in the place of Socialist Realism would be just as meaningless."

Increasing opportunities to show his work in China encourages Zhang Peili to maintain a steady output of new work. The emergence of a diverse range of temporary and unofficial art spaces around the country has now finally begun to map out an arena for engaging the public that was non-existent in the late 1980s. One of these independent spaces was No. 31, located on the outskirts of Hangzhou, and founded and funded by Zhang Peili, together with Geng Jianyi and a group of ostensibly like-minded aesthetes who conceive it as a platform for experimenting with contemporary culture. Local bands perform on a stage in the main bar area, whilst philosophical discussions babble over the soundtracks of classic 16mm Chinese propaganda films screened in the courtyard outside. The cluster of outbuildings—this was formerly a psychiatric institution—are usually filled with works by young artists, often from all over China. The viewing experience of his own private cinema inspired Zhang Peili to produce two works which, when shown as part of a locally curated exhibition in Suzhou, attained the yearned-for impact upon the local audience that he has pursued for almost twenty years. The works *Actors' Lines* and *Last Words* are both centred on tightly edited scenes from post-1949 propaganda films, particularly those of the Cultural Revolution. Sitting in the quiet of No. 31's courtyard one evening,

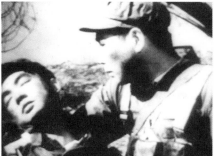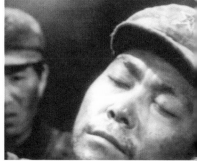

Λ Last Words, 2002

absently watching the film in progress, Zhang Peili was struck by the overwhelmingly exaggerated mannerisms ascribed to revolutionary heroes during Mao's regime. Equally, the speeches that flowed from the actors' mouths; those pragmatically formulaic assertions of political ideology once accepted as national goals and values. Every component of such films conspired to make dramatic moments monumental, in gestures regimented as stringently as the immutable guidelines for creative expression that dogged Zhang Peili's student days.

But there was more. Revisiting the cinematic fiction of the Mao era within the permissive climate of the present, the innocent intimacy that passed between two male comrades in a great number of scenes came across as intentionally ambiguous. Passionate exchanges on the subject of commitment, doubt, determination and fear are thus almost indistinguishable from a profession of intimate emotions between lovers. Hands fall on the shoulders of another with measured deliberation. Eyes lock in intense gazes, or coyly turn away. *Actors' Lines* features a scene in which two men, a soldier and his commanding officer, stand on a bridge in the solitary hush of evening. With consummate tenderness, the officer attempts to understand the soldier's clearly distracted state of mind: "What are you thinking about? Why are you silent?" After a tormented pause, the soldier replies with glistening eyes, "My heart is in turmoil". The officer sighs, before proffering brotherly advice and encouragement. As the words have their desired effect, conversation over, the pair walks away arm-in-arm, as if they were Cary Grant and Grace Kelly—or Keira Knightley and Orlando Bloom. "The metaphor invoked here corresponds to the image of the nation as patriarch to the masses which are the children of the revolution, required to follow the leader as a child obeys the father. But that's an intellectual rational. I was simply struck by the body language." The present corrupts the innocence of this body language, which was clearly oblivious to anything else in its blinkered focus on propagating revolutionary struggle, in a way that none of the perceived threats to Maoist ideology could ever have achieved.

Visually, *Actors' Lines* is an awkward piece, breaking with the gentle rhythms common to the majority of Zhang Peili's video works. Technological advance effected a shift in direction, primarily in terms of style, which includes the use of techniques he

previously eschewed. *Actors' Lines* is an unabashed exploitation of the function of editing, the entire sequence built on a jarring repetition of spoken lines and gestures, cut together in imitation of a scratched record, with edits jumping back over a section again and again, as scratch video, ultimately turning phrases or words into nonsense as the pace increases. According to Zhang Peili, repetition works to mock the language of revolution, alluding to the repeated use of phrases during Mao's rule, and the abstract quality that resulted as they fell on jaded ears. And not just words but the gestures too, like the motion of the officer's hand gliding over the young soldier's shoulder, almost as a lover seeking forgiveness. In the sequel *Last Words*, as its title suggests, Zhang Peili extracts scenes pivoted on the final moments of an individual's life. Here, the affirmation of ideology is embodied in the dramatic swivelling away of heads as their owners exeunt this mortal plane.

These two pieces are exceptions to an approach that prefers to analyse and dissect simple acts and objects so as to give viewers pause for thought. Zhang Peili's video works ask people to reflect upon immutable human activities, in actions that are timeless and where nothing should be taken for granted. "The longer I work with video, the more fascinating it is. Most people are familiar with moving images—as television or film—which moderates any lack of confidence they might have in looking at conceptual art, particularly in China. It's all about ambiguity: for what people see in video art in exhibitions is what they know, yet not."

For a medium that was without a place in contemporary art in the late 1980s, video has come far. Zhang Peili can claim a defining role in the progress that has been achieved: for the history of video art in China will always begin its story with this one subtly candid individual.

With the staff of the Asian Art Museum, Fukuoka, 1999
courtesy the artist

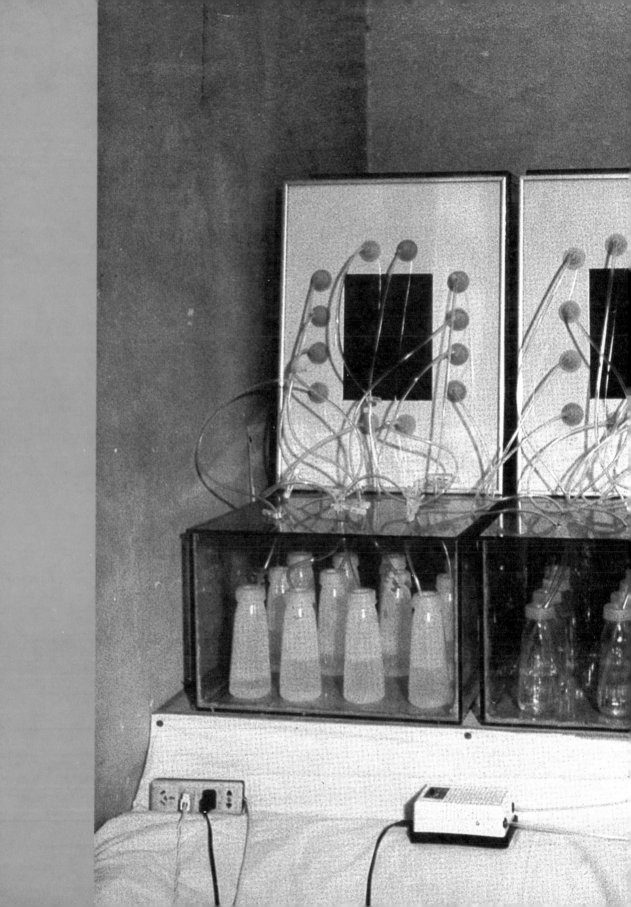

WANG JIANWEI:

DOES GREY MATTER?

Document, 1992

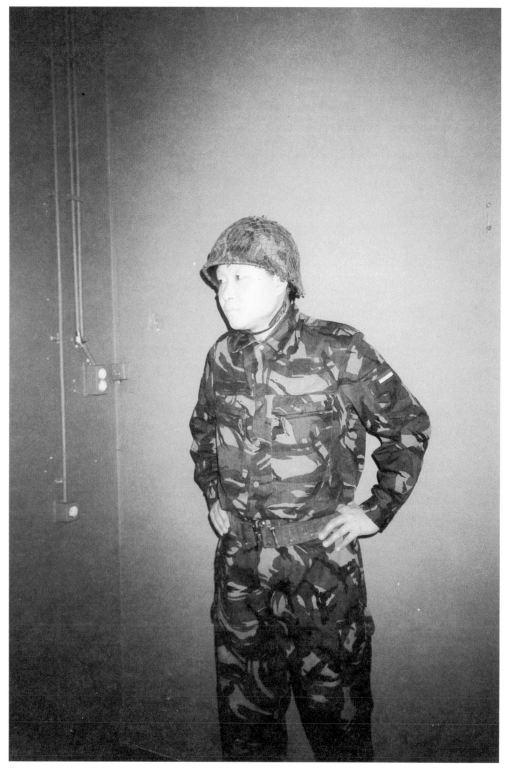

Performance-installation at "Another Long March" held in former army barracks in Breda, Netherlands, 1997. Wang Jianwei drew upon his own military experiences to script a day in the routine life of a solider. A recording of the script, narrated by a Dutch national, was replayed in the space, in which a selection of standard issue Dutch military accoutrements were displayed. The debate here was of commonalities in army life beyond the ideological forces that inform military positions.

"The biggest advance in recent years is not all the new technology, nor the developments in economics and the market. It is that there are less and less limitations imposed upon people ... and yet their awareness of how to negotiate freedom is altogether perplexing ... "

Wang Jianwei does not believe in definitive meanings of words and terminology for categorising art and branding culture. Whilst accepting the broadly generalised implications that have become embedded within the term "artist", his first impulse is to question, if not exactly what kind of artist is meant, then at least what the speaker understands by their use of the word. Should further discussion be pursued, Wang Jianwei is equally keen to ascertain how much his interlocutor has grasped of what Wang Jianwei's art intends to convey. If the answer is unsatisfactorily little, the conversation will take an altogether different turn. Whether or not the turn is satisfactory to the interlocutor depends on the intellectual capacity Wang Jianwei perceives them to possess.

Conversely, on the subject of art or architecture, philosophy or socio-cultural politics, in which Wang Jianwei's interest is immense, he is pedantic about the use of words; often tediously so. He makes little attempt to disguise his disdain for those too quick to apply terms, wantonly or thoughtlessly, to art and life. Be opinionated, controversial, conservative even, but rationalise an argument with cliché or empty rhetoric and Wang Jianwei withdraws from the dialogue, politely but with an unmaskable, even contemptuous, air of disappointment.

It is not only the cultural intellect of the humble proletariat that gives Wang Jianwei pause for thought. He is especially wary of creative practitioners who indecorously describe themselves as "artist" when it is the celebrity of the metier, the envisioned status and profile, to which they aspire, as opposed to the creative visionary that

Wang Jianwei believes the word ought to describe. Why split hairs about a term that has common currency in defining anyone who elects to pursue a creative urge? In the egalitarian lexicon of contemporary culture—which China's contemporary artists seek to embrace—surely artists make art? And where globally the parameters of art have been thrown wide open, what do specifics matter?

"What", Wang Jianwei begins, "is in a word?" It is a question that carries enormous significance relevant to his own life, to the challenge of being an artist within his immediate cultural context, and in his striving to become an artist through the several decades of socio-political transformation from a communist state to the current era of Socialism with Chinese Characteristics. For people of Wang Jianwei's generation, being the progeny of the People's Republic, words were—and, to a large extent, remain—everything. With words, Mao incited a cultural revolution, which demonstrated that, in terms of struggle, the pen could be as deadly as any sword, and an especially efficient tool for subjugating a people. Within the context of this era's ideology, the word "artist" implied "State tool" for manufacturing propaganda; a term that carried none of the romance ascribed to an artist in the European tradition.

In terms of defining the work Wang Jianwei produces, if it were as simple as the customary name-by-creative medium-or-artistic form, the issue would be easier. He began as a painter, producing compositions that, even taking account of the undeniable debt he owes to British painter Francis Bacon, are distinct in their way. But that's where the local definition of an artist—primarily as painter or sculptor as Maoist tenets describe—ceases to apply. Since the early 1990s, Wang Jianwei has produced installations and conceptual works, involving video and site-specific performances, and more recently, plays. Thus, the generic mode "artist" is most applicable, even if it remains a vague concept for the general populace in China. It is this vagueness that Wang Jianwei yearns to dispel, and much of his work centres on the distillation of academic theories into simple socio-human parables in which, words and the thoughts they outline are deployed with precision and restraint. In the documentary-style of video art Wang Jianwei began to explore in the late 1990s, incidences of imprecise and unrestrained words could not be avoided. The speeches and statements made by the people he filmed were, of themselves, an unforeseen yet perfect illustration of the proliferation of grandiose projections that persistently course through verbal exchanges in China, born of equally grandiose declarations made to bolster the socialist revolution and the masses' belief that they would be rewarded for patiently enduring the hardships they faced. That it has been preserved in the present is not due to arrogance or vain pretensions, but because authoritative pronouncements continue to buoy up a patriotic faith in China's prowess. None of the interviewees in the early documentary works are directed, nothing is scripted—that came later as Wang Jianwei grafted the peoples' earnest desires and cogent fallibility onto the characters of his plays. In the process of presenting the unvarnished stories of people in the provinces, the original flow of the subject's delivery is kept intact without the aid of any editing that would enhance their clarity.

By showing people for what they are, Wang Jianwei paints a profoundly honest picture of the broad cultural reality deep in the provinces beyond the booming cities of Beijing, Shanghai or Guangzhou, which suggest an altogether other image of a rapidly modernising nation; one that is equipped to match the challenges of the domestic and global climates. The gulf between rural communities, which clumsily ape urban lifestyles, and the residents of the major metropolis is glaringly apparent to Wang Jianwei, at times disturbingly so, as living standards in the cities continue to rise leaving those in the provinces far behind. From 2001, in embracing theatre as an extension of multimedia art, he found an intensely dramatic vehicle for exploring such issues via a sombre yet playful language that is loaded with irony. His scripted exchanges combine the familiar vernacular of the common people with the deliberately ambiguous vocabulary of oratory conventions that go back beyond Mao's poetically manipulative rhetoric, to the subtle inflections of the literati and the cleverly couched utterings of learned mandarins. The stage also offers the kind of captive experience that Wang Jianwei hoped would inspire his audiences to reflect upon their own individual thought and speech patterns, as well as the sources of information that inform both. Though the plays were commissioned by European impresarios, with the entire dialogue in Mandarin, Wang Jianwei was resolute about presenting them in China—Beijing, specifically—to a local audience familiar with the references, nuances and metaphors they contained. The plot of each play is centred on an assumption that, human nature being what it is, the present might not be so different from the past. This is a well-established device in China, often being the only means of highlighting a circumstance of the times to which direct reference was unwise. It was conventionally left to an astute audience to make the link. In the face of what were pretty stiff odds against securing either official permission or financial support, Wang Jianwei succeeded in obtaining both.

Wang Jianwei almost matches Zhang Peili in the degree of forthrightness with which he speaks his mind; mindfully where he senses his words might be wasted, recklessly when anger, provoked by the irrationality of others, clouds his usual rational response. Yet, he speaks with an honesty that is unbiased and altruistic. Predictably, he does not suffer fools but has endless patience for those with something to say. Wang Jianwei is a staunch and perceptive debater who can read between the lines, even over the telephone. Many discussions are conducted this way for it allows him to edit time-wasters out of a busy schedule which he follows in the privacy of a study-cum-library-cum-edit suite, pouring over books, rushes, or a notepad, working alchemy with a pen and a digital camera.

Simultaneously, and ironically in the light what is inferred above, in striving to achieve precise communication, the vocabulary of Wang Jianwei's spoken language is at times arcane in its convolutions. He possesses a compulsive need to clarify precisely the principles behind his multifarious works. Where these relate to social phenomena engendered by opening and reform and the incursion of acceptable western values and practices, Wang Jianwei resorts to creating new Chinese words, unfamiliar compounds created to parallel western terms specific to philosophy and

western social phenomena that have no readily identifiable parallel in standard Mandarin. Lacking a traceable etymology these invented words sit awkwardly on tongues unacquainted with their task. Even an educated Chinese person who does not speak a particular brand of cultural vernacular struggles to grasp exactly what it is that artists like Wang Jianwei mean. Generally, this is not important because although the images in Wang Jianwei's works—in particular the plays and videos produced from 2001 onwards—are dominated by sentiments specific to situations within China—from the imperial past through the last fifty years to the present—they are powerful enough to draw people over the first hurdle, which is to approach the work, and not dismiss it at a casual first glance. Even so, philosophical musings occasionally carry Wang Jianwei off to another realm, and blinker him to basic and obvious—too obvious perhaps—facts of his work which, for foreign and uninitiated Chinese audiences, do need to be stated. Particularly in regard of the audiences for his plays. Without a basic guide to the story and the background, the actors' displays of literary gymnastics are almost impenetrable. Instead of setting the scene, the text Wang Jianwei initially penned in 2001 to preface his first stage production as an overview for the audience, read as a poetic conundrum—especially to the translator. At such junctures, the staff of the theatre in which the play was to be staged would discreetly intervene.

Wang Jianwei is a veritable sociologist in his thinking. He sees visual art predominantly as a powerful conduit for social analysis. In another time and place he believes he might have studied to become an anthropologist. Yet it was precisely the time and place that was China from the 1960s to the end of the twentieth century, which spawned his interest in the forces and effects of social conditioning. "I am interested

On the rural outskirts of Chongqing, Sichuan province, 1989, as he began work on the Teahouse paintings
courtesy the artist

in the possibilities for an individual voice in society, and what these possibilities imply for contemporary art in China. How can these voices navigate the framework of modern life that has evolved here since 1979, and remain relevant where life changes on a daily basis."

Thus, the issues Wang Jianwei addresses are consistently of a socio-human nature, even where the conceptual forms accorded his works are at times less than universally comprehensible to the common man, who is both his muse and his desired audience. An ardent individualist, Wang Jianwei carries a horror of crowd mentality and a dread of conformity without reason. Leaving the army in the mid-1980s, he stringently avoided the group ethic, which, in his quantifiable experience, swallows up individuals as drops of water sunk in earth. From that point on, he maintained a distance from anything that might, as a voice absorbed into a choir, relieve him of his individual sound. That used to mean large group exhibitions of China's new art, before the growing confidence of individual artists in the late 1990s began to loosen such collaborations and focus on individual standpoints. This particular response to collectives arose out of experiences that contradicted the communal goals enshrined in the nation's intractable ideology. It pivoted on being confronted by hypocrisy and having naive illusions shattered. Each incited frustration and disbelief: as a former soldier who trusted to the motto "Serve the People", invoked as the guiding ethos of the PLA, Wang Jianwei refused to believe those tanks would roll across Tiananmen in 1989. As a member of the avant-garde eager to see China attain equal footing on the international art scene, he despaired of the impact that precious opportunities to exhibit abroad had in establishing a politicised style as the model for Chinese avant-garde art—at least amongst those anxiously impatient for recognition, which at many stages appeared to infect the majority.

As a teenager, Wang Jianwei was soused in earnest, youthful idealism. It was a sign of the times, and the onslaught of disillusionment left him righteously angry as only a young idealist can be. Anger mellowed in time, and latterly, as ideological politics bow to economic politics within the national agenda, the human propensity for saying one thing and subscribing to another, of parroting protocols yet stubbornly flouting regulations, became a sociological issue that, forthwith, demanded serious investigation. Were the people aware of the gap—the grey area, as Wang Jianwei likes to call it—between the Utopian ideal so stridently proclaimed in public and the private reality being lived? Echoing the thoughts of Zhang Peili and Geng Jianyi, he questioned how art could demonstrate that gap and inspire individuals to think for themselves about prosaic issues they commonly overlooked. The intensifying of this interest would lead him away from the fictional world of the picture plane in search of a socially interactive art directly related to what Wang Jianwei discerns as the leading concerns for the proletariat. Hailing from their ranks, he felt impelled to challenge the passivity the masses exhibited in their unquestioning acceptance of the Party line. With empathy, with compassion and, above all, with insight born of his own experience, Wang Jianwei is determined to offer an alternative view. Fully aware of the limited education that most Chinese people receive, he does not expect

to transform them into intellectuals: "It's a simple matter of being able to think for yourself. I don't care if people are for something or against. They should know why they hold their view and be able to trust their own belief in what is right or wrong, otherwise how can anyone make a rational decision, or understand what being a part of society means?"

Wang Jianwei's shift towards a socially-oriented art has a parallel in the nation's ineluctable shift from Marxist-Leninist Communism to Socialism with Chinese Characteristics through the 1990s towards 2000, as China prepared itself for a seat at the table of global politics and trading with accession to the World Trade Organisation. As sections of the inevitable model of modern market—capitalist, first-world—economics were tested, the "iron rice bowls" that cushioned a significant portion of the proletariat through the several preceding decades became untenable. In encouraging private enterprise, the new order offered individuals a chance to make a difference to their personal prospects, which up to that point had been subject to the dictates of the State. The freedom to choose a lifestyle was now theirs to command. Although perhaps not perceived this way by the State, this set in motion the dissolution of the singular prescription of communist doctrines. For a social structure aligned with the one enforced operational mode of the bureaucratic system, individualism had never been an option. Now, the fact of that option contradicted the former ideology of one state of mind and being. Previously immutable parameters were shifting. It was a challenge Wang Jianwei had no hesitation in accepting. Desiring an art form that had meaning for society, within reach of all people, and of whatever form that might occasion, he learned to cross the boundaries between creative disciplines without inhibition.

A: Are you Gu Hongzhong?

Gu: Who are you? ... What do you want?

A: You are under arrest. I am here to check your identity in accordance with this form, which lists a total of 28 distinguishing marks. Apart from that, it is not my job to give you further explanations, or to assist you in understanding.

Gu: Oh, I get it ... Haven't you forgotten something? Where is my [birthday] cake?

A: We do not provide breakfast.

Gu: Were you sent here by my friends, by any chance? Excellent idea, but the joke has gone far enough ...

A: I have already told you, you are under arrest. I am not responsible for other matters. As Gu Hongzhong, you are not allowed to leave this room ... I have been entrusted to make sure who you are, that you are not an impersonator, and arrest you—if you really are Gu Hongzhong.

Gu: You say I am under arrest yet I'm not handcuffed or tied. How can you prove that I am truly under arrest?

A: I never resort to such methods ... I only arrest. I do not prove you are arrested. That is another procedure ... Moreover, if you insist you are not Gu Hongzhong, you are free to go. The person I wish to arrest is Gu Hongzhong.

Where this dialogue sounds Kafka-esque, Wang Jianwei makes his point. His play *Screen*—from which this exchange is taken—highlights and mocks the logic of manipulative power politics in which individuals are reduced to mere pawns. Here, characters change identity with their clothing, shifting allegiance with each new guise where opportunity beckons; or do they? Personal ambition is seen to manipulate others through syntax. Friendship, trust and the appearance of things fluctuate as circumstance demands. All is held in check by a finely balanced wording that points to the ever-present gap between intended meaning and actual individual interpretation. When the actors speak, not everything is received as it is meant, because as the plot unfolds each character is led to doubt his instincts and the motives of erstwhile friends. *Screen* is a parody of life psychologically enslaved by an insuperable political regime, and turned into theatrical farce.

The starting point for the play is a series of hypotheses that Wang Jianwei lines up like dominoes. He supposes that *The Night Banquet of Han Xizai*, an historic masterpiece of Chinese painting, has disappeared; that the emperor who commissioned it, Li Houzhu (937–978),[1] commands an investigation into its disappearance and, that to validate the facts portrayed in the painting, proof is required of the existence of its author, the painter Gu Hongzhong, and of his presence in the home of the accused—the "wayward" official Han Xizai. The basis for these suppositions lies in an assumption that the painting presents incontrovertible historical fact—an emperor's displeasure with an official perceived to have given himself up to a life of hedonistic pleasure. A thousand years on, we can only trust to the accepted deductions of scholarly research of history and aesthetics as pertain to the painting, but these allow Wang Jianwei a cogitative re-reading of the facts, in which imagination is led on by the plausible quality of his supposition. The result is a tale set in an undefined time and place, with no discernible boundary between the text of yesteryear and the performance of the present. The two intertwine in mutual manipulation, allowing us to draw parallels and place the action where we choose.

Wang Jianwei is an avid reader, a habit he developed during his years in the army, driven by a thirst for knowledge that outranked the perpetual danger of keeping books within his PLA barracks. At that time, literature was limited to official or accepted versions of history and to heroic, spiritually uplifting fiction, that habitually applied folk tales to collective, socialist mores. It was only later—in the 1990s with the development of commercial relations with the outside world—that available reading matter expanded to include other, at times non-official versions of history—past and present—as well as philosophy, new social theory, social sciences and cultural

1. Li Houzhu, imperial name Li Yu, was the last emperor of the Southern Tang dynasty (943–975).

politics. Wang Jianwei's fascination for sociology is that form specific to China and born of its political structure and system, the evolutionary progress of which owes much to the period from 1950s to the present, but also stretches back centuries before. He focuses his observations on the behavioural phenomena engendered in individuals who have been subjected to the imposition of an inflexible hierarchy. He began writing semi-autobiographical fiction in the early 1990s, but initially did not give serious consideration to adapting the texts to his art. The prompt was an invitation ten years later in 2001 to participate in the annual Brussels theatre festival, an invitation which came out of his much-envied—by many members of the Chinese avant-garde—participation in Catherine David's Documenta in 1997. An unanticipated door had been opened, which he nonetheless walked through without a second thought. By this time, having begun to style himself a "conceptual artist", Wang Jianwei relished the depth and layering of theatrical space. His inner author rose to the linguistic challenge of exploiting the metaphor and double entendre that in his own experience had, courtesy of the ideology promulgated through his formative years, spawned vast areas of grey fact within the rules and regulations of social existence. The opportunity to stage a play gave Wang Jianwei an opportunity to play with history, to turn it to metaphor as George Orwell harnessed an "animal farm" to his fiction.

Screen's densely woven script contrives to map out a contemporary Chinese screen using complex, and at times abstract, verbal exchanges and stark imagery. This is the ambiguity Wang Jianwei believes the function of a traditional screen embodies. A conventional Chinese screen is a series of hinged wooden frames, each filled with a decorated panel that might be an ink painting on Chinese silk (*juan*) or rice (*xuan*) paper, or a carved bas-relief. But the screen is more than a decorative architectural device. Traditionally, its purpose further served to conceal what its owner would not have seen by outsiders, thus marking a boundary beyond which the uninvited could not step. Wang Jianwei extrapolates the screen as a metaphor of deep cultural significance in the same vein as the European castle was deployed by Kafka; the castle, a symbol of defence, steadfastness, and the power of the man who dwelt within; the screen, a refined attribute of a cultivated and learned owner that could also conceal secrets. Wang Jianwei uses the screen as metaphoric evidence of "the physical world being altered and redefined by human intervention. I believe the nature of that desire was shaped by China's specific cultural ideology, which in turn, shaped the character of society and all the individuals it contained."

∧ Opening sequence of Screen,
performed in Beijing, 2001

Screen—stills taken from a
video recording made during
the Beijing performance, 2001

The Night Banquet of Han Xizai demonstrates how effectively the screen could be used as a pictorial, as well as architectural, device within a painting. Gu Hongzhong masterfully incorporates a series of screens as scene markers, and so subtly as to not interrupt the arterial rhythms that undulate through the sequential episodes which flow across the scroll. This careful deployment of the screen cleverly focuses the viewer on the activities within, and permits Wang Jianwei to interpret *The Night Banquet of Han Xizai* as the evidence of a spy presented in the most sophisticated of guises—as an exemplary ink painting. "There are issues here that fall outside of art history", Wang Jianwei asserts.

Clearly, Gu Hongzhong was successful in assuming the passive role of guest and being admitted to the activities of the intimates gathered in Han Xizai's home. The activities are made the focus of the painting, each accorded its own vignette, neatly framed by an arrangement of screens. Thus, beyond providing a cryptic account of an actual historical plot, Gu Hongzhong chronicles the lifestyle of a particular household of the time, one common to the class of wealthy and educated men. The divide between high moral virture and debauchery is delineated by the element of frivolity (wine, women and song) and decadence that adorns each scene. But looking at the painting today, it is perhaps not entirely apparent that a work of undeniable grace is, possibly, a defamatory report of the wayward life of a scholar-official who lived more than a thousand years ago. We can be sure that the rationale for such a commission would have been couched in a more subtle timbre by imperial lips at the time. What remains a mystery is the exact means by which Gu Hongzhong was selected—or persuaded—to undertake the task, or how that task was defined by the emperor Li Houzhu. Certainly, in the absence of photojournalists, Gu Hongzhong's skills as a painter were commandeered to document the facts of Han Xizai's daily life, with the result being as damning as a paparazzi's exposée.

In staging *Screen* as a kind of inquisition, Wang Jianwei introduces multimedia devices that transcend conventional visual art and theatre. The play has no real characters, no real plot. It is hardly a play in the absolute sense. Wang Jianwei describes it instead as "a kind of archaeological digging around the fact of the painting and using the pieces of information uncovered to restructure or reconstruct the evidence." So, is *Screen* about history past, or history in the making? What has changed? Certainly not the duplicity of which individuals are capable, and to which society conspires.

 Screen—stills taken from a
video recording made during
the Beijing performance, 2001

Screen points to the shades of ambiguity and greyness engendered by the type of political misjudgment that led to the Cultural Revolution but which also overshadows Chinese culture through much of its recorded history, inculcating the present too.

At the two dress rehearsals for *Screen* in Beijing, there was not a vacant seat in the house. The fact of a contemporary artist gaining permission to present an unknown play in a State theatre was significant. Many more people turned up for a third night only to be disappointed. The convoluted plot required a high degree of mental agility, which left some members of the local audience slumped clueless, and unconvinced in their seats. But when the curtain fell, the unusual combination of techniques and mediums Wang Jianwei brought to the stage left no one in doubt that experimental theatre in China had taken a great leap forward. For a significant number of those who didn't get it, that fact that *Screen* was apparently beyond their grasp merely confirmed its progressiveness, and succeeded in making them think. More importantly for Wang Jianwei, the play demonstrated that his career had evolved beyond anything he could have predicted when he started out as a "painter".

Born in 1958, Wang Jianwei grew up in an age thick with rhetoric, slogans and officially guided thinking, dominated by an all-pervasive unity. It was a period in which human endeavour was channelled into specific and narrow tunnels of employ: unity in name—in the *danweis* and communes—but not always in nature. People were busy surviving, saving their own skin or suffering the consequences of the ranks into which they were born. Martyrs were decided by the Party, not by individual bravado.

Wang Jianwei was born in Shuining, a small city in Sichuan province, but his family left before he was old enough to have any recollection of it. His father was a cadre in the PLA, and the family was constantly on the move, subject to the whims of Party manoeuvres, campaigns and organisational brainstorms designed to maintain political stability by keeping the population engaged in an all-consuming social momentum. Between 1949 and 1981, Chinese society undertook twenty-five separate and major political campaigns, each one ushered in with reams of rhetoric addressing a new set of attitudes to be adopted and carried forth. Contradictions—yesterday's black becoming today's white and tomorrow's green—were not open to question. More

than just making a simple, lasting impression on Wang Jianwei's life, the sound of the system imprinted itself deep in his psyche as the people blindly followed the ideology like a mass of sheep all bleating in one voice. This monotone voice became his greatest source of perplexity.

Wang Jianwei's own experience of being sent to the countryside, with all the regulations of the communes, and of being in the army, are pivotal to the attitudes and theories that underpin the themes in his art. The two experiences converge exclusively in a video work entitled *My Visual Archive*, produced in 2003, which juxtaposed film footage from revolutionary operas of the 1960s and early 1970s with that of Chinese-produced war epics from the 1930s. Both monopolised the masses' visual experience to the late 1970s. *My Visual Archive* was created for the exhibition "Alors, La Chine?", the first event of the Sino-Franco year of cultural exchange in 2003, and for an audience denied any information to the contrary, it overlapped somewhat with the image of that politicised style that Wang Jianwei abhors. This work, however, is far less playful than either Political Pop or Cynical Realism in its insinuation. The two years Wang Jianwei spent in the countryside had proved gruelling. This was the minimum required for the "re-education" of high-school graduates. "After that we could apply to return home, if we had been "good" and could wrest a recommendation from the *pinnong* [literally the poorest (*pin*) of the peasants (*nong*)]. I feared these people the most. They were the least sophisticated of the social hierarchy: the ill-informed, in whose hands power was ultimately wielded without (the safeguard of) any logical rationale." As poor peasants, the *pinnong* were deemed the most revolutionary and worthy of the masses. Occupying the lowest rung of the social hierarchy through centuries of feudal governance, they had never been in a position to exploit or oppress anyone and stain their class pedigree. Then came the Cultural Revolution, which put the power of righteousness into their hands.

The official "entering the PLA" portrait, 1977
courtesy the artist

Wang Jianwei escaped at the end of 1976 by opting to join the army. After basic training near Beijing, he was assigned to a battalion of guards on the capital's northern-most border at Qinghe. In joining the army he had innocently placed himself at the disposal of another social hierarchy where claims to power were rationalised by an internal mechanism beyond reproach. Wang Jianwei had anticipated an unquestioning acceptance of army regulations. The reality of a soldier's existence, however, was harsh and soul-destroying in ways for which he was quite unprepared.

For Wang Jianwei six years in the PLA was an exhaustive lesson in homogeneity. There he learned what it meant to be one of sixty soldiers in a dormitory, each attired, presented, and drilled until they were as indistinguishable from each other as machine-tooled ball-bearings. Each soldier's day-to-day existence was identical—from their modulated actions to the food they ate, from the tasks they were assigned to the rules they observed and the air that they breathed. Wang Jianwei refers to the experience as "frightening", in a tone that encompasses all shades of sentiment from insufferable to terrifying. "I hated it [army life]. We lived on a pin. We couldn't sneeze without permission." The tiny photographs of his army career that he preserves serve as a reminder of a period that is representative of everything that as an artist he seeks to negate. They also recall an uncomfortable personal state against which he subsequently took comfort from the measure of his own spiritual growth.

Life in the PLA led Wang Jianwei to the conclusion that grooming individuals to total anonymity is a profoundly disturbing objective. Where army life equates with discipline, good soldiers understand the importance of initiative, even where they must ask permission to take it. In the PLA, this was not part of the equation. Initiative was sacrificed to neither stepping out of line nor demonstrating individual aspirations. The PLA existed to serve the people, its battalions were tools put to defence, social stability and the frontline of political campaigns. It was neither as glorious nor rewarding as the image projected. The rigorous training Wang Jianwei received left him with an obsessive, deep dislike of narrow conformity but a penchant for neatness. Surprisingly, it did not spur him into becoming a hard-headed rebel, or incite advocating an anarchistic freedom. Wang Jianwei's aspiration pivots on the

basic right to an opinion and to a voice, where to hold an opinion was the result of individual acts of thinking, above and beyond a legal right to speak out. Should a person wish to do so, the right to a voice required the marking out and safeguarding a space across which voices could, without fear, be heard.

On May 5, 1999, in Melbourne, Australia, where Wang Jianwei was participating in the First Melbourne International Biennial, he watched with heartfelt ill-ease the televised reaction in Beijing to the NATO bombing of the Chinese embassy in Belgrade. As nationalistic fervour swept his homeland, in the space of a few hours in the Chinese capital, thousands of students and protesters descended upon the diplomatic districts in the east of Beijing. The US embassy took the brunt of the anger, the British coming a close second. Stones, paint bombs and anything else that came to hand were flung through the protective railings, pelting the young PLA guards who, in addition to being powerless to stop them, found themselves without protection against their own people. They remained in place but the division in their loyalties was clear in their nervous, uncertain expressions. Windows were smashed, walls smeared with paint, the exterior plasterwork pocked by home-made missiles, and the usually trim driveways leading up to the "imperialists" doors strewn with debris. The protesters caused hundreds of thousands of dollars worth of damage, which took many months to make good. For several hours the Chinese government was silent, only stepping in when the people's point had been made and the situation looked like it was getting out of hand—and possibly shifting to issues of discontent closer to home.

From the end of the Mao era to 1999, Chinese society had experienced huge advances. The bombing in Belgrade and the riotous response occurred against international summit talks on the subject of China's accession to the World Trade Organisation. At this juncture, discussions were distinctly shaky. Across China, and particularly in the rural areas, insidious signs of the people's fears of burgeoning unemployment and rocketing inflation were seeping forth. The unfortunate—"mistaken"—bombing of the Chinese embassy in Belgrade acted as a pin piercing an irascible blister from which nationalistic indignity flowed forth. For the first time since the student demonstrations in 1989, the people were permitted to have their say in what were largely unfettered protests. And they felt vindicated. The bombing was an act of "foreign aggression towards China" to which they had stood up and said "no".[2] For a first-world-allied force such as the United States, which boasted state-of-the-art precision technology, to make a mistake sounded to the Chinese people plainly absurd.

Wang Jianwei was torn between patriotism and frustration. He knew well that the hands throwing stones that day would have no qualms about filling in an American visa application the next. He did not doubt their love of the motherland but seriously questioned how much the people understood of the emotions consuming them. "The actions of the protesters were the same as those used during the May Fourth Movement, during the Cultural Revolution, and against the Japanese [protests in the

2. A reference to a book published in 1995 titled *China Can Say No*, in deference to the nation's history of invasion and rule by non-Chinese to which the population had woefully submitted—in particular to the Allied Forces in the early nineteenth century. See at Wang Guangyi From Mao to Now, p.69.

Stills from My Visual Archive, 2003, which juxtaposes the formative visual memories of Wang
Jianwei's youth: propaganda war films, and revolutionary operas

latter half of the 1990s against Japan's failure to apologise for the Nanjing Massacre in 1937]. It was the same again with June 4. It shocked and scared me that following nearly a century of socio-political development in China, almost twenty years of opening and reform, and recent strides forward in economic advance, the gestures had not changed. The mentality was the same. Had we learned nothing? Why had no different voice evolved? This event confirmed to me that if nothing else, Chinese artists should strive to find a different voice to speak out with; at the very least offer a different perspective and propose other possibilities."

"When I was young I had no real idea of becoming an artist. I don't think anyone then truly comprehended what being an artist meant. I remember around the age of nine, seeing a cripple repairing a propaganda painting of Mao on the street. At that time [1967], no one had much of a desire or ambition to do anything but survive, so seeing someone entirely absorbed in the act of painting drew people's attention. I sensed this was something I could do."

This incidental childhood experience shaped Wang Jianwei's life, for it awakened in the boy an awareness of difference within a society plagued by sameness. It was the catalyst that allowed him to survive being sent down to the countryside, followed by six years of his own choosing in the army, and that subsequently took him from the role of painter to conceptual artist, to filmmaker and latterly playwright. Back in 1967, to a young mind already aware of the constraints suffocating the world in which he lived, absorption in painting suggested a means of escape, and the possibility of standing alone, of not being condemned to life as a generic cog on a mould-made wheel. It did not occur to the nine-year-old Wang Jianwei that a paraplegic, discounted as a non-person in a society that calculated human value in terms of physical strength and the ability to contribute physically to the communal good, had no other choice of work. Nor that the painter's concentration was more likely fear of an unwitting slip of the brush that would make him vulnerable to accusations of counter-revolutionary activities. But that was then. Fifteen years later, in the early years of the 1980s, against the tentative beginnings of opening and reform, the avant-garde embraced a full century of modern western art and proceeded to rip through it in little more than two decades. Wang Jianwei's arms were flung wide open in readiness.

"Like others, I painted in every style imaginable. We were not trying to create something new as much as to assimilate the history of western modernism and bring ourselves up to speed with major western art centres like New York, London, Berlin," Wang Jianwei recalls. His "every style" was common to the students who entered the newly reopened art academies in the early 1980s. He drank in Hegel, Nietzsche, Pop Art, American Abstract Expressionism, Francis Bacon, Willem de Kooning and Andy Warhol with as much thirst as the next desiccated soul, exhibiting a healthy eagerness to look at everything, which ultimately morphed into a singular, obsessive focus on the West. What is art without experiment, Wang Jianwei would begin to ask himself repeatedly. "What I thought of as art then was pure technique, the

activity of painting a picture. What was important was that art could make you forget your surroundings." As a child, these surroundings were various small to mid-sized towns in Sichuan province, to which his father was assigned before the family finally settled in Chengdu. And although they might have lacked appeal at the time, fond memories of these places would later surface, drawing Wang Jianwei back, and inspiring him to use the provincial towns as the focus or site of his work. In these regions, the national political line remained staunch; it would be years before change of any consequence would penetrate these communities.

At the Summer Palace, Beijing, 1981, during the May First holiday. Wang Jianwei stands on the far right
courtesy the artist

Wang Jianwei is tall by the average standards of Han Chinese people native to the southwest of China. He has a handsome, boyish face and a quiet air of self-assurance. He habitually dresses in a co-ordinated wardrobe of dark blues, greys and black—more Prada than Boss—of suitably worn-in jeans, tailored trews, and quality leather shoes polished to a sheen rarely seen in the dusty northern capital. He does not favour the crew-cut fashionable amongst the art crowd. When he left the army in 1982, he grew his hair long for a while, but that was more to mark his personal liberation from regimented discipline than to follow a trend. This is emphasised in stories he tells of artist friends of the era who attempted to contrive seventies-style flares from locally produced jeans, which were sewn so tight they were apt to split open at the slightest movement. Wang Jianwei refused to allow himself to suffer such indignity in the name of fashion.

The instant Wang Jianwei closed the door on his career as a soldier, several new windows opened. First, and of immense importance, happily discharged and in his final hours in the capital, prior to taking the first train the next morning back to Sichuan province where his parents now lived, the heavens pushed a little warmth his way. At that time, Beijing had none of the restaurants or bars that line the streets today. What restaurants there were closed their doors at 6:30 p.m. or thereabouts, the dining hour being 5 p.m. The only alternative to roaming the streets whilst he waited for his train was to drop in on comrades at another barracks. Here, a friend introduced him to Zhu Guanyan, a selfless, gentle army nurse, who worked in the medical department of the PLA Publishing House (*Jie Fang Jun Baoshe*). They married less than a year later in October 1983, but it would be many years before they were able to live together as husband and wife. An elegant, physically frail woman, Zhu Guanyan is a devoted partner who runs their home with quiet efficiency, accepting

responsibility for much of the paperwork that circulates around Wang Jianwei's art and career. She is his first sounding board and trusted critic. "Wang Jianwei has always been determined to achieve his goal," she muses. "Being constantly dissatisfied made him work doubly hard. Many ideals were shattered for our generation [As a child Zhu Guanyan showed herself to be a gifted pianist but because of the political situation, she was not able to practice, foregoing any hope of a professional career] but whatever the circumstances, Wang Jianwei fought to keep painting. Because I had been forced to give up my dream, I wanted to see him realise his."

Government policies on designated residency during this period ordained strict legal control over the locations in which individuals were permitted to live. As well as maintaining a divide between urban and rural communities, the policy also prevented urban residents from relocating to other cities at will. Wang Jianwei's papers fixed him in Chengdu, whilst Zhu Guanyan's registered her in Beijing. The difficulties for two people living so far apart—for what was to be almost seven years—in different provinces, were severe. Except for the annual Chinese New Year Festival, there were no public holidays, nor any personal holiday allowance, a fact that did not change until the early 1990s. As the commune system struggled to meet production quotas in the absence of a supply-and-demand market for products, and which at best drew slim profits, the people hardly earned what could be termed a salary. Instead, the bulk of individual wages was paid in kind—subsidised housing and heating, rations of oil and other basic foodstuffs, and coupons for clothing and household items. Travel required both money and time. The eight yuan price of a train ticket between Beijing and Chengdu in Sichuan province—a three-day train ride—then in 1983 is the current equivalent of a domestic airfare (a full price fare—from the early 2000s, competition-led discounts made air travel affordable, but they did not exist in the 1980s). Newly married couples, however, were permitted a one-month honeymoon and, in theory, a few days annual leave if they were living apart. A few days did not even get Wang Jianwei and Zhu Guanyan to each other's city. "My parents were totally against the relationship," Zhu Guanyan recalls. "My elder sister had married under the same circumstances and was already divorced".—which was not without its social stigma.—"Most of all they despaired of every penny we earned being spent on train travel."

Having obtained a discharge from the PLA, Wang Jianwei was obliged to return to Chengdu where his parents lived and to

With his wife Zhu Guanyan in Sydney, 1997
courtesy the artist

which his residency papers were tied. With Zhu Guanyan and a view to marriage on his mind, he needed a *danwei* in order to qualify for compassionate leave. He also needed an income to meet the inescapable expense of travelling between Chengdu and Beijing. More importantly, if Fate was kind, a compassionate *danwei* cadre might be persuaded to oversee the transfer of his future wife's dossier to Chengdu, and provide them with married quarters. This latter arrangement was essential. Unmarried workers lived in the *danwei*'s segregated communal dormitories: usually two to a room, the basic facilities shared by all. Even if the couple had had the financial means, it was impossible to rent an apartment; housing was State owned and rented lodgings were almost non-existent. In January 1983, through slowly garnered connections, Wang Jianwei managed to secure the humble position of stores master at the Chengdu Painting Institute, which he believed would place him amongst artists and allow him time to paint. Ultimately, he was to be disappointed; it was here that he would be fed a first taste of the disillusionment that would so strongly inform his aesthetic a decade later.

In the early 1980s, painters were still artisans, tools of the nation's mighty propaganda machine. Painting institutes were the factories to which these tools belonged, continuing as such until opening and reform kicked in and the diminishing emphasis on Maoist aesthetic formulae rendered them defunct. Today, they still linger on in name, but with neither official function nor funding. "At that time, the compartmentalising of particular skills and vocations provided a convenient form of control under which everything was clearly defined, and everyone was clearly labelled. Painters went to painting institutes. There was no other choice then, so that's what I elected to do."

As the institute's stores master, Wang Jianwei was responsible for everything from dispensing the artists' materials to procuring their meals, but he did at last find some time to paint. Up to this point, he had had little in the way of formal art training beyond brief exchanges as a teenager with a man who painted backdrops for the local theatre troupe. Against the modest conventions of Chinese dress, the social mores restricting interaction between men and women, and a visual experience pivoted upon Socialist Realism, Wang Jianwei was shocked to learn from his teacher that in the "old society" students painted from a life model at the art academies. "I could not conceive of a naked woman posing for paintings! He showed me examples of nudes by Russian artists, which I kept hidden from my parents, terrified that they might be discovered. I had grown up in army compounds. My father was essentially a simple peasant who joined the PLA. The only wisdom he sought to impart to me was "Love the People, Love the Party". Mine was a typical ideological upbringing of the times, with no trace of anything artistic." In the view of his father, the life studies that came unbidden into Wang Jianwei's possession were tantamount to pornography, which was strictly forbidden, both politically and morally.

As with Wang Guangyi, Wang Jianwei's parents did not oppose his interest in painting: "Certainly they had no idea of what art or being an artist meant, much less as it evolved through the 1990s. I wouldn't know where to begin in describing

what I do to them now, or the concerns that motivate me. They have never asked. Their son lives well in Beijing, is able to fill his stomach three times a day, has more than a couple of pairs of trousers to his name, and takes good care of his wife and his parents. For them, that is enough."

Wang Jianwei used his time at Chengdu Painting Institute well. In the summer of 1984, three of his paintings were accepted for the annual national art exhibition, which represented an enormous honour. It was the first national art exhibition to incorporate the works of recent young academy graduates with those from the established crop of "official" artists affiliated with government sponsored painting institutes and artists' organisations. However, the exhibition was tainted by the force of the Anti-Spiritual Pollution campaign implemented in the autumn of 1983. This campaign aimed

to stem the unforeseen magnitude of western cultural influences that were infiltrating the ranks of the masses, mainly in the form of music, literature and general information provided by magazines and books. In adhering to the tenets of these new guidelines on weeding out pollutants of the soul, the 1984 National Art Exhibition appeared to take a huge step back culturally, to the brink of reiterating the Maoist line on creative expression. Interestingly, the organisers determined that Wang Jianwei's works fell within the proscribed parameters. The problem that now arose was not one of artistic values but

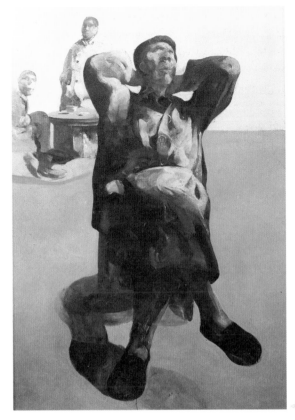

Still Lives 2, 1992–94

of social status. Officially, Wang Jianwei was not an artist. He was a stores master, which compelled the director of the Chengdu Painting Institute to intervene. As an employee of the institute, Wang Jianwei was not entitled to paint for anything other than personal amusement, strictly on his own time, exactly as he had been doing. Not being an accredited artist, he was not expected to put his daubings forward as candidates for selection alongside those of "real", accredited artists. The exhibition organisers, who out-ranked the director, insisted that permission be given for at least one painting, and finally the director relented. Wang Jianwei's painting went on to be awarded the first prize in its category. The institute took the credit, and attitudes towards the stores master were transformed following a respectful reappraisal of his talents.

Wang Jianwei was profoundly disappointed. Why was it, he asked himself, that members of the institute needed a third party to be able to see what was right there in their midst? Why were they unable to decide for themselves the value of a painting simply because it was not produced by an "artist"? This incident was cataclysmic. Against all conventional wisdom of the times, Wang Jianwei decided to move on, but was forced to endure his discomfort for another two years until 1986, when he was able to leverage his stretch in the PLA to enter university without sitting the required entrance exam, even though he was over the proscribed student

age limit. His choice was the oil painting department of Zhejiang Academy of Fine Arts. A lack of formal training prohibited him from following the standard degree, so over the next two years, he followed a post-graduate course specifically aimed at grooming a new generation of teachers.

Finally his real art training could commence. But as with the majority of the nine artists in this book, Wang Jianwei found the experience contrary to all aspirations. "My experience at the academy taught me that art school [in China] had very little relation to contemporary art. The training was entirely geared towards producing technically proficient artisans. It was like being in a State *danwei*, with everyone hustling for a position. I learnt almost nothing practical about painting in terms of developing my own practice. We spent six months studying English, and the rest of the time was devoted to the technical applications we were supposed to teach students when we graduated. I passed most of the days in the library—the academy had the best library in the country. It was during this time that I realised art was not the chunk of idealism we had been brought up to believe it was. I knew it had to relate to real life, not the illusory Utopian tomorrow that Socialist Realism projected onto our psyche." At the end of his studies, Wang Jianwei knew he was not cut out

Still Lives 3, 1992–94

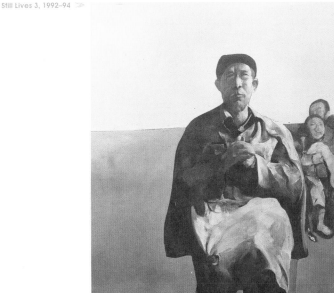

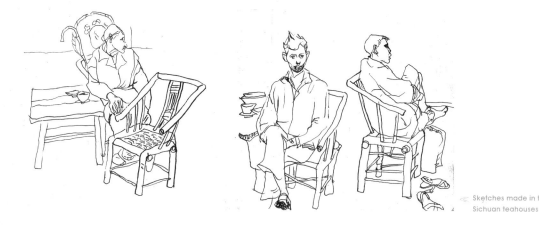

to be a teacher. "I couldn't be part of a system where "serving the people" was a government directive and not a human instinct. The people, the masses, were that defined by the Communist Party and the definition changed as it suited the needs of the government. I could not be a tool of such abstract whims."

The unyielding structure of the course at the academy was not all negative in effect, for it encouraged Wang Jianwei to want to identify an alternative form of expression. Following his graduation, the multitude of influences he absorbed at the academy resulted initially in an individual approach to painting in concept and content. At first though, his explorations were inhibited by the stringent, unbending notions of technique with which he had been filled day after day at the academy. The scourge of realism and an irrepressible fascination with Francis Bacon's work were all too obvious in the compositions he produced. Nonetheless, the resultant works have an arresting presence and caused many critics and—latterly—collectors to lament Wang Jianwei's decision to lay down his brushes in 1994.

During his free time at the Chengdu Painting Institute, Wang Jianwei had whiled away long hours sketching in the local teahouses, simultaneously studying the micro societies that continued within, despite the spirit of these social gatherings being contrary to that of the Cultural Revolution. The mountainous Sichuan region, whose mountains acted as a buffer to the rest of China, remained predominantly agricultural and, in general terms, social advance had, in the mid-1980s, had little impact. In the visible characteristics of feudal society it retained, teahouse society mirrored the world outside, even if the liberation that the communists extolled had yet to exert a radical impact upon the existence of these peasant communities. So, in the dimly lit wooden structure of the teahouse, Wang Jianwei could sit unnoticed and sketch a clientele as rich in earthy characters as those found in any one of the taverns frequented by Brueghel or Chaucer. Inside, as the hierarchies and mentality spawned by centuries of practice flourished unabated, Wang Jianwei filled volumes of small sketchbooks. These shacks were a laboratory, a lens through which to analyse the thoughts and issues that the activities of his "lab mice" prompted. Wang Jianwei came to understand the teahouse as a centre for gossip, storytelling and conversation, in

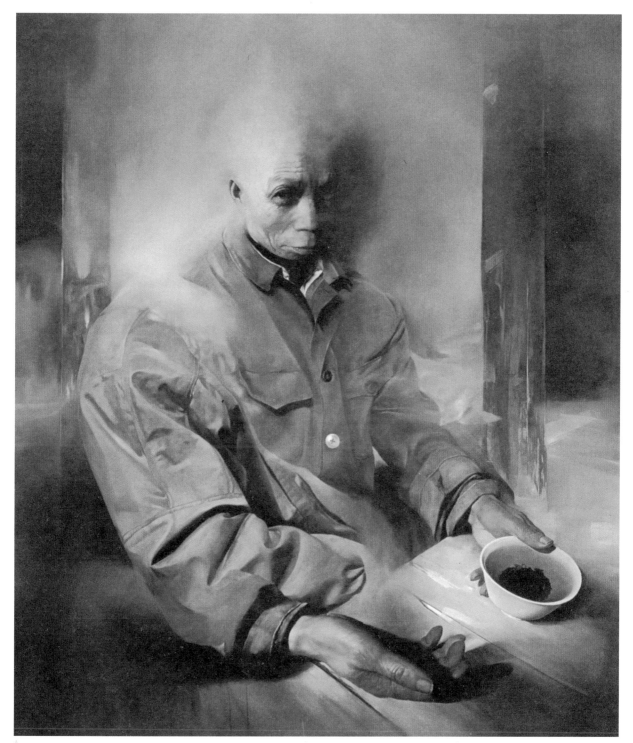

Tea*Heart, 1989

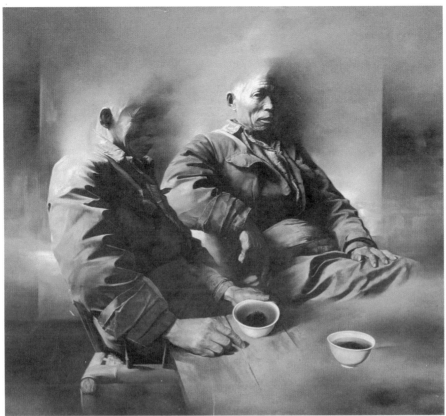

which people congregated to chat, to exchange news and views, leaving all external social polemics at the door. Once inside, indulging in what was tantamount to petit bourgeois banter, each tea drinker was only as important as the attention his words could command. "It was clear that under the paradigm of social equality, where every individual was supposed to have the same vision and contribute equally to society, consciously or subconsciously, everyone yearned for some kind of power, for holding a degree of power was the only personal asset Communism afforded. Commanding attention through speech is a form of power. So, when people spoke, they required an audience, to impress others and command the power of recognition. The teahouse allowed them the illusion of owning real power, which of course they did not because it was decided by things totally unrelated to the nature of the power they believed themselves to wield."

In the rural outlying areas of Chengdu, this situation remains an obdurate fact of life amongst the peasant communities whose standards of living have yet to rise. "When I interviewed people for *Teahouse* "—a documentary produced in 1998—" no one wanted to talk in their private quarters. All chose to be filmed in public where they could be seen speaking to the camera. To me, this is what social dynamic of the teahouse is all about."

On graduating from Zhejiang Academy, Wang Jianwei was finally free to pursue his own trains of thought in whichever manner he pleased. Returning to the volumes of sketchbooks he had filled in the Chengdu teahouses, the drawings now inspired a series of paintings. In addition to experimenting with technique and form, he deployed his received impressions in a vision of the ethos of this curious world. The small number of large paintings completed between 1989 and 1992 remain some of the most haunting images of China's new painting. They have a metaphysical quality that arises from their focus, which is not of those speakers who hold sway in the conversation, but centred on those relegated to the sidelines because their voice carries no weight. One imagines that the youthful Wang Jianwei—whose thwarted inroads to becoming an artist lent him an air of silent reticence—occupied just such a position in the teahouse as he sketched alone on the periphery of the group. In the paintings, the simplicity of the physical environment and the drabness of the figures' attire act as counterpoints to the complexity of the internal discomfort and sense of vulnerability Wang Jianwei invokes. The figures are deliberately fragmented and disjointed. The jarring image of a face, part angled this way, part angled that, of an armless hand, a legless foot, and teacups that float in mid-air, suggest an anxious restlessness. Ghostlike, one pose merges with another resulting in a sense of distortion that turns these worlds surreal. The light source is always obscure, multiple, and provides a nebulous temporal paradigm in which the past blurs with the present. The physical dislocation of what we know ought to be related elements creates confusion as to what is closest to or furthest from the eye. Nearest and furthest, being simultaneously possible and evident, become irrelevant. There are deliberate flaws on the surface, a red dot, a smudge of blue, to jog the perfection and remind you that this is just a painting, nothing more. Yet, the wisdom in the silent, accepting gazes of the tea-drinkers is devastatingly real, a sensation that transcends the specific cultural circumstances that inspired the artist. Alienation is an awkward human predicament.

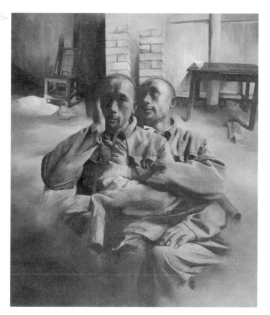

Inexorable Doom, 1989 >>

Having wrestled this emotional response out onto canvas, Wang Jianwei found he had said about as much as he was inclined to venture in paint. With little options to hand, no studio in which to experiment, and a circle of artist friends devoted to painting, he struggled on for about a year, largely due to his obsessive need to dissect and reinvent the scorching aura of

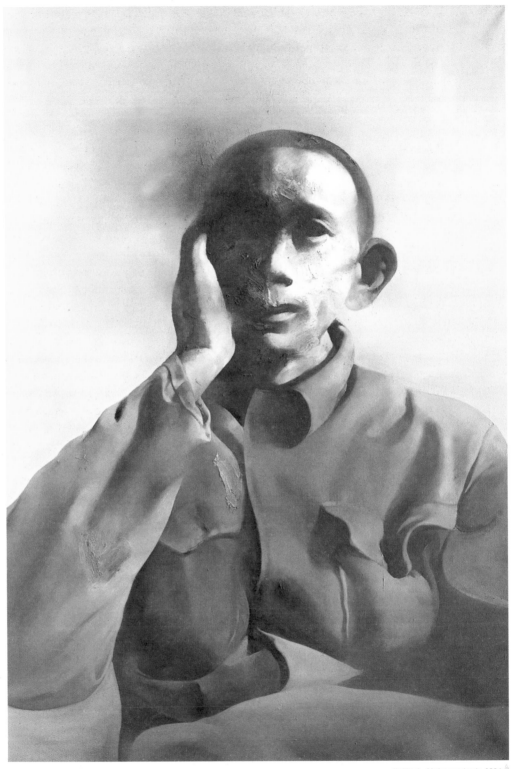

Untitled—Metamorphosis, 1994
private collection Beijing

isolation Francis Bacon wrapped around his subjects. How did the barest minimum of pictorial devices manage to hollow out such cavernous spaces on a picture plane or erect such immutable barriers? Wang Jianwei experimented with Baconesque forms, but couldn't manage to make them his own. When he found himself becoming illustrative of ideas, he abandoned canvas for concept, decided to push himself back into society and research an art form that might be more interactive.

When Wang Jianwei graduated in 1988, he could finally claim to be an "artist". Having determined not to teach, he was once again without employ, and faced with returning to Chengdu with neither income, nor *danwei*, nor wife by his side. In 1990, he decided to leave Sichuan province for Beijing, having managed to wrangle a transfer from the Chengdu Painting Institute to the Beijing Painting Institute as the "painter" he had long dreamed of becoming. Wang Jianwei could now enjoy the best of all worlds for, after almost seven years apart, he and Zhu Guanyan were finally able to embark upon married life. By 1990, painting institutes were beginning to feel the pinch as State commissions and government funding dwindled, losing the elasticity required to stretch to all institute outgoings. The greatest portion of these outgoings represented monies devoted to the housing and supplementary facilities of the painters. The financial deficit that now accrued to all institutes, meant that for any new graduate lucky enough to be assigned to one, admission was forthcoming on the understanding that the status was granted without the customary benefits, although in most cases studio space was provided. With Zhu Guanyan housed in the PLA Publishing House's women's dormitory, and slim hope of being allocated marital quarters, Wang Jianwei's most pressing problem was where to live—and where to paint, for unfortunately studio space at Beijing Painting Institute was entirely spoken for. Until a small, damp ground-floor apartment was made available through Zhu Guanyan's family in the PLA compound in Ping'anli where the couple first met, their only option was to share a tiny two-roomed apartment with another family. "We were all on show twenty-four hours a day, every breath, every smell, every sigh ... " Wang Jianwei explains with a stoic expression. "After three years, we finally got our own room, but still had no kitchen. Every day Zhu Guanyan brought food back from her staff canteen. It was another year before we got a place with a kitchen. It seems so far removed from the present where artists are so blasé about owning villas, apartments, cars ... "

Although Wang Jianwei did not abandon painting completely until 1994, by 1991, prompted in part by the confines of his living environment where too much time was expended on moving the furniture around to accommodate the paintings, his thoughts were already drifting in other directions. He had become aware of conceptual ideas that stirred new thoughts, which he brought to tentative experiments with installation art. The cramped, musty and dim-lit room in Ping'anli—to the north of Jingshan Park in the centre of the capital—still retains the memories like a tomb, for it is crammed full of the components of the early installations. The fact that they were realised is significant. Through the first half of the 1990s, where most artists' living

Document, 1992

quarters were limited to one or two rooms covering less than ten square metres, three-dimensional installations were habitually conceived and mapped out through diagrammatic sketches on paper, leaving the structures and suitability of materials untested. On one hand this resulted in a number of astounding fantasies, which, whilst impossible to construct at the time, allowed imaginations to flex as never before. On the other, artists were encouraged to be entirely impractical. Wang Jianwei now advanced ahead of his peers, and prior to the 1993 exhibition "China's New Art, Post 1989", which provided a landmark opportunity to make a number of these fantasies a reality, he was offered a second solo exhibition in Hong Kong, a follow up to the first; a show of *Teahouse* paintings in 1991. Keen to shift into three-dimensions,

he made a test work titled *Document*. The concept was inspired by a textbook titled *The Grey System* which outlined the State's latest guidelines on economics for Socialism with Chinese Characteristics. It struck Wang Jianwei as significantly evocative of the moment. *Document* comprised a collection of dense and meaningless documents that parodied this "grey" theory in a format that conformed to standard bureaucracy but in which the theories outlined represented an impossible conundrum. To achieve this, Wang Jianwei created the illusion of a scientific process of input, distillation and various implied laboratory tests leading to an imagined output, or result, the substance of which was marked by its absence. The complex and authentic tools of science deployed in the work acted as a smoke screen to occlude this absence; a metaphoric parallel with the ambiguous language of *The Grey System*'s economic theories, which sounded good but, if analysed carefully, promised little in the way of tangible results. The work was also a cutting reference to the grey areas of individual understanding of the situation engendered by the transition from one system to another. *Document* was only to be seen in the Ping'anli apartment. Latterly, dismantled permanently, the form of the installation was equally impossible to decipher, confused by tangle spew of tubing, a stack of dusty beakers, a pile of rubber nozzles and a nest of string-thin wires.

Incident –Process * State, 1993

Subsequently, in trying to conjure a sense of its integrity for inquisitive visitors, many of them critics or curators, by way of illustrating his theory, Wang Jianwei resorted to the dense documentation that accompanied the piece. *Document* was the first of Wang Jianwei's experimental works to demonstrate that while the actual forms and elements he brought together were on the whole clear, the viewers' reading of the installation was confused by written texts, which frequently obscure the artist's impulse. The documents did however achieve two things relevant to Wang Jianwei's

art and the critical response to it. Firstly, they spoke volumes about Wang Jianwei's attitude towards knowledge because it was assumed that he understood the dense sources that he drew upon for his own equally dense prognoses. Second, in his own way, Wang Jianwei was exploring the same type of use and misuse, or misappropriation, of language that lies at the core of Xu Bing's *Book from the Sky*. The documents were offered as diagnostic instructions and diagrams of a process—of thought as much as creative expression. They were not offered as aids to understanding, because what Wang Jianwei understood as art could never be explained by words. It had to be felt. So, although he never attempted to explain them as such, the documents are a red herring, a test, a challenge to his audience to examine their own visual habits and thought processes. In a way, this approach was a very direct response to the blindness of the director of the Chengdu Painting Institute and the artists it employed, and their reaction to Wang Jianwei's status as stores master. Equally, the work alluded to the illusory cloaks of power that tea drinkers in Sichuan teahouses wove around themselves.

Wang Jianwei's 1991 trip to Hong Kong for the exhibition of *Teahouse* paintings was his first sojourn abroad. "What was impressed upon me most was that people in Hong Kong didn't seem to have much more freedom of choice than people in the Mainland. Rather the abundance of choice before them impeded their ability to make decisions or form opinions. It was a contradiction that perplexed me for a long time, until I realised that too much choice leads to enormous mental restrictions. It appeared that the only difference between the people in the Mainland and those in Hong Kong was that Hong Kong people believed they arrived at their own choices freely."

In 1992, Gallery 13, which organised the exhibition of *Teahouse* paintings, arranged a solo show for Wang Jianwei at the Hong Kong Art Centre, affording him the opportunity to create an installation. Preserving the scientific feel achieved in *Document*, Wang Jianwei produced *Incident—Process * State*, which effectively turned the exhibition hall into a laboratory where visitors could apparently witness the process of an experiment. The inference was of an undisclosed matter, subjected to a sequence of conditions—heat, cold, motion—and exposure to chemical elements such that would alter its state. As with subsequent works like *Reproduction*, which centred on the monitoring of a pregnancy, and *Operation*, which posited a system for cleaning books, a wonderful satire on Mao's notion of sanitising entire libraries of reading matter. *Incident—Process * State* was a metaphoric indictment of the implications and effects of subjecting people to a theoretical premise and the unfamiliar conditions of proving such a premise that were necessarily visited upon them.

Social issues were now firmly invested as the driving impetus of Wang Jianwei's art. As the capital of a vast nation, Beijing was developing in ways that were already rendering it less typical of the broader social climate across the provinces. Its focus was dominated by politics that largely overshadowed the fundamental, common issues facing the enormous majority of people living outside the city's perimeters.

Burgeoning economic development made it an exciting place to be, but Wang Jianwei's humble origins in the provinces were deeply ingrained in his being, and the turgid existence of the local people in his parent's environs in Sichuan reiterated with every visit home. Wang Jianwei could not ignore his roots. In mid-1993, he decided to take his conceptual practice back to Sichuan, to the peasant community, in the first of a series of works that set out to experiment with connecting contemporary art to the cultural framework.

In this vein, *Circulation—Sowing and Harvesting* was a practical activity that recorded the year-long process of growing a crop of barley from planting to harvest. Adopting the role of the State in prescribing the crop a typical agricultural commune was to produce, Wang Jianwei negotiated a contract with a group of farmers, which required them to allocate a designated portion of their land to growing the barley. For Wang Jianwei the project was a ground-breaking interaction with peasants who had no idea about

Λ Circulation—Sowing and Harvesting, 1993

contemporary art, nor did he see any need to enlighten them. That accepted, all his creative prowess was brought to persuading the farmers to sign the necessary contract and work alongside him in the field to produce the crop. In terms of its connection to the people—the real people that formed the bulk of the population—Wang Jianwei subsequently came to consider *Circulation—Sowing and Harvesting* as his most successful social intervention in China.

In its own way it inspired a similar engagement of ordinary people—although of the kind who go to contemporary art exhibitions—in societies abroad. Taking his lead from the encroaching insurgence of consumerism within China's major metropolis, in 1996 Wang Jianwei took the idea of market forces as the theme of *Input><Output*. The ostensibly scientific nature of the piece—a nod to *Document*—pivoted on an experiment with barter exchange. His "product" was a gimmicky rubber ear designed by the artist to resemble those used to illustrate acupuncture and acupressure points for students of these medical arts. Each ear was fitted with a sound byte so that when

squeezed it squeaked, inverting the listening function for which the ear is intended. In each of several museums in different nations at different times between 1996 and 1997, Wang Jianwei placed a thousand ears in a glass container at the exhibition site, surrounded by colourful, medical diagrams, and video footage of a hand squeezing the rubber form. Members of the audience could use any medium of exchange they felt appropriate as payment for taking an ear away with them. The revenue included a poem written by a Japanese schoolgirl, a range of handkerchiefs, buttons, snacks, books, scarves, pens, and even a toothbrush, as well as money. On the surface, Wang Jianwei appeared to be playing with the universal culture of the bazaar, yet *Input><Output* clearly demonstrated the odd choices individuals make in deciding the value of a purchase, prompting a reflection upon the elements that inform these opinions. Naturally, inviting audience participation in culture is taken in a far more light-hearted and spontaneous spirit than that with which people usually address expenditure on necessary or frivolous items. Yet what was perhaps less obvious to the foreign audience was the poignant parallel with the irrational behaviour of consumers in China, for whom purchasing power has come to represent a social status that has little to do with informed choice or actual need, but everything to do with being seen to be achieving advancement.

By the late 1990s, similar to the majority of the leading members of the avant-garde, Wang Jianwei's career was primarily developing abroad, however, the experience of witnessing audience response to his own work, as well as his own response to works by international artists, highlighted the social situation back home. Again, as Beijing, Shanghai, Guangzhou and Shenzhen powered ahead in economic growth through the late 1990s, Wang Jianwei was constantly reminded of the lethargic pace of change in provincial areas. Video had now become a medium of choice, and in 1998, he embarked upon a fly-on-the-wall documentary film that took him almost two years to complete as he stumbled along a tricky path of social engagement. The work took the title *Living Elsewhere*, and the scene was once again the suburban periphery of Chengdu, and the unmitigated nullity of life for natives located at the bottom of the social ladder. One of the most evocative shots in the film shows one of the four families featured seated on the second floor of the villa in which they

they'll find you and force you to go away.

my asparagus lettuce could grow

Stills from Living Elsewhere, 1998

have squatted. The husband and wife—he distinct for unaccountable outbursts of laughter, her for a prevailing air of mental anguish—sit with their hapless, bawling child and an unidentified male—who retreats before the camera like the guiltiest of interlopers. For a long moment, in total and incommunicative silence, each stares out at the derelict emptiness that spreads before them. They have nothing to do, nothing in their minds, they are blank, lost. The openness where a closing wall should be turns the space into a stage—an aspect that Wang Jianwei subconsciously returned to when, having accepted the opportunity to create a play, his drew upon his experience to conceptualise a stage upon which to present a social reality. But the scene on this stage in *Living Elsewhere* is no drama; it is painfully real. Against all that was being proclaimed as modern, rapidly changing China, since Wang Jianwei's youth, change in this part of the world was imperceptible. Some people had become rich. There were an increasing number of cars on the road, a creditable number of new businesses, new stores, up-to-the-minute fashions, fine goods and lascivious entertainment, but all lay in the hands of an elite few. With the largest population of any province, labour in Sichuan was plentiful and life was cheaper still. So the family sits ... and waits ... "When I saw this, I found myself right back as a teenager on those eternal days where we had nothing to do but watch time pass. Life revolved around mealtimes purely for the activity they generated—certainly not for the food they offered. We had no books worth looking at, no classes worth studying, no television, no radio, nothing. And we would sit there, just as they sat there, staring out into nowhere, yet dreaming of nothing because we were unable to imagine any alternative or any other kind of life."

A long piece—sixty hours of footage edited down to a viewing time of just under three hours, which seems much more—*Living Elsewhere* is not intended to be a gripping watch. It succeeds in evoking the interminable meaninglessness of the families' existence and shines a compelling light on a side of life in contemporary China that never makes it into the news. The daily activities of the families it follows are mundane to the extreme. With no work or hope in the countryside, people like this cross the line into the fringes of the city. Luckier than most, these few families are able to take up residence in a cluster of grand villas, originally

built in anticipation of a market demand amongst Chengdu's nouveau riche. That was until the developer discovered that the location of the land, under the flight path to Chengdu airport, rendered them less than desirable retreats. No buyers were forthcoming. The developer went bankrupt, and the development was abandoned. What Wang Jianwei recognises here, and which most Chinese artists prefer to ignore, is that the majority of Chinese society has yet to acquire the values and lifestyles that are increasingly commonplace in Shanghai and Beijing. In the lesser urban cities beyond the major metropolises, entrepreneurs and opportunists—or opportunist entrepreneurs—receive but a superficial image of what these lifestyles entail; lifestyles that are not yet transferable to the poorer provincial areas. Here, on the fringe of Chengdu, in anticipation of demand, local builders took it upon themselves to slap up approximations of luxury homes and were baffled when their projects failed. Across China through the late 1990s and early 2000s, an innumerable number of residential building projects were left empty, inhabited only by the elements. Some became home to those that society had abandoned, ironically the jobless, floating population whose land was being eaten up by new development.

For the people in *Living Elsewhere*, life hinges on basic survival, with nothing to their name but the barest minimum of possessions. The first family portrayed has only three chairs and rudimentary cooking utensils to their name. In the second family, an uncle cries unashamedly when his bicycle is confiscated by the police, proudly showing the tools he owns when later he successfully pleads for its return. In the third family, an old man pulls together bricks, tin drums and a wooden board to form a make-shift dining area as he awaits the arrival of his sons for dinner. The sons arrive bringing with them their own cooking bowls and food for the dinner. "When they had finished, they offered us [Wang Jianwei and his cameraman] noodles, wiping their bowls, because they had no others and no water to wash them with, with a piece of rag that was as dirty as the floor. It was a test of our camaraderie: did we really want to understand their lives? Did we, as city boys, really believe we were social equals enough to step down to their level? Of course equality is a separate issue to unhygienic practices that arise out of poverty and ignorance, and might have wrecked our stomachs as a result. Although the cameraman was extremely reluctant, I knew we could not refuse; not because we needed their co-operation to continue filming, but because we were confronting the very issue of contemporary Chinese reality that motivated the project. When we finally sat down to eat and the family discovered I had done my time in the country and in the army, they opened up completely. Country people respect the hardship of those days and those who did their duty. Few know better than they do the tough nature of that life, and how hard it was for the uninitiated."

In *Living Elsewhere*, as winter turns to spring, an ancient toothless man, grandchild strapped on his back, asks another who is weeding his vegetable patch, how much produce he needs to sell to survive. "If I can make 3 yuan a day I'll be fine". In 1998, three yuan was approximately 35 American cents. And just into Chengdu city proper, in fashionable bars like that run by the painter Zhang Xiaogang's now

ex-wife Teng Lei, artists and the trendy elite drank beer, wine and spirits at ten, thirty, forty yuan a shot, many times over into the early hours of each morning. In this respect, the film reveals sentiments that are close to Wang Jianwei's heart; the living standards of rural farmers who work all available hours, against those of a cultural elite fixated on the West, courtesy of which it owns previously unimaginable lifestyles. It is an unwitting fixation that eclipses the reality surrounding successful new artists by effecting proverbial ivory towers within which the avant-garde is all but segregated from the immediate locale. *Living Elsewhere* points to Wang Jianwei's experience twenty years earlier, and where his compassion is palpable, the work gains exponential strength. In twenty years, he had pulled himself out of the small town mentality and a background that offered little in the way of opportunity: he got educated. Experience taught him that an awareness of self, the holding of personally rationalised opinions, is all that counts. But how long, he laments, will it take before these simple people can arrive at the same conclusion?

It was a question given particular relevance in early 2000, when an extract of *Living Elsewhere* was screened for a delegation of museum curators and art foundation heads from Europe and North America. The venue was the Loft New Media Art Space, an arty Beijing restaurant-cum-bar-cum-visual space haunted by a trend-setting crowd of unfettered Chinese youth keen to embrace a contemporary lifestyle in which leisure plays a major role. Against the background thud of a techno beat and the babble of well-healed diners, the film unfolded at a painfully slow pace, swiftly disengaging the foreign viewers' attention, so overwhelmed were they by the music and the phenomenon of trendy youth in Beijing. Within an environment that the visitors immediately compared to New York's Soho, the painful reality of *Living Elsewhere* was hard to grasp. Yet, nothing could have better illustrated the social divide between the astounding economic advance of cities like Beijing and Shanghai through which the visitors passed, against the vast provinces across the Mainland still entrenched in the intractable ideals of Mao's Socialism. The screening established a poignant meeting of these extremes. The lackadaisical response of this revered collection of visitors—in the run up to their arrival members of the local art community had been feverishly vying for an audience with the group—did not perturb Wang Jianwei unduly. Instead, he took courage from the experience of a literary hero who hailed from an environment equally peripheral and unfamiliar to a western audience. "After reading Gabriel Garcia-Marquez' *One Hundred Years of Solitude*, I came across a paper by the author in which he explains his choice of the word solitude. In it, he describes the problems of the Colombians as experienced within the country and its society from the perspective of the people themselves. In the paper, he compares this to an outsider's impression of the same problems seen from a non-Colombian perspective. For Garcia-Marquez "solitude" was the gulf between the two; a gulf across which people do not, cannot, communicate directly, and where for the local people, speaking into such a void generates a tremendous sense of isolation. For me, this description is equally applicable to China. We might decide that the political problems in China are greater than those

in other countries, but we should also recognise that through its denial and desire to control creative expression, in terms of the western world, the Chinese government provided a great platform for its contemporary artists."

Indeed, the repression of contemporary art in China, and the constraints imposed upon the artists initially provided a flexible and efficient leverage with the media and with audiences abroad. Exactly how repressed and constrained that environment actually is varies according to the individual aspirations of different artists and art collectives, and often in direct relation to the talents possessed; talent tends to speak for itself, and where artists were found lacking, the poor repressed artist card was once extremely effective. Even where repression is documented fact, it cannot be seen as separate to those boundaries set on the freedoms of any Chinese individual of the period. However, from the late 1990s artists began to enjoy a life of relative comfort in China; a fact apt to be contested or dismissed by those who preferred their China red and repressive. Unregulated by the system, the artists lived—and continue to do so—in their own circles without too many constraints upon their time or motion. Their incomes might be unstable, yet remain relatively higher than most ordinary Chinese people could imagine. Members of the avant-garde community

Of the Masses, By the Masses, For the Masses created for the Third International Shanghai Biennale, 2000

were always acutely aware of the unspoken rules of the local cultural game. It is all a question of approach, and often less about the work itself than the language it is explained in, in whose voice, and to which official contact. There were also times when the notoriety engendered by the closure of a show aided an otherwise mediocre cause. Both gave Wang Jianwei cause for comment. "China was isolated for so long, the people habitually push the reasons for their situation onto history—that we were colonised by foreigners who forced their ways and culture upon our own. What is colonialism but a language that imposes itself upon another socio-cultural situation? Weren't Marxist doctrines a form of colonialism? Even Mao's theory on art and literature was a form of colonising Chinese culture by imposing a paradigm that was totally alien to the culture and art."

Around 1998, as he filmed *Living Elsewhere* in Sichuan, Wang Jianwei developed a fascination with how urban development affects the lifestyle and function of city dwellers. By now, he had travelled widely and become aware of the work of architect and sociological urbanist Rem Koolhaas, whom he would soon meet through collaboration with the multi-faceted curator Hans-Ulrich Obrist. For a while, nothing engaged him with greater fervour than the company of architects and designers who were attempting to find solutions for the issue of urban development in China. Travels in Sichuan allowed him to observe the impact of commercial aspirations saddled to political strategies for achieving a modern environment. This also incurred an introduction to the incidental by-products of advancement, and inspired Wang Jianwei to produce a series of ten thirty-minute documentaries, each exploring a specific aspect of architectural phenomenon in China. Sichuan features in two of the episodes. First, in terms of the rural environment. Here, as in many other outlying provinces, the flourishing field of entertainment has given rise to a proliferation of whorehouses masquerading as fancy restaurants and karaoke halls. Entire villages of peasants have built modern brick dwellings glazed with blue and mauve glass—so when they look out of the window the sky is perpetually cornflower. Exterior walls are clad with white ceramic tiles to make them appear clean and modern, whilst pigs, chickens and ducks wallow, scratch and waddle on the earthen ground floors. In the rural areas, houses suddenly became large because the new economy permitted them to be so, yet the families who dwell within still kept to one or two rooms on the upper floor, leaving the rest for the storage of things they didn't possess and perhaps never will. "I interviewed the residents of a new apartment building in Sichuan that had been constructed to re-house them. Each had decorated their new home themselves. I wanted to know how they made their choices. They each gave the same response: to be different from everyone else. Yet each one was exactly the same. It was astounding to me that they absolutely refused to see the similarities in identical apartments standing side by side." Against this, Wang Jianwei cites Chengdu's main square, which is dominated by a statue of a waving Mao; a typical example of how ideology shaped and defined public space within the PRC.

In 1997, Wang Jianwei moved into a neat three-roomed apartment in the north of Beijing, in a building that negates the very ethos of architecture and design. The area, once considered peripheral to the city, is fast being sucked into the expanding centre of the capital as it spills out towards the fourth ring road—once entirely agricultural suburbs. The building is a standard 1980s housing block, the common areas dim and dirty, but once inside Wang Jianwei's home, the decor is neat, modern, if simple, with all the trappings of material, modern high technology. His working space is occupied by two desks, which face each other. At one he edits video works, using a state-of-the-art digital set up. At the other, beneath a muslin-frosted window, he answers an increasing volume of international correspondence, fields requests for this exhibition and that film festival, and writes proposals, articles, plays and film scripts, and most recently, orchestrates performances for exhibitions.

◁ The Concealing Wall, 2000, produced for "Translated
Acts" at Haus der Kulturen der Welt, Berlin

Whilst countless contemporary artists have acquired plots of land in the suburban
band around Beijing, building cavernous studios-cum-homes, Wang Jianwei prefers
to remain in the city—grudgingly conceding the need for an upgrade in space and
environs in 2005 he bought a larger apartment, on the fringe of the rapidly expanding
metropolis. "Retreating to the villa in the countryside is merely the modern equivalent
of "escaping to the mountain cave" adopted by those ancients who felt pushed to the
periphery without a voice", he said in 2002. "I realise it is much more interesting
to be in the city, to work within the framework it maps out and observe how the
attitudes of city people towards modern life are changing. Where contemporary artists
are removed from the thick of life, too many of the artworks being produced since
the early 2000s are divorced from what ought to be the artists' real experience of
living in present-day China."

This experience is increasingly regurgitated through performance works that directly
challenge audiences in a physical and emotional way. Particularly as a quixotic
curatorial vogue emerged in the early 2000s for inviting Wang Jianwei to stage
interventions in museums or public spaces during the opening of exhibitions in which
he was participating. Whilst delivering him maximum audience capacity, the final

outcomes are often subjected to the same casual attention given to any entertainment booked to enrich the launch of a cultural event. As a fine example of the success this approach could achieve, in 2000, *Concealing Wall*, produced for the exhibition "Translated Acts" at the Haus der Kulturen der Welt in Berlin. Wang Jianwei invited all the local artists into the space to join in singing the Internationale in an inversion of the unwitting exclusion of local artists in a space established to show the works of artists from world—specifically non-German—cultures; and an exclusion that most Chinese believe is exclusive to their own social environment, and inconceivable in the free western world. To the amusement of the staff and local community, Wang Jianwei turned this on its head. Where the chorus of the *Internationale* succeeded it was largely due to the volume of sound, which drowned out all chatter in the immediate vicinity. Silence proved the undoing of *Observe*, which was enacted at the opening of the First Guangzhou Triennial in 2002. Determined to use this domestic platform to show how "under whatever conditions, the experiences of daily life can be made to become art",[3] Wang Jianwei commandeered two-hundred high-school students for the evening vernissage. For a total of 45 minutes, the students, randomly dressed in teenage attire, were required to "observe" the invited audience without cease. To aid them, and trigger the audience to examine the way in which they habitually observed art in the museum environment, each student was supplied with a pair of sunglasses with a highly reflective external surface. Looking at the students, viewers observed only themselves. The impenetrable blackness of the lenses effectively unified the two hundred individual expressions with a homogenous façade, and ought to have made for a stunning and arresting confrontation between observers and the observed. Unpredictably, the audience hardly seemed aware of the children, glancing back in a double-take only when they saw the glasses—themselves?—as

3. Wang Jianwei, "The First Guangzhou Triennial", published by Guangdong Museum of Art, Guangdong, China, 2002, p. 478.

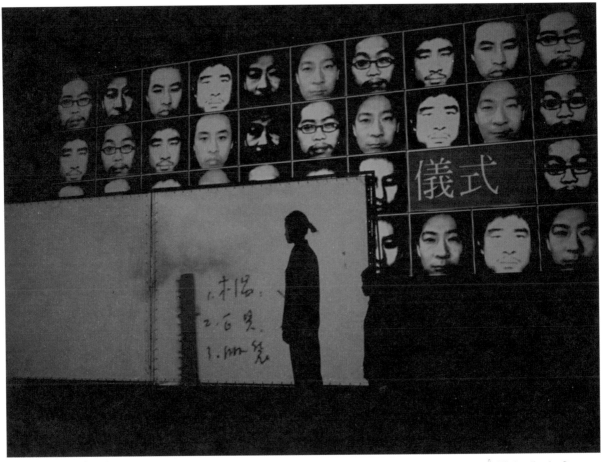

Stills from the play Ceremony, 2003

they pushed past them and through the fray to tour the artworks: demonstrating exactly that which Chinese artists are up against in capturing the attention of local audiences; a situation little changed since the days of the Pond Society's activities in Hangzhou in 1987.

The theatre stage continues to achieve the best impact for Wang Jianwei's works, and following the success of *Screen* in 2002, he was gratifyingly invited to produce a second work. A by-product of public reaction to his performance works, Wang Jianwei was more quizzical than ever about the "grey" vagary in which public attitudes towards culture in China were clearly embroiled. Through recent years of increasing cultural freedom in China, most people seem to accept, without the slightest question, that art—especially contemporary art—was not good unless shrouded in an unfathomable yet potent air of mystery. It is an outlook Wang Jianwei views as being particularly groundless in China, which lacks the West's evolutionary march from Enlightenment to Post-Modernism that predominantly informs attitudes towards and interpretations of art. What the Chinese people do know—or believe they know—is their history. Or do they? For his next project, *Ceremony*, Wang Jianwei wove three

versions of the same story, recorded in subsequent dynastic eras, but differing in the fundamental facts of each plot, which had been reworked at historical intervals to match the particular moral fibre of the times.

The plot was initially inspired by the classical tale entitled *Drum Rolls to Criticise Cao Cao*,[4] and the story is simple: Mi Heng, a storyteller-drummer at the court of tyrannical emperor Cao Cao (155–220), openly insults the supreme leader. Furious, Cao Cao wants the miscreant executed but finds himself unwilling to give the command for fear of appearing impetuous, cruel or even unjust and, thereby, losing public favour. "He is famous and you are well known for your love of talent. Your reputation will suffer if you kill him. Which is more important, his life or your name?" Wang Jianwei has a courtier of dubious morality whisper to his emperor. Thus, Cao Cao sends the troubadour into the service of an extremely impetuous, quick-tempered courtier. The outcome is as expected: when Mi Heng criticises this equally irascible personage he is executed.

How did well-known historical figures imagine they would be recorded for posterity? In *Ceremony* Wang Jianwei looks back at the scant records of the maligned scholar Mi Heng, whose penchant for speaking his mind a thousand years ago bordered on arrogance, and cost him his life. How he came to be executed and the nature of his crime crop up in three separate classical Chinese texts. Each offers a different perspective arising out of the socio-political mood of the period in which they were written. Which, if any, is factually correct is not the question Wang Jianwei sets out to answer. In the manner of a Shakespearean tragedy, he merely revisits the inevitable: the duplicitous facts of recorded history. This multimedia presentation begins with the archaeological discovery of a drum—the embodiment of the rites of a ritualistic past—projected symbolically upon a screen. Mi Heng's drum was the instrument of his humiliation and the harbinger of his own demise. In this visually stark performance, the four main actors switch between roles and time periods without

4. Cao Cao was the self-appointed imperial secretary of the Han Dynasty and the de facto ruler of Northern China during the beginning of the period of Three Kingdoms.

∧ Stills from Spider, 2004

warning as they debate the merits of historical remembrance: why this person over that? The presence of a two-person chorus—in the tradition of Greek tragedy—on the stage provides the key to the action. *Ceremony* is a simple drama presented in a disorienting, complex and intrinsically Chinese fashion. Familiarity with the classical novel *Romance of the Three Kingdoms* is of enormous help in grasping the nature of imperial Chinese spin upon which *Ceremony* pivots.

In video works, installations, plays and performances, Wang Jianwei remains faithful to a tireless probing of Chinese culture and the relevance of a contemporary art to contemporary society. As with his painterly homage to Francis Bacon, Wang Jianwei becomes fixated upon a theme, wrestling with it across several works before exhausting its visual power and metaphoric value. Hence the repeated appearance of masks, puppets, triangulated plots and gestures as a vehicle for indicting history and the encroaching social predicaments aroused by modernisation. Positively perhaps, in much of what he does, Wang Jianwei's opinions perturb many of his own generation, even those he counts as friends. To some he is a wacky eccentric who spends too much time alone, too much time thinking. Some simply cannot grasp his perspective or are distracted by single elemental details, such as the opening video sequence to *Screen*, where naked bodies press hard against glass, hands grope malleable clutches of another person's flesh as limbs swerve sensuously in a bath of fruit saturated liquid. Raunchy, sexy stuff, his friends joked over dinner, with no sense of its integral role in the whole play. Wang Jianwei is one artist that others (in China at least) tend to view through details, because they find it harder to follow the links that join his chains of thought. This constant entwining of motifs and styles, and the sudden switches between mediums, is not a deliberate ploy on his part, but one that gives him certain satisfaction. "I have never stopped in one place, mentally or creatively, and thus never given anyone the possibility to pigeonhole me." As if to prove his point, in 2005, he added "curating" to his endeavours. So, far from being a black and white career path, which to Wang Jianwei is all that matters.

Seated in front of one of the paintings from the Teahouse series,
exhibited at the inaugural show of the CourtYard Gallery, Beijing, 1997

AFTERWORD

In the process of approaching publishers with this book project, the question I was most frequently asked was: Why only nine artists? It was the opinion of Harald Szeemann that I should have been writing about hundreds of artists. From the perspective of the culturally rich continent of Europe, it is not hard to see why people thought this way. Given the number of artists at work in most nations, most people imagine that a country the size of China, home to 1.3 billion people, would also have a sizeable community of artists commensurate with the population. Yet, this is not so. In 1995, during a discussion between seven artists from Beijing and the same number from Berlin, one of the Berliners asked how many contemporary artists there were in China. The Chinese group went into a huddle and there was five minutes of excited whispers before they turned with pride to announce the figure of two hundred. Pride turned to bewilderment when the Berliners replied that there were three thousand registered practicing artists in Berlin alone. The reason why there are relatively few artists per head of the population in China goes beyond aggressive politics and is rooted in the long periods of cultural isolation that China endured as much as the poverty that afflicted most of the people. At least prior to opening and reform, and the twenty-first century.

In 1985 when the artists profiled here emerged the community comprised little more than a handful of graduates in each city. The numbers soon proliferated. In 2002, artists living within the Tongxian community in the eastern suburb of Beijing produced a directory of the village and its environs listing nearly four hundred artists. Classes at the art academies now run to as many as forty or fifty students—four to five times that of the 1980s and early 1990s. Yet a smaller percentage of graduates become "artists".

The second question, one inalienably tied to the political correctness of our times, was why no women artists appear. The answer proved equally perplexing to anyone who asked it: The simple fact that no woman artist had a hand in shaping the first wave of avant-garde in China, nor made an enduring contribution in the 1980s. The exception that might be proposed in Xiao Lu, the lady

who shot her artwork down at the opening of the "China/Avant Garde" exhibition in 1989. This is the event that opens the next act, the evolution of avant-garde art in China through the 1990s. But in all fairness to other artists, where the work that sustained the bullet hole was Xiao Lu's graduation work, she had hardly taken a first step on the scene before the incident forced her retreat to Australia where she remained until 1995. She, like the other women artists who emerged through the 1990s, and did exert considerable influence upon the art being made, will be accorded their place in the next installment.

There was one further reason why, in terms of the New Art Movement, the first wave of avant-garde art in China, the number of artists profiled seemed to me to be just right. Together they cover all the schools, styles and trends that emerged from 1985 to the early 1990s. Further, together they laid the foundation for all that exists today. Given that the entire number of avant-garde artists is small, and against the Chinese penchant for imitating, for taking ideas and reworking them—to greater and lesser degrees—innovation comes within very limited pockets. The nine artists I chose here are innovators, leaders; that's not to say others were "followers". but that they weren't quite as ahead of the fleld as these nine were. The selection was also made with consideration to those artists who remain in China—with the exception of New York-based Xu Bing, but who produces many works in the PRC—and of whose evolution I have had firsthand experience. I could not have done such justice to the lives of Huang Yongping or Chen Zhen—living outside their worlds, in Paris—and against the comprehensive writings of curators like Fei Dawei and Hou Hanru.

As Chinese art gains a wider exposure in China, the influence of these founding fathers becomes increasingly distinct. In November 2004, Wang Guangyi, Zhang Peili, Wang Jianwei and Xu Bing were all appointed to the board of OCAT, the OCT Contemporary Art Terminal in Shenzhen; a significant affirmation of their status. For these reasons and so many more, these nine artists have a unique edge on their contemporaries.

THANKS TO:

Liu Heung Shing for his memorable portraits of the artists

Howard Farber, China Avant-Garde Inc., New York and the Farber Collection

Uli Sigg, and the Sigg Collection, Switzerland

Jean-Marc Decrop at Galerie Loft, Paris

Larry Warsh

Alice King at Alisan Fine Arts, Hong Kong

Lorenz Helbling, Laura Zhou, Helen Zhu and Chen Yan at ShanghArt Gallery, Shanghai

The late Nikos Stangos

Michael Rush, PBICA, USA

Francesca dal Lago

Fei Dawei, Paris

Zheng Shengtian, Vancouver

Hu Fangfang

Also particular thanks to:

Zhang Jing, Creative Director; Yu Shuai & Xie Ming designers

Beijing Yuemutang Art, Design & Photography Ltd.

Susan Acret for her meticulous editing

Teresa Go for being the most diligent and efficient editor a writer could hope to work with

Melinda Liu, Conrad Del Villar, for comments and suggestions

May Cheung for support

He An for logistics

And especially to all the artists for sharing their impulses and experiences